ROOKWOOD
and the
AMERICAN
INDIAN

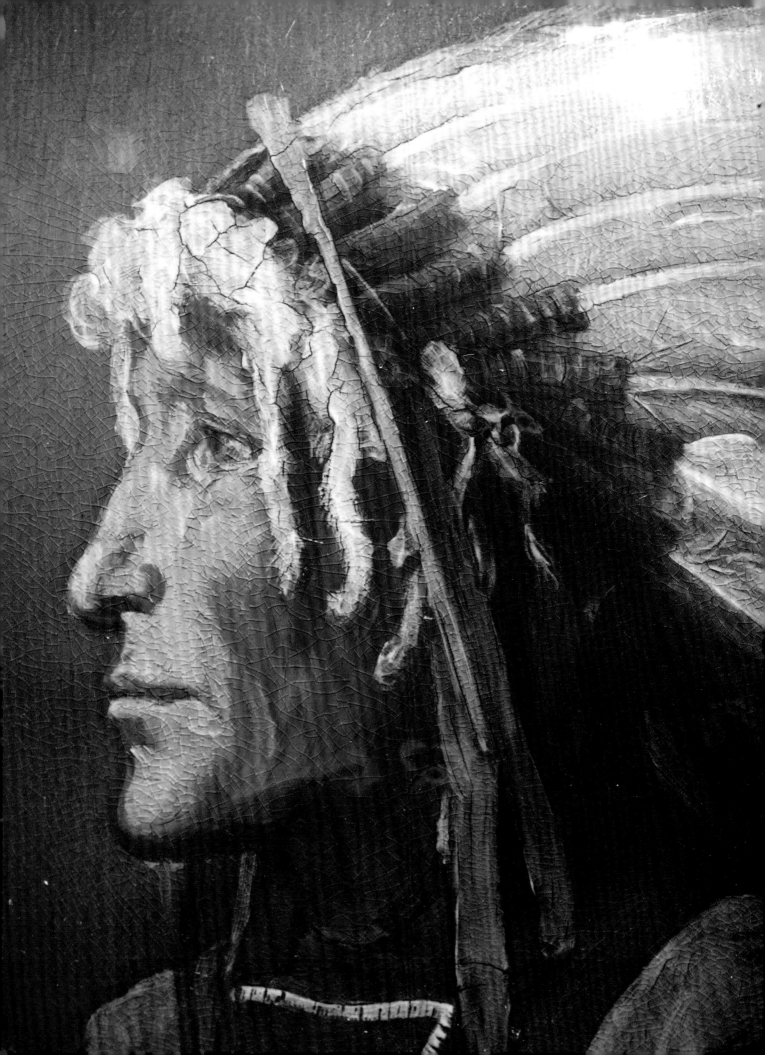

ROOKWOOD
and the
AMERICAN
INDIAN

Masterpieces of American Art Pottery
from the James J. Gardner Collection

Anita J. Ellis

Susan Labry Meyn

Foreword by George P. Horse Capture, Sr.

CINCINNATI ART MUSEUM

OHIO UNIVERSITY PRESS

ATHENS

Ohio University Press, Athens, Ohio 45701
www.ohio.edu/oupress
© 2007 by the Cincinnati Art Museum

Printed in China

Ohio University Press books are printed on acid-free paper ∞ ™

15 14 13 12 11 10 09 08 07 5 4 3 2 1

Library of Congress Cataloging-in-Publication Data

Ellis, Anita J.
 Rookwood and the American Indian : masterpieces of American art pottery from the James J.
Gardner collection / Anita J. Ellis, Susan Labry Meyn ; foreword by George P. Horse Capture, Sr.
 p. cm.
 Exhibition catalog.
 Includes bibliographical references and index.
 ISBN-13: 978-0-8214-1739-3 (cloth : alk. paper)
 ISBN-10: 0-8214-1739-8 (cloth : alk. paper)
 ISBN-13: 978-0-8214-1740-9 (pbk. : alk. paper)
 ISBN-10: 0-8214-1740-1 (pbk. : alk. paper)
 1. Rookwood pottery—Exhibitions. 2. Rookwood Pottery Company—Exhibitions. 3. Indians
in art—Exhibitions. 4. Gardner, James J.—Art collections—Exhibitions. 5. Pottery—Private
collections—Ohio—Cincinnati—Exhibitions.. I. Meyn, Susan L., 1942– II. Cincinnati Art
Museum. III. Title.
 NK4340.R7E428 2007
 738.09771'7807477178—dc22

 2006038396

Contents

Foreword *vii*

Preface *ix*

Acknowledgments *xi*

Introduction *xv*

Enduring Encounters: Cincinnatians and American Indians to 1900 *1*
Susan Labry Meyn

Rookwood and the American Indian *60*
Anita J. Ellis

Catalogue of the James J. Gardner Collection *129*

Appendix 1. Rookwood Artists of Indian Portrait Decoration *273*

Appendix 2. Photographers of American Indians Whose Work
Was Used at Rookwood *275*

Bibliography *277*
Enduring Encounters *277*
Rookwood and the American Indian *282*

Index *287*

Foreword

WHEN LOOKING around today, one can see many different kinds of people one has never seen before. Many of the newcomers started their journey here from faraway exotic places, such as Cambodia, Burma, India, China, Africa, California, and, of course, Europe and Mexico. And each group has its own pot boiling. As usual, the American Indian people find themselves at the bottom of the list because numbers decide important matters and there are only two and a half million of us. When we came to this hemisphere well over ten thousand years ago, we were the only human beings, and our world was filled with peace and calm. Now it often appears that our values and our world are lost in the chaos of the multitudes.

But on occasion a book pops to the surface of the maelstrom and its clarity and depth provide insight and confirmation that the American Indian people are indeed deeply embedded in the fundamental bedrock of the hemisphere and closely woven into its complex fabric at all levels. If one looks closely, one can see we are nearly everywhere. Over the centuries we left deep footprints across the face of the hemisphere and still do.

Upon first hearing of Plains Indian images on pottery, a non-Plains item, I associated them with the non-Indian items decorated with Indian designs and motifs made by the Plains Indian "students" at Hampton, Virginia, in the late 1870s, then by the Indian "students" at Carlisle, Pennsylvania, in the 1880s. That notion was dispelled at first glance. The Rookwood American Indian pottery revealed another example of the Indian people's lasting impact within a curious admixture. It added another stick to the bundle that binds the Indian people and Cincinnati closely together. Such binds are everywhere.

The impressive, well-researched historical essay by Co-curator Susan Labry Meyn leads one down a familiar Indian history trail, one I often travel to keep my head straight. But this time the trip can be compared to a chain, with the overview of Indian history forming its length, and each link telling its own distinct story as it circles around,

completing itself at Cincinnati. The Ohio River and Valley, the Indian people, their trails, the Mounds, the settlers, the Cincinnatians, the Indian removal, the "Wild West show," the Indian visitors, continued contact, and other links in the chain tell the ongoing story—and they all touch Cincinnati. Once readers recognize the structure of the links, they might wonder, as I did, "What's next? What other Cincinnati-Indian associations are there?"

This trend becomes more concentrated in the highly detailed, sometimes parallel essay by Director of Curatorial Affairs and Curator of Decorative Arts Anita J. Ellis. In this section we explore a commercial type of pottery that is decorated with painted images of real Indian people, some known, others unknown, and then glazed by a thick, rich, colorful layer of glass. And again the Cincinnati links began to form as the parties were introduced—all from this fair city: the owner, Maria Longworth Nichols; the company, Rookwood Pottery; a painter of Western Indians and a key painter of the Rookwood images, Henry F. Farny; a painter of Western Indians and an influential force at Rookwood, Joseph Henry Sharp; and many others. And the text is filled with technical pottery details for the connoisseur.

So, come along for this special ride to the Cincinnati region and discover several different worlds connected by the American Indian. This story is a unique addition to the enduring legacy of the American Indian.

George P. Horse Capture, Sr.
Senior Counselor to the Director Emeritus,
National Museum of the American Indian, Smithsonian Institution
April 2006

Preface

I FIRST MET Mr. James J. Gardner with his lovely wife, Joan, in 1988. Jim was just beginning to collect Rookwood pottery and was doing so for the purest of all reasons: he liked it. He liked the beauty of it, and he liked the history that it represented. For him the lyrical forms and decorations were unsurpassed in art pottery; and the product informed the history of Cincinnati at one level, and spoke to the history of America at another. It is not surprising that as his collecting evolved, his favorite type of Rookwood depicted the American Indian, a genre that embraces both history and beauty.

What Jim did not realize when he graciously consented to our request for an exhibition of his favorite pieces was that he would be sharing history and beauty in additional ways. Historically, the exhibition is the first dedicated to Rookwood's American Indian subject matter; and aesthetically, it is the foremost collection of its kind. It is historically significant at another level as the first Rookwood exhibition in Cincinnati to equally combine the separate academic disciplines of anthropology and art history into one study for greater enlightenment. The beauty is that the exhibition is made available through an exceptionally fine gentleman. Jim Gardner never ceases to share his success (in collecting and other endeavors) with the community around him. He is sensitive, helpful, kind, quietly generous, and proud of his beloved Cincinnati. We in turn are proud to know someone as fine as Jim Gardner, and we recognize that he is very much a part of the history and beauty that enhances the quality of our daily lives.

Jim, we salute you, and warmly express our sincere gratitude for all you do.

Anita J. Ellis
Deputy Director, Curatorial Affairs

Acknowledgments

The success of this exhibition and catalogue could not have been achieved without the support, advice, and expertise of many individuals. Much appreciation goes to former Cincinnati Art Museum Director Timothy Rub for his commitment to the exhibition, and to Director Aaron Betsky for his interest and total support as it came to fruition. Special gratitude is due to Michele and Randy Sandler and Riley Humler of Cincinnati Art Galleries, who freely shared their extensive photographic library of Rookwood pottery for the catalogue and exhibit.

Librarians and historians in Cincinnati performed yeoman's service—they led the authors to obscure references, generously gave of their time and knowledge, and answered numerous picky questions. An enormous debt of gratitude is due Librarian Rick Kesterman and also to M'Lissa Kesterman, assistant librarian at the Cincinnati Historical Society Library; both shared their knowledge of Cincinnati history. Other librarians and their staff also added to the scholarship: Alice Cornell, former head of the Rare Book Department at the University of Cincinnati; Sylvia V. Metzinger, manager of the Rare Books and Special Collections Department at the Public Library of Cincinnati and Hamilton County; Anne B. Shepherd, reference librarian at the Cincinnati Historical Society Library; and Don Tolzman, curator of the German-Americana Collection at the University of Cincinnati. Librarians in far-flung areas of the United States also assisted with the research—Frances B. Clymer, a librarian at the Buffalo Bill Historical Center in Cody, Wyoming; and manuscripts librarian Mattie Sink and her staff in Special Collections at the Mitchell Memorial Library, Mississippi State University. A special thank you goes to Marcella Cash, director of the Sicangu Heritage Center at Sinte Gleska University, who was kind enough to introduce Meyn to Lakota Sioux elders on Rosebud Reservation.

Utmost gratitude goes to Cincinnati Art Museum Administrative Assistant Carrie Cline, who assisted in the academic research and adeptly discovered the source photography for the images of the American Indians depicted on the pottery. The source photography that she could not find electronically was discovered in Washington, DC, by the excellent site researcher Susan Hormuth. Also ably assisting in the academic research were Assistant Curator of Decorative Arts Amy M. Dehan and Curatorial Assistant Katherine Rush. Beyond those in the Museum's curatorial division, numerous individuals have contributed their counsel and skills: in the Operations Division, Director of Finance and Operations Debbie Bowman and her superb crew; in the Finance Department, Assistant Director of Finance and Administration Carol Renfro and her skilled personnel; in the Development Division, Deputy Director for Institutional Advancement Susan L. Dorward, Director of Development Susan Laffoon, and the excellent staff in that division; in the Marketing Division, Director of External Relations and Marketing Cindy Fink, Assistant Director, Communications Natalie Hastings, and the outstanding personnel in that division; in the Education Division, Curator of Education Ted Lind and his accomplished curators Amber Le Lucero-Criswell, Emily Holtrop, and Marion Cosgrove-Rauch, as well as Manager of Docent Programs Julia Vienhage; and the remarkable Museum Services Division—Deputy Director Stephen Bonadies; Chief Registrar Kathryn Haigh; Registrar, Permanent Collection Jay Pattison and the unfailing registration staff; Photographic Services Coordinator/Rights & Reproductions Administrator Scott Hisey, whose skill and knowledge in the realm of imaging is unsurpassed in any museum; and Exhibition Designer Matt Wizinsky with Graphic Designer Julie Nedzel, Chief Preparator Christopher P. Williams, and the expert design and installation crew that physically made the exhibition a showcase.

Special recognition is owed to copublisher Ohio University Press, with Director David Sanders and his proficient and gracious staff who make top-quality publishing look easy. Anita Buck's editorial skills enhanced the catalogue and John Painter's detailed knowledge of Plains Indian photographs enabled us to fine-tune the commentaries. Some of the material relating to the Rosebud Sioux encampment has been published in a different form in the *Journal of American Indian Culture and Research*. Herman Viola, historian emeritus of the Smithsonian Institution, and Bradley T. Lepper, curator of archaeology at the Ohio Historical Society, graciously agreed to review the "Enduring Encounters" essay. Kathryn A. Russell deserves the utmost recognition as she managed this catalogue for the Cincinnati Art Museum with her usual excellence in copyediting, picture research services, and all those things necessary to prepare it for submission to the copublisher.

No exhibition and catalogue could ever become reality without the kindness and generosity of its sponsors. The Cincinnati Art Museum wishes to offer sincere gratitude to the Henry Luce Foundation for supporting our ongoing research of Cincinnati's artistic heritage. In addition, the Cincinnati Art Museum gratefully acknowledges project support from the Farny R. Wurlitzer Foundation, an anonymous donor, and several friends of the museum. Unreserved appreciation for operating support goes to the Fine Arts Fund, the Ohio Arts Council, and the City of Cincinnati.

And of course, more gratitude than can be expressed is owed to James J. Gardner, who started it all when he began collecting Rookwood pottery.

Anita J. Ellis
Deputy Director, Curatorial Affairs

Susan Labry Meyn
Consulting Ethnologist

Introduction

THIS EXHIBITION and catalogue seek to examine the purpose, process, history, and artistic quality of American Indian imagery on Rookwood pottery. By singling out one form of decoration, this examination can focus on the day-to-day operations of the Rookwood Pottery Company as never before. The questions of why the imagery was chosen, why it was expressed in a particular style, and why it was ultimately discontinued have one answer: marketability. The Pottery's Native American imagery sold well, and once it ceased to do so, it was dropped from Rookwood's portfolio of decorations. Still, the fundamental question remains: Why did it sell well? Economics alone cannot answer the query. Certainly the Pottery's prowess in ceramic engineering figures into the explanation, as does the artistic ability of the company's decorators, but there were additional forces at play in the market.

The key element is America's nostalgia for its disappearing frontier and the people and activities associated with it. Through art and literature Great Plains Indians, in their feather warbonnets and fringed leathers, became the powerful stereotype for all Indians. To understand the history of the American Indian in white America is to understand the overarching reason for the use of Native American imagery. Consequently, the academic discipline of decorative arts has been complemented by anthropological research in equal measure. Offering parity to two disciplines gives heightened promise to the catalogue and offers a broader, more meaningful understanding of Native American imagery on the Rookwood product.

Anita J. Ellis
Susan Labry Meyn

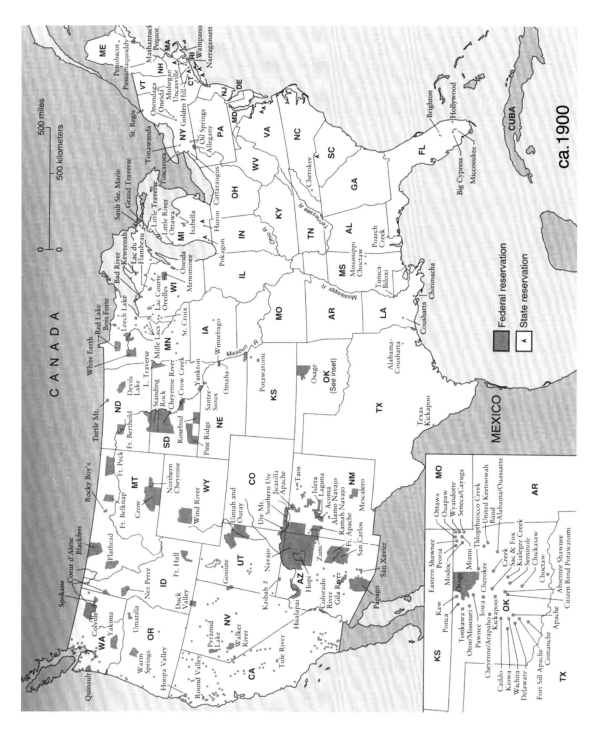

"Federal and State Reservations," from *Encyclopedia of North American Indians,* edited by Frederick E. Hoxie. Copyright © 1996 by Houghton Mifflin Company. Reprinted by permission of Houghton Mifflin Company. All rights reserved.

ROOKWOOD
and the
AMERICAN
INDIAN

ENDURING ENCOUNTERS

CINCINNATIANS AND
AMERICAN INDIANS TO 1900

Susan Labry Meyn

> Notwithstanding all that has been written and said, there is scarcely any subject on which the *knowing* people of the East, are yet less informed and instructed than on the character and amusements of the West: by this I mean the "Far West;"—the country whose fascinations spread a charm over the mind almost dangerous to civilized pursuits.
>
> —George Catlin

CINCINNATIANS EXPERIENCED the dangerous charms of frontier life for about a decade and then, almost before they realized it, their frontier years were over and they were citizens of the sedate Queen City of the West.

Cincinnati's frontier period began on an icy day in December 1788, when a group of settlers stepped off their flatboats and founded Losantiville, the village that eventually became Cincinnati. Above them, literally covering the upper plain of the future city, were "low lines of embankments," the earthen remains of a prehistoric Indian population.[1] Soon after the pioneers' landing, roaming parties of hostile Indians began attacking the infant settlement, which by early 1790 was protected by a large garrison of federal troops at Fort Washington. The Treaty of Greenville in 1795 brought peace to the troubled region, and with peace, numerous immigrants, so that by 1818 Cincinnati was officially a city.

Throughout the late eighteenth and nineteenth centuries, Cincinnatians had many opportunities to meet Native Americans and experience Native culture. During this time Cincinnatians' encounters with living American Indians ranged from hostile confrontations in the region that became known as the "Miami slaughter house" to enthusiastic interactions with visiting Wild West show performers.[2] Their responses to Indian art and artifacts ranged from careless destruction of Indian mounds to admiration and emulation. The legacies of these diverse encounters and interactions endure to this day.

The American frontier was a wide-open borderland where nonconformists, outlaws, and entrepreneurs of all types interacted with one another and with settlers and Native inhabitants in a dynamic free-for-all. As the frontier moved steadily west, farther and farther from Cincinnati, the public's perception of Indians also changed. Whether white society thought of Indians as noble savages or savage Red Men often depended on how ferocious real confrontations were. By the late 1800s Cincinnatians, as well as other Americans, had romanticized Indians, creating an ideal Indian based on exaggerated or stereotypical images of America's aboriginal people.[3]

As the frontier receded into the western horizon, Indians living on the Great Plains, rather than the Eastern Woodland Indians with whom Cincinnatians were familiar, evolved as the stereotype of the Native American. This image was promoted by early American artists such as George Catlin, who featured Plains peoples, especially renowned warriors, in paintings and in exhibits of their artifacts and weaponry. Later, William F. "Buffalo Bill" Cody's popular frontier reenactments, complete with rugged scenes of the nation's Wild West and the Congress of Rough Riders of the World, entered the public imagination and fused with the nation's identity.[4]

The tale of Cincinnatians' contact with Native Americans is a labyrinth that scholars enter at their peril. The quest for authentic history—for a relevant and unprejudiced view of Indian relations with the city's first settlers—is complicated by the inaccuracy and sheer wild invention of most of the early material.[5] However, a few select sources whose information is confirmed by early documents or letters of that pioneer period illuminate the naked reality of frontier life during the city's earliest years.

During the first quarter of the 1800s, Cincinnatians' attitudes toward and perceptions of Indians varied widely. A few prominent citizens expressed their hatred of Red Men, while others immortalized them with personal collections kept as "cabinets of curiosities." These exotic collections, crudely documented and quaintly organized by modern standards, often were haphazard displays of foreign coins, unique seashells from distant

regions, and moundbuilder artifacts, organized as much by personal whim as by any temporal or scientific relationship between the specimens and artifacts. The collectors—often educated men or wealthy businessmen, and the occasional scientist—later donated these antiquities, together with more contemporary Indian artifacts, to local museums.

Other influential citizens chose to preserve a few Indian characteristics by joining the Tammany Society, a national political organization that came to Cincinnati in 1811. The society was named for the Delaware leader Tamenend, a benevolent man held in high esteem by early colonists. Members belonged to a "wigwam" (geographical division), smoked the calumet pipe, and participated in other Indian-inspired activities. While the society was democratic in principle, it was distinctly aristocratic in practice.[6]

Literary-minded Cincinnatians from a variety of social classes also admired Indians and featured the nation's first people in poetry, fiction, and historical accounts, albeit not always accurately. Artists portrayed Indians in a wide variety of media—even Rookwood's pottery. Hundreds of works of art or invention emerged from the fertile minds of Cincinnatians who encountered prehistoric relics, contemporary Indian artifacts, or living Indians.

Without realizing it, and for the same reasons, Cincinnati's first settlers had selected a site on "*the* thoroughfare" used in prehistoric time, the picturesque Ohio River.[7] The town's heavily forested site, located between the Great and Little Miami rivers and directly across from Kentucky's Licking River, embraced two plains, a lower and an upper plain (fig. 1). Present-day Third Street runs almost parallel to the brow that divides the bottomland beside the river from the upper region. William Henry Harrison, who examined the city's mounds with General Anthony Wayne in 1793, noted, "All the early voyages on the Ohio, and all the first emigrants to Kentucky, represent the country as being totally destitute of any recent vestiges of settlement." What appeared to the settlers to be an abandoned region was in fact a functioning hunting ground and battleground for rival Indian tribes living south of the Ohio and those in Indian country north of the river. For this reason, the "great highway" between the two Miami rivers became known as the "Miami slaughter house."[8]

This verdant, seemingly uninhabited scene invited settlement, deforestation, and agriculture. Civilized farming was the dream of each settler; wresting the wilderness from heathen savages was deemed proper and worth the risk. Numerous exaggerated tales about Indian-settler confrontations fill the early literature. Fortunately, some learned men had an eye for facts rather than hair-raising tales of Indian depredations.

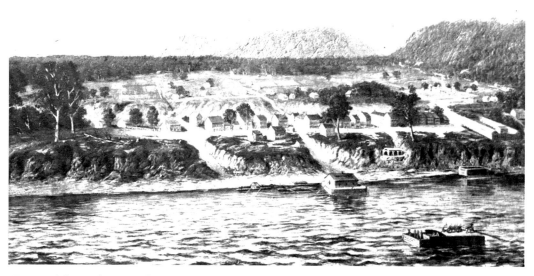

Figure 1. This early view of Cincinnati is from a 1903 painting, *View of Cincinnati–1800,* by Rudolph Tshudi (1855–1923). The scene illustrates the two plains on which Cincinnati was settled. The "brow," present-day Third Street, divides the bottomland from the upper region that was covered with various types of earthworks. *Courtesy of the Cincinnati Museum Center.*

Tales of Early Settler and Indian Conflict

In 1838 Doctor Daniel Drake, possibly the most respected physician, scientist, and literary personage west of the Alleghenies during those early years, delivered a speech, literally a historical memoir of the Miami country for the years 1779–94. Many of the city's aging early pioneers attended this important event celebrating the semicentennial of Cincinnati's first permanent settlement. Drake spoke for three hours to an overflowing audience who remained "enchained" while he narrated events that had occurred at Losantiville, North Bend, and Columbia, three villages now part of Cincinnati. Before relating stories of Indian and settler encounters, he enumerated the reasons for the antagonism, stopping to remind his listeners that prior to the settlement of the city in 1788, Indians already had been at war with eastern colonists. Drake maintained that the ensuing hostile relations and "almost every interesting incident" in Cincinnati's early history "may, directly or indirectly, be ascribed" to that protracted war. Moreover, Indians were dis-

satisfied with the treaties that gave the colonial government their lands, they disliked the conduct of traders who made the Indians drunk in order to ensure favorable dealing, and they vehemently disapproved of white encroachment and hunting on their land. To complicate matters further, whites acquired some lands from tribes who may not actually have had the right to cede them, thereby setting the scene for major misunderstandings and outright conflict, because both parties believed they had "unquestionable rights" to the land. The confusion generated hard feelings, resulting in retaliations that harmed innocent people on both sides.[9]

Drake told of horrible scenes of frequent bloodshed and grim privation, including stories of scalpings by Indians and by white settlers alike. Other tales demonstrated the Indians' desire for horses and explained why settlers frequently used oxen to pull their plows. For example, Indians attacked men working in their cornfields; when the farmers ran for their guns, the Indians quickly unhitched the horses and fled. In another incident Drake recounted, Indians stole horses tethered outside a "house of entertainment" on Main Street frequented by officers of the garrison.[10]

"Bloody 1791," Drake said, was "emphatically the romantic & military year of our history." That summer presented a "novelty" with the capture of more than sixty "pianke-shaw [Piankashaw] Delaware and Kickapoo" Indians, who were transported to and imprisoned at Fort Washington, the city's military post, built in 1789. Drake confessed he was unable to "collect anecdotes concerning them." He probably names the tribes correctly, because his account of the attacks that brought the Indians from Indiana to Fort Washington is accurate. In May 1791, General Charles Scott burned Wea and Kickapoo villages on the Wabash River; in August, General James Wilkinson attacked Miami town on the Eel River, and again burned Wea towns. (The Wea and the Piankashaw are sometimes grouped with the Miami in Indiana.) The captured Indians were marched to Fort Washington via Kentucky, possibly because the Kentucky militia was involved in both attacks.[11]

Two hundred years later, the anecdotes that eluded Drake can be found in an early diary kept by Johann Heckewelder when he traveled down the Ohio River in 1792–93. Heckewelder was the well-known Moravian missionary who worked and wrote about his experiences among Ohio's Indians. He published his detailed journal in Germany in 1797; it remains the earliest firsthand account of our city and other nearby towns.

Heckewelder and General Rufus Putnam arrived together in Cincinnati on July 2, 1792. The missionary chose not to stay at the fort with the general, preferring instead to stay in a local tavern and mingle with the townspeople. Despite some fearsome tales of

"savages" and the fact that the town was "overrun with merchants and traders and over-stocked with merchandise," Heckewelder was impressed with the fact that the settlement kept a minister. After a brief rest Putnam and Heckewelder visited the Indian women and children imprisoned at the fort—the Indians that Drake mentioned in his speech. They were being held under a strict guard and were grateful when Putnam told them that their "redemption was near at hand." The "Muster-master" assured Heckewelder that the lengthy imprisonment of "upwards of sixty prisoners" had cost the government over sixty thousand dollars. On August 16, 1792, the prisoners and their interpreter left Fort Washington for "Post St. Vincent," probably Post Vincennes on the Wabash.[12]

The dishonesty of "worthless traders" sometimes led Indians to retaliate against the settlers.[13] Drake and Judge John Cleves Symmes, who settled North Bend in 1789, agreed on this.[14] In one surviving story, traders "villainously cheated" Indians by selling them watered-down whisky that froze in the casks before they reached their camp. On other occasions Indians complained to Symmes about being overcharged for gun repairs.[15] During his 1792 Ohio River journey by flatboat, Heckewelder landed briefly at North Bend and visited Judge Symmes, who he said had gained the "love and friendship" of the Indians. This caring attitude, Heckewelder thought, was "better protection to the place, than a regiment of soldiers."[16]

Another source of conflict centered on the government's treaties with American Indians. James Hall—a Cincinnati lawyer, judge, historian, novelist, and publisher—recognized as early as 1835 that negotiations with Indians were "full of the strangest contradictions." The treaty system, the young government's method of dealing with its aboriginal people, acknowledged that those living within its territory were independent, autonomous nations, yet at the same time, treaties forbade them from acting as such. Indians, for example, were not allowed to sell their lands to anyone but the United States government. A hotly contested decades-long debate between humanitarian reformers and politicians ensued over the abolition of the treaty system, which was finally done away with in 1876. Hall's assessment of a major cause for Indian retaliation against white settlers was absolutely correct.[17]

No account of Indian-settler interactions would be complete without a story about a settler captured by Indians and allowed to live in captivity among them. Cincinnati's most memorable abduction occurred at Fort Washington during several days of celebration held in honor of the Fourth of July in 1792. Rounds were fired from the cannon, and a ball and a fine dinner were held at the fort. Colonel Oliver Spencer, a prominent pioneer who emigrated to the settlement at Columbia at the mouth of the Little Miami

in October 1790, had traveled downriver by flatboat with his family for the festivities in Cincinnati. While in the settlement, Spencer's only son, a lad of ten, was taken by Indians. His story, written forty years later and republished many times, recounted tales of horse thievery, the first scalp to come "to the infant settlement," his family's near massacre, and General Scott's capture of the Indians imprisoned at the fort. Young Spencer's account of traveling with his captors, his aborted escape attempt, life with the Indians, his ultimate release seven months later, and his lengthy journey home permits a tiny insight into Indian life at that time. Heckewelder also remarked on this frightening incident in his journal.[18]

Indians in Popular Literature

Terrifying events such as Spencer's abduction spawned numerous works of fiction about the West. The popular new genre known as the dime novel received its name from Beadle's *Dime Novels*, a reference to the paperbacks' highly affordable price of ten cents. The "spirited" dime novels, launched by Beadle and Co. in 1860, cornered the market on frontier stories for years to come. Thousands of Civil War soldiers read dime novels, and their popularity endured precisely because the stories belonged only to America. Tales of the frontier featuring exaggerated conflicts between Indians and settlers, gold miners, and cowboys in an eternally wild country were based on original American themes. Two novels actually were set in Cincinnati: *Joe Phenix's Double Deal* and *Deadwood Dick, Jr. in Cincinnati*.[19]

The most widely known author in this genre was E. Z. C. Judson, writing as "Ned Buntline," who created the literary persona of Buffalo Bill, thereby making William F. Cody a household name. Judson lived in Cincinnati in about 1844, prior to his success with Buffalo Bill, and together with H. A. Kidd published numbers one and two of the *Southwestern Literary Journal and Monthly Review* in the city. Later issues were published in Nashville.[20]

In addition to fictional stories originating from authorial flights of fancy, Cincinnatians also produced authentic frontier histories. The venerable publishing firm of Robert Clarke & Co. (1858–1909) gathered material typical of the area in its *Ohio Valley Historical Series*. All seven volumes, published between the years 1868 and 1871, contain early historical accounts of the region.[21] Nor did schoolchildren escape the influence of the frontier, thanks to William Holmes McGuffey, immortalized by the series of Eclectic Readers that bear his name. McGuffey arrived in Cincinnati in 1835 from Miami University in Oxford,

Ohio. "The Lone Indian," in the *New Sixth Eclectic Reader,* fostered a nostalgic attitude toward Indians in the story of Powontonamo, the last member of the Mohawk tribe, whose people had suffered the ravages of white civilization. The 1867 edition of the *New Sixth Eclectic Reader* was published in Cincinnati.[22]

Early Cincinnatians and Indian Mounds

Initially the city's pioneers did not realize that, long before their arrival, a prehistoric people had selected exactly the same beautiful and strategically important site on which to build. Inconspicuous earthen relics—mounds, embankments, and enclosures—of the earlier civilization stood on the upper plain above the river's bluff. The once numerous unknown people (today we know they were the ancestors of American Indians) who built the earthworks came to be known as the moundbuilders. The mounds themselves generated a great deal of speculation about the origins of their builders, including the theories that they were creatures from another race and that they were related to the Romans.[23]

In a history of Ohio's aborigines he wrote not long before he was elected president, William Henry Harrison recalled the day when, as a young officer, he examined the earthworks. "The number and variety of figures in which these lines [of earthworks] were drawn, was almost endless" and nearly covered the plain (fig. 2).[24]

The first official notice about Cincinnati's tumuli, as the mounds were referred to at the time, appeared in a letter dated September 8, 1794. Colonel Winthrop Sargent, secretary and governor *pro tem* of the Northwest Territory, wrote to Dr. Benjamin Smith Barton of Philadelphia and included drawings of "some utensils or ornaments" taken from an "extensive" mound on August 30, 1794. Several skeletons and bones were found with the artifacts, leading Sargent to think that the mound probably functioned as a burial site.[25] Later, Robert Clarke, publisher of the *Ohio Valley Historical Series,* suggested that the mound could have served as a watchtower for approaches from Kentucky.[26] This earthwork stood at the intersection of Third and Main streets, where a busy thoroughfare passed through the mound's western side. Drake, in his 1815 publication *Natural and Statistical View, or Picture of Cincinnati and the Miami Country,* gave the measurements as "about eight feet high, one hundred and twenty feet long, and sixty broad." At one time, he wrote, the mound attracted a great deal of attention, but due to the grading of Main Street, had been "almost obliterated." Drake lamented the fact that the mounds had

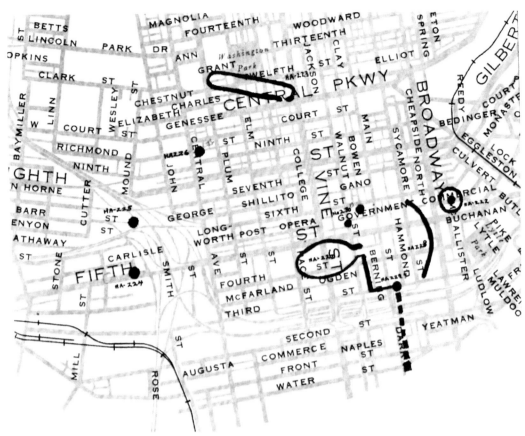

Figure 2. Map of prehistoric earthworks superimposed on a map of Cincinnati streets ca. 1960. President William Henry Harrison, a young officer when he surveyed the mounds, said that the variety of earthworks was "almost endless" and that they nearly covered the plain. *Cincinnati Museum Center—Cincinnati Historical Society Library.*

been "hastily and superficially" "examined by strangers" and that the city's citizens had "generally neglected" them.[27]

Cincinnati's largest mound stood at the intersection of Fifth and Mound streets. Drake described it as being about twenty-seven feet tall and said that General Wayne, in 1794, had cut about eight feet off the top for the purpose of erecting a sentinel post. In 1841, when the mound was again cut away for the grading of another street, the Cincinnati Tablet was found (fig. 3).[28] The tablet, consisting of a fine compact sandstone measuring five inches long and three inches wide at each end, excited scholars and the public alike. In later years, scientists began to debate its authenticity. Some archaeologists claimed the tablet was an outright fake produced by an "artful and sinister-looking man"

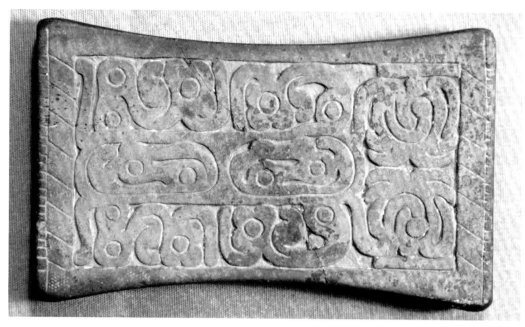

Figure 3. The Cincinnati Tablet was found in 1841 in a mound located at Fifth and Mound streets in Cincinnati. *Cincinnati Museum Center—Cincinnati Historical Society Library.*

in a "marble shop." Others thought it might have been deposited in the mound by a laborer. This furor prompted Robert Clarke to write *The Pre-Historic Remains Which Were Found on the Site of the City of Cincinnati, Ohio with a "Vindication of the Cincinnati Tablet."* Clarke traced the history of the carved tablet from the moment of its excavation. He reviewed all pertinent publications and interviewed knowledgeable parties, even J. L. Wayne, a boy when he took the stone from the mound.[29] Ultimately, the Cincinnati Tablet proved authentic; today it is in the Cincinnati Museum Center collections.

Drake scolded the public for its lack of interest in America's antiquities: "In the United States, there is indeed no redundance of time or money; but even in this young and parsimonious state, it is not uncommon to see appropriations of both, to objects of greater expense and lesser interest, than a survey of these curious relics."[30] Cincinnati's citizens were no different from most other Americans. In their haste to build a city, they leveled the ancient earthworks before they were properly surveyed and excavated. Yet there were several local poets who acknowledged the importance of Cincinnati's mounds. In 1823 Moses Guest published his poem "On viewing the Mound in the western part of Cincinnati," dedicating his work to the once spectacular earthwork at Fifth and Mound streets. Other poets, too, penned works entitled "Ancient Works upon the City's Site" and "To the Old Mound."[31]

Cincinnati Archaeology

In order to understand how the mounds themselves and the material excavated from them influenced Cincinnatians, we need to review briefly the work of an eminent Ohio geologist and a few Cincinnati archaeologists, both amateur and professional. In time, their zealous explorations captured the attention of some of the country's most prominent scientists, who featured Ohio moundbuilder artifacts, maps of the earthworks, and publications about Ohio mounds at local and national expositions. The Bureau of American Ethnology (BAE), founded in 1879 under the aegis of the Smithsonian Institution, published scientific papers discussing Ohio mounds and moundbuilders, including Cincinnati sites. These scholarly publications and the exhibitions of moundbuilder artifacts and art had far-reaching influence on the work of future painters, pottery artists, and silversmiths. The drawings in the BAE publications stimulated them to fashion moundbuilder-inspired works of their own. Two of several Rookwood pottery vessels feature decorations replicating moundbuilder shell gorgets, a type of artifact presumably worn below the throat: cat. no. 7 is a vase with the gorgets made of copper overlay and cat. no. 43 is a loving cup with the gorget made of silver overlay.

Charles Whittlesey, a geologist and former president of the Western Reserve Historical Society, stands out for his work as a topographical engineer of Ohio. As a member of the corps that assisted with a geological survey of the state, he investigated venerable ruins—ancient tumuli, forts, excavations, ditches, and lines of embankments—during the years 1837 and 1838. He personally examined the ruins and credited some of the earlier descriptions as being accurate, finding others downright "fictitious." The team completed two survey reports before funds were suspended. In his 1850 Smithsonian publication, *Descriptions of the Ancient Works in Ohio,* Whittlesey discussed the "Ancient Works at Cincinnati (Now Obliterated)," stressing the fact that both the moundbuilders and the "city builders of our own times" had selected many of the same sites for occupation.[32]

In 1845 Ephraim Squier and Edwin Davis began, at their own expense, a systematic exploration of the hundreds of earthworks throughout Ohio; they published the results of their research in the first volume of the *Smithsonian Contributions to Knowledge* in 1848. Whittlesey generously gave them the survey information they requested, and they in turn acknowledged the importance of his early fieldwork.[33]

The December 1841 discovery of the Cincinnati Tablet captured everyone's attention —scholars and public alike—and roused a hotly contested debate about its authenticity. Squier and Davis discussed the tablet, noting that it is nearly impossible to replicate the

tablet's delicate curvilinear carving, and admitting also that deducing its function "is another matter."[34] Many archaeologists today think that the tablet might have functioned as a printing stamp for leather and hide because red ochre has been found on other stone tablets from the same period.[35]

Later, the enigmatic moundbuilders and their earthworks became the avocation of Dr. Charles L. Metz, a physician from Madisonville, Cincinnati. He organized a group of amateur archaeologists under the name Literary and Scientific Society of Madisonville. Their work, conducted mostly in the late 1870s and 1880s, was well directed and resulted in carefully prepared articles that described their archaeological work and findings in the *Journal of the Cincinnati Society of Natural History.*[36] Even though these endeavors demonstrated they were more than "mere weekend dilettantes," the society's real interest was in artifacts found in the mounds. Several accounts describe the group standing beside a Madisonville burial site "eagerly waiting to snatch its contents" for their personal collections.[37] Metz's obituary claimed that he "had the distinction of being the first person to find gold buried in prehistoric mounds." In fact the term "gold" is used metaphorically: Metz did indeed excavate rare and valuable moundbuilder ceremonial artifacts in Anderson Township, but none were actually made of the metal gold. Fortunately, many of these objects in the Madisonville Society's collections found their way into Cincinnati Art Museum collections.[38]

The Madisonville Society's discoveries in the Little Miami Valley enticed Professor F. W. Putnam, of the Peabody Museum of Harvard University and the Chief of the Department of Ethnology and Archaeology for the upcoming World's Columbian Exposition, to become involved in excavating the dense concentration of mounds in Anderson Township. Prior to this time members of the society conducted excavations at their own expense. Putnam retained Dr. Metz as the director of the excavation.[39] In 1891, after the Columbian Exposition assumed financial responsibility for the excavation, Metz received an official notice appointing him Special Assistant in Putnam's department. Putnam also asked Metz to oversee the construction of a relief map of the Little Miami River, displaying "its banks, then the terraces and the position of the earth-work on the upper terraces, with the hill, and the Whittlesey mound, rising above."[40] Metz, under the title "collector," received twenty-five dollars for work done during June 1891, and, at the conclusion of the Columbian Exposition, a bronze medal and diploma for his scientific model.

While the society's excavations lacked today's precise methods and scientific knowledge, the members' archaeological work and their personal collections attracted a great

deal of attention from the local businessmen who planned the city's well-known industrial exhibitions. Metz's first acclaim came in 1883 when the Ohio Mechanics Institute awarded him a silver medal for his arrangement of archaeological relics at the Industrial Exposition held that year.[41] For Cincinnati's 1888 Centennial of the Ohio Valley and Central States Exposition, the planners specifically asked Metz to prepare "as extensive and complete an archaeological display as possible." Metz became known for his explorations both in Madisonville and in Anderson Township, and for his extensive collection. This prompted yet another request, from an officer for the Ohio Centennial exposition that was held in Columbus that same year.[42]

Cincinnati's Western Museum

Public interest in displaying local archaeological material in exhibitions and in museum settings can be traced to Daniel Drake, a true Renaissance man and progressive thinker. Drake respected the city's excavated antique Indian relics and kept his own extensive collection of objects gathered from the mounds, together with fossils and shells. He and other like-minded citizens contributed their artifacts and oddities to the Western Museum Society, which on June 10, 1820, opened the museum in rented rooms belonging to Cincinnati College, today the University of Cincinnati. Drake addressed the assembled audience, stating his goal—to present a complete illustration of the region's natural history with an emphasis on Ohio Valley zoology, fossil zoology, geology, and anthropology, along with a collection "of the weapons, utensils, trinkets, and other manufactures of our neighboring Indians." Some were obtained from Indian tribes themselves or from their deserted villages, together with objects "disinterred from the rude stone or earthen tumuli."[43] Some of Drake's ambitious plans for making Cincinnati the scientific capital of the West included scholarly investigations of Big Bone Lick in Kentucky and an in-depth study of the ancient Indian cultures of the Ohio Valley. In 1823, however, Drake suffered a reality check: the museum's operating expenses exceeded income; meanwhile, the entire city was suffering an economic depression. Ultimately Drake and the other managers handed the collection over to Joseph Dorfeuille, the museum's newly hired curator.

Dorfeuille, a Frenchman, possessed many of the same traits that would later make P. T. Barnum a national figure. Dorfeuille moved the museum close to the Public Landing, an area pulsating with activity—and with people who willingly paid to see not only

the scientific displays but also the sensational new waxwork exhibits, including the lurid "Dorfeuille's Hell." An 1828 review of the museum, however, claimed that the case containing Indian mound relics was the "most striking" part of the museum.[44]

During its heyday, under Dorfeuille, the Western Museum boasted a national reputation. After a disastrous fire and Dorfeuille's death in 1840, the institution languished and was dissolved in 1867.[45] In time a few of the moundbuilder relics from the Western Museum entered a private collection and eventually were donated to the Cincinnati Art Museum.[46]

Collectors and the Rise of Expositions

In addition to Metz, other prominent local individuals, such as Judge Joseph Cox, the Civil War general Manning Ferguson Force, and the wholesale grocer Thomas Cleneay, kept cabinets of curiosities containing archaeological collections (fig. 4). Cleneay, for example, one of the city's "old-time businessmen," possessed not only one of the largest coin collections in the United States but also an extensive group of "arrowheads" and "archaeological treasures" that he donated to the Cincinnati Art Museum.[47]

Cincinnati collectors' passion for their archaeological hobby prompted them to exhibit their collections at various expositions: the Cincinnati industrial expositions, the 1888 Centennial Exposition of the Ohio Valley and Central States in Cincinnati and Columbus (a number of expositions commemorating the anniversary of the first settlement of the Northwest Territory and State of Ohio were held statewide), and national exhibitions in Philadelphia, New Orleans, and Chicago. While planning for the 1888 Ohio centennial expositions, state archaeologists considered the expense of preparing an exhibit of moundbuilder relics worthwhile; they hoped the displays of stone tools, projectile points, shell beads and ornaments, and human bones would generate interest in local archaeological treasures and elicit sufficient funds to produce a quality publication that would be a credit to the state. This was not idle reasoning; Ohio had received first place for its archaeological exhibits at expositions in Philadelphia and New Orleans. However, because of a shortage of funds, archaeologists had to draw their displays from existing collections, thereby leaving sections of the state unrepresented. Instead of assembling a full and complete exhibit of the state's archaeology by going into the field and conducting fresh excavations, they were forced to depend on the generosity of collectors. Although lacking artifacts from some regions, the collections displayed were outstanding,

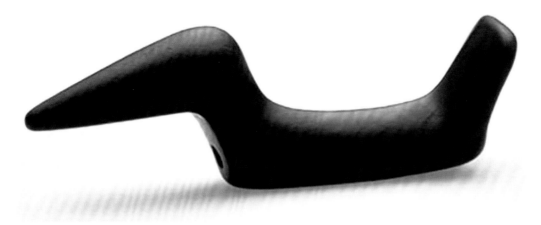

Figure 4. The source of this slate birdstone is unknown, but it was probably a surface find in the vicinity of Cincinnati. In 1885 Judge Joseph Cox gave the birdstone to the Cincinnati Art Museum. *Cincinnati Art Museum. 1885.512.*

leading the archaeologists to recommend that Thomas Cleneay's "magnificent collections" be exhibited in their entirety and become the property of the state.[48]

The history of exhibiting these personal archaeological collections helps us understand that, while some people relished the prospect of looking at grooved stone axes and chipped flint arrowheads, the majority of the public remained unenthusiastic unless the exhibit was enhanced in some way to capture their interest. Drake himself discovered that scientific exhibits alone could not generate enough admission income to offset the Western Museum's expenses. During the last quarter of the nineteenth century, exhibition planners and promoters, in Cincinnati and elsewhere, quickly realized that they needed to engage the public. They did so by adding and publicizing sideshow-style oddities and freaks of nature, exotic animals, and, increasingly, ethnographic displays of living aboriginal peoples from America and around the world. As disease, war, and poverty subdued Native Americans and the government confined the remaining Indian populations to reservations, American Indians became more attractive and romanticized because they were less of a threat.

Cincinnati had jumped on the bandwagon of hosting local expositions early in its history. The Ohio Mechanics Institute sponsored nineteen of these events, the first held around 1832.[49] Initially, the city's expositions were designed to educate the buying public about various useful and beautiful manufactured products newly available at the time, and were held with varying success until they were discontinued at the onset of the Civil War.

Difficult economic times after the war led to the resumption of annual expositions featuring "every branch of manufacture in the city and vicinity," in the words of Alfred T. Goshorn, who became known as the "father" of the Cincinnati industrial expositions. This brilliant series of industrial expositions began with a grand endeavor in the fall of 1870, and in future years followed the same general plan. Goshorn took over the 1871 and 1872 expositions, adding a department of natural history that included not only the expected fossils, minerals, and coins, but also displays of archaeological relics. (Goshorn's reputation for mounting successful exhibits led to his appointment as director general of the Philadelphia Centennial Exhibition in 1876.) Cincinnati's industrial expositions came to an end with the most elaborate one—the Centennial Exposition of the Ohio Valley and Central States—held from July 4 through October 27, 1888.[50]

The 1870 guidelines for exposition exhibitors were specific, stating that they must advertise extensively to "insure crowded halls." Awards encouraged exhibitors to prepare extravagant displays. Medals and diplomas were given for important machines capable of producing marketable items. Several awards went to the Cincinnati and Ohio archaeological presentations, including, in 1883, an Ohio Mechanics Institute silver medal to Metz for his display of archaeological artifacts.[51]

Opening in September 1879, the seventh Cincinnati Industrial Exposition, the most successful on record, boasted more than a thousand exhibitors. P. T. Barnum's six giant elephants were engaged to join the parade festivities. Elaborate exhibit halls of arts and industries displayed everything from kitchen stoves to enormous horticultural arrangements. The department of natural history embraced all aspects of the natural world, including archaeology. The exposition catalogue claimed this "may safely be considered the finest collection of this nature ever seen here, either in completeness or arrangement."[52]

The 1881 exposition prompted "a Vassar graduate" under the pseudonym "Clara De Vere" to write her own tongue-in-cheek "sketchbook" account of the exhibits (fig. 5). Cincinnati artist Henry Farny, later famous for his paintings of Plains Indians, illustrated the sketchbook. Farny's cover drawing is a lighthearted homage to the famous painting *The Artist in His Museum,* by Charles William Peale. (Peale, whom Drake knew, was a Philadelphia painter-naturalist and the founder of America's first public museum of science and art.) Farny's cover shows a demure yet steely-eyed Victorian woman, complete with bonnet and fan, gracefully holding back a curtain to reveal her own cabinet of Cincinnati curiosities—a Rookwood vase (almost certainly by Rookwood founder Maria Longworth Nichols herself), books, furniture, and a bust by Hiram Powers, the Cincinnati sculptor who crafted waxworks for Dorfeuille at the Western Museum and

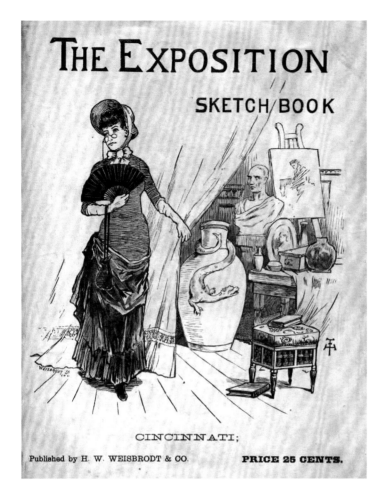

later became one of the most important artists of the nineteenth century. Farny's other drawings for this booklet are caricatures of the fairgoers viewing the various oddities, such as the natural history hall, which the author calls the "The Chamber of Horrors." There, viewers strolled among specimens of "dreadful and impossible creatures," including a mammoth that stood sixteen feet tall. They peered into numerous display cases—some of which probably housed some of the city's beautiful archaeological relics.[53]

The Emerging Role of Anthropology in Expositions

Cincinnati's successful track record in its local expositions led to important roles for Cincinnatians on the national exposition scene, especially for Alfred T. Goshorn, director-general of the 1876 Philadelphia Centennial Exhibition. Congress appropriated $1,500,000 for this celebration of the nation's hundredth anniversary. By the standards

of the day, Ohio's aboriginal culture was well represented. The archaeological exhibit was housed in sixteen large cases holding moundbuilder artifacts and historic Indian antiquities. A "series of charts" showed several "interesting" earthworks and "impressions taken from track rocks and rock shelters." Full-size reproductions of the state's pictographs were featured. A large map noted the position of nearly all known tumuli, the former territories of the different Ohio Indian tribes, and "all that could be thus shown of historical and archaeological interest." Eleven Cincinnatians lent artifacts to the archaeological display. The exhibit demonstrated that it was the "result of much labor and love," and the State Archaeological Society received an award for it.[54]

The 1876 Centennial Exhibition is important because ethnology was regarded as a critical component of a national fair; however, government officials and fair planners were uncertain about the most appropriate way to portray America's Native peoples. Spencer F. Baird, the secretary of the Smithsonian Institution, had the responsibility of overseeing the entire Indian exhibit. A primary goal was to have "a series of objects illustrating the habits, customs, peculiarities, and general condition of the various tribes" in addition to the relics of their predecessors. The dilemma facing the government centered on whether to have Indians present a living demonstration of their culture or to produce simply a "static display of Indian arts, crafts, and ethnology."[55]

Baird sent anthropologists into little-known areas of the United States to collect objects from Indian tribes who were under government pressure to acculturate, to become more "civilized" by abandoning traditional life ways and acquiring farming skills. Baird was concerned that large areas of the country would be underrepresented, so he sought the assistance of the Bureau of Indian Affairs (BIA), which in turn asked Indian agents on the different reservations to collect objects used at the time or in earlier times.

As the opening day of the exposition loomed closer, Baird focused on the idea of direct Indian participation. Again, BIA officials remained unenthusiastic, and after investigating the cost of such an endeavor, Congress refused to appropriate funding. Instead, Indians were reduced to the status of museum objects. Indian clothing was displayed on mannequins. Two famous frontier photographers contributed their images of Indians, thereby making it appear that Indians no longer existed. Without Indian participation the exhibit lost a key element that would have attracted audiences; the more profound loss was that white society failed to see any value in Indian societies. Ironically, the death of Custer and his troops at Little Big Horn occurred on June 25, during the Centennial Exposition, so Indians were featured prominently in the news of the day, though in an extremely negative light.[56]

Live Indians as Attendance Boosters

When costs for fairs and expositions soared, questions about their real purpose surfaced, forcing planners to consider the relevance of public pageantry or diversions such as the Art Department, which emphasized contemporary American artists. James Allison, president of the 1888 Cincinnati extravaganza, admitted in his report, "An exhibition of the Arts and Industries, pure and simple, no matter of what excellence, fails . . . to attract or satisfy the general public." It was only when he introduced "certain forms of light amusements, that any appreciable increase in attendance was noted."[57]

Businessmen, organizers, and promoters—including government officials and anthropologists—were responsible for the financial success of fairs and expositions as well as for the underlying agenda. For this reason they sometimes decided to include ethnological exhibits in their plans. These lucrative attractions were an important component of international expositions in such major cities as Chicago, Philadelphia, Omaha, Atlanta, Buffalo, San Francisco, St. Louis, and New Orleans. Placing ethnological exhibits on the midway gave the expositions the aura of one of P. T. Barnum's sideshows. In addition to satisfying the entrepreneurs and entertaining the white attendees who were the overwhelming majority, these multiracial exhibits reinforced the cultural supremacy of white society and the power of the United States. Whites, whether sipping lemonade or riding the Ferris wheel at the 1893 World's Columbian Exposition, could view the "exotics" in an aloof manner.[58]

Indian Delegations and Visits

Beginning early in our nation's history, numerous Indian delegations had made the difficult journey from their homelands in the West to Washington, where they aroused a great deal of curiosity. During the 1820s and 1830s powerful Indian leaders and their families traveled east, hoping to speak with the Great Father about pressing issues such as land allocation and the negotiation of treaties. They also planned to do a little sightseeing.[59]

Presidents and other federal officials practiced subtle intimidation through diplomacy. Indians were showered with gifts and honors. Exalted chiefs were given peace medals, and brought to inspect military installations, arsenals, and troops. These peace medals were cherished possessions to be buried with the individual or passed down

from generation to generation. Meanwhile, the Indian visitors returned home with amazing tales about what they had seen and with a heightened respect for American power and wealth.[60]

In late 1821 a delegation of influential headmen from different western Indian tribes traveled to Washington with government agent Benjamin O'Fallon. The Indians so impressed Washington society that they were invited not only to balls and parties but to private homes for tea. Their magnificent appearance and dignified deportment led Thomas L. McKenney, founder of the Bureau of Indian Affairs, to commission the American portraitist Charles Bird King to paint individual portraits of many of the delegates on canvas.[61] Through his association with the Indian office, King painted more than one hundred pictures of prominent Native leaders between 1822 and 1842; the collection became commonly known as the War Department gallery of Indian portraits.

McKenney envisioned a mammoth publication featuring the gallery. However, he had difficulty identifying a funder for the project. After several major setbacks, McKenney joined forces with Cincinnatian James Hall, a prominent judge who was also a prolific writer. Hall became the project's editor and agreed to write a biographical sketch of each Indian portrayed—a Herculean task requiring nearly a decade of research, because the promised background material for each Indian never appeared. McKenney and Hall's *History of the Indian Tribes of North America* is doubly important because many of King's original paintings were lost in a fire at the Smithsonian in January 1865, making the lithographic images created for the book the only surviving record of these Indians.[62]

Great Plains Indians and the Public Imagination

In the spring of 1833, Cincinnati was the site of what was probably the earliest showing of George Catlin's Indian portrait gallery. Catlin's mission was to record Plains Indians in the Far West before they passed into oblivion. During his journey he visited dozens of Plains Indian tribes, sketching and painting hundreds of individuals, all wearing traditional clothing and ornaments. He also painted famous warriors, "now prisoners of war," such as Black Hawk, the Sauk war leader. Beginning on May 27 the *Cincinnati Daily Gazette* advertised the exhibit on four different days.[63] This exhibition, held shortly after Catlin's return from the West, exposed Cincinnatians early on to the image that soon became the stereotype of the American Indian.

During the early 1800s accomplished artists such as Catlin and the Swiss painter Karl Bodmer (who accompanied German scientist Maximilian Alexander Philipp,

Prince of Wied-Neuwied, on his exploration of the Upper Missouri River) functioned like the photographers of the future. Their sketches and paintings enabled people east of the Mississippi to witness the frontier. As the western frontier became more settled and moved farther from eastern population centers, these same images became the ideal to which eastern imaginations turned. People yearned to see Plains Indians, in flowing fringe, galloping after bison across a wide-open prairie. The artists' written accounts of their experiences among the Indians disseminated the stereotypical image of the Plains Indians even farther, to Europe.

In 1832, on Catlin's search for the true "Far West," he first journeyed through Cincinnati. Here citizens told him, "Our town has passed the days of its most rapid growth, it is not far enough West."[64] The following year Catlin exhibited more than one hundred Indian portraits and explained the customs and manners of the people he had painted. Judge James Hall reviewed the works of this "ingenious artist" who at great personal expense and "hazard of life" had created an original enterprise. The collection also included sketches of the noble buffalo and open landscapes. A series of four pictures depicting a religious ceremony of the Mandans captured Hall's particular interest. He deemed the gallery a "most valuable addition to the history of our continent, as well as to the arts of our country."[65]

Cincinnati and the Indian Removal Act

Catlin's decision to paint Indians in their homelands west of the Mississippi coincided with the aftereffects of the Indian Removal Act of 1830. This law, inspired by white greed for Indian land, gave the federal army permission to forcibly remove eastern tribes to Indian Territory, a thinly settled area mostly in what today is the state of Oklahoma. President Andrew Jackson justified the act, claiming that relocating Indians on this land west of the Mississippi would keep Indian-white conflicts to a minimum. The tragic removal of the Cherokee tribe, which resulted in the deaths of thousands as they traveled on foot to their new home, is known as the "Trail of Tears." Ohio's tribes, all living in the northern part of the state, and Indiana's tribes also were forced to relocate.

Hundreds of Indians passed through the Queen City on their journey west. During the 1840s Cincinnatians witnessed large groups of Indians in transit. Some stayed for a period downtown. The Indians' activities have endured in local newspaper articles and in a memoir that includes artist Henry Farny's illustration of an Indian family walking down a city street (fig. 6).[66]

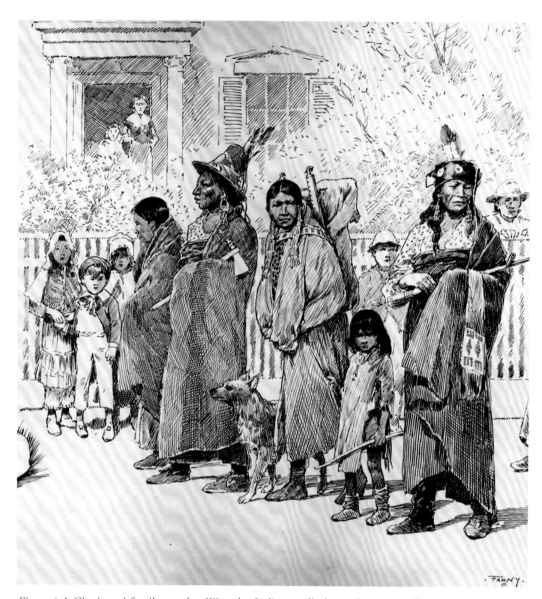

Figure 6. A Cincinnati family watches Wyandot Indians walk down the streets of Cincinnati to board a steamer bound for Indian Territory. The sketch, drawn by Henry Farny, appeared in William Dean Howells's book *A Boy's Town* (1890). *Private Collection.*

On August 19, 1843, approximately 650 Wyandot from Crawford County, Ohio, arrived in a long "melancholy" procession with wagons and horses. One columnist observed that the Wyandot "were but a sorry specimen of the 'Noble Indian,' of whose traits history and poetry, and romance have filled our mind with admiration." The group camped for the night at the steamboat landing and embarked the next morning on the *Nodaway* and *Republic*. During their brief stay "fire water" was "liberally" given

to many of them. One intoxicated young Indian fell into the water and drowned. "And who," asked one reporter, "is licensed by this Christian city to deal out death to the infatuated Indian?"[67]

The next to arrive were a Miami Indian chief, his family, and other headmen and their families. Along with approximately three hundred and fifty others, they had left their home on the Wabash River and were headed west. Most arrived via the Miami Canal on October 12, 1846, and walked down Main Street to the Ohio River, where they all boarded the *Colorado* for St. Louis. The contempt with which white people still viewed Indians is evident from the newspaper section under the headings "By the Miami Canal" and "Shipments." The report listed "350 Indians, with their Baggage." At the time, whites viewed Indians as a "shipment" on a par with "30 tons of Dry Goods" and "32 casks Government Stores."[68]

Watching Indians walk through the city's streets so impressed the young William Dean Howells that he wrote about the event in later years, when he was an established novelist. In *A Boy's Town,* Howells described the Wyandot removal through the eyes of a shy lad who lived with the hope of seeing a real Indian. Boys knew circus Indians were just white men dressed up and never dreamed live Indians would come to their river town. "The boys' fathers must have known that these Indians were coming, but it just shows how stupid the most of fathers are, that they never told the boys about it. All at once there the Indians were, as if the canal-boats had dropped with them out of heaven."[69] Howells confused the Wyandot's method of transportation with that of the Miami. It is in this Howells work that Farny's drawing of a white family watching the Wyandot walk past their house appears. In *Stories of Ohio,* Howells wrote that as a boy in Hamilton during the early 1840s he "saw the last of the Ohio Indians passing through the town on three canal boats" and "out of the land that was to know them no more forever."[70]

Not all the Indians traveling through Cincinnati in the mid-nineteenth century were on a forced march, however. Just a few years after the passage of the unfortunate Miami and Wyandot, in late November 1848, thirteen Chippewa—six chiefs, four head warriors, two women, and a baby—rode around Cincinnati in a wagon beating a drum and announcing their visit to the city. They stayed for about a week in Cincinnati before leaving for Washington, hoping to meet with President James K. Polk and make him aware of their plight. Although, in the early years of the nation, Indian diplomats frequently traveled to Washington at government expense, the Chippewa visit was unusual in that they were taking themselves on tour. They paid for their trip with the money earned from their daily presentations. Through their interpreter, the Chippewa told a

Cincinnati reporter that they planned to visit other major Eastern cities, dress in all their finery, and present exhibitions of their dances, songs, and games. In Cincinnati they hoped to raise traveling funds for their journey by presenting scheduled musical performances from the balcony of the Masonic Hall, facing Third Street. Their rhythmic chants had the desired effect—"letters, at the post office, were left unasked for—the banks suspended their discounts—brokers dropped their piles of gold uncounted, and all Third st. [*sic*] stopped, stood still, and seemed lost in silent admiration." The reporter thought this was an excellent opportunity for citizens to learn something about aboriginal manners and customs.[71]

Through the power of literature and art, the stereotype of the Indian evolved so that in time Plains Indian images, abilities, and character traits became the Indian Americans yearned to see. All types of circus show owners, medicine showmen, Wild West show organizers, and even government officials used this Indian image. However, at the time of the Chippewa visit, most American artists did not consider either Indians or their picturesque western environment a worthy topic. Most artists tended to paint Indians "in the more attractive aspect of his demi-civilized degradation than in the wild freedom of aboriginal manhood." Artists concentrated on the semi-assimilated Indian rather than showing Native Americans posing in "eminently picturesque and interesting" scenes peacefully sitting by their campfires or stealthily tracking an enemy or prey animal.[72]

Buffalo Bill and the Wild West

Realistic or even romanticized frontier scenes with Indians may not have titillated American artists, but the encounters certainly intrigued authors like E. Z. C. Judson, whose pseudonym was Ned Buntline. His dime novel *The Scouts of the Prairie,* featuring William F. Cody as Buffalo Bill, made Cody a hero and engraved his name into the history of the Great Plains. Prior to venturing into his well-known Wild West outdoor reenactment, Cody and Buntline took the Scouts on a stage tour. After appearing before a sold-out house in Chicago, the troupe opened a weeklong run in Cincinnati in late December 1872. Indian yells erupted from the crowd as they waited to purchase tickets. The play, according to the *Daily Gazette,* had "all the thrilling romance, treachery, love, revenge, and hate of a dozen of the richest dime novels ever written." No fewer than "forty braves and pale faces" were killed during the course of the play. The "braves" were painted white impostors, who shouted, danced, and shot "with more regularity than any genuine sons of the forest." Only one authentic Indian, an Apache, appeared. A week

later the newspaper stated that the spectators, who had packed themselves into the gallery of Pike's Opera House, were not from the "cleaner classes of our population." The house, the announcement continued, would be closed for a few days of fumigation after enduring its riotous western raid.[73]

Interest in Buntline's and Cody's stage presentation of the Wild West waned, but escalated once Cody moved the show to an outdoor arena for an Independence Day celebration in his hometown of North Platte, Nebraska, in July 1882.[74] A year later, on June 2, 1883, Buffalo Bill arrived in Cincinnati again—this time with eight buffalo, an elk herd, Texas steers, and "comical Mexican burros burdened with the outfits of wandering miners." Sioux and Pawnee Indians in "full war-paint and feathers" marched to the "Base Ball Park," accompanied by Buffalo Bill, the self-proclaimed marksman Dr. W. F. Carver, a band, and the actual Deadwood stagecoach. An immense crowd waited in the sun for the start of the "most original, sensational and pleasing street picture" and besieged the ticket office for nearly two hours. The park itself assumed a Wild West character. A whitewashed fence encircled the inner field and functioned as a racetrack for quarter-mile races. Cowboy, cook, and dining tents were located in the right-field corner and Indian tipis occupied the center-field corner. It was "a small, though complete picture of wild Western life transferred in realistic form to the heart of civilization."[75]

Buffalo Bill himself enthralled everyone with a remarkable sharpshooting performance. Once he broke two glass target balls simultaneously while holding his rifle with one hand. The outdoor show played to packed audiences, staying until June 10.[76] The following year, on October 19, 1884, the most celebrated of all frontier scouts again brought his Wild West to the "Base Ball Park." Cody's presence gave "an air of reality to the mimic business." The company was larger still. Texas steers and buffalo ran freely, then were lassoed and ridden by cowboys and Mexicans. The performance concluded with a simulated Indian attack on a settler's cabin, complete with cracks of rifle shot.[77]

During these early years the show endured financial difficulties and some hard luck, but Cody's idea was gaining steam. Annie Oakley, who at age fifteen was supplying game for a Cincinnati hotel, joined Buffalo Bill's Wild West in 1885; Sitting Bull, the famous Lakota Sioux chief who dubbed Oakley "Little Sure Shot," toured with the troupe that same year—Sitting Bull's only tour with the legendary Great Scout.[78] The rest is history. Thousands and thousands of spectators in America and on the Continent, including European royalty, paid to watch a dime novel in action.

By 1893, the year of the World's Columbian Exposition in Chicago, Buffalo Bill's show was practiced and highly sensational, acting out the romanticized "historical" scenes and western myths that people expected to see. Among other highly publicized events,

the program included a buffalo hunt, the Congress of Rough Riders, Indian war dances, the reenactment of Custer's Last Stand at Little Big Horn, and scenes from the Ghost Dance. Buffalo Bill's Wild West exhibition actually adjoined the Columbian Exposition fairgrounds near the main entrance; it was not part of the official site nor even affiliated with the exposition itself. Yet the show's profit "was estimated at $700,000 to $1,000,000 for the season." Exposition visitors felt they needed to see Buffalo Bill in order to say they had been to the world's fair.[79] Indians themselves enjoyed seeing both events.

For his "educational" shows Cody hired Indians, mostly Oglala Lakota Sioux, at the Pine Ridge Reservation in western South Dakota. Cody accepted Indians as equal to the other performers. His prestige and reputation for honest dealing allowed him to hire the Lakota without alarming either the Bureau of Indian Affairs or the Indian agents on the reservations, who were unnerved by any unexpected actions.[80]

The Tragedy of Wounded Knee

On December 29, 1890, the Massacre of Wounded Knee occurred at a creek of that name on Pine Ridge Indian Reservation. This horrific event, called the last of the Indian wars, resulted in the death of an estimated three hundred Native American men, women, and children mowed down by Hotchkiss guns as they were surrendering to the Seventh Cavalry, Custer's old unit. Throughout November the possibility of an impending Indian war in the West had frequently been front-page news in Cincinnati. Sitting Bull's death during an arrest by the Indian police on December 15 intensified the situation that led to the massacre.

Sitting Bull had openly challenged the government's land decision opening the Great Sioux Reservation to white settlement and dividing the land into six smaller reservations, thereby robbing the Sioux of millions of acres. Sitting Bull was also a disciple of the Ghost Dance movement, a religious ceremony prevalent on the Great Plains at that time. The people danced in circles and prayed for the return of their ancestors to earth, the restoration of Indian lands, and the return of the traditional Plains Indian way of life. The years before Wounded Knee had been grim; the despair and suffering on western reservations led many Indians to participate in the ceremony, a phenomenon that concerned some Indian agents. The Lakota Sioux were starving, owing to the near extinction of the buffalo and severe cuts in their government annuities. Even as far away as Cincinnati, newspapers reported on the desperation and hopelessness among the Sioux. These events led to the tragedy of Wounded Knee.

Prior to the massacre, a local reporter asked Cincinnati artist Henry Farny about the happenings in the West and the death of Sitting Bull. Farny was regarded as an "authority in Indian matters" because he had made trips west and had spent a great deal of time studying and painting Indians. He called the slaughter of Sitting Bull a "needless cruelty," saying that he was afraid that Sitting Bull's death might "cause a great deal of bloodshed." Farny maintained that the better policy would have been to arrest Sitting Bull and move him to another part of the country. Sitting Bull, Farny reminded the paper's readers, had come into prominence during the aftermath of the Custer disaster. Farny then proceeded to relate an anecdote from years before about the change in Sitting Bull's demeanor when Farny had introduced the great chief to General Ulysses S. Grant. Instantly Sitting Bull "straightened up and assumed a dignified and important bearing." Farny presented his ideas about the best way to solve the Indian question. Granting Indians citizenship (this did not happen until 1924, even though many had fought in the First World War) was one of Farny's recommendations.[81] Farny's understanding of the importance of Sitting Bull's death to the Lakota Sioux and the botched handling of the event proved prescient. He illustrated the far-reaching effects of the Massacre of Wounded Knee with his drawing of a grieving woman sitting beneath a burial scaffold that holds a dead warrior's body and shield. The illustration, entitled "The Last Scene of the Last Act of the Sioux War," appeared in an early 1891 issue of *Harper's Weekly*.[82]

Indians in 1890

The 1890 U.S. census precipitated an enumeration of all Indians living, literally a census of all Native Americans living within the United States, except the Alaska Territory. The goal was not only to count the Indians, but also to present a comprehensive study of their condition. This enormous project, with Thomas Donaldson as its director, resulted in a voluminous document with the unusual title *Report on Indians Taxed and Indians Not Taxed*. Summaries of all aspects of Indian life, plus many maps and numerous photographs, were included. To illustrate the report, artists journeyed west and painted elegant portraits of Indians, including one of the last pictures of Sitting Bull, dated September 1890.[83]

The report is sobering. For example, it states that while in 1822 Ohio claimed 2,407 Indians—all residing in the northern part of the state—in 1890 Ohio reported only 206 Indians. Thirteen of these Indians, twelve males and one female, were in prison and thus not counted in the general census; 193 Indians were self-supporting and hence taxed and

counted. This meant that Ohio's once plentiful Indian population had all either become acculturated (taxed) or moved west to Indian Territory. That region, mostly today's state of Oklahoma, reported an Indian population of 51,279.[84]

The 1890 census pointed to another important fact—a demographic change in the population of the West. Areas once nearly devoid of people were now populated, proving that the frontier, with its unsettled border zone, really was disappearing. Popular literature had kept the mythic West alive by stimulating the imagination of Americans about this forever-wild region and its unique inhabitants as settlers advanced across the continent. Real events, however, the near extinction of the buffalo and the Massacre of Wounded Knee, were proof positive that the open spaces once roamed by bison and American Indians were populated by farmers, ranchers, and city dwellers who lived in place year-round. Maps—especially those with colorful pictures that depicted the physical features of North America, "the advancement of American settlement," and "immigration intrusion"—illustrated the evolution of pioneer communities from a "primitive to a developed economy." A census bulletin discussed the population density for 1890, stating that "at present the unsettled area has been so broken by isolated bodies of settlement that there can hardly be said to be a frontier line."[85]

The Closing of the Frontier

While Buffalo Bill was presenting his wildly successful rendition of the frontier adjacent to the 1893 World's Columbian Exposition, a young historian, Frederick Jackson Turner, presented his "frontier thesis" before the American Historical Association's meeting when he read his groundbreaking "The Significance of the Frontier in American History" at the exposition that July.

These two events emphasize the power of the idea of the frontier, one breaking attendance records with exaggerated reenactments of western history, the other postulating that the distinctive features of American civilization are a result of our country's unique frontier environment. Ironically, Turner did not attend Buffalo Bill's performance in company with the other historians, preferring instead to put the finishing touches on his paper.[86]

Turner's thesis maintains that the most distinctive feature of the frontier was "the existence of an area of free land, its continuous recession, and the advance of American settlement westward." People, as they moved west taming the forests and plains, could

shed "cultural baggage" and the "complexities of civilization." When more people arrived, however, those who put down roots in the newly settled areas "struggled" back to "maturity," attempting to recreate the social structures and organizations they had left behind. Although they pursued cultural activities modeled on those in the East, their frontier experience inevitably transformed the resulting "civilizations" into something different from their eastern models.[87]

At the time many historians accepted Turner's hypothesis unquestioningly. However, contemporary historians realize that he presented a one-sided analysis of the facts, forgetting that many factors such as diverse populations and resources profoundly affect history. The concept of a free, open land with its equally freethinking inhabitants led Americans to fall in love with their disappearing frontier. The creation of enduring stories and myths is an indication of the public's love for its open spaces.

World's Columbian Exposition, Chicago 1893

The World's Columbian Exposition stands as a watershed anthropological event. Frederic W. Putnam of the Harvard Peabody Museum became chief of the Department of Ethnology and Archaeology, Department M, for the exposition. Early in the planning phase, Putnam decided to focus on the anthropology of America. Thus he determined the direction of the systematic and comprehensive exhibits, as well as living displays on the mile-long Midway Plaisance. Department M's other exhibits, arranged in a special Anthropology Building, were organized to teach a lesson about "the advancement of [the] evolution of man."[88] Scientists from the Smithsonian planned their own anthropology exhibits, to be housed in the Government Building, and agreed that their smaller but no less important displays about evolutionary progress would not duplicate those of Department M.[89] The ramifications of all these ideas eventually trickled south to Cincinnati.

Ethnology, or the branch of anthropology that deals with the comparative study of cultures, was a distinctive feature of the exposition's Midway, where a "great variety of races" lived in "highly instructive villages."[90] The commercial Midway Plaisance, with its Ferris wheel and displays of peoples from all over the world, "humanity in all its dissimilitude," scandalized some visitors with its strange sights and sounds. Most important to exposition planners, the Midway greatly increased gate receipts.[91] Cairo Street, for example, had a theater where women danced in a "shockingly interesting way" and a thatched village where the Dahomeyans "in all their barbaric ugliness" performed war

dances and thrust dangerous weapons into the air.[92] The western artist Frederic Remington claimed he "did all the savages in turn, as every one else must do who goes there, and Buffalo Bill's besides, where I renewed my first love." Remington believed that this "Barnumizing" of the Midway fulfilled "its mission as a great educator" in which the "universal Yankee nation" had "an opportunity to observe that part of the world which does not wear Derby hats and spend its life in a top-and-bottom tussel [sic] with a mortgage bearing eight percent."[93]

Henry Farny also observed ethnology in action at the fair. In March 1893, he had served as a member of the national jury of painters responsible for selecting works by American artists for the fair.[94] Sometime later Farny returned to Chicago, strolled down the Midway, and sketched the Dahomey dance for *Harper's Weekly*.[95]

Many years later Farny recalled seeing two Indians walking side by side down the Plaisance. As they came close he noticed that the little fingers of their inside hands were joined. Farny realized they were from different nations; this was their way of communicating with a friend. He recognized one man as a Lakota Sioux and spoke to him in "rusty" Lakota. The Lakota man told Farny that the cabin in which Sitting Bull had been killed was on the fairgrounds and that he, as a hired performer, was obliged to go into the dwelling on a regular basis. The Indian was visibly distraught because he had seen the spirit of Sitting Bull in the cabin and was worried about why the spirit had come all the way from South Dakota to Chicago. Farny understood the man's fear and gave him train fare to return home.[96]

Despite the popularity of the living ethnology displays, under Putnam's direction of Department M it was archaeology that stood first in importance. Putnam's plan included Cincinnatian Charles Metz, of the Literary and Scientific Society of Madisonville. In May 1891, Putnam wrote Metz, appointing him "Special Assistant" and telling him that "I am anxious for you to stir up an interest in Ohio in favor of the Exposition." Putnam envisioned a "thorough representation of the archaeology" of Ohio. He told Metz that a relief map of Serpent Mound was in progress and asked Metz to investigate a "few places" at the Turner group and prepare a relief map of those mounds and enclosures. Metz's $25.00 invoice for "salary for June 1891" was not itemized. In a handwritten note at the bottom Putnam tells Metz that when "you have expenses the items must be entered in detail even to a postage stamp." It is hard to say if Metz, a practicing physician, continued in this employment under these circumstances; however, he did receive an official award for two models of mounds.[97] Putnam also appointed Warren K. Moorehead as a "field assistant for Ohio about January, 1891." On April 1 Putnam and

Figure 7. Archaeologist Warren K. Moorehead and his crew in 1891. The image is captioned: "In camp, Warren Co. Ohio July–Sept. '91, World's Col. Expo. Survey." Moorehead, a knife in his belt, stands third from the left. *Courtesy of the Ohio Historical Society.*

his World's Columbian Exposition team began excavating in various parts of Ohio in preparation for the archaeology exhibit. Moorehead organized a team of eleven or twelve men and worked at Fort Ancient in Warren County and at another site several miles away for four or five months (fig. 7). On Putnam's recommendation Moorehead attempted to contact Metz, but was unsuccessful and proceeded with his own excavations until February 1, 1892.[98] The "nucleus of exhibits" resulting from this work—cases of skulls and stone or flint relics together with cases of maps and dioramas showing the results of "systematic" excavations and well-known mounds—grandly illustrated the archaeology of Ohio.[99]

Yet Moorehead, an Ohio citizen, felt that the state's exhibit was "not that which Ohio could make." The display was "largely confined" to specimens taken "from the cabinets of several gentlemen" and the maps were "decidedly crude and insignificant" and had already been shown at other fairs and exhibits. Moorehead maintained that the Ohio commissioners should have "drawn upon the Cincinnati Art Museum, Cincinnati

Figure 8. Archaeologist Warren K. Moorehead and others located limestone graves by probing with a long sharp-pointed iron pole until they hit stone. The excavation was part of the work done in Warren County, Ohio, for the 1893 World's Columbian Exposition held in Chicago. Moorehead described the work in an article for *Scientific American Supplement,* August 27, 1892. The caption reads: "Graves at Fort Ancient—Sounding for Graves with an Iron Rod." Henry Joseph Breuer, who worked for Rookwood as a pottery decorator from 1880 to 1882, drew the picture. *Courtesy of the Ohio Historical Society.*

Society of Natural History, or the Western Reserve Historical Society." Then Ohio "could have made an exhibit which would have been both scientific and important." Moorehead was probably correct in this assessment because the lists of borrowed objects do not contain any spectacular moundbuilder art objects (fig. 8).[100]

Another section of the ethnology department planned to show the "customs and arts" of different people "before they were influenced by the whites." Again, American collections predominated. Unlike the sensationalistic living displays of the Midway, education was the stated goal of this display, and Indians from different parts of the United States, such as the Pacific Northwest coast, came to the fair to demonstrate their Native industries and use their ceremonial objects. "The meaning of the ethnographical specimens is made clearer by the presence of a small colony of Indians, who live in their native habitations near the Anthropological building." Two "instructive" groups were the Iroquois in their bark houses and the Indians from British Columbia in their houses with their carved totem poles.[101] The idea of having real Indians demonstrate traditional lifeways concerned Commissioner of Indian Affairs Thomas J. Morgan, who feared criticism over the contradictory message being presented to fairgoers. At the same time the govern-

ment sought to acculturate Indians by strongly discouraging any vestiges of their traditional culture, there would be an exhibit of live Indians conveying the message that Indians were an "exotic race" with little relationship to contemporary mainstream America.[102]

Putnam's plan, with Indians living in traditional houses, infuriated Richard Henry Pratt, a former brigadier general of the U.S. Army and head of the United States Indian Industrial School at Carlisle, Pennsylvania. Pratt maintained that the effect of the exhibits "contrived" by the Smithsonian and the Bureau of Indian Affairs "was calculated to keep the nation's attention and the Indian's energies fixed upon his valueless past, through the spectacular aboriginal housing, dressing, and curio employments." The Bureau of Indian Affairs exhibit of boarding schools on Indian reservations only encouraged Native Americans "to remain a separate and peculiar people." Putnam's focus on the anthropology of America and Pratt's mission of leading Indians "into civilization and citizenship" had vastly different goals. Pratt said the two had "opposite and inimical purposes."[103]

The controversy over the best way to present America's first people points to the wide discrepancy between the two organizers' goals. Frederic Remington's opinion about the educational benefits to ordinary Americans of seeing so many diverse foreign people cannot be ignored, but nevertheless the ethnological displays must have subtly reinforced the idea that whites were the superior race. One school of historical thought maintains that the Midway gave visitors an "ethnological, scientific sanction for the American view of the nonwhite world as barbaric and childlike."[104] However, one cannot help but wonder what the Indians and participants from foreign lands thought about the manners of the gawking, pointing fairgoers.

The popularity of the World's Columbian Exposition's sensational living displays along the Midway confirmed the fact that the presence of Indians and people from foreign countries attracted an enthusiastic public that willingly spent its money. Not surprisingly, some Cincinnati businessmen decided to exploit the trend. Kohl and Middleton's Dime Museum, located on Vine Street between Fifth and Sixth streets, promised to enthrall and educate spectators by exhibiting oddities of nature, such as an eight-footed Arabian horse and a "dusky beauty who walks on swords."[105] On two occasions a mixed-blood Indian and his "white wife" from the Cheyenne River Reservation in South Dakota traveled to Kohl and Middleton's, probably to discuss traditional lifeways and demonstrate dances. The supervising agent at Cheyenne River maintained that such a museum display was "a concern of an entirely different nature from the 'Wild West' show."[106] Kohl and Middleton's Dime Museum is listed in the *Williams' Cincinnati Directory* as operating in the city between the years 1886 and 1895.[107]

Cincinnati's Wild West

In 1895, when the owner of an unsuccessful Wild West show abruptly abandoned a group of Cree Indians in Bellevue, Kentucky, the Cincinnati Zoo's administration acted quickly to exhibit live Indians. The Cree camped on the zoo's grounds for two months that summer and the zoo's admissions revenue increased. It was a win-win situation: the Cree earned enough money from the zoo to pay their fare home to Havre, Montana. So successful was the venture that one enthusiastic newspaper printed the headline, "What the World's Fair Was to Chicago the Zoo Is to Cincinnati!"[108]

John Goetz Jr., president of the Cincinnati Zoological Society, justified the zoo's decision to incorporate ethnological exhibits: "The presentation of wild people is in line with zoology, and so, when we exhibit Indians, or South Sea Islanders, or Esquimaux, or Arabians, or any wild or strange people now in existence, we are simply keeping within our province as a zoological institution."[109]

For zoo officials, the idea of producing a more grandiose—and profitable—spectacle modeled after Buffalo Bill's show held tremendous financial potential. The entire United States was gripped with nostalgia for the frontier. The memory of the sensational Columbian Exposition was still fresh. Buffalo Bill had visited Cincinnati three times with great success; even the Kohl and Middleton Dime Museum had exhibited live Indians. Capitalizing on the nation's interest in its early history seemed a logical way to increase the zoo's profits. An expanded program on a Wild West theme, the society reasoned, would appeal to everyone. The fact that the version would be mythical probably did not concern zoo officials, if they thought of it at all.

On April 11, 1896, Will S. Heck, the zoo's manager, wrote his first letter requesting Indians from "Western Reservations" for the purpose of exhibitions.[110] A rapid exchange of letters between Heck and various Bureau of Indian Affairs officials took place over the next few weeks, and by the end of April, permission for an Indian visit had been granted (fig. 9).[111]

After receiving this official permission "to engage the services of, not to exceed one hundred, Indians," Heck wrote the Indian agents at both Pine Ridge and Rosebud Reservations.[112] On May 11, J. George Wright, the Indian Agent at Rosebud, wrote Heck about the Indians' salaries. The average salary, Wright said, was "$25.00 per month for each individual male Indian; $10.00 and $15.00 per month for each woman, and $5.00 per month for each child. Chiefs or head men would probably demand $30 or $35, or possibly $50 per month."[113]

Figure 9. A group of Lakota Sioux men from the Sicangu band stand around Fred Nevin (*seated left*) and Will S. Heck (*seated right*). *Left to right:* Goes to War, Little Bald Eagle, Valentine McKenzie, Young Iron Shell, and an unknown man. They are some of the Indians who participated in the 1896 encampment at the Cincinnati Zoo. McKenzie, the man in the white hat, was educated at Carlisle Indian School and served as interpreter. *Courtesy of the late Jean Linde Wagner.*

Wright told Heck that in addition the Indians would bring their "native costume, feathers, etc." and that he, Heck, "would have no trouble whatever in controling [*sic*] these Indians, provided strict discipline was maintained, and they not [*sic*] permitted to obtain liquor under any circumstances."[114]

The Society decided to "engage the services" of the Indians and Heck forwarded the required $10,000 bond to Thomas Smith, the Acting Commissioner of Indian Affairs. This bond guaranteed the Indians' salary and safe return to the reservation. Heck told Smith that Fred E. Nevin, a representative of the Zoological Society, would start for Rosebud Reservation on May 31.[115]

On June 11, Charles E. McChesney, United States Indian Agent at Rosebud Reservation, wrote the Commissioner of Indian Affairs, "I have the honor to transmit herewith fifty-nine Articles of Agreement between Fred E. Nevin, duly authorized representative

of the Zoological Society of Cincinnati, Ohio, and sundry Indians of this Agency. These agreements cover 89 persons, who left this Agency for Cincinnati, Ohio, today."[116] This procedure—posting a bond, signing contracts, and sending a representative—was identical to the one Buffalo Bill followed when hiring Indians.

The contract was paternalistic. The Society promised to protect the Sicangu

> from all immoral influences and surroundings, and to provide all needful medical attendance and medicine, and do all such other acts and things as may be requisite and proper for the health, comfort and welfare of the said party of the second part, and to return [them] to the said Agency within the time specified by the Interior Department from the date hereof.[117]

When Nevin signed the contracts, the society incurred a serious financial responsibility. Goetz justified his decision in the annual report by saying that the board of directors believed that the $25,000 earned in 1895, the year the Cree camped at the zoo, "could be kept up and probably exceeded."[118] The board was banking on the public's fascination with Wild West shows to offset any of the zoo's current deficits. Also, both Will Heck, the zoo's manager, and Fred Nevin, who represented the zoo and signed the contracts as a witness, had worked at the Kohl and Middleton Dime Museum and hence had additional experience with visiting Indians.

Thus, on June 11, eighty-nine intrepid men, women, and children from the Sicangu Lakota Sioux band embarked on a journey of more than a thousand miles from Valentine, Nebraska, a small town near their home on Rosebud Reservation in western South Dakota, to Cincinnati. The Sicangu packed their fine Plains clothing and large tipis, boarded their horses onto the train, and departed for the unknown. Their contracts called for them to camp on the Zoological Garden's grounds for three months and participate in a series of educational programs illustrating frontier and pioneer life for Cincinnati's citizens—a program that flagrantly imitated Buffalo Bill's Wild West show (fig. 10).[119]

Before departing for Cincinnati, the Sicangu posed in front of Charles P. Jordan's trading post on Rosebud for an official photograph by John A. Anderson, who documented numerous other Rosebud Sioux activities. The men looked splendid in their Plains Indian finery, many astride their horses with women and children seated on the ground in front.[120] By Saturday, June 20, Cincinnati residents knew that "legitimate Indians" were at the zoo, living in a "picturesque village" where visitors could see aboriginal life firsthand and meet Little Bald Eagle, Young Iron Shell, Spotted Owl, Goes to War, and other Sicangu.[121] Newspaper articles invited the public to walk around and witness the

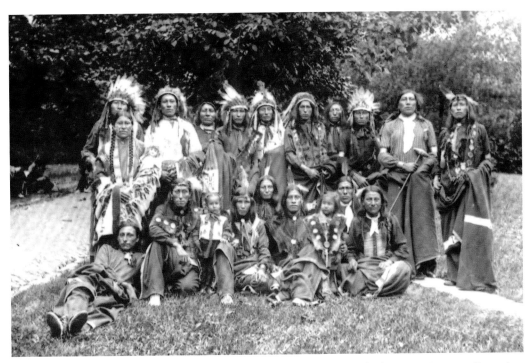

Figure 10. Some of the Sicangu who traveled from their home on Rosebud Reservation pose for a photograph on the Cincinnati Zoo's grounds. The group camped for three months at the Cincinnati Zoo and allowed Cincinnatians to stroll through their "living" village. *Cincinnati Museum Center—Cincinnati Historical Society Library.*

frontier as it once was; the board of directors felt that this event "gave a rare opportunity of showing the character and mode of life of the Indian tribes" to the city's citizens.[122] One headline claimed the zoo's drama was "The Only Genuine Wild West Show and Congress of Rough Riders of the World Here This Season."[123]

Valentine McKenzie, a Sicangu who had been educated at Carlisle Indian School, served as interpreter when Cincinnati dignitaries, reporters, and visitors toured the camp. In Anderson's photograph, and in many others taken that summer, McKenzie can easily be identified by his white cowboy hat, which is also noted in local newspaper articles. The Sicangu erected their tipis in the northeastern portion of the zoo's garden, a lovely wooded section quite different from most of the landscape in the Great Plains. One local reporter described the open-air camp: "The [Sicangu] village is diversified by hill and dale, and plain and valley. The tepees, whose sides are covered with rude pictures, showing the Indian's passion, if not his talent, for drawing, are distributed with a charming disregard for symmetry and distance over the grounds."[124]

Figure 11. Two women wear their best blankets for photographer Enno Meyer. The blanket on the left is a trade blanket with a beaded blanket strip; the one on the right is a second-phase "Chief's Blanket" woven by a Navajo woman. The textile, distinguished by small red bars in the center and edged stripes, indicates that its wearer was a wealthy woman with considerable status. *Cincinnati Museum Center— Cincinnati Historical Society Library.*

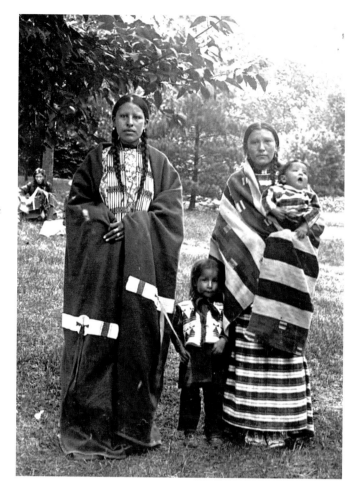

The landscape probably was not the only thing that surprised the Sicangu. Cincinnati's humidity must have made it uncomfortable to perform in leather or to wear their customary woolen blankets. Two Sicangu women brought and wore their finest apparel —Navajo Chief Blankets, coveted by Plains peoples, who did not weave, but appreciated superb craftsmanship and design (fig. 11). Numerous photographs, newspaper articles, and an unpublished manuscript reveal that the Sicangu were good sports as they went about their job of rehearsing for and performing in two entertainments daily, at 3:00 p.m. and 8:30 p.m. Advertisements recommended that spectators attend the evening performances because the electric and pyrotechnic lighting and red-fire effects intensified the stirring frontier and pioneer scenes.

If the Sioux were surprised by the climate, Cincinnatians were equally surprised by the Sioux. The chefs, probably of German descent, hired by the zoo to prepare meals for the Sicangu quickly learned that the Indians had sophisticated palates. Soon after their arrival the Sicangu, accomplished butchers themselves, requested choice cuts of

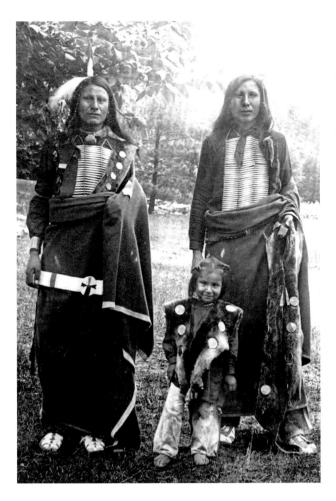

Figure 12. Two Sicangu men and a child display their Plains finery for photographer Enno Meyer. The Sioux participated in two Wild West shows daily; in between they posed for photographs, toured the city, and shopped in local stores. *Cincinnati Museum Center—Cincinnati Historical Society Library.*

beef, like sirloins and porterhouses, rather than the cheaper cuts the chefs had initially prepared. "Then they wanted more vegetables and expressed a preference for cabbage. Later they wanted blackberries and watermelons while nothing in the bake-shop came amiss."[125] Obviously, the Sicangu enjoyed eating foods different from those available at Rosebud (fig. 12).

By late June, a couple of weeks after the Sicangu arrived, performances became more elaborate and even included the zoo's interpretation of Buffalo Bill's Congress of Rough Riders: Sicangu Lakota Sioux and Bedouin Arabs, who were on tour from the Near East, excitedly thundering around the zoo's outdoor arena in "a grand combination drill of horsemen from the Wild West and the Wild East."[126] Other features on the program were the introduction of the Lakota chiefs and warriors, Native dances of all types, and reenactments of well-known historical events and stereotypical Indian-white encounters: the Massacre at Wounded Knee, the Battle of Little Big Horn, an attack on a frontier stagecoach, and the proverbial burning of a prisoner at the stake. A company of the First

Regiment of Infantry from the Ohio National Guard played the roles of the U.S. soldiers. These "educational" dramas distilled for Cincinnatians the romance of the West.

As the summer progressed, the zoo's leaders, fired with creativity, staged *Historical Cincinnati,* a play that purported to portray the frontier history of the city. This engaged the zoo's Rosebud Sioux visitors in an anachronistic show that stereotyped the eastern frontier of a century before. For the new play the Sicangu, wearing their Plains clothing, played the parts of Eastern Woodland Indians and participated in a sham battle staged before a gigantic scene depicting Fort Washington. The intense confrontation culminated in a thrilling attack on the fort, which was being bravely defended by frontiersmen. When they asked Indians to storm and attack Fort Washington, the zoo's officials rewrote Cincinnati history. The fort had never suffered any attack whatsoever, and if it had, Plains Indians would not have been involved. Incidents in the lives of such renowned frontiersmen from the Ohio Valley as Daniel Boone, Simon Kenton, James Smith, and Colonel William Crawford were also depicted. The playwrights at the zoo used these historical figures to enliven their performances and fatten their gate receipts.[127]

In addition to the planned Wild West dramas, the Sicangu sometimes participated in special activities at the zoo. For example, when the McKinley Club opened the Republican presidential campaign, the Indians paraded in a spectacular grand entry.[128] As a souvenir, McKinley supporters gave everyone a campaign button with his picture on it; the Sicangu liked these mementos. Thomas H. Kelley, an attorney who was an accomplished amateur photographer, took a picture of the Sicangu Goes to War wearing a campaign button; he had pinned it beneath his United States Indian Police badge. At least five other Indians posed for Kelley that summer.[129]

Even though the Sicangu were busy participating in two programs each day and posing for numerous photographers and artists, they still found time to dress in their finest Plains clothing for touring and shopping for themselves and their friends back on Rosebud. They visited the city's best stores and purchased discriminatingly, being particularly fond of colored shirts, silk Windsor ties, and red blankets.[130] Newspaper reporters frequently followed them on their various excursions. One article states that Young Iron Shell's daughter bought large cotton handkerchiefs, beads, a feather duster, some sticks of peppermint candy, a red and yellow workbasket, and a majolica beer mug.[131]

Zoo officials felt responsible for the Indians' welfare and, as far as is known, behaved professionally toward them. Two occasions in particular are documented. One night a major thunderstorm, accompanied by blasts of lightning and violent wind, caused zoo officials to urge the Sicangu to hurry to "an old road and lay flat so as not to blow away."

Another incident occurred when Little Left Hand Bull became ill. Black Bear, a traditional medicine man, conducted a healing ceremony, while zoo officials enlisted the services of a Dr. Thompson. Despite both men's efforts, the child died. Relatives dressed him in Lakota finery and performed a mourning ritual. Following the ceremony, Black Bear carefully placed the child's body in a small casket, which was then put inside a white hearse provided by a local undertaker. The grief-stricken entourage included four additional carriages for relatives and friends and Black Bear, astride his horse, rode behind the procession. Mourners proceeded down the hill to Cincinnati's central train depot, where the child's parents and Young Iron Shell departed for the interment on Rosebud.[132]

The photographer Enno Meyer, whose images first catalyzed contemporary research into the Lakota's Cincinnati visit, became friends with some of the Sicangu men close to his own age of twenty-one. Meyer's nephew William Meyer recollects a family story about Enno Meyer and Enno's father taking some Indians downtown to the family's photography studio for some portrait shots. (This probably explains the plain backdrop seen in some of the images.) Following this session the group went upstairs for coffee and cake. William Meyer remembered that one of the elderly Sicangu was not acquainted with stairs and was initially frightened by them. Another family story pertains to the fact that one of the Indians was fluent in English. Most likely this was McKenzie.[133]

On the Sunday before the Indians departed, the *Cincinnati Enquirer* noted that friends would be visiting the garden "in order to shake hands with them and bid them good-by before they turn their faces toward the setting sun." The reporter wrote that they would not forget their stay and that "in their Western lodges this winter, around the blazing fagot fire while the wind is careening over the prairie, they will sit about and tell their friends who remained at home what wonderful things they saw in the Queen City of the West."[134]

The Sicangu's lengthy stay—shows began on June 20 and ended on September 6—allowed some Cincinnatians time to develop friendships with the Indians. Some people went to the zoo repeatedly to photograph, draw, or simply visit the Sicangu. Sometimes Cincinnatians took their Indian friends on excursions throughout the city, creating an unusual sight on the streets and in stores.

Young Enno Meyer's friendship with the Sicangu endured beyond the summer of 1896. Meyer not only took pictures of his new friends, but also wrote to them after they returned home to Rosebud. A few Sicangu wrote back and sent him different kinds of beadwork. These objects are in the Cincinnati Museum of Natural History, now part of the Cincinnati Museum Center. Meyer's fond memories of his experiences that summer

prompted him to save his glass negatives and photographs of the Sicangu, as well as their letters to him, among his personal effects. Even though the letters are short, they are invaluable because they provide a rare view of Sicangu life from the Indians' perspective.

The letters of the Sicangu Lakota who corresponded with Meyer and called him *kola* (friend) opened a window to their thoughts and the activities on Rosebud. Six of these letters survive today: Arthur Belt, whose Indian name was Blokaciqa, wrote on April 3, 1900, and April 2, 1901; Good Voice Eagle, whose Indian name was Wanbli Ho Waste, wrote on December 11, 1896, May 4, 1898, and August 8, 1898; and Oliver T. Bear wrote on May 29, 1901. A seventh letter, written by Belt to Joseph Henry Sharp, has been found in the collections of the Buffalo Bill Historical Center in Cody, Wyoming.[135] Writing must have been arduous for each of the correspondents, just as it would be for us to compose a letter in a foreign language, but they were writing to a *kola*.

While in Cincinnati the Indians had established relationships with other people who frequented the zoo during their stay, particularly Henry F. Farny and Joseph Henry Sharp, artists renowned for their paintings of Plains Indians. In his 1900 letter, Arthur Belt asked Meyer: "Please let me know where is Mr. Farnning [Farny] you know him. and I am remember Mr. Sharp. But I don't know his number street. tell him I send him my best regards." He also inquires about Will Heck, reminding Meyer that "he is Manger [manager] in Zoo Garden. I want write to him" (fig. 13).[136]

Another major hurdle to the correspondence was the scarcity of stamps on the reservation. Meyer's friends begged him to send them stamps so that they could write to him. Wanbli Ho Waste, Good Voice Eagle, wrote, "I wait for you letter after while when I get a money I send you indian word I want some stamps I shade [shake] hand with you."[137] Blokaciqa, Arthur Belt, also needed financial assistance and offered to sell Meyer some Plains beadwork:

> and now I got some bead work But I don't Know How I sent you. if you can send me $1. I sent you some nice bead work for you. and I wish you send me a good Indian women picture. I know that you lots of pictures. I like have one of picture (goes to war) wife some of women picture too. don't forget will you.[138]

These letters reveal that Meyer's portrait-style photographs of the Sicangu as they posed on the zoo grounds or in his father's studio downtown were popular because each of the correspondents either thanks Meyer for the photographs he sent or requests additional ones. Obviously Oliver T. Bear saw the potential for marketing these pictures on Rosebud. In his 1901 letter he requested additional pictures (fig. 14):

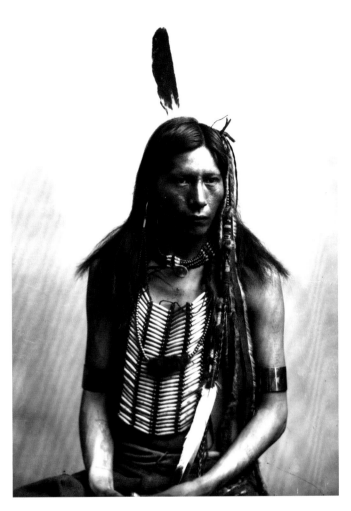

Figure 13. Even though the contracts in the National Archives give the English names of the Sicangu men who traveled to Cincinnati, it is still difficult to identify all the people in Enno Meyer's photographs because Meyer did not label many of them. This man, however, had his Indian name, "Blokaciqa," tattooed on his upper left arm. He was also known as Arthur Belt and Little Stallion. After his return to Rosebud, he corresponded with both Meyer and Rookwood artist Joseph Henry Sharp. *Cincinnati Museum Center—Cincinnati Historical Society Library.*

Just received my picture and I am very glad that you have sent me my picture so again dear friend please sent me two of the picture which I stand with Black Hawk and his wife and also 3 of then Eagle Deer sister which she stand with Black Hawk wife and when you sent them please write to me and Let me know if you could sent all the different picture you got when we were at zoo garden. and I will pay you for it Because Indian are buying picture and it may be that if you sent them these picture they mine pay you for. Enclose my letter for this time Good bye friend bye bye

Your truely

Oliver T. Bear[139]

Requests also came for tail feathers from the eagles at the zoo and pieces of red, blue, green, and yellow ribbon. Meyer must have been able to send some feathers because Good

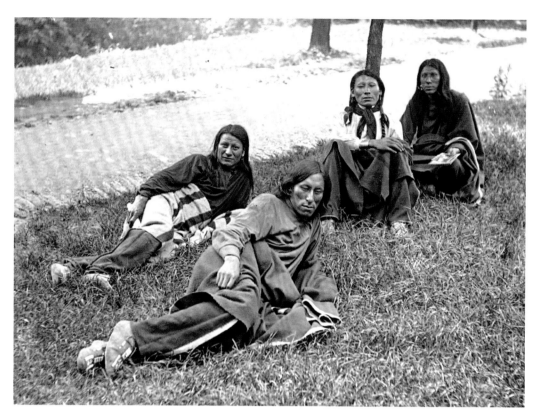

Figure 14. The Sicangu liked the pictures Meyer made and even requested additional prints after they returned home to Rosebud Reservation. Here, several men relax on the Cincinnati Zoo's grounds; one holds some pictures in his left hand. *Cincinnati Museum Center—Cincinnati Historical Society Library.*

Voice Eagle asked for them again, reminding Meyer that "feathers I ask you Eagle tail Indian very want Eagle tail me made over head [probably meaning he made a warbonnet] you see last time I want send me to much when you get this letter."[140]

Their letters also reveal how the Sicangu felt about participating in another "play" at the zoo. In December 1896, Good Voice Eagle asked, "and I want questian Samething zoological play it Now I want your tell me which month get indian tell me and How many pay all he get tell me I want when the indian caming [coming] I came [come] Say and I come There." Then in May 1898 he repeated his question, "Today I am going to write to you again How is Zoological words you have no more shows at zoologi[cal] or run again we want to hear that things." On August 8, 1898 the same inquiry appeared, "Will [indecipherable word, but probably refers to Heck] now you know him To tell me and run Show again to tell me we want that Zoological gardens word."[141]

The reason the Indians wanted to return pertained to their situation on Rosebud. Buying something as insignificant as a stamp proved a financial burden. Paper must have also been a problem because Good Voice Eagle's 1896 letter is written on a zoo "Daily Report" form. The potential for earning a salary was critical to the destitute, reservation-bound Sicangu. But for the Zoological Society, the Sicangu visit that summer of 1896 was a financial disaster.

Despite high expectations, the Zoological Society's speculative Wild West endeavor failed to generate the anticipated monetary returns. It failed for several reasons. Pawnee Bill's Historic Wild West and Great Far East show, a smaller competitor of Buffalo Bill's show, overlapped the Sicangu's encampment for several weeks, and undoubtedly siphoned off some of the zoo's potential attendance. More important, the streetcar facilities did not provide easy access to the Zoological Garden, and the inclement weather of that summer was not conducive to outdoor programs. The society's president, John Goetz Jr., admitted that the "expense of exhibiting these Indians . . . exceeded by several thousands of dollars our receipts." He blamed the nation's economy, but felt "the real and principal cause of our loss this year was the unprecedentedly rainy season." He said that it rained forty-six of the one hundred days of extra amusements and when it was not raining, the sky was "cloudy and threatening." To make his point he prepared a table comparing the attendance and receipts of 1895 with those in 1896 for twenty-four of the rainiest days of the season. "On these twenty-four rainy days, the total attendance was 25,490 and the receipts were $5,670.65; the total attendance for the corresponding days of 1895 was 77,180 people . . . and the receipts were $14, 724.50." Even though the deficit was enormous, Goetz continued to believe that ethnological villages should be scheduled because they had "vast educational value" and were a "profitable investment."[142]

Unfortunately, the financial burden the society incurred through the Sioux visit was not relieved by the 1897 admissions, and the Zoological Garden went into receivership the following year.[143]

A Pragmatic Evaluation

There were times when Indian participants in Wild West shows and other ethnological displays were exploited and sometimes abandoned, as happened with the Cree in Kentucky in 1895. But performing Indians understood the risks involved and some found meaningful careers that enabled them to travel the world. Such was the case with the

twenty-six Cheyenne and Arapaho Indians, including women and children, who joined Pawnee Bill's show, the Zoo's competitor that summer of 1896. They had left their reservation surreptitiously one early morning, having made arrangements with a go-between for Pawnee Bill without permission from government authorities. The Indians were willing to break rules and risk consequences in order to travel and perform.[144]

When the Rosebud Sicangu consented to participate in an educational program in Cincinnati, they committed themselves to an event that brought the romantic western frontier east. Their three-month stay left a legacy that created ties between Cincinnati and Rosebud; their visit generated not only official documentation, photographs, and an unpublished manuscript, but also fond memories of that summer that have survived generations. As one newspaper reported, "Many [Cincinnatians] have gone so often [to the zoo] that they have formed the acquaintance of a great many of the Indians."[145] Five years after the visit, Arthur Belt inquired about "my girl," Dora Tucker, one of his Cincinnati friends.[146]

The Sicangu encampment also resulted in a treasure trove of additional documentation that has disclosed the complete story of this nearly forgotten event and permitted a study of Rosebud Lakota Sioux activities at the time when they were being forced to abandon their traditional ways of life. The research involved in the rediscovery of the Rosebud Sioux's connection to Cincinnati included fieldwork opportunities with the Sicangu over a number of years.

The initial goal in 1989 was to identify the Sicangu in Meyer's photographs by matching the names on the contracts to the images. Several Sicangu were identified in a photograph album Meyer kept, but many of Meyer's original identifications of the people he photographed had become separated from the glass negatives. The Lakota Archives and Historical Research Center at Sinte Gleska University has become involved with the Sicangu visit project, and a complete record of all photographs, archival material, and other information as it continues to be discovered is deposited at the university.[147] Since the initial deposition, for example, a Swedish researcher who studies Rosebud photographer John Anderson has been able to identify some of the Sicangu in the photographs.

Photographs of the Sicangu visitors continue to surface. The rare book section of the Public Library of Cincinnati and Hamilton County contains six undated and unidentified images of the Sicangu Sioux taken by Henry Farny. The photographs, unposed images of the people at the zoo, show them astride their horses or standing beside a tipi (fig. 15).[148]

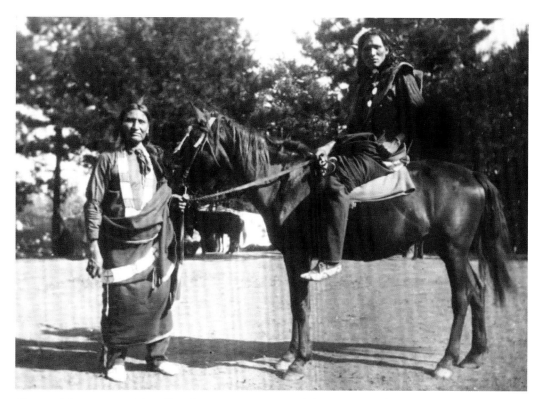

Figure 15. Newspaper articles tell us that Henry Farny visited the Sicangu at the zoo. He also photographed them; some of these images are in the Public Library of Cincinnati and Hamilton County. *Courtesy of the Public Library of Cincinnati and Hamilton County.*

In 1997 the elderly granddaughter of Cincinnati Zoo manager Will S. Heck contacted the zoo about some pictures and a collection of Indian objects she had inherited. The pictures comprised another group of previously unseen images of the Cree and the Sicangu. The donor recalled a tale her grandfather used to tell about an Indian who sometimes hid in a hollow tree on zoo grounds; when night fell, he walked to a local bar. Heck had difficulty with the behavior of a few Indians, and the granddaughter did not recall how Heck resolved these issues. Most likely he relied on the chiefs to assist him.[149]

In 2002 previously unseen Sicangu images from the Rookwood Pottery Company collection were consigned to a Cincinnati auction house. The Rookwood designers used the company photo collection as inspiration for images of Indians on vases. Each of these new photographs was identified and the name matched to the census record. To date three images of the Sicangu—Eagle Deer, Young Iron Shell, and Owns The Dog— taken at the Cincinnati Zoo have matched the company's finished pieces.

American Indian Observations

The Sicangu visit to Cincinnati has yielded information not only about Indian participation in Wild West events, but also about the deprivations and pleasures of life on a Lakota reservation at the turn of the last century.

The negative aspects of participating in these anthropological exhibits were numerous, beginning with the fact that exhibiting themselves had to be demeaning for many of the Indians. Even though the zoo's officials carefully oversaw the needs of the Sicangu, most of the authorities and journalists probably still viewed the Sicangu in a paternalistic manner and retained a superior attitude toward them. The zoo's leaders hoped to resolve their financial deficits by placing the Indians on display, and the newspapers hoped to garner additional readership by printing articles about the fierce Indians encamped at the zoo. There is no denying the fact that these Wild West shows placed the Sicangu in an anthropological zoo where visitors could stare relentlessly at their traditional clothing and foreign lifeways. In addition there was a language barrier, so visitors could not learn the Indians' true feelings or really discover more about their culture. When Indians agreed to participate they had to trust the sponsor, who may or may not have been honest.

In today's world of political correctness, displays of people, such as the Sicangu encampment, often cause a knee-jerk reaction leading critics to assert across the board that all exhibits of this type were deleterious to the participants. Before making this judgment, however, it is important to examine the specific incident fully and review it in the light of that time. All human experiences contain positive as well as negative aspects. A good case can be made that the zoo's encampment enriched Sicangu lives by providing the people with hard cash, new experiences, and insights into the world beyond the reservation at a time when only Indian leaders generally traveled to the east.

For Indians participating as actors, performing may have prompted pride in their skills as audiences cheered them loudly. Wild West plays gave Native American men the opportunity to display their horsemanship and wear their regalia before an admiring audience. Other actors probably viewed the performances the same way most people think about a job—as a necessary activity to earn money.

It must be remembered that participation in the zoo's event was voluntary; no one was forced to leave the reservation. The Sicangu certainly cherished no illusions about how whites regarded them and treated them. If being gawked at was the price they had to pay to see a new part of the world, no doubt the Indians decided the experience was worth that price. Another important fact is that the Indians, while being observed by

whites, observed white society in turn. Whether performing or resting in their "village," the Native Americans could see how whites behaved to one another and to their children, how much liquor they consumed, and then could discuss their insights with each other just as people of all cultures do.

Probably the most valuable outcome of the Sicangu encampment was the friendship forged between Cincinnatians and Indians. Some visitors to the zoo cared enough to take and save photographs of their friends—photos passed down in their families for more than a hundred years. Today, the Sicangu have the opportunity to see those photographs in their archives and learn about a forgotten event in the history of their people.

The zoo's Wild West event in 1896 lasted almost three months; Buffalo Bill's visit in early May of that year lasted only two days.[150] The ripple effects of this, Cincinnati's own Wild West show, and its numerous other encounters with Indians have endured through time. Today the legacy of Cincinnati's diverse Indian encounters is probably best reflected in the work of the city's artists who became famous for their paintings of American Indians: most notably Henry Farny, John Hauser, and Joseph Henry Sharp. Each traveled west, met, and sometimes lived among Native Americans. Each painted in a studio crowded with mementoes of Native Americans—photographs, artifacts, and in one instance a letter from an Indian the artist had met years earlier.

In April 1901 Arthur Belt wrote Sharp, telling him, "This time I know where you are." Enno Meyer had sent Sharp's address to Belt, who said he wanted to see and talk to him. Belt also asked Sharp to send him four bottles of beer (fig. 16).[151]

Sharp and Farny, having spent time on Indian reservations, realized that Indian lives were changing, often in ways that did not benefit the people.[152] The Bureau of Indian Affairs "order" instructing agents to insist that Indians cut their hair prompted Sharp to write William A. Jones, commissioner of Indian Affairs, in January 1902. Sharp pleads the Indians' case, saying that this would be the "greatest sacrifice you could have them make." Only on rare occasions, when their grief was overwhelming, did such traditional Indians cut their hair.[153]

Farny, after his return from a meeting with the Apache leader Geronimo at Fort Sill in Indian Territory, expressed his opinions about the overly strict government regulations. Like Sharp, he objected to the regulation relating to short hair. He thought it would be diplomatic if Uncle Sam catered "somewhat to the native taste in toilet of his savage soldiery [Indian police] by modeling his uniform on the general lines of Indian costumes." This, Farny believed, would please the Indians and make them more comfortable.[154] Haircuts and less restrictive clothing may seem insignificant to us, but these

Figure 16. In April 1901 Arthur Belt, Blokaciqa, wrote Joseph Henry Sharp telling him that he wanted to see and talk to him. He also asked Sharp to send him four bottles of beer. *Buffalo Bill Historical Center, Cody, Wyoming: Gift of Mr. and Mrs. Forrest Fenn, MS 22 letter.*

requests to BIA officials demonstrate that Cincinnati artists had become knowledgeable about the people they painted and were concerned for their welfare.

On occasion Farny tried to educate Cincinnatians about the situation on Indian reservations from an Indian viewpoint. During one interview he took the time to explain why there were outbreaks of violence among Indians, saying that they retaliate "only when driven by hunger or an outrage upon their religious sentiment." Government officials, he said, were "constantly interfering with their religion" and had suppressed certain ceremonies.[155]

Traditional Indians and their lifeways captured the imagination of the artists, who wanted to paint the real thing and believed that these subjects commanded an audience. According to an article in the *Cincinnati Enquirer,* the city's artists felt their Indian paintings should bring good prices. Hauser spent $2,000 living in the Pueblo region for six months, an astronomical amount at that time, and Sharp spent approximately $800 living there for two months. "One of the artists said he could buy a better meal at a bird

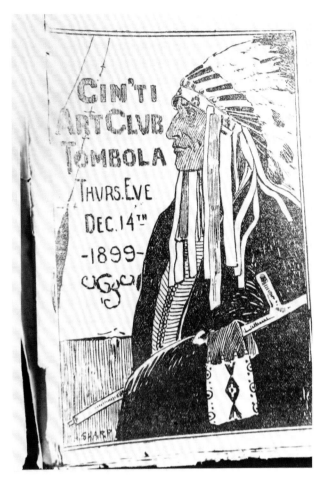

Figure 17. Even in Cincinnati, the frontier myth of the Wild West, complete with Indians in eagle feather warbonnets, refused to die. Artist Joseph Henry Sharp sketched a Plains Indian for the Cincinnati Art Club Tombola, a party at which funds are raised through a sort of lottery. *Buffalo Bill Historical Center, Cody, Wyoming: Gift of Mr. and Mrs. Forrest Fenn, MS 22.424.*

store here than he would pay a dollar for there."[156] During the summer of 1896, when the Rosebud Sioux were camping at the zoo, the newspaper published a feature about Indians as a subject for artists. Hauser's goal, the reporter said, was to "faithfully" interpret "the life and character of the race which is so fast disappearing."[157]

So enthusiastic were the local artists that it seems they were consumed by all things Indian. Around the turn of the century, for example, invitations to a number of events at the Cincinnati Art Club featured Plains Indian images and motifs. A photograph taken at the Cincinnati Art Club's 1896 Christmas party shows some attendees dressed in Indian attire; Enno Meyer is wearing a beaded blanket strip around his neck and a pair of moccasins.[158] (The blanket strip is now in the Cincinnati Museum Center collection. The moccasins appear in a photograph of Meyer's personal Indian collection and that photograph is also in the Cincinnati Museum Center.) We can see that, even though prominent local artists were well informed about Indian lives, they sometimes preferred to let themselves fall under the magical spell of the West (fig. 17).

In reality, the Wild West was no more. "The march of civilization has already turned a wild, savage populated country into a chain of cities and towns where education and civilization abound. . . . There are hardly anymore buffaloes," the *Cincinnati Times Star* lamented in 1896.

And still, the myth persisted: "Indians, Indians, everywhere, yet not a scalp to take!"[159] Cincinnati had its civilized pursuits, but, like the rest of the nation, refused to let go of the dangerous fascinations of the mythical West.

Notes

The epigraph to this essay is taken from George Catlin, *Letters and Notes on the Manners, Customs and Condition of the North American Indians* (1841; reprint, Minneapolis: Ross and Haines, 1965), 1:62.

1. William Henry Harrison, *A Discourse on the Aborigines of the Valley of the Ohio* (Cincinnati: Cincinnati Express, 1838), 12.

2. Milo Milton Quaife, ed., *The Indian Captivity of O. M. Spencer* (New York: Citadel Press, 1968), xv.

3. Philip J. Deloria, *Playing Indian* (New Haven: Yale University Press, 1998), 20–21.

4. John C. Ewers, "The Emergence of the Plains Indian as the Symbol of the North American Indian," in *Annual Report of the Board of Regents of the Smithsonian Institution* for the Year Ended June 30, 1964, 531–44 (Washington, DC: GPO, 1965).

5. James Hall, *The Romance of Western History: Or, Sketches of History, Life, and Manners, in the West* (Cincinnati: Applegate, 1857), 5–9; W. H. Venable, *Beginnings of Literary Culture in the Ohio Valley* (Cincinnati: Robert Clarke, 1891), 16.

6. Philip J. Deloria, *Playing Indian,* 13, 46–59; Samuel W. Williams, "The Tammany Society in Ohio," *Ohio Archaeological and Historical Publications* 22 (1913): 349–70.

7. Warren K. Moorehead, *The Stone Age in North America* (Boston: Riverside Press Cambridge, 1910), 2:360.

8. Harrison, *Discourse on the Aborigines,* 12, 14, 31; Quaife, *Indian Captivity of O. M. Spencer,* xv.

9. Beverly W. Bond Jr., ed., "Dr. Daniel Drake's Memoir of the Miami Country, 1779–1794," *Quarterly Publication of the Historical and Philosophical Society of Ohio* 18, no. 2–3 (1923): 40, 45–46.

10. Ibid., 59–62, 82, 86.

11. Ibid., 87; Quaife, *Indian Captivity of O. M. Spencer,* 17; John R. Swanton, *The Indian Tribes of North America* (Washington, DC: Smithsonian Institution Press, reprint 1979), 237–39; Helen Hornbeck Tanner, ed., *Atlas of Great Lakes Indian History* (Norman: University of Oklahoma Press, 1987), 72–73.

12. Don Heinrich Tolzmann, *The First Description of Cincinnati and Other Ohio Settlements: The Travel Report of Johann Heckewelder (1792)* (Lanham, MD: University Press of America, 1988), 7, 29, 40, 45, 53; Tanner, *Atlas,* 58; Bond, "Dr. Daniel Drake's Memoir," 87.

13. A. E. Jones, *Extracts from the History of Cincinnati and the Territory of Ohio, Showing the Trials and Hardships of the Pioneers in the Early Settlement of Cincinnati and the West* (Cincinnati: Cohen, 1888), 57.

14. Bond, "Dr. Daniel Drake's Memoir," 57–58.

15. Jones, *Extracts from the History of Cincinnati*, 57.

16. Tolzmann, *First Description of Cincinnati*, 54.

17. James Hall, *Sketches of History, Life, and Manners, in the West* (Philadelphia: Harrison Hall, 1835), 1:29, 102–15; Francis Paul Prucha, *The Great Father: The United States Government and the American Indians* (Lincoln: University of Nebraska Press, 1986), 1:528–33.

18. Quaife, *Indian Captivity of O. M. Spencer*, 20, 39; Tolzmann, *First Description of Cincinnati*, 47.

19. Albert Johannsen, *The House of Beadle and Adams and Its Dime and Nickel Novels* (Norman: University of Oklahoma Press, 1950), xxiii, 4; Albert W. Aiken, *Joe Phenix's Double Deal; Or, the Diamond Daggers* (New York: Beadle and Adams, 1897); Edward L. Wheeler, *Deadwood Dick Jr. in Cincinnati* (New York: Beadle and Adams, 1889).

20. "Nate Salsbury Originated Wild West Show Idea," *Colorado Magazine* 32, no. 3 (1955): 206–7; W. H. Venable, "Literary Periodicals of the Ohio Valley," *Ohio Archaeological and Historical Publications* 1 (1887): 203–4.

21. Charles H. McMullen, "The Publishing Activities of Robert Clarke & Co., of Cincinnati, 1858–1909," *Papers of the Bibliographical Society of America* 34, no. 4 (1940): 315–26; Venable, *Beginnings of Literary Culture*, 203–4.

22. Walter Sutton, *The Western Book Trade: Cincinnati as a Nineteenth-Century Publishing and Book-Trade Center* (Columbus: Ohio State University Press, 1961), 171; William H. McGuffey, *McGuffey's New Sixth Eclectic Reader: Exercises in Rhetorical Reading, with Introductory Rules and Examples* (Cincinnati: Winthrop B. Smith, 1857), 81–82.

23. M. F. Force, "To What Race Did the Mound-Builders Belong?" in *Some Early Notices of the Indians of Ohio* (Cincinnati: Robert Clarke, 1879), 41–75; Josiah Priest, *American Antiquities, and Discoveries in the West* (Albany, NY: Hoffman and White, 1833), 38–51; Bradley T. Lepper and Jeff Gill, "The Newark Holy Stones," *Timeline: A Publication of the Ohio Historical Society* 17, no. 3 (2000): 16–25.

24. Harrison, *Discourse on the Aborigines*, 12.

25. Winthrop Sargent, "A Letter from Colonel Winthrop Sargent to Dr. Benjamin Smith Barton," *Transactions of the American Philosophical Society* 4 (1799): 177–80.

26. Robert Clarke, *The Pre-Historic Remains Which Were Found on the Site of the City of Cincinnati, Ohio with a Vindication of the 'Cincinnati Tablet'"* (Cincinnati: Robert Clarke, 1876), 19.

27. Daniel Drake, *Natural and Statistical View, or Picture of Cincinnati and the Miami Country, Illustrated by Maps* (Cincinnati: Looker and Wallace, 1815), 199, 205.

28. Ibid., 204; Clarke, *Pre-Historic Remains*, 11, 20, 28; Erasmus Gest, "Ancient Hieroglyphic Stone," *Cincinnati Gazette,* December 24, 1842, 2.

29. Clarke, *Pre-Historic Remains*, 26–32.

30. Drake, *Natural and Statistical View,* 199.

31. Moses Guest, *Poems on Several Occasions* (Cincinnati: Looker and Reynolds, 1823), 73–75, 157; Henry A. Ford and Kate B. Ford, comps., *History of Cincinnati, Ohio* (Cleveland: L. A. Williams, 1881), 14, 15.

32. Charles Whittlesey, *Descriptions of Ancient Works in Ohio,* Smithsonian Contributions to Knowledge 3 (Washington, DC: Smithsonian Institution Press, 1850), vi, 11; Charles C. Baldwin, *Memorial of Colonel Charles Whittlesey, Late President of the Western Reserve Historical Society* (Cleveland: Williams' Book Publishing House, 1887), 411.

33. Baldwin, *Memorial,* 411; Ephraim G. Squier and Edwin H. Davis, *Ancient Monuments of the Mis-*

sissippi Valley, Smithsonian Contributions to Knowledge 1 (1848; reprint, Washington, DC: Smithsonian Institution Press, 1998), xxxv.

34. Baldwin, *Memorial,* 423; Squier and Davis, *Ancient Monuments,* 274–76, note on 276.

35. Ted Sunderhaus, conversation with author, September 2, 2005.

36. Charles L. Metz, "The Prehistoric Monuments of the Little Miami Valley," *Journal of the Cincinnati Society of Natural History* 1, no. 3 (1878): 119–28; Metz, "The Prehistoric Monuments of Anderson Township, Hamilton County, Ohio," *Journal of the Cincinnati Society of Natural History* 4, no. 4 (1881): 293–305; Charles F. Low, "Archaeological Explorations near Madisonville, Ohio," parts 1–3, *Journal of the Cincinnati Society of Natural History* 3, no. 1 (1880): 40–68; no. 2 (1880): 128–39; no. 3 (1880): 203–20.

37. Stephen Frederick Starr, *The Archaeology of Hamilton County Ohio* (Cincinnati: Cincinnati Museum of Natural History, 1960), 6–7. The museum first published this as vol. 23, no. 1 in 1960.

38. "Dr. C. L. Metz Dies at 79," *Cincinnati Commercial Tribune,* December 22, 1926: 2; Carolyn R. Shine, "Art of the First Americans: In Search of the Past," in *Art of the First Americans: From the Collection of the Cincinnati Art Museum* (Cincinnati: Cincinnati Art Museum, 1976), 8–11; Warren K. Moorehead, "Commercial vs. Scientific Collecting. A Plea for 'Art for Art's Sake,'" *Ohio Archaeological and Historical Publications* 13 (1904): 112–17; 563–66.

39. Starr, *Archaeology of Hamilton County,* 7; Warren K. Moorehead, "Recent Archaeological Discoveries in Ohio," *Scientific American Supplement* 34, no. 869 (August 27, 1892): 13886–90.

40. Frederic Putnam to Charles L. Metz, May 22, 1891, Metz Papers, Cincinnati Museum Center, Mss M596, box 11, file 4. Hereafter, Cincinnati Museum Center is cited as CMC.

41. Metz Papers, CMC, Mss 596, box 11, file 4.

42. Abner L. Frazer to Charles L. Metz, May 28, 1888; A. A. Graham to Charles L. Metz, July 16, 1888, both in Metz Papers, CMC, Mss 596, box 11, file 4.

43. Henry D. Shapiro and Zane L. Miller, eds., *Physician to the West: Selected Writings of Daniel Drake on Science and Society* (Lexington: University Press of Kentucky, 1970), 140. In an 1818 article, Drake and the managers described the classes of objects to be housed in the museum. Daniel Drake et al., "Art. XXIII. An Address to the People of the Western Country," *American Journal of Science* 1 (1818): 203–6.

44. Louis Leonard Tucker, "'Ohio Show-Shop': The Western Museum of Cincinnati, 1820–1867," in *A Cabinet of Curiosities: Five Episodes in the Evolution of American Museums.* Whitfield J. Bell Jr. et al. (Charlottesville: University Press of Virginia, 1967), 73–105; Timothy Flint, "Cincinnati Museums," *Western Monthly Review* 1 (May 1827–April 1828): 79.

45. Tucker, "'Ohio Show-Shop,'" 97.

46. Shine, "Art of the First Americans," 9–10.

47. "Thomas Cleneay's Death," *Cincinnati Times Star,* October 21, 1887, 7; Shine, 9.

48. M. C. Read, "The Archaeological Exhibit for the Ohio Centennial," *Ohio Archaeological and Historical Publications* 1 (1887): 170–73.

49. Philip D. Spiess II, "Exhibitions and Expositions in 19th Century Cincinnati," *Cincinnati Historical Society Bulletin* 28, no. 3 (1970): 171.

50. Ibid., 171, 173, 179.

51. Ibid., 176–80; Metz Papers, CMC, Mss 596, box 11, file 4.

52. Spiess, "Exhibitions," 184–86; Exposition Commission, *Seventh Cincinnati Industrial Exposition: Official Catalogue and Exposition Guide* (Cincinnati: Seventh Cincinnati Exposition Commission, 1879), 26.

53. Clara De Vere, *The Exposition Sketch Book: Notes of the Cincinnati Exposition of 1881* (Cincinnati: H. W. Weisbrodt, 1881). The pages are not numbered. Clara De Vere is probably a pseudonym for Clara Anna Rich Devereux, a well known Cincinnati newspaperwoman.

54. *Final Report of the Ohio State Board of Centennial Managers to the General Assembly of the State of Ohio* (Columbus: Nevins and Meyers, 1877), 6, 15–16, 30–32, 81–141.

55. Robert A. Trennert Jr., "A Grand Failure: The Centennial Indian Exhibition of 1876," *Prologue* 6, no. 2 (1974): 118–19.

56. Ibid., 118–29, 126.

57. Spiess, "Exhibitions," 186.

58. Robert W. Rydell, *All the World's a Fair: Visions of Empire at American International Expositions, 1876–1916* (Chicago: University of Chicago Press, 1984), 60–68.

59. Herman J. Viola, *Diplomats in Buckskins: A History of Indian Delegations in Washington City* (Washington, DC: Smithsonian Institution Press, 1981).

60. Ibid.

61. Herman J. Viola, *The Indian Legacy of Charles Bird King* (Washington, DC: Smithsonian Institution Press, 1976), 29–31.

62. Ibid*., 15–21, 79, 118.

63. "Exhibition of Indian Portraits," *Cincinnati Daily Gazette,* May 27, 1833, 3.

64. Catlin, *Letters and Notes,* 3, 62.

65. "Mr. Catlin's Exhibition of Indian Portraits," *Western Monthly Magazine* 1 (1833): 535–38.

66. William Dean Howells, *A Boy's Town* (New York: Harper and Brothers, 1890), 150–51.

67. "The Wyandot Indians," *Niles' National Register,* August 26, 1843, 414–15.

68. "Emigrating Indians," *Cincinnati Gazette,* October 12, 1846, 2; "The Miamis," *Cincinnati Gazette,* October 13, 1846, 2–3; "Daily Receipts by the Miami Canal" and "Shipments," *Cincinnati Gazette,* October 13, 1846, 3; "Removal of Indians," *Cincinnati Daily Enquirer,* October 13, 1846, 3.

69. Howells, *Boy's Town,* 150.

70. William Dean Howells, *Stories of Ohio* (New York: American Book Co., 1897), 215–16.

71. "The Chippewas," *Cincinnati Daily Atlas,* November 28, 1848, 3; "Things about Town," *Cincinnati Daily Atlas,* November 30, 1848, 3.

72. "The Indians in American Art," *Crayon* 3 (January 1856): 28.

73. "Amusements," *Cincinnati Daily Gazette,* December 31, 1872, 4; January 6, 1873, 4.

74. Don Russell, *The Lives and Legends of Buffalo Bill* (Norman: University of Oklahoma Press, 1961), 290.

75. "Buffalo Hunt," *Cincinnati Commercial Gazette,* June 3, 1883, 2.

76. "Close of the 'Wild West' Show Last Night," *Cincinnati Commercial Gazette,* June 11, 1883, 5.

77. "Buffalo Bill's Wild West at the Ball Grounds Yesterday," *Cincinnati Commercial Gazette,* October 20, 1884, 8.

78. Russell, *Lives and Legends,* 315–17.

79. Don Russell, *The Wild West* (Fort Worth, TX: Amon Carter Museum of Western Art, 1970), 43.

80. Vine Deloria Jr., "The Indians," in *Buffalo Bill and the Wild West* (Brooklyn, NY: Brooklyn Museum, 1981), 53.

81. "A Needless Cruelty," *Cincinnati Commercial Gazette,* December 18, 1890, 12.

82. Henry Farny, "The Last Scene of the Last Act of the Sioux War," *Harper's Weekly* 35, no. 1782 (February 1891): 120.

83. Thomas C. Donaldson, ed., *Report on Indians Taxed and Indians Not Taxed in the United States (Except Alaska)* (Washington, DC: GPO, 1894), 24, and between 574 and 575.

84. Ibid., 6, 82, 242, 527.

85. Ray Allen Billington, *Frederick Jackson Turner: Historian, Scholar, Teacher* (New York: Oxford University Press, 1973), 117.

86. Ibid., 127.

87. Ray Allen Billington, *The American Frontier* (Washington, DC: Service Center for Teachers of History, American Historical Association, 1958), 1–2.

88. Rydell, *All the World's,* 57.

89. Franz Boas, "Ethnology at the Exposition," *Cosmopolitan* 15 (May–October 1893): 607–9; Moorehead, "Recent Archaeological Discoveries in Ohio," 13886–90; L. G. Moses, "Indians on the Midway: Wild West Shows and the Indian Bureau at World's Fairs, 1893–1904," *South Dakota History* 21 (Fall 1991): 216; Rydell, *All the World's,* 57–62; L. G. Moses, *Wild West Shows and the Images of American Indians, 1883–1933* (Albuquerque: University of New Mexico Press, 1996), 136–39.

90. Boas, "Ethnology at the Exposition," 609.

91. Frederic Remington, "A Gallop through the Midway," *Harper's Weekly* 37, no. 1920 (October 1893): 963; "Barnumizing the Fair," *Harper's Weekly* 37, no. 1920 (October 1893): 967.

92. Remington, "Gallop through the Midway," 963; Rydell, *All the World's,* 66.

93. Remington, "Gallop through the Midway," 963.

94. "The National Jury," *Cincinnati Commercial Gazette,* March 12, 1893, 9.

95. Henry Farny, "Columbian Exposition—The Dance of the Dahomans in the Midway Plaisance," *Harper's Weekly* 37, no. 1920 (October 1893): 965.

96. "Ancient Indian Lore Familiar to Farny Who Reveals Secrets," *Cincinnati Times Star,* August 25, 1911, 11.

97. Frederic Putnam to Charles L. Metz, May 22, 1891, Metz Papers, CMC, Mss M596, box 11, file 4.

98. Warren K. Moorehead, *The Hopewell Mound Group of Ohio,* Anthropological Series 6 (Chicago: Field Museum of Natural History, 1922), 79–81; Moorehead, "Recent Archaeological Discoveries in Ohio."

99. Boas, "Ethnology at the Exposition," 607–8; "Ninth Annual Report of the Ohio State Archaeological and Historical Society to the Governor for the Year 1893," 36–39. Mss 106, Archives 1175, Ohio Historical Society. Even though this unpublished report states that the Society of Natural History participated, the objects lent by the society consisted primarily of human skulls, bone or stone implements, and animal bones and teeth.

100. Ibid.; Warren K. Moorehead, "The Ancient Man," *Cleveland Leader,* June 25, 1893. The article is in Moorehead's scrapbook, Mss 106, Ohio Historical Society, 82–83.

101. Boas, "Ethnology at the Exposition," 607–9.

102. Moses, "Indians on the Midway," 212n9.

103. Richard Henry Pratt, *Battlefield and Classroom: Four Decades with the American Indian, 1867–1904* (New Haven, CT: Yale University Press, 1964), 294–310.

104. Rydell, *All the World's,* 40.

105. "Kohl & Middleton's Dime Museum," *Cincinnati Commercial Gazette,* March 12, 1893, 10; *Cincinnati Illustrated Business Directory* (Cincinnati: Spencer and Craig, 1887–88), 47.

106. Agent Charles E. McChesney to Commissioner of Indian Affairs Thomas Morgan, November 15, 1889, #33536, Record Group 75, National Archives, Washington, DC. Hereafter cited as RG, NA, DC.

Herbert Welsh to Morgan, June 4, 1891, Letters Received 1891, #20212; Morgan to Herbert Welsh, June 13, 1891, Land–Vol. 109, RG 75, NA, DC. Commissioner Morgan sent Welsh the replies from various Indian agents to an Indian Office circular calling for information on the effects of Wild Westing.

107. *Williams' Cincinnati Directory* (Cincinnati: Cincinnati Directory Office, 1880–1900). These years were reviewed.

108. "To-Day at the Zoo," *Cincinnati Enquirer,* June 23, 1895, 19; "The Zoo To-Day," *Cincinnati Enquirer,* July 7, 1895, 19. The present name of the zoo is the Cincinnati Zoo and Botanical Garden. Susan Labry Meyn, "Cincinnati's Wild West: The 1896 Rosebud Sioux Encampment," *American Indian Culture and Research Journal* 26, no. 4 (2002): 1–20. I am indebted to the journal for granting me permission to publish information from the article.

109. *Twenty-third Annual Report of the Zoological Society of Cincinnati for the Year 1896* (Cincinnati: Webb Stationery and Printing, 1897), 15.

110. Will Heck to John Carlisle, April 11, 1896, and Will Heck to Daniel Lamont, April 11, 1896; Letters Received 1896, #15220 (both letters), RG 75, NA, DC.

111. Will Heck to Hoke Smith, April 16, 1896; Letters Received 1896, #15237, RG 75, NA, DC. Jacob Bromwell to Daniel Browning, April 22, 1896; Letters Received 1896, #15327, RG 75, NA, Washington, DC; *Twenty-third Annual Report,* 10.

112. Will Heck to Thomas Smith, Acting Commissioner of Indian Affairs, May 2, 1896, Letters Received 1896, #16705, RG 75, NA, DC.

113. J. George Wright to Zoological Society, May 11, 1896, Outgoing Correspondence for Rosebud, 1878–1910, Book 25, RG 75, NA, Kansas City Branch.

114. Ibid.

115. Will Heck to Thomas Smith, May 30, 1896, Letters Received 1896, #20489, RG 75, NA, DC. Charles E. McChesney to Commissioner of Indian Affairs, June 11, 1896, Letters Received 1896 #22637, RG 75, NA, DC. The contracts, #22637, are stored with #20489.

116. Ibid.

117. Ibid.

118. *Twenty-third Annual Report,* 10.

119. J. George Wright to Zoological Society, May 11, 1896; Outgoing Correspondence for Rosebud, 1878–1910, Book 25, RG 75, NA, Kansas City Branch. Charles E. McChesney to Commissioner of Indian Affairs, June 11, 1896, Letters Received 1896 #22637, RG 75, NA, DC. The contracts, #22637, are stored with #20489.

120. Henry W. Hamilton and Jean Tyree Hamilton, *The Sioux of the Rosebud: A History in Pictures* (Norman: University of Oklahoma Press, 1980), plate 96. Even though the caption under the photograph reads "1897," this is incorrect because there was no Indian exhibit at the zoo that year. This photograph is also reproduced in Paul Dyck, *Brulé: The Sioux People of the Rosebud* (Flagstaff, AZ: Northland, 1971), plate 21. The captions are different in the two books because they are derived from different sources.

Susan Labry Meyn, "Who's Who: The 1896 Sicangu Sioux Visit to the Cincinnati Zoological Gardens," *Museum Anthropology: Journal of the Council for Museum Anthropology* 16, no. 2 (1992): 26n3.

121. "Indian Shows at the Zoo," June 20, 1896, 6; "Indian Squaws," June 26, 1896, 9; "Our Indian Village Inhabited," July 3, 1896, 8. All articles are in the *Cincinnati Enquirer.*

122. *Twenty-third Annual Report,* 10.

123. "Indian Shows at the Zoo," June 20, 1896, 6; "The Zoo's Wild West," June 28, 1896, 19; "The Only Genuine Wild West Show," June 29, 1896, 5. All articles are in the *Cincinnati Enquirer.*

124. "To-Day at the Zoo," *Cincinnati Enquirer,* July 26, 1896, 19.

125. James Albert Green, unpublished manuscript, 3, Mss G797u Box 2, CMC, Cincinnati Historical Society, Cincinnati, Ohio.

126. "The Zoo's Wild West," June 28, 1896, 19; "Notes," June 30, 1896, 7. Both articles are in the *Cincinnati Enquirer.*

127. "Notes," August 12, 1896, 10; "Historical Cincinnati Because . . . ," August 16, 1896, 19; "The Zoo To-Day," August 23, 1896, 19. All articles are in the *Cincinnati Enquirer.*

128. "Small Was the Gold Meeting Held at the Zoo by the McKinley Club," *Cincinnati Enquirer,* August 20, 1896, 10.

129. Green's unpublished manuscript contains six photographs taken by Kelley.

130. Green, unpublished manuscript, 3.

131. "A Sioux Maiden," *Cincinnati Enquirer,* August 20, 1896, 6.

132. "Death Rode upon the Blast" and "Stormswept Was This City Last Night," August 23, 1896, 1 and 5. Both articles are in the *Cincinnati Enquirer.* A lead story details the widespread destruction left by the storm. Francis Paul Two Charger and Marie Kills Plenty to Meyn, June 22, 1993. The couple identified one of Meyer's photographs as Francis Paul's great-grandfather, Paul Two Charger, and said that he was married to Cheyenne Woman. Her name matches the census record. The couple then related a story about a storm, and their remembrance coincides with a newspaper article describing a night of heavy rain and wind. Marie Kills Plenty also recognized some of the beadwork designs as being a family pattern. For a description and sketches of the ceremonies surrounding the child's illness and death see "Weird Scene in the Sioux Camp," *Cincinnati Enquirer,* August 1, 1896, 8, and "Weird and Wild Was the Ceremony," August 3, 1896, 8. The name of the father is incorrect, because there is no contract for Big Brave, but there is one for Left Hand Bull, and his recently discovered photograph shows him with a young son.

133. William Meyer to Meyn, March 29, 1990. At the time, the family's studio was located at 1309 Vine Street in downtown Cincinnati.

134. "Last Day of the Indians," *Cincinnati Enquirer,* September 6, 1896, 19.

135. The six letters to Meyer are in the CMC, Cincinnati Museum of Natural History and have the numbers TT4899, TT4901, TT4902, TT4904, TT4905, and TT4906. For the seventh letter, see figure 16 in this essay.

136. Arthur Belt to Enno Meyer, April 3, 1900, TT4899.

137. Good Voice Eagle to Enno Meyer, August 8, 1898, TT4904.

138. Arthur Belt to Enno Meyer, April 2, 1901, TT4905.

139. Oliver T. Bear to Enno Meyer, May 29, 1901, TT4906.

140. Good Voice Eagle to Enno Meyer, August 8, 1898, TT4904.

141. Good Voice Eagle to Enno Meyer, December 11, 1896, TT4901; May 4, 1898, TT4902; August 8, 1898, TT4904.

142. *Twenty-third Annual Report,* 10–13, 15.

143. David Ehrlinger, *The Cincinnati Zoo and Botanical Garden from Past to Present* (Cincinnati: Cincinnati Zoo and Botanical Garden, 1993), 37.

144. Woodson to Commissioner of Indian Affairs, June 23, 1896, Letters Received 1896 #23925; RG 75 NA, DC. Pawnee Bill's group of show Indians did not sign contracts with the federal government because the Department of the Interior rejected Pawnee Bill's request.

145. "Show Gossip," *Cincinnati Enquirer,* September 2, 1896, 9.

146. Arthur Belt to Enno Meyer, April 2, 1901, TT4905.

147. Meyn, "Who's Who," 21–26 and Susan Labry Meyn, "Mutual Infatuation: Rosebud Sioux and Cincinnatians," *Queen City Heritage: Journal of the Cincinnati Historical Society* 52, nos. 1–2 (Spring-Summer 1994): 30–48.

148. Theodore A. Langstroth Collection Lithographs, #616, rare book section of The Public Library of Cincinnati and Hamilton County. Langstroth was an obsessive collector who, according to library notes, colored Farny's prints. The photographs may be identified on the reverse side, but they are glued to a piece of poster board. John Fleischmann, "The Labyrinthine World of the Scrapbook King," *Smithsonian* 22, no. 11 (1992): 79–87.

149. Personal communication, Jean Linde Wagner to Meyn, October 1998.

150. "Great Is Buffalo Bill, But Far Greater Is His Wild West Show," *Cincinnati Times Star,* May 5, 1896, 3.

151. Arthur Belt to J. H. Sharp, April 2, 1901, Buffalo Bill Historical Center, McCracken Research Library, Mss 22, series 1, box 3, folder 2.

152. "Painting Indians on Custer's Battlefield," Buffalo Bill Historical Center, McCracken Research Library, Mss 22, series 1, box 3, folder 2. The article has the handwritten date of December 29, 1903.

153. J. H. Sharp to Commissioner of Indian Affairs William A. Jones, January 18, 1902, Buffalo Bill Historical Center, McCracken Research Library, Mss 22, series 1, box 1, folder 21.

154. "A Painter on the Plains: Artist Farny's Autumn Outing among Aborigines," *Cincinnati Commercial Gazette,* October 28, 1894, 22.

155. "A Needless Cruelty," *Cincinnati Commercial Gazette,* December 18, 1890, 12.

156. "Art and Artists," *Cincinnati Enquirer,* November 11, 1894, 19.

157. "Art Notes," *Cincinnati Enquirer,* July 5, 1896, 23.

158. Forrest Fenn, *The Beat of the Drum and the Whoop of the Dance: A Study of the Life and Work of Joseph Henry Sharp* (Santa Fe, NM: Fenn, 1983), 99. The blanket strip, catalogue number A 13350, is now in the Cincinnati Museum Center collection. The moccasins appear in a photograph of Meyer's personal Indian collection; that photograph is also in the Cincinnati Museum Center.

159. "Grand Display Was the Parade Made by Buffalo Bill's Wild West Show Monday Morning," *Cincinnati Times Star,* May 4, 1896, 10.

ROOKWOOD
and the
AMERICAN INDIAN

Anita J. Ellis

THE ROOKWOOD Pottery Company's fascination with the American Indian is a rich and intriguing story. It involves the interplay of a female entrepreneur, her business manager, and premiere artists and educators—all entwined in the nation's evolving attitude toward Native Americans. During the course of this story, Rookwood's policies reflect a contradictory attitude of exploitation and sympathy toward the first Americans. In the end, masterpieces of art pottery depicting noble Indians were created.[1]

Enter Frank Duveneck

The story begins long before Cincinnati's foremost American art pottery opened for business in 1880, when a young man with artistic promise left Covington, Kentucky, just south of Cincinnati across the Ohio River, in November 1869 to study art in Munich, Germany.[2] Twenty-one-year-old Frank Duveneck (1848–1919, fig. 1), the son of German immigrants, had shown artistic talent, first as a sign painter, then as an apprentice decorating Catholic churches under the auspices of the Order of Saint Benedict. Fluent in German, and with Benedictine connections in Germany, Frank left for the Royal Academy

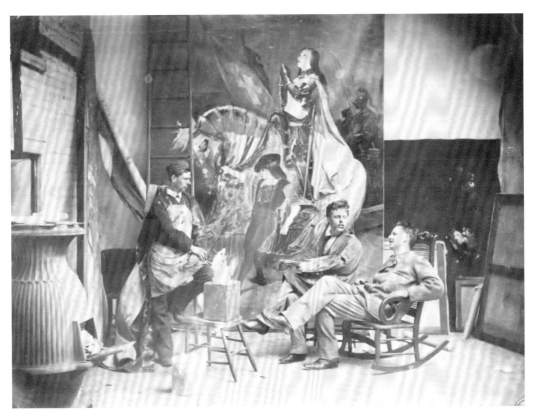

Figure 1. Frank Dengler (1853–79), Frank Duveneck (1848–1919), and Henry Farny (1847–1916) in Duveneck's studio, 1875, in front of a painting, *Prayer on the Battlefield,* representing Joan of Arc, which Duveneck and Farny painted for the 1875 Cincinnati Industrial Exposition. *Cincinnati Art Museum. Art Academy of Cincinnati Archives.*

of Fine Arts in Munich, where his Covington mentor, Wilhelm Lamprecht (1838–after 1901), had studied.

During the 1870s Munich was considered the art capital of Germany and a leading art center in Europe.[3] Its academy was a public institution open to any qualified student for a modest fee. Foreign students were welcomed without prejudice. The dominant discipline was painting, but sculpture, architecture, and engraving were also taught. Duveneck was so talented that he skipped many of the beginning classes, and by the fall of 1871, he had reached the final stage of the academy's curriculum. At this point he studied painting technique under the charismatic Wilhelm Diez (1839–1907). Mostly self-taught, Diez specialized in a delicate, detailed style of small-format paintings in imitation of the Dutch masters, and challenged his students to freely experiment in the application of paint. Duveneck absorbed two basic elements from Diez: imitation of the

Old Masters, especially of the Dutch and Flemish schools; and a deep interest in technique, or how to apply paint to the canvas. In imitating the Old Masters, Duveneck also gained an appreciation for subject matter from daily life. The second Munich influence on Covington's son was Wilhelm Leibl (1844–1900), a painter who had considerable knowledge of French painting and understood the contemporary French concept of *l'art pour l'art* (art for art's sake). From Leibl, Duveneck learned to use color and brushwork in an expressive manner that accentuated painting solely for the sake of painting, or art for art's sake. Because of Diez and Leibl, by 1872 Frank was executing figures emerging from darkness that were strong, colorful, and alive with brushwork that effectively contrasted deep shadows with bright areas of color (fig. 2). It is this Munich style that would eventually come to bear on Rookwood's Native American images. Duveneck's personal interest in the American Indian is evident in letters that he wrote home during his stay in Munich. They are profusely illustrated with sketches of American Indians (fig. 3).[4] Curiously, this personal interest so strongly suggested by his numerous sketches does not seem to have translated professionally into oils on canvas. The only known painting of an Indian in Duveneck's oeuvre is an undated, unsigned portrait of an unidentified sitter (fig. 4). Although Frank Duveneck became one of the most revered and talented American painters of his day, he never chose to emphasize American Indian imagery in his professional work.

Enter Maria Longworth Nichols

As Frank Duveneck was returning home to Cincinnati and Covington in 1873 to national acclaim for his Munich work, another artistic career was beginning in the Queen City. Mrs. George Ward (Maria Longworth) Nichols (1849–1932) was experimenting with china paints.[5] The field of ceramics was one of the few art disciplines in which society allowed women to excel, and Maria intended to do just that. She cultivated her skills in china painting well into the 1870s, applying decoration on porcelain over the glaze. In 1878 or 1879 she began working in the newly discovered technique of decorating ceramics under the glaze. Firing her wares at a local commercial pottery frustrated her desire for total control over the process, so by the end of the decade, she decided to start her own pottery. On November 27, 1880, the Rookwood Pottery Company drew (i.e., emptied) its first kiln and was open for business. The entrepreneur founder of Rookwood was able to establish her own pottery because she was born into an extremely

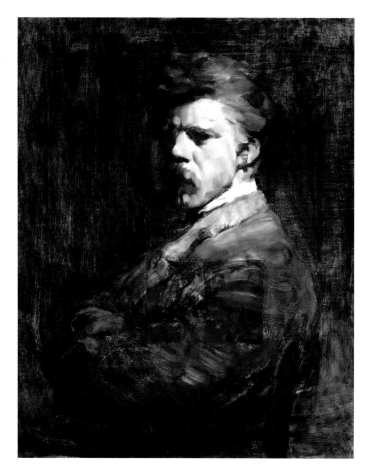

Figure 2. Frank Duveneck, *Self-Portrait,* ca. 1877, oil on canvas. 25 5/16 x 23 11/16 inches. *Cincinnati Art Museum. Gift of the artist. 1915.122.*

wealthy Cincinnati family. When her grandfather Nicholas Longworth died in 1863, accounts of his estate show that he was the second or possibly third richest man in America.[6] Her family was not simply wealthy by Cincinnati standards; it was exceedingly wealthy by national standards. So when she decided on a plan of action as economically questionable as establishing an art pottery, she could do so without qualms. What is more, she could afford to instantly equip it with everything that promised success, including the immediate hiring of the finest people in the field. Maria, who wanted for nothing in life, had a dominating personality "with a touch of daring and sometimes even rashness."[7] Put in less politically correct terms by one of her contemporaries, "[She] was a spoiled child of fortune who generally got what she desired as soon as it could be procured for her."[8] Her strong personality and unbounded wealth were two of Rookwood's greatest assets. When Maria was asked why she founded her pottery, she simply replied, "My principal object is my own gratification."[9] Included in that principal objective was nothing less than the premiere success of Rookwood.

Figure 3. Indians smoking a pipe. A letter sent from Frank Duveneck, December 13, 1871, Munich, Germany, to his family, Covington, Kentucky. Reprinted from Josephine W. Duveneck, *Frank Duveneck: Painter—Teacher* (San Francisco: John Howell, 1970), second illustration following page 40. *Courtesy of Elizabeth Dana, daughter of Josephine W. Duveneck.*

LETTER HEADING, 1871 (*See Chapter 4*)

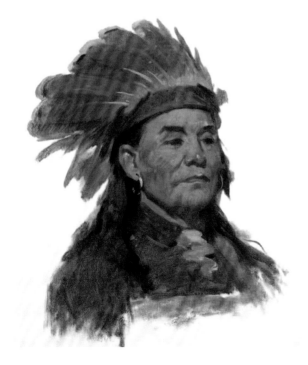

Figure 4. Frank Duveneck, *Indian Head,* date unknown, oil on canvas. 24 x 20 inches. Property of David L. Duveneck. *Courtesy of Ramiel M. Howitt Fine Art.*

Enter Henry Farny and the First Indian Decoration

To design her company's first trademark, she hired Cincinnati artist Henry François Farny (1847–1916, fig. 1).[10] By 1880 Farny had been a practicing artist for fifteen years with a reputation as an illustrator of books and magazines.[11] His facility as a printmaker suited Maria's needs. She used the logo for her stationery and the first, and only, printed mark used on her ceramics.

Henry Farny, who later became nationally noted as one of the foremost painters of the American Indian, was the first to decorate Rookwood with Indian imagery. His earliest encounter with American Indians seems to have been as a boy, between the years 1854 and 1859, when his family lived near a reservation of the Onandaigua tribe in Warren County, western Pennsylvania.[12] His mother Jeannette often doctored members of the tribe, and her son became friends with many. As an adult, Farny's serious interest in all things Indian began around 1880, shortly before he became involved with Rookwood. His first journey west occurred sometime after August 1, 1881, when he visited Fort Yates, approximately seventy miles south of Bismarck, on the Missouri River. The massacre of General George Custer and his men at the Little Big Horn in 1876 and the surrender of Sitting Bull (1834–90), the warrior chief of the Dakota Sioux who led the Sioux War of 1876–77, in the summer of 1881 focused national attention on the "Indian question."[13] The newspapers of the country eagerly reported virtually every move made by Sitting Bull and his followers. Approximately six thousand Sioux who had surrendered with him were taken to Fort Yates, where they lived in their tipis near the fort.[14] Perhaps the summer's newspaper stories sparked Farny's journey. When the artist arrived at Fort Yates, he found that Sitting Bull had been removed to Fort Randall to keep the chief from inciting discontent among his people. Farny's stay was fruitful nonetheless, and when he returned to Cincinnati on November 5, loaded with his sketches of mostly Indian portraits, 124 photographs that he had taken, and numerous artifacts, he began to paint. Before his trip, Farny had difficulty supporting himself by his painting, and thus he worked mostly as an illustrator. After his trip, when he began incorporating Indian subject matter into his painting, all that changed. As one reporter aptly put it, "Farny has struck an artistic bonanza."[15] He subsequently left Rookwood and ended his illustrating career. The market for Indian paintings was very good and continued to support him for the rest of his life.

In 1881, either before or after his journey to Fort Yates, Henry decorated four plaques for Rookwood. The only one known to survive (cat. no. 9) depicts a portrait of

Blackfoot Sioux Indian Chief John Grass on red clay. The red clay was obviously chosen to reflect the red ware pottery created by the Indians. The transfer-printed portrait image with its painted black background is surrounded by painted geometric designs reminiscent of Indian pottery. Rookwood experimented unsuccessfully with printed decorations on a white-bodied ware in 1881.[16] Perhaps the red ware plaques were also part of that failed experiment. In any event, they were technically unsuccessful and remained in Rookwood's collection until 1937, when, in the throes of the Great Depression, at least one of them was sold to B. Altman and Co. of New York.

The Farny plaques of 1881 mark the first appearance of Indian imagery on Rookwood pottery. The subject matter was probably inspired more by the artist's personal interests than by any formal marketing plan on Rookwood's part. Farny's use of the printed method of decoration could have been part of Maria's attempt to cut costs through the mass production of printed wares. They could almost be considered anomalies in this story except that, like all such subsequent imagery, they were inspired by the nation's ongoing complex discourse on Native Americans.

Enter William Watts Taylor

In the spring of 1883, Maria Longworth Nichols, who never enjoyed the business end of the Pottery, hired her longtime friend, businessman William Watts Taylor (1847–1913), to manage Rookwood.[17] Taylor knew nothing about the pottery business, but he was an able administrator with a keen mind and good judgment. He examined costs and analyzed sales; he studied production methods and space usage for better efficiencies; and he developed a marketing plan that created what today would be called a brand identity. Until his death thirty years later, Taylor was the moving force behind Rookwood. The Pottery's greatest successes were achieved during his tenure. Rookwood's fascination with the American Indian was nurtured and grew under William Watts Taylor.

A Time of Change, 1881–88

The next known use of Indian imagery at Rookwood Pottery was in 1888. To be sure, the U.S. government's Indian issue had not abated or disappeared between 1881 and 1888, but once Farny left in 1881, there was no one at the Pottery promoting these decorations.

Albert Robert Valentien (1862–1925), who was hired in 1881 to be in charge of the decorating department, specialized in floral decorations.[18] During much of the 1880s, Rookwood was selling primarily to women, and floral decorations appealed to them. By the end of 1887, William Watts Taylor noted that Rookwood "decorations are almost entirely flowers."[19] Valentien never chose to use Indian imagery during his tenure, although he was one of the finest artists at the Pottery and could easily have done so. He preferred floral decorations, and-without objections from management, encouraged such imagery in the decorating department. He left Rookwood in 1905 for California, where he was commissioned by Ellen Browning Scripps to paint about fifteen hundred watercolors of wild flowers native to that state.[20]

By 1888 things were changing at Rookwood. Technology was improving rapidly. Even though the kiln temperature was still judged by the color of the flame, and slip colors used for underglaze decorations were still limited, years of trial-and-error research into glazes, clay bodies, and slip colors were beginning to pay off. Clarence Cook (1828–1900), influential writer, art critic, and editor of *The Studio* magazine, praised Rookwood's accomplishments in an 1887 review: "Outside of Japan and China we do not know where any colors and glazes are to be found finer than those which come from the Rookwood Pottery. The yellows, greens, reds, and browns are clear, bright and strong, and of great depth and richness in the tones."[21] By 1888 the Pottery had matured to a point where it could shift its emphasis from technology to aesthetics and concentrate on decoration. Motivated by reasons of marketability as well as aesthetics, William Watts Taylor began looking for new imagery, and one of the places he found it was in America's native cultures.

Rookwood and the Wild West

Prior to this, on September 7, 1887, Taylor wrote to Howell and James, "the Tiffany's of London," which refused to include Rookwood in an exhibition of American wares that was to coincide with Buffalo Bill's Wild West show, saying, "If the exhibition is merely a sort of 'side show' to Buffalo Bill we [too] would rather let it alone."[22] William Frederick Cody (1846–1917), an American showman known as Buffalo Bill, who had served as an army scout in the Sioux wars and as a Pony Express rider, formed a Wild West show and began touring it to great acclaim in America in 1883.[23] In 1887 his show began a European tour in London, where it ran for six months and was timed to coincide with Queen

Victoria's Golden Jubilee celebrating the fiftieth anniversary of her ascension to the throne. The exhibition, known simply as the American Exhibition and meant to high-light American manufactures and commercial products, was contiguous to the stadium where the Wild West show was being performed. The industrial fair received poor re-views, while Buffalo Bill's extravaganza was a smash hit. It was estimated that more than two and a half million people attended the Wild West spectacle, including the queen, who broke her long-standing custom of declining to appear in public places. None of this was lost on Taylor, who would have followed reports in the newspapers and trade journals. True, Bill Cody's show was also wildly popular in the United States, but there it did not beg the question, what is distinctively American? In writing a letter of endorse-ment for the Wild West show in England, Mark Twain addressed this question: "It is often said on the other side of the water that none of the exhibitions which we send to England are purely and distinctively American. If you take the Wild West show over there you can remove that reproach."[24] The American West was distinctive, and integral to that distinction was the American Indian. Another lesson emphasized by, although not exclusive to, Buffalo Bill's Wild West was that the subject matter was lucrative as well as popular.

To Be, or Not to Be . . . American

To be American was important to Taylor, but he did not see it as having anything to do with the Wild West, the American frontier, or the American Indian. Until the late 1880s he saw the uniquely American qualities of Rookwood as being in the clays, techniques, and quality the ware incorporated. In October 1887 he wrote, "What we are doing how-ever is to copy no one, to make a distinctive American ware and to produce broad artistic effects on simple forms with qualities of color such as are produced nowhere else in the world."[25] Even reviewers who agreed with Rookwood's distinctive American quality never include a discussion of subject matter depicted on the ware; for example, one reviewer wrote, "Decidedly the most interesting feature in the growth of pottery in the United States has been the recent efforts to make expressive American ware, original, strong, and distinctive. The largest results have been reached in the Rookwood Pottery of Cincinnati."[26]

To Be American

All this began to change in 1888 when Taylor turned his attention to decoration. In October of that year, Taylor wrote to the Bureau of Ethnology in Washington, D.C., "The only publications we have are the 2nd and 3rd Annual Reports of the Bureau of Ethnology—dated respectively 1880–1 and 1881–2. We shall appreciate highly any further 'material' with which you may favor us. We may not be able to incorporate it as much as we would like into our work but we think the experiments in that direction ought to be continued."[27] The "material" of which he spoke could have been books or printed material, but it also could have been photographs. The Bureau of Ethnology (renamed Bureau of American Ethnology in 1897) was administered by the Smithsonian Institution, under the Department of the Interior. From 1867 to 1879 the government sponsored geographical and geological surveys of the western United States for purposes of military reconnaissance under the direction of the War Department. During 1879 the purpose of the surveys shifted to geological and ethnological studies controlled by the Department of the Interior and executed by the newly created Bureau of Ethnology. The government considered photography an essential means of gathering information about Native American groups.[28] Copies of the photos taken by the Bureau of Ethnology could be purchased from the Smithsonian Institution, which was probably noted in the bureau's reply.

Enter Artus Van Briggle and Indian Motifs, 1888

The first known results of Rookwood's experiments with "material" from the Bureau of Ethnology can be seen in two known vases: one is a Standard glaze line bowl; the other is a Tiger Eye glaze line vase (fig. 5).[29] Both are dated 1888, and exhibit incised decoration by Artus Van Briggle (1869–1904). Van Briggle moved from Felicity, Ohio, to Cincinnati in 1886 to study and pursue a career in art.[30] In 1887 he was hired at Rookwood after a brief stay at the Avon Pottery, and soon became one of Rookwood's finest decorators. Incorporated in his painted and incised decorations on the two 1888 vessels are North American shell gorgets (e.g., fig. 6), taken from the article "Art in Shell of the Ancient Americans," found in the *Second Annual Report of the Bureau of Ethnology, The Smithsonian Institution*.[31] Images of these shell badges of office or distinction that were worn around the neck appear to be the first American Indian motifs found on Rookwood since

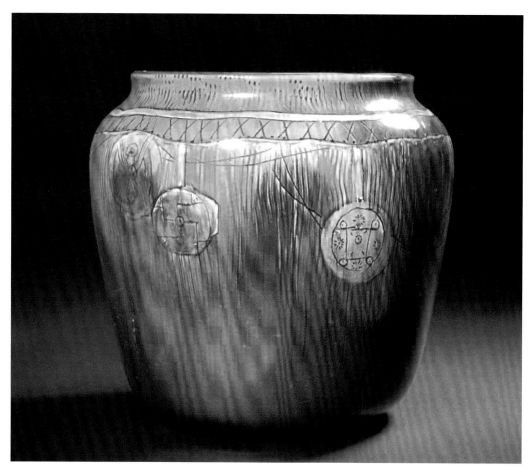

Figure 5. Artus Van Briggle (1869–1904), Vase, manufactured by the Rookwood Pottery Factory, Cincinnati, 1888. Stoneware, D: 17.2 cm. ©*The Cleveland Museum of Art. In Memory of Hattie M. Horvitz from her sons Harry, Leonard, and Bill. CMA 1984.185.*

Farny's failed experiment. Decorators at the Pottery continued to use shell gorget motifs taken from this source at the end of the century, but in combination with silver and copper overlay motifs on vessels depicting Indian portraiture (e.g., cat. nos. 7, 43).

Cincinnati's Centennial Celebration

In 1888, Cincinnati was celebrating its centennial and looking to Native Americans as the first settlers of the land. About three thousand years ago the Ohio Valley, which includes Cincinnati, had been the home of people who came to be known as the moundbuilders, because they built prominent mounds and massive earthworks found scattered over lands west of the Appalachians.[32] Trying to discover the age of the mounds and the

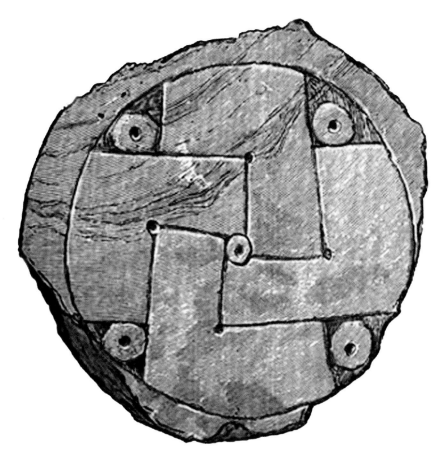

Figure 6. Shell gorget, taken from William H. Holmes, "Art in Shell of the Ancient Americans," *Second Annual Report of the Bureau of Ethnology, The Smithsonian Institution, 1880–81* (Washington: GPO, 1883): 185–305, pl. LII, fig. 1.

identity of their builders, the Bureau of American Ethnology led explorations from 1881 to 1893 into the mounds, especially in the Ohio Valley, where the most intensive inquiry took place. *The Second* and *Third Annual Report of the Bureau of Ethnology,* books mentioned by Taylor as being in Rookwood's possession, offer reports on the bureau's archaeological fieldwork into the mounds, as well as contemporary Indian culture. The gorgets were thought to have been by the moundbuilders. Coinciding with this activity and the Queen City's centennial queries into its earliest natives, the Cincinnati Art Museum received and displayed Thomas Cleneay's collection of over three hundred Indian archaeological artifacts (including shell gorgets); Judge Joseph Cox's Mound Builders collection of over four hundred archaeological specimens found in the immediate vicinity of Cincinnati and Madisonville (which was then on the immediate outskirts of Cincinnati, and is now a suburb of the city); the R. O. Collis collection of archaeological specimens

from the mounds at Madisonville; and the C. W. Riggs collection of Arkansas Mound Builders' pottery.[33] Personnel at Rookwood certainly saw these artifacts on exhibit. Taylor said that the influence of the museum was a constant help to the Pottery.[34] Cincinnati's centennial celebration, the reports from the Bureau of Ethnology, and the displays at the Cincinnati Art Museum, all combined to inspire the gorget motifs on Rookwood and the Pottery's use of Native American imagery in 1888. The subject matter lent itself to decoration, and the fact that it was topical suggested that it would also lend itself to sales.

The First Indian Depiction, 1889

The next known use of Indian imagery at Rookwood was in the following year. It consists not of archaeological but of contemporary Indian subject matter on a crucible (tri-cornered) pitcher (fig. 7) decorated by Artus Van Briggle, the decorator of the gorgets. Depicted on the pitcher is the profile of an Indian highlighted by the moon or the sun. Several Indian artifacts surround the profile, including two leather shields. The painting is not as accomplished as Van Briggle's later pieces, and the profile is too vague and sketchy to be the portrait of a particular individual; but more than just a symbolic gesture, like the gorgets, it is a depiction of a contemporary American Indian. The source for this depiction is unknown. It could have been taken from a print source, or perhaps from sketches created by Van Briggle himself. There were certainly enough American Indian artifacts at his disposal. In addition to the archaeological specimens displayed in 1888, the Cincinnati Art Museum also received and displayed eighty specimens of American Indian artifacts from the United States National Museum, Smithsonian Institution, Washington, D.C., representing contemporary Indian culture from across the country; the Manning F. Force collection "embracing American Indian costume, textiles, pottery, weapons, tools, etc.," which included two shields; and specimens from the Alaskan Indian cultures in the Helen L. Fechheimer collection; and from the W. W. Seeley collection.[35] To date no other examples of Rookwood pottery from 1888 or 1889 depicting Indian motifs have come to light. Since the two known examples are by Van Briggle, it suggests that, as with Farny, Van Briggle might have been the original agent of inspiration. To be sure, William Watts Taylor was actively involved and agreed with the direction. Nothing known about Artus Van Briggle at this point in his life suggests that he held any special interest in Native American cultures. Curiously, two out of three of the next known Indian depictions, all from 1893, are also by this artist, but the imagery is light years apart in quality and expression from his earlier pieces. Why such a difference?

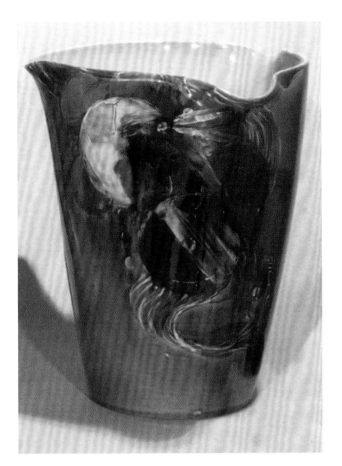

Figure 7. Crucible pitcher, 1889. The Rookwood Pottery Company (1880–1967), decorated by Artus Van Briggle (1869–1904). 8 inches high. Unknown collection. *Courtesy of Cincinnati Art Galleries.*

Between 1889 and 1893 something fortuitous happened to Rookwood that created a sea change in overall subject matter, painting technique, and quality of decoration.

Maria Longworth Storer vs. the Art Academy of Cincinnati

Maria Longworth Storer (the widowed Maria had married Bellamy Storer in 1886) always maintained close connections with the Art Academy of Cincinnati. Her father, Joseph Longworth, founded and endowed the art school with a gift of $371,631, a considerable sum for the time.[36] Moreover, she hired the academy's finest students to work as decorators at her Pottery, so she had a vested interest in its success. There had been long-standing sentiment in the community, beginning as far back as 1875, when the Art Academy was still the School of Design of the University of Cincinnati, that the academy was poorly run and outdated.[37] Maria fervently agreed. She thought the principal of the Art Academy, Thomas Satterwhite Noble (1835–1907), was seriously mismanaging the school.

During the 1889–90 school year, she took an oil painting class from him and commented, "There is supposed to be a class in oil painting, but as it is put under the instruction of Mr. Noble, who has everything else on his shoulders, from the cellar to the roof, it is impossible for him to be in enough places at once to give the time it requires, and the pupils grow disheartened and drop off one by one."[38] She had a point. Out of more than three hundred pupils at the school that year, only six had registered for Noble's class, and only four, including Maria, had attended.[39] He was the only painting instructor at a time when painting was considered the ultimate test of student accomplishment, and yet students seemed to shun his classes. You can imagine the slight it was for Noble to neglect a class that included the founder's daughter, who was one of the richest people in America, employed his students, and was used to being treated with deference. She held Noble in utter contempt. Maria fully believed that the classes and mode of teaching at the Art Academy were a disservice to the community, not to mention her father's endowment and her Pottery.

To correct this, she had her name submitted for nomination to the Board of the Cincinnati Museum Association, the governing body of the academy and the Cincinnati Art Museum. In a case of biting the hand that feeds it, the board turned down her nomination because she was a woman. The *Cincinnati Commercial Gazette* noted, "There are those who would like to have seen a new face on the Board. But these are a revolutionary and almost anarchistic minority. The good old steady regime is the best, and Cincinnati always wants the best."[40] As one citizen noted in a letter to the editor of the *Cincinnati Commercial Gazette,* "Mrs. Storer was a woman, and worse than that, a woman with ideas, and with a knowledge and appreciation of art greater (with probably one exception) than all the Board put together."[41] Joseph Longworth's daughter was not about to give up. Never a lightweight or one to think small, she decided to counter the Art Academy by founding her own art school. This was news.

Reenter Frank Duveneck

On Sunday, May 18, the *Cincinnati Commercial Gazette* placed the story on the front page above the fold.[42] The entire episode was laid out in all its juicy details. Included was the fact that for the first instructor she had hired Frank Duveneck to teach oil painting at a salary of $3,600 per year. Duveneck was then in Boston where, unlike Cincinnati, his avant-garde style of realism was warmly received. In 1875 he had gone back to

Munich, with stays throughout Europe, including Paris, Venice, Rome, and Florence.[43] He had become famous as an artist, and was considered one of the best teachers of art in America.

It was not in the Art Academy's best interest to be held in disfavor by the formidable Maria Longworth Storer. The Museum Association, which governed the Cincinnati Art Museum and Art Academy, could not afford the breach and was the first to blink. The very next day the *Cincinnati Commercial Gazette* ran a follow-up article noting, "There is no misunderstanding between Mrs. Storer and Mr. Noble," and, "Mr. Noble, Principal of the Art School, has kindly offered to assist this class in every way in his power."[44] What is more, the class "is intended to help the Art School by giving higher instruction to its pupils and a foreign scholarship [to travel abroad] of $1,000 as a prize [to one of the students] at the end of each year." Curiously, the Board of the Cincinnati Museum Association, the very board that had rejected Maria's nomination, saw to it at great expense that a studio was prepared for Duveneck's classes on the third floor of the museum directly above its rotunda, and that the Art Academy would offer six tuition scholarships to deserving students for the class.[45] This was obviously a gesture of appeasement on the part of the Cincinnati Museum Association, not wanting to offend the powerful Longworth family, whose money and art collections greatly enhanced the academy and the museum.

The Duveneck Classes

The Duveneck class began October 21, 1890, with over thirty pupils enrolled.[46] There were two models, one posed at the east end and one \at the west end of the fifty-six-foot-square room.[47] The models posed daily in both the morning and afternoon, with criticism (or instruction) offered twice a week on days that would not interfere with academy work.[48] The studio was open daily from 9:00 a.m. to 4:00 p.m. to allow students ample time to address their work. The course ran through the end of April. Duveneck taught for two years, in 1890–91 and 1891–92, after which he took a leave of absence and traveled in Europe.[49] When he returned, the course was not reinstated. By this time Maria was living in Washington, D.C., following her husband's career as a U.S. congressman[50] and pursuing new endeavors. Duveneck later joined the faculty of the Art Academy in 1900, and upon Noble's retirement, became chairman from 1905 until his death in 1919.[51]

Cincinnati Art Museum archives for the Duveneck course (which are incomplete) and the Art Academy (also incomplete), newspapers, and especially photographs taken

Figure 8. Photograph of the first Duveneck class, 1890–91. *Cincinnati Art Museum. Cincinnati Art Museum Archives.*

during the course combine to offer the most extensive list of students. The Rookwood decorators are almost all pictured in a photograph (fig. 8) of the first class. They are Matthew Andrew Daly (1860–1937), Charles John Dibowski (1875–1923), Bruce R. Horsfall (1869–1948), William Purcell McDonald (1865–1931), Kitaro Shirayamadani (1865–1948), Albert Robert Valentien (1862–1925), Anna Marie Bookprinter Valentien (1867–1947), Artus Van Briggle (1869–1904), and Grace Young (1869–1947). A second photograph (fig. 9), as well as the archives, also records Sara Alice "Sallie" Toohey (1872–1941) as having taken the class in both 1890–91 and 1891–92. Others known to have taken the class both years that it was offered are Matthew Andrew Daly, William Purcell McDonald, Albert Robert Valentien, and Artus Van Briggle. It is probable that other decorators took Duveneck's course for either one or both years. For example, Art Academy catalogues listing students in oil painting for 1890–91 and 1891–92 list Elizabeth Wheldon "Bessie" Brain (1870–1960) and Sadie Markland (1870–99). Still others, such as Olga Geneva Reed (1874–1955), are listed as having taken courses during the Duveneck years; and Harriet Rosemary Strafer (1873–1935) and Harriet Wilcox (1869–1947) are not

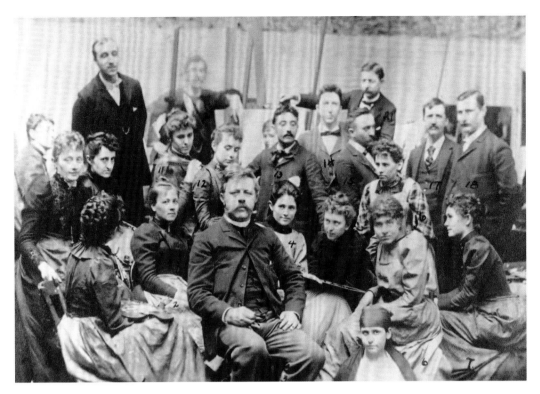

Figure 9. Photograph of the Duveneck class. *Cincinnati Art Museum. Cincinnati Art Museum Archives.*

listed in print, but could easily have been among the unidentified or obscured individuals in the photos.[52] It could also have been that they simply were absent when the photographs were taken. A letter dated September 28, 1891, to Thomas Noble from William Watts Taylor noted that Mrs. Storer would pay the tuition for (i.e., offer scholarships to) her decorators for the course, but he could not reach a decision "just yet" in regard to how many he could afford to let go.[53] Suffice it to say, certainly all the senior decorators and probably all the junior decorators at Rookwood between 1890 and 1892, as well as some who joined the Pottery later but were taking the course, studied under Duveneck.

Frank Duveneck's Legacy

Duveneck was an excellent teacher who brought his brand of the Munich School to the Pottery. He encouraged the study of the Old Masters of the Dutch, Flemish, and Spanish schools. The students could do this vicariously by studying the copies of the Old Masters

that Duveneck had painted and brought back, or in a much less gratifying way, through printed reproductions. Of course, what Duveneck really taught was portraiture that captures the soul. One newspaper noted that the artist's "peculiar forte is the painting of heads."[54] Indeed, the photographs of his classes show paintings from the model emphasizing the element of portraiture. He instilled in his students an interest in technique and freer paint application. A meticulous finish was not what he wanted. He wanted accuracy, but within the application of broader brushwork. In his painting class, strong figures emerged from darkness effectively contrasting deep shadows with bright areas of color. Eventually all this affected Rookwood imagery.

Grotesque Decorations

In April 1890, about five months before the Duveneck classes began, William Watts Taylor wrote, "We do not do figure work."[55] That was soon to change. By February 1891, four months after the Duveneck class began, he was writing, "Our newest things are grotesque subjects mainly in mugs, ale sets etc., some drawn from proverbs and some in 'Alice in Wonderland' fashion etc.'"[56] For example, an 1889–90 ale set (fig. 10) by Harriet Wilcox depicts ghostly characters on the pitcher and four mugs.[57] Other examples include an 1891 whiskey jug depicting the caricature of a pipe-smoking man with spectacles holding a mug, painted by Anna Valentien; or a pair of 1890 mugs, one depicting a bug-eyed, elflike character eating watermelon, the other depicting a bug-eyed, elflike character kneeling in prayer, both by Grace Young; or an 1892 mug by Harriet Wilcox depicting the "Five of Spades Child" from *Alice's Adventures in Wonderland*.[58]

Gender in Marketing

The rationale for the subject matter lies in the ceramic forms used for the depictions. They were generally wine or ale pitchers, mugs, jugs, tobacco jars (humidors), and ale sets, forms commonly used by men. Rookwood's floral decorations appealed to women. The fact that Rookwood originally appealed to women is not surprising since, as Taylor put it, "Pottery as an institution is 'Woman's Work,'" and the company was founded and owned by a woman.[59] Taylor often received requests asking that examples of Rookwood be sent to exhibitions featuring art by the fair sex. His response was always similar:

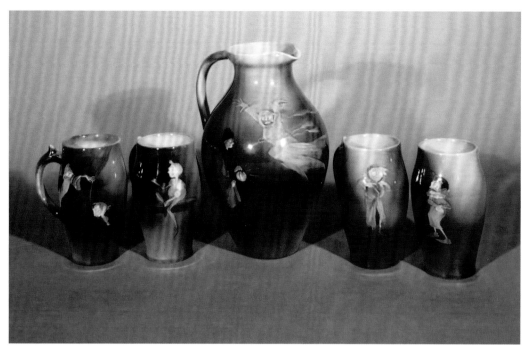

Figure 10. Ale set (one pitcher and four mugs), 1889–1890. The Rookwood Pottery Company (1880–1967), decorated by Harriet Wilcox (1869–1943). Height of pitcher 10 ½ inches; height of each mug 6 inches. Unknown collection. *Courtesy of Cincinnati Art Galleries.*

"Practically all the high-class work we now have on hand is done by men and could not well be classified in the department of womens [*sic*] work."[60] As late as 1904 he was still bemoaning the female reputation of Rookwood: "The Pottery has been written about to a rather tiresome degree from the 'woman's standpoint.'"[61]

Exit Maria Longworth Storer—Taylor Takes Control

In 1890 Maria, who was now actively involved with her husband's political career, transferred her interest in the Pottery to Taylor, who incorporated the company.[62] As a good businessman, and now president and treasurer of the firm, he wanted to broaden the company's horizons. He did two things: he set in motion plans for a new site and larger building for the company, and he began to market to men as well as to women. He was immensely gratified when someone saw the male aspect in the product: "You please us highly in calling Rookwood Pottery 'virile.'"[63] During the year of incorporation, ceramic forms such as wine or ale pitchers, mugs, whiskey jugs, ale sets, and tobacco jars began

to proliferate. Decorating them with flowers was not in keeping with the intended use or user, so additional subject matter was sought. Taylor wrote to a city artist named Lundgren in December 1890 that he still could not hire him, but "I thought of something for ale pitchers and mugs such as we make in sets. What would be wanted would be [drawings of] figures treated somewhat in the grotesque and simple enough in outline not to present too great difficulties for the copyists."[64] Slightly prior to this letter, Taylor wrote to Davis Collamore and Co., a leading American retailer and importer of fine china, cut glass, and crystal, and Rookwood's retailer in New York, "We are sending by express today in a special pkg. (invoice enclosed) some ale sets jugs and mugs with grotesque figure subjects. . . . We think they will address themselves especially to the male sex and attract immediate attention."[65] Grotesque subject matter was obviously introduced before the Lundgren letter, but it won such favor as to be pursued further. In the end, how it was that ghosts, little people with bulging eyes, and overall grotesque subjects were chosen may never be known, but they seemed to work.

The Move to Mount Adams

On January 26, 1892, the Pottery opened in its new, picturesque quarters atop Mount Adams overlooking the Queen City.[66] The Tudor Revival building was meant to suggest a quaint, inviting cottage industry rather than an industrial factory. Among other improvements, it provided a chemical laboratory for experiments. Every mixture of color for underglaze decoration and its trial-by-fire was studied to offer a multiplication of effects not possible before. In February Taylor noted in the company's annual report, "I think it fair to expect a steady improvement in quality and to some extent in quantity of work per hand during the coming year."[67]

The Beginnings of Portraiture as Decoration

During 1892, the last year of the Duveneck classes and the move to improved quarters, portraits of monks, generally drinking ale or wine, began showing up on forms "that address themselves especially to the male sex." Although probably taken from printed material or photographs, one such decoration (fig. 11) by Matthew Andrew Daly, a Duveneck student, reveals his mentor's influence through expressive paint application

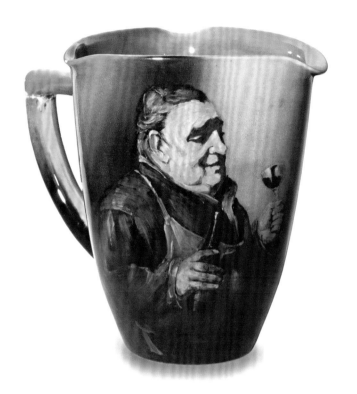

Figure 11. Crucible pitcher, 1892. The Rookwood Pottery Company (1880–1967), decorated by Matthew Andrew Daly (1860–1937). 8⅜ x 9 x 6½ inches. *Cincinnati Art Museum. Gift of Florence I. Balasny-Barnes in memory of her parents Elizabeth C. and Joseph Balasny. 1992.87.*

capturing the heart of a subject from daily life. These were more than just the grotesque characters or Alice in Wonderland figures that began appearing in 1890. They were the beginnings of portraiture on Rookwood made possible through training in the Duveneck class and improved technology for underglaze decoration.

To be sure, painting with underglaze slip colors is not the same as painting with oil colors. A slip is clay mixed with water to the consistency of thick cream. When used as paint colors, a coloring agent (metallic oxide) is added. Because slip colors are water-based, unlike oil colors, they dry quickly and are unforgiving. Mistakes have to be removed entirely and applied again. In addition, the color is not revealed until after the firing, so the artist has to picture the color in his or her mind while applying the slip. Also, where an object is placed in the kiln, and what is placed next to it, can make a difference in the colors. If an underglaze slip-decorated object is fired too high, the colors will burn out; if it is fired too low, the colors will peel off. Until technology improved substantially in the mid-1890s, the window of opportunity for firing was about a five-degree range—at a time when the temperature in the kiln was determined by the color

of the flame. These are just a few of the endless issues that make decoration under the glaze, let alone portraiture with expressive paint application under the glaze, a formidable task.

The depicted monks were the first step in a direction that was leading to accomplished portraiture in general, and consummate Indian portraiture in particular. The Indian portraits came the following year with the World's Columbian Exposition held in Chicago.

The World's Columbian Exposition, Chicago, 1893

The World's Columbian Exposition, highlighting an international array of products of art and industry, celebrated the four hundredth anniversary of the landing of Christopher Columbus in 1492.[68] Because of organizational complications, the fair did not open in 1892, but rather on May 1, 1893, and continued through October 30. Taylor knew about the coming exposition as early as April 1891 and began applying for space at the fair in January 1892.[69] Perhaps knowledge of the fair added to the impetus for the new imagery that began appearing in 1892.

The World's Columbian Exposition once again raised the question of the existence of truly American art. Unprecedented numbers of immigrants streaming into the nation during the 1890s exacerbated the concern for "Americanism." An 1890 census report noted that the unsettled land of the West was so rapidly disappearing that the "frontier line" had finally been obliterated. Centering on this fact, American historian Frederick Jackson Turner delivered a historically seminal address at the fair late on the evening of July 22. It has since been lauded as "the single most influential piece of writing in the history of American history."[70] He deplored the loss of the frontier because he believed that everything unique about Americans was due to its existence. The frontier offered Americans a sense of energy, freedom, opportunity, and above all—identity. Without the frontier, Americans were simply European derivatives. Long before the closing of the frontier, the American art world had been trying to shed its condemning aura of European derivation. Perhaps unknowingly, Turner had hit upon the key to the identity of distinctively American art. Could it have something to do with the frontier? Turner's definition of frontier was "unsettled," an expanse of land yet to be explored. For him, the American frontier first presented itself to Christopher Columbus, and the frontier line had continuously moved westward ever since until there was no more land to settle. Curiously, the Hudson River School of American painting, which depicts the then fron-

tier, has come to be considered the first truly American art movement. As the frontier line moved westward, so did the artists. Is the next distinctively American school that of Cincinnati landscape painting, depicting what was then considered the frontier? If something so seemingly superficial as subject matter is key, can we follow the westward movement of the frontier line in American history to suggest that the next truly American art would depict subject matter from what is now known as the West? Whatever the case, the definition of American art would be tested at the very fair where Turner gave his address. One of the major goals of the World's Columbian Exposition was to "prove to the most doubting and critical spirit that American art exists."[71]

Rookwood at the World's Columbian Exposition

Rookwood, of course, was comfortable with its American identity, which was still seen for the most part as being the combination of material, technique, and quality. Its ware was displayed in four separate exhibits at the fair: in the Fine Arts Building; in the Manufacturers and Liberal Arts Building in the jewelry section, along with exhibitions of silver, gold, jewelry, and ornaments; in the exhibit of the Gorham Manufacturing Company, which displayed pieces embellished with silver overlay; and in the Cincinnati Room in the Women's Building.[72] Rookwood was very sensitive about its presence in the Fine Arts Building. In a marketing booklet, after noting its award in Chicago, the Pottery proudly stated, "Also, exhibited in the Fine Arts Building by invitation," as if this were an award also. In a very real sense, it was. Halsey Cooley Ives, director of the St. Louis School of Fine Arts, and chief of the Art Department at the World's Columbian Exposition, believed that there should be no distinction between the fine arts and the industrial arts.[73] Lamenting the separation of artists from craftsmen, the Arts and Crafts Movement promoted equality between the fine and industrial arts, now called the decorative arts. Ives was a champion of this belief and tried to implement it by including decorative arts in the Fine Arts Building. For Rookwood to be invited to display in this building was confirmation of its parity with the fine arts. An art pottery could not ask for more. In the end, Ives's intentions were thwarted when, incomprehensively, American artisans failed to submit work for the division of fine arts. Rookwood's foremost display was in the Manufacturers and Liberal Arts Building where, for the first time at an international fair, it had a sumptuous display to itself (fig. 12). Much of Rookwood's showcase consisted of its unique and highly lauded crystalline Tiger Eye and Goldstone lines that

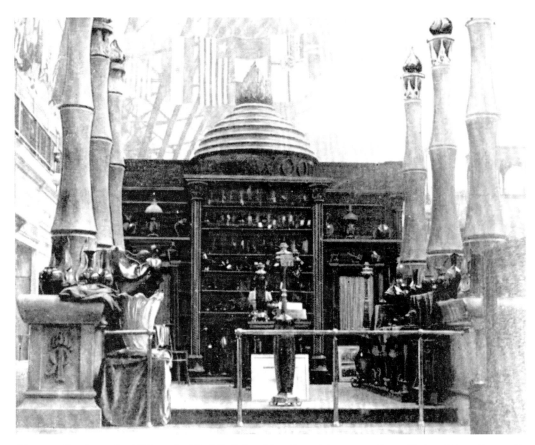

Figure 12. Rookwood exhibit at the World's Columbian Exposition, 1893. From Hubert Howe Bancroft, *The Book of the Fair* (Chicago: Bancroft, 1893), 168. *Courtesy, The Winterthur Library: Printed Book and Periodical Collection.*

won a gold medal for the Pottery at the 1889 Paris Universal Exposition.[74] But there was more this time, and it was equally unique and equally American. At least two pieces of Rookwood (cat. nos. 36, 37) depicting American Indian imagery were displayed at the World's Columbian Exposition.[75] Both were by Artus Van Briggle, the decorator of the 1888 and 1889 examples (figs. 5, 7) mentioned earlier.

Enter Joseph Henry Sharp

Records show that Van Briggle attended the Art Academy of Cincinnati during the 1892–93 school year, the year after the Duveneck classes.[76] Beginning with this school year, Joseph Henry Sharp (1859–1953) was hired to teach oil painting and drawing at the

school.[77] Sharp received his art education at the McMicken School of Design (later to be the Art Academy of Cincinnati) in the 1870s. He took his first trip to Europe in 1881, and in 1882 returned to rent a studio in the same building as Henry Farny's. In 1883 he made his first trip west. In 1890 he painted his first posed Indian portrait, and continued painting Indian subject matter (e.g., fig. 13), especially portraits, for the rest of his life. Sharp resigned from the Art Academy in May 1903 to pursue his career out west. Today he is considered one of the foremost painters of Indian life and portraiture. Van Briggle studied at the Art Academy the first year Sharp taught painting there. Unfortunately, records do not tell us what courses Van Briggle took, or whether he studied under Sharp, but that seems likely, given his seeming natural inclination toward Indian subject matter and the Rookwood pieces that he decorated for the World's Columbian Exposition. As for Van Briggle's abilities, in 1891, Rookwood decorator Grace Young thought that Van Briggle "had more talent than anyone I had ever known."[78] In 1895 the preeminent American ceramic historian, Edwin AtLee Barber, noted that Van Briggle, whom he referred to as an American artist currently being educated abroad by Rookwood, "has shown unmistakable talent in ceramic figure and portrait painting."[79]

Indian Decoration at the Fair

The laudatory comments of Young and Barber are reflected in the 1893 pieces decorated by Van Briggle. They are two plaques painted with Indian portraits: one depicting Governor Ahfitche (cat. no. 36) demonstrating the pump and drill method of making holes in turquoise and shells, the other (cat. no. 37) an unidentified Hopi man spinning wool. Each decoration is inspired by an 1879 photograph taken by John K. Hillers, staff photographer for the Bureau of Ethnology.[80] Probably as early as 1888, Rookwood purchased many of the bureau's photographs for the company's library, and most of Rookwood's American Indian portraits were taken from these photographs. Artists could also have taken them from other sources, such as their own sketches, illustrated advertising, newspapers, calendar art, or posters. These plaques, made for the World's Columbian Exposition and retained by Rookwood thereafter for the company's historic collection, presumably hung in the Pottery's main display in the Manufacturers and Liberal Arts Building but, in spite of their size, cannot be discerned in the photograph taken of that display. It is intriguing to think that they could have been made to hang in the Palace of Fine Arts next to oil paintings.

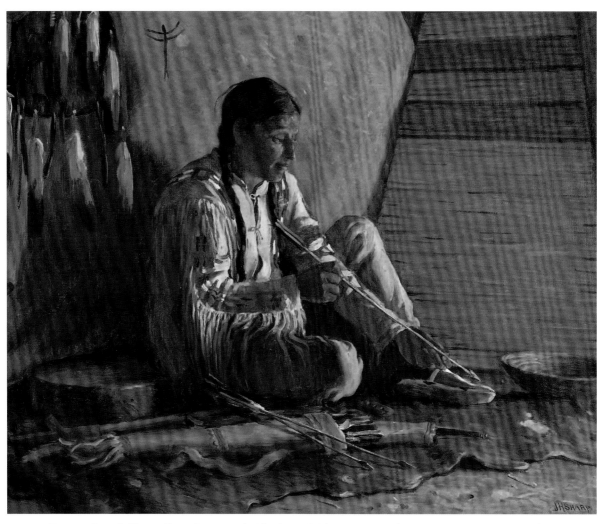

Figure 13. Joseph Henry Sharp (1859–1953), *The Arrow Maker,* ca. 1920, oil on canvas, 8¹¹/₁₆ x 10¹¹/₁₆ inches. *Cincinnati Art Museum. Bequest of Melba R. Townsend in memory of her parents, Mr. and Mrs. Louis Schott. 2001.60.*

The third known Indian Rookwood example to date from 1893 is a vase (cat. no. 10) by Bruce Horsfall. Horsfall had taken the Duveneck class the first year and won the foreign scholarship to travel abroad to Munich and Paris, which he did from late 1891 until 1893, when he returned to work for Rookwood. He left the Pottery in 1896 and eventually became internationally known for his paintings of wildlife.[81] Indian images do not stand out in what is known of his work. The Indian decoration chosen for the 1893 vase was taken from a poster (cat. no. 10, fig. 1) depicting an Indian on horseback atop a grassy knoll, peering into the distance. This poster was first used to promote Buffalo Bill's Wild West in 1885.[82] In 1893 it was also used for Buffalo Bill's Wild West that performed

just opposite the entrance to the World's Columbian Exposition for the duration of the fair. This time, added to the color lithograph were the words "Congress Rough Riders of the World" and, more important, "An American." The poster's title, "An American," is taken from this designation. By 1893 American Indian issues had subsided and the reservation Indian was no longer considered savage, but peaceful, and was to be respected as the first American, however unfortunate. This poster reinforced a goal of the exposition that was to be "relentlessly high-minded and didactic."[83] Reflecting the American mood at the time, the fair promoted the Indian as a subject of nobility. All of Rookwood's employees were given one week off with pay to visit the Exposition.[84] Bruce Horsfall could have seen the poster at the fair, or he easily could have seen it prior to the fair as promotional material. It also could have been in Rookwood's library. Perhaps William Watts Taylor encouraged use of it after realizing what a staggering success the Wild West was in London, where it was contiguous to another fair. Popularity by association would have insured the vase's salability, especially since the poster image would have been well recognized by most fair attendees numbering more than twenty-seven million people. The fact that the vase is nicely enhanced with the Gorham Manufacturing Company's silver overlay suggests that it is one of the Rookwood pieces noted as shown in Gorham's display at the fair. Unfortunately, there are no known records that can confirm this hypothesis.

The interesting point about the poster is that, unlike photographs of that time, the poster is in color. Not only can we compare Horsfall's version to the poster, we can also compare his use of color. The poster has a great deal of red in it, which was a difficult color to achieve in ceramic underglaze decoration in 1893. Either Horsfall, knowing this, chose not to use as much red, or it has simply fired out. An example of choice can be seen in the horse blanket, where the artist has reversed the black and red pattern so that the red does not predominate. At other places it may have fired out, such as in the Indian's hair ribbons and the part of the horse's bridle that goes behind the ears. We can be thankful that the red feather still holds its color. The yellow tint in the glaze that covers the decoration helps to make a red look orange-red. In general, because of the problems in firing the color red, decorators used it sparingly, and would often substitute less troublesome colors such as blue, brown, green, or white, even if they knew that an Indian costume called for red.

In each of the three known 1893 examples, the Indian portrayed is engaged in activity —drilling, spinning, and scouting. Their activities, not their identities, are the subject of the depictions. Nancy Owen, in her excellent study on Rookwood's Indian decorations, is absolutely correct when she points out that they "clearly played into the sentimental

adulation accorded Native Americans as inhabitants of the former frontier and as members of a vanishing race."[85] These initial depictions were clearly moving in that direction, and Rookwood's Native American subject matter would subsequently reach its fullest meaning when the emphasis was placed purely on portraiture. In 1893 the Pottery's movement toward portraiture was in its nascent stage, but it was so phenomenal that Edwin AtLee Barber commented on it at the time: "The pieces which attracted most attention [at the World's Columbian Exposition], however, were some vases and plaques decorated with ideal and grotesque heads, figures of monks, and other designs after engravings and photographs. . . . It is understood that not only fancy heads, but actual portraits, have been attempted with most gratifying results, and the day is not far distant when it will be possible to procure from the Rookwood Pottery painted portraits equal in all respects, and more satisfactory in some, to the oil painting."[86] Barber goes on to note that "among the foremost of those who have attempted this new style of decoration are Messrs. M. A. Daly, A. Van Briggle, and W. P. McDonald."

Introducing Three New Glaze Lines, 1894

During 1894 we see virtually no Indians on the Rookwood product. In fact, we see few if any "fancy heads" at all. Besides Indians and monks, the fancy heads that Edwin AtLee Barber had written about were depictions after paintings by Old Masters, especially Dutch, Flemish, and Spanish artists. Not surprisingly, they were all by decorators who had studied under Frank Duveneck and through him had acquired an appreciation for the work of artists such as Rembrandt, Velasquez, Van Dyck, and Franz Hals, among others. Of the two artists who appear to be the first to depict Native Americans, Van Briggle was sent by Rookwood to study abroad and left in January 1894 for two and a half years, and Bruce Horsfall's output of fancy heads for 1894 seems to be limited to a portrait of a Dutch gentleman. To date, no other fancy heads, including Indians, are known for 1894, although it is possible that they exist. Since this genre was so well received at the 1893 fair, one cannot help but question the almost total disappearance of it the following year. The reason is that Rookwood was preparing to introduce three new glaze lines and all the artists were working toward that debut. In November, December, and January 1894–95, the Pottery presented the Iris, the Sea Green, and the Ariel Blue glaze lines.[87] Unlike the Standard glaze line, with its yellow-tinted translucent glaze and overall brownish appearance, the new glaze lines were brighter in appearance, with a limpid, crystal-clear glaze

for the Iris and Ariel Blue lines and a green-tinted, translucent glaze for the Sea Green line. Iris offered light ground colors; Ariel Blue utilized light to medium blue ground colors; and Sea Green displayed blue-green ground colors in accord with aquatic subject matter. Taylor noted that they added freshness to the Standard production and wider opportunities to the decorators. Some of the artists relished the greater opportunities for decoration in the new lines; others preferred to return to the Standard style.

There was a decline in the monetary value of Rookwood's production in 1894, and two reasons were offered. First, smaller-sized ware dominated production to "accord with the times." The economic Panic of 1893 and the subsequent depression slowed the market. Smaller pieces cost less and had a greater chance of selling. Also, at a time of heightened experiments, the cost of the resulting losses of smaller pieces in the firing was less than that of larger pieces. The second reason for the decline in value of production for the year was that there were fewer pieces produced. Production was slower due to the multiple attempts involved in the experimental stage of the new styles of ware. In addition, there was strong pressure brought upon the decorators during the last six months for quality rather than quantity.

Productivity and the Cree Encampment, 1895

In 1895 the average size of pieces increased, the quality of decoration was excellent, and the general morale at the Pottery greatly improved.[88] The larger objects were more conducive to portraiture, and the improvement in morale probably had something to do with the fact that the artists were no longer pressed to decorate for the new glaze lines. What is more, Taylor almost certainly agreed that it was in Rookwood's best interest to perfect the portraiture technique that had been so popular at the Chicago fair. Rookwood participated in The Cotton States and International Exposition held in Atlanta, Georgia, during the summer of 1895 and won a gold medal for its pottery. This was a small fair compared to Chicago's, but perhaps it rekindled what was most promising before the new glaze lines appeared. In addition, in 1895, the Cincinnati Zoo and Botanical Garden accommodated a band of Cree Indian performers who had been abandoned by their organizer/speculator just across the Ohio River opposite Cincinnati in Bellevue, Kentucky.[89] The destitute Cree were invited to camp at the zoo until the band could earn enough money from an expected increase in zoo admissions to return home to Havre, Montana. Within two months the Cree were able to return home, and the zoo enjoyed

Figure 14. A Rookwood office showcasing the latest pottery, Mount Adams, Cincinnati, ca. 1895. This photograph has previously been identified as Rookwood's Showroom at its first location on Eastern Avenue. The number of flames depicted over the logo in the fireplace center stone suggests that it is at least 1891, the year the Mount Adams complex was built. The objects, which are biscuit-fired but not yet glazed to prevent reflections in the photograph, show at least three Indian portraits on the mantel shelf and on top of the cabinet, and fancy heads on the side table to the left. Lighter glazed ware decorations on objects in the cabinet tell us it is at least 1894, and the size of the fancy heads suggests 1895 at the earliest. This shot is obviously for publicity purposes because the staining on the wall over the fireplace, caused by coal heating, shows that a picture was removed for the photograph. *Cincinnati Museum Center–Cincinnati Historical Society Library.*

heightened attendance. It is uncertain if the Cree encampment inspired anyone at Rookwood, except perhaps Bruce Horsfall, to paint Indian portraiture on the pottery during 1895. It did, however, spark another encampment the following year that strongly influenced decoration at the Pottery. In the meantime, the Duveneck followers at Rookwood were happy to return to the fancy heads that had seemingly been suspended during 1894 (fig. 14).

For 1895 there are twenty-one known fancy heads: nine are after Old Masters, one is a monk, three are portraits of African Americans, and eight are Indian portraits (e.g.,

cat. no. 11) by Bruce Horsfall. Van Briggle was away in Europe, which explains the absence of Indian pieces by him. All of the fancy heads are in the Standard glaze line. Because the palette used for Old Master paintings was compatible with that achievable in the Standard glaze line, the line was ideal for depictions of these paintings. The Standard line was also compatible with the use of the darker tones of the Munich style that persisted among the Duveneck students. Even though the Pottery strongly encouraged artists to work in the new glaze lines, when it came to fancy heads, the decorators were steadfast in their loyalty to the Standard line, not to mention to their mentor. That is not to say that the artists did not attempt portraiture in the new glaze lines. For example, William McDonald painted a portrait after Velasquez on an 1895 Ariel Blue plate and a portrait of George Washington after Gilbert Stewart on an Iris stein.[90] But the results could not offer the depth of mood and were never as satisfying in the lighter-colored lines, and such examples are exceedingly rare. The known 1895 non-Indian fancy heads in the Standard line are by Grace Young, William McDonald, Sallie Toohey, Matt Daly, and Bruce Horsfall, all Duveneck students. Two are pieces by the one exception to this rule, Sturgis Laurence, who arrived at Rookwood in 1895 from his decorator position at the Ceramic Art Company (est. 1889) of Trenton, New Jersey, where he painted underglaze human characters. The fact that nine of the fancy heads, including the two by Sturgis Laurence, were taken from Old Masters demonstrates the continued strength of the Duveneck influence.

The Sioux Encampment, 1896

In 1896 and 1897 the number of Indian portraits began to increase. One reason was because of what took place at the Cincinnati Zoo as a result of the positive experience with the Cree encampment the previous year. Lasting three months during the summer of 1896, an encampment of eighty-nine men, women, and children from the Sicangu Lakota Sioux band of Indians of the Rosebud Reservation in western South Dakota settled by invitation at the Cincinnati Zoo and Botanical Garden.[91] To educate Cincinnati, the zoo had decided to illustrate life on the Plains with a living Indian village. Unlike the Cree encampment, the Sioux encampment programming included repeated performances of a Wild West show closely following the manner of Buffalo Bill's staged dramas. "Thousands and thousands of pale faced visitors" attended. Certainly, Rookwood decorators were among the attendees, and they could easily have been among the artists reported to have sketched the Indians. Edward Timothy Hurley (1869–1950), who joined

Rookwood in 1896, visited the encampment many times, and often joked with his children about "Maggie Sittin' On A Heap," a supposed Indian at the zoo.[92]

Because the decorators of the fancy heads worked mostly from black-and-white photographs, they would have paid particular attention to the coloring on the Indians' costumes. For example, they would have recognized that the beaded brow bands of the eagle feather bonnets were nearly all white with red designs. When Rookwood decorators depicted them on the pottery, however, blue was often substituted for red because of the difficulty of firing the red color. Blue was often the color of choice when substituting for red because it would always fire true (i.e., blue) under any intensity of heat, and provide an equally strong alternative color for the composition.

Henry Farny and Joseph Henry Sharp became friends with many of the Sioux Indians, and Farny took multiple photographs of the encampment. Many Cincinnati photographers, especially Enno Meyer, documented the visit. Some of the Indians at the encampment appear on Rookwood wares; for example, Goes to War (fig. 16), Young Iron Shell (cat. no. 26), and Owns The Dog (cat. no. 27). Their portraits were taken from photographs in Rookwood's library. While most of the photographs in Rookwood's library were purchased from the Smithsonian Institution, an unidentified Rookwood photographer, perhaps T. H. Kelley, a former president of the Cincinnati Camera Club, or Rookwood decorator Constance Baker, imaged many of the Indians at the Cincinnati Zoo for the Pottery.[93] The image of Young Iron Shell is taken from such an example.[94] Ed Hurley noted that the Indians would come and sit for their photographs at Rookwood.[95]

1897

Indians and Old Masters, especially Dutch Masters, seemed to be part of the zeitgeist in Cincinnati by 1897. The Cincinnati Art Club, an all-male artists' club, held an annual Christmas dinner with themed costuming from a particular culture or historical period. A photograph of attendees of the 1896 Christmas dinner shows members dressed as Dutch portrait sitters or American Indians.[96] Seated in the center is Henry Sharp dressed not like an Indian, but like a burgomaster. In 1897 the club included Rookwood artists Kataro Shirayamadani, Albert Valentien, Matt Daly, William McDonald, and Artus Van Briggle, and non-Rookwood artists Joseph Henry Sharp, Henry Farny, and Frank Duveneck.[97]

By 1897 Rookwood decorators painting Indians on pottery, besides Bruce Horsfall and Artus Van Briggle, who returned from Europe in June of 1896, were William Mc-

Donald, Matt Daly, Sturgis Laurence, Harriet Wilcox, Sadie Markland, Sallie Toohey, Marie Rauchfuss (1879–after 1941), and Olga Geneva Reed. Of that group, only Marie Rauchfuss and Sturgis Laurence had not taken the Duveneck class. Both had, however, taken oil painting classes at the Art Academy of Cincinnati while Henry Sharp was teaching there. In the latter 1890s, Sadie Markland spent time in Colorado hoping for a cure for her tuberculosis. While there, she produced a number of western monotypes that were probably shared with her Rookwood colleagues.[98] She succumbed to the disease in 1899.

Progress in Technology

It was not uncommon "for a large percent of the contents of a kiln to be destroyed, and this after the designers have finished their work."[99] Most of the cost of production was invested in a piece by the first firing. Except for mat-glazed wares, decoration was applied to unfired ware, called green ware. In 1888 Taylor noted that seven-eighths of the Pottery's expense was invested in a piece by the first firing.[100] In 1910, after the mat-glazed wares had been introduced, he was writing that it was seventy-five percent of the cost "before the fire touches it." In 1896 and 1897, new technology greatly increased Rookwood's success ratio in the firing process. Stanley Gano Burt (1871–1950), Rookwood's "chemist," or ceramic engineer, brought back Seger cones from Germany in 1896. Seger cones, named after their German inventor, Hermann Seger, are a series of elongated ceramic pyramids that melt at different specific temperatures, and thus register the heat in the kiln. This was considerably more exact than reading the color of the fire to determine kiln temperature. In 1897 Rookwood began using the new pyrometer, an even more exact device used for measuring high temperatures. According to Taylor, "Many sources of loss have been removed and the way to further improvement made plainer."[101] Needless to say, this also contributed to the greater output during these years.

The Omaha Trans-Mississippi and International Exposition, 1898

From 1898 until 1900, Rookwood's production of the non-Indian fancy heads began to decline in number while the Indian portraits increased dramatically. Thirty-eight Indian portrait examples are known for 1898, thirty for 1899, and twenty-nine for 1900. Two

things appear to have sparked this proliferation of Indian portraiture at the Pottery: the Omaha Trans-Mississippi and International Exposition, and the 1900 Paris Universal Exposition. From June 1 to October 31, 1898, the Omaha Trans-Mississippi and International Exposition held in Omaha, Nebraska, presented the products, industries, and cultures of states west of the Mississippi.[102] It was the most successful exposition held in America up to that time. Most American expositions had offered a limited number of "live exhibits" of Indians, but the 1898 exposition exhibited chiefs of most Indian nations at the first "Indian Congress." A total of 545 Indians from thirty-six tribes attended. The exposition's Indian Congress had far-reaching consequences. Among them, Frank A. Rinehart was contracted by the Bureau of American Ethnology to be the official photographer. Rinehart intended to take full advantage of what he saw as the last chance to study the Indians before they were absorbed into the white culture. His realistic portrayals are one of the greatest influences on how we view Indians today. Rookwood purchased many of Rinehart's 1898 photographs in preparation for the 1900 Paris Universal Exposition. A newspaper article from the 1898 to 1900 period noted that William McDonald left Rookwood for a week to travel to New York and Washington, D.C.[103] While in Washington, he visited a photographer famous for his pictures of Indians. The date of the newspaper clipping is unknown, and the name of the photographer is not given, but Rookwood's annual report for the year ending January 31, 1898, noted that William McDonald "had charge of the [decorating] room to raise the standard of work among the junior decorators."[104] Given McDonald's responsibilities and the preparations being made at Rookwood for the Paris Exposition, it was probably McDonald who visited Rinehart during the latter part of 1898 and selected and purchased many of Rinehart's Omaha Trans-Mississippi and International Exposition Indian photographs for the Pottery.

The Paris Universal Exposition, 1900

Without question, the push toward Indian portraiture at Rookwood from 1898 through 1900 was in preparation for the 1900 Paris Universal Exposition. William Watts Taylor would have known about this fair at least two years in advance. The 1900 Exposition was designed to be the grandest international industrial fair ever held, and it is still considered by many as such today. Taylor was determined to surpass all other art potteries in the world. In part, he planned to do this with portraiture, a phenomenal accom-

Figure 15. Decorator Matt Daly in his studio at the Rookwood Pottery Company, ca. 1900. In this photograph Daly is painting an Indian portrait on a vase. *Cincinnati Museum Center–Cincinnati Historical Society Library.*

plishment in decoration under the glaze. And for subject matter, he was going to emphasize the Native American. One publicity photograph for the 1900 Paris fair (fig. 15) showed decorator Matt Daly in his Rookwood studio painting a Native American portrait on a vase. To the left of the artist is the very photograph from which the painted depiction was taken. There could not have been a more truly American subject for decoration. Late in 1898, John Valentine noted in an article for *House Beautiful* that Rookwood's efforts had been to develop "a native art, not an imitation of foreign achievement."[105] As with the 1893 World's Columbian Exposition, it was imperative to showcase the distinctively American quality of the Rookwood product. If it was important in Chicago to demonstrate that Americans were not simply European derivatives, it was even more so in Paris, a European capital.

By 1899 Taylor had the Pottery in full stride: it was achieving near technical perfection in the chemical (i.e., clay and glaze) and firing departments, sales had practically

doubled since 1892, and the quality of decoration was at its highest level ever.[106] For the two years prior to 1900 the very best pieces were reserved for the upcoming fair. Nearly all the pottery exhibiting Indian portraiture from 1898 to 1900, especially the large pieces, went to the exposition. While they were by no means the only type of Rookwood displayed, they contributed to the Pottery's success, and the Pottery flaunted them by providing images for reviewers. For example, a vase painted with an Indian portrait by Sturgis Laurence was depicted in an article on Rookwood at the Paris Universal Exposition in a review by *Deutsche Kunst und Dekoration.*[107] That same image plus an additional one of a vase decorated by Grace Young with the full figure of an Indian can be seen in a *Keramic Studio* article illustrating a few of the pieces that the Pottery would be sending to the Paris fair.[108] Rookwood won the Grand Prix, surpassing all other art potteries; Albert Valentien, representing the decorators, was awarded a gold medal; and Stanley Gano Burt, representing the "ware-making" departments, was awarded a silver medal, the highest prize allowed for the nonartistic end of the industry. In addition, William Watts Taylor was decorated with the Chevalier of the Legion of Honor by President Émile Loubet of France.[109] While all types of Rookwood sold well at the fair, the type most favorably regarded was the Iris line. Taylor was always sensitive to what sold best, and he used the information to steer Rookwood's production. The older Standard line was giving way to the newer product, and with it so was Indian portraiture. This may not have been obvious in 1900; however, it would come to bear later. Nevertheless, the 1900 Paris Universal Exposition was a crowning event for the Rookwood Pottery Company, and the Pottery and Cincinnati were duly proud.

Artists who were contributing to the increase in Indian portraiture by this time, besides those previously mentioned, were Constance Baker (1860–1932), Bessie Brain (1870–1960), Virginia Demarest (dates unknown), Edith Regina Felten (1878–1962), Adeliza Drake Sehon (1871–1902), Harriette Strafer (1873–1935), and Jeannette Carick Swing (1868–1942). Of all the artists, Grace Young, Harriette Strafer, and Bessie Brain had studied under Duveneck; Edith Felton, Adeliza Sehon, and Jeanette Swing had studied at the Art Academy during the years Sharp was teaching; and the educational backgrounds of Constance Baker and Virginia Demarest are unknown. Ed Hurley had not formally studied under Duveneck, but he knew him well and "worshiped" the master.[110] It should be noted that in March 1899, Artus Van Briggle left Rookwood and moved to Colorado Springs, Colorado, where he started the Van Briggle Pottery. He moved west for the dryer climate because he had contracted tuberculosis. He died of the disease five years later on July 4, 1904.[111]

All the World's a Fair, 1901

In 1901 Rookwood exhibited at the Pan-American Exposition in Buffalo, New York. The Pan-American was the first great American exposition since 1893. The country was prosperous, and with the prestige of Rookwood's Paris success, Taylor thought that sales would be good. In fact, "sales were excellent until the tragic death [i.e., assassination] of President McKinley which seemed to paralyze the whole enterprise."[112] In a review of the Pottery's wares at the Pan-American fair, an Indian vase decorated by Sturgis Laurence is depicted, and the writer noted, "Indian heads which started the present craze for things Indian, are as effective as ever."[113] But Taylor wrote that "the demand was largely for the later types of ware"—that is, for lighter colors and mat-glazed pieces.[114] The same year the Pottery also exhibited at the International Exposition of Ceramics and Glass in St. Petersburg, Russia. Rookwood received a gold medal (the highest award possible) in Buffalo, and a Grand Prize in St. Petersburg. However, the most important story of these fairs was not in Indian portraiture, or even in the Standard glaze line, but in the new mat-glazed ware, which is why Taylor lamented that "probably ninety per cent of the visitors did not know Rookwood in any but the Standard type." It was obvious where the market was going.

Mat-Glazed Ware—Feeling Grueby

In 1897, the Grueby Pottery of Boston, Massachusetts, began producing mat-glazed pottery to great acclaim.[115] It was awarded one silver medal and two gold medals at the 1900 Paris Universal Exposition, and in 1901 it received another gold medal at the International Exposition of Ceramics and Glass in St. Petersburg, Russia. Grueby ushered in the rage for mat-glazed ware that was to last until World War I. Other potteries such as Teco (Terra Cotta, Illinois), Van Briggle (Colorado Springs, Colorado), and Tiffany (Corona, New York) soon followed suit. Newcomb (New Orleans) and Rookwood also followed suit but added floral and/or faunal decorations to the marriage of sculptured shape and mat glaze. Grueby's signature green mat became known as Grueby Green and was emulated by virtually every art pottery in the country, including the Cincinnati firm.

Rookwood had begun experimenting with mat glazes as early as June 1896, when Van Briggle returned from Paris and initiated the development of this novel look.[116] He had probably seen Chinese examples in Paris collections that were sparking great interest.

Rookwood's first non-experimental (i.e., salable) mat wares, produced in 1900, did not go through the decorating department, but were decorated with incised lines by the "clay workmen," or potters under the supervision of William McDonald. Curiously, the incised decorations were mainly taken from American Indian designs. Stanley Gano Burt, on a directive from William Watts Taylor, took up the development of mat glazes in 1899, when Van Briggle left the Pottery. In 1901 it was too early to judge the salability of the mat work, but the prospect looked favorable, and the Pottery's ware was officially introduced at the Pan-American Exposition. These mat pieces could be sold at moderate prices since there was a surplus of labor in both the Clay Department and the Kiln Department, resulting in a relatively low manufacturing cost. As of January 31, 1901, approximately 438 pieces of these solid-color mat vessels had been made. And it did not stop there. Experimentation introduced artist-decorated pieces and brought them to perfection. Taylor was optimistic in his 1901 report: "While this [artist-decorated] work is not cheaper than other [artist-decorated] Rookwood it is so decided and beautiful a novelty that it can hardly fail to meet a ready sale." Mat-glazed ware was on the rise, and it would eventually put an end to Standard decoration under the glaze, which included fancy heads and Indian portraiture.

Mat glazes are by their nature opaque; you cannot see through them. Consequently, painting a composition under them is useless. With decorated mat wares, the glaze is the decoration. Since these glazes are thicker than slips, they cannot offer delicate or intricate compositions such as portraiture. Also, their pronounced downward flow in the firing creates problems even with broad or stylized compositions. Nevertheless, Rookwood went on to produce finer and greater varieties of mat lines than any other art pottery.[117] But in 1901, the talk was all about Grueby.

Indian Portraiture Continues, 1901–3

American Indian portraiture continued at Rookwood in spite of the popularity of mat glazes, although examples were fewer. Twenty such pieces are known for 1901. Besides those artists previously mentioned, only one additional decorator at Rookwood, Anna Valentien, contributed to the genre. Anna Valentien studied sculpture at the Art Academy for many years, and her only known contribution to Indian portraiture is a plaque (fig. 16), not painted, but carved in relief with the frontal portrait of Goes to War.[118] It dates from 1901 and is covered in a yellow mat glaze.

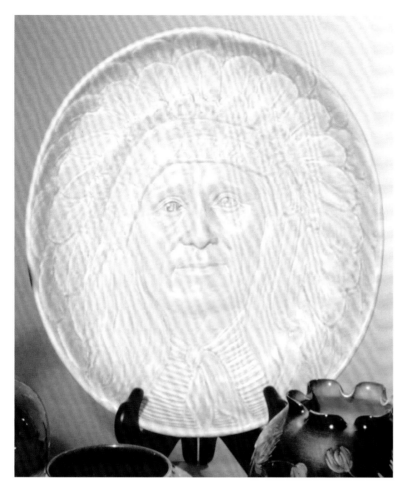

Figure 16. Charger: Chief Goes to War, 1901. The Rookwood Pottery Company (1880–1967), decorated by Anna Marie Valentien (1862–1947). Diam. 13 ½ inches. Unknown collection. *Courtesy of Cincinnati Art Galleries.*

There is a huge drop in the number of Indian portraits produced in 1902. Only three are known, and all are by Grace Young, who also produced the five known portraits after Old Masters that year. Rookwood saw the coming fashion, and it was not in the Standard line. While the Indian and fancy heads were not altogether abandoned, the emphasis now was on mat glazes. During 1902 Rookwood exhibited at the International Exposition of Modern Decorative Art in Turin, Italy, where it won one of the few awards of the highest class, a Diploma of Honor. Taylor remarked that commercial results at this exposition were not important, and were not expected, but that the exhibit was widely noted abroad.[119] He then casually noted, "The results of the year call for no special comment." First-class awards at world fairs seem to have become commonplace for Rookwood.

There are five known American Indian examples by Rookwood for 1903. Four are by Grace Young. On an Iris line plaque (cat. no. 52) she painted Kiowa men on horseback,

the same scene as that on a Standard line vase (cat. no. 42) she had executed in 1899. Also that year she painted another Iris-glazed plaque depicting Native Americans, possibly Eskimo, canoeing in the shadow of a snow-capped mountain.[120] Strictly speaking, these are not portraiture but depictions of Indians engaged in activity. The earliest known Indians on Rookwood by Van Briggle (fig. 7; cat. nos. 36, 37) and Horsfall (cat. no. 10) were also engaged in activity. With these depictions by Grace Young, it seems that the genre was coming full circle as it was coming to an end.

It should be noted that for 1903 there are fourteen known fancy heads inspired by Old Masters, all by Grace Young. These are the last known depictions borrowing from Old Masters except for a 1907 vase by Edith Felton. In 1903, Grace Young's last year at the Pottery, she seems to have almost single-handedly brought the fancy heads, including Indian portraiture, to a close in one last burst of energy. Rookwood obviously let her do what she did best, but directed her emphasis on the Old Masters. The preponderance of Old Masters over Indians suggests that the Pottery thought that, by this time, the Old Masters were an easier sell. This was, no doubt, true. From about 1900 until the beginning of World War I, American culture was fascinated by the Low Countries (Belgium, Luxembourg, and the Netherlands), especially all things Dutch.[121] Rookwood took advantage of this fashion through Grace Young's work, and through mat-glazed architectural tiles depicting Dutch scenes.

The End of Indian Portraiture— the Louisiana Purchase Exposition, 1904

Only one Standard line Indian portrait by the newly hired Edith Noonan is known for 1904. This is the last known Indian portrait of the era. Rookwood did, however, exhibit Indian pieces, obviously earlier ones, in 1904 at the Louisiana Purchase Exposition in St. Louis, Missouri. They were the last to be exhibited, for it was during this exposition that the death knell sounded for Indian portraiture. The St. Louis Exposition, which began April 30 and ended December 1, 1904, celebrated the centennial anniversary of the purchase of the Louisiana territory by the United States from France. Like all previous American fairs, it looked to American history for its purpose and advanced its theory of anthropology with its sideshow of "living exhibits," including the American Indian.[122]

Halsey Cooley Ives, former chief of the Art Department at the World's Columbian Exposition in Chicago, was now chief of the St. Louis Exposition's Department of Art.

Continuing his vision of unifying the fine and decorative arts, he determined that "applied arts" would be displayed in the Palace of Art along with fine arts. The superintendent in charge of the applied arts displayed in the Palace of Art was Frederick Allen Whiting, secretary of the Society of Arts and Crafts in Boston.[123] His personal taste was as sober as it was narrow. In ceramics he disliked painted surface ornamentation, preferring the severe restraint of a solid glaze on a simple or sculpted form. In short, he promoted the narrowest ceramic definition of the Arts and Crafts Movement that became fashionable from ca. 1900 to 1914 as in essence he became the one-man judge and jury for the display of the applied arts. Taylor submitted sixty-three pieces thought to best represent an array of Rookwood Pottery's product. Much to his surprise, not to mention his anger, Whiting rejected forty-eight pieces and accepted only fifteen.[124] In a letter to Halsey Cooley Ives, Whiting said that "he hoped to limit Rookwood's display to a group of 'undecorated pieces' with 'dull glazes,' since he preferred them to the glossy 'indian' [sic] head and flower vases which usually [made] up their exhibits at most international expositions."[125] Incensed, Taylor wanted to withdraw the entire exhibit, but then thought better of it. Ultimately, he conceded and displayed Rookwood's primary exhibit, not in the Palace of Art, but in the Palace of Varied Industries (fig. 17), where Whiting had no control. Not surprisingly, Grueby, which was based in Boston like Whiting, had a large display of forty pieces, more than any other art pottery in the Palace of Art. According to Dr. Beverly Brandt in her article for the *Archives of American Art Journal,* "Overall, the arts and crafts exhibit at St. Louis did not provide an impartial overview of American craftsmanship in 1904. Instead, it featured costly masterpieces from a specific geographical region [the Northeast], produced by members of a single organization [the Society of Arts and Crafts] and reflecting a very conservative aesthetic and technical approach [Whiting's]."[126] Taylor had a terse one-sentence comment on the fair in that year's annual report: "While the Pottery received two Grand Prizes, one each in the Vase [Palace of Varied Industries] and Faience [clay industries] Departments [not in the Palace of Art], the sales were disappointing and the expenses relatively very large."[127]

Even though one reviewer recognized that "for the present, at least, Rookwood leads the ceramic world in America," Taylor was not pleased.[128] Rookwood was so accustomed to the respect it commanded at world fairs that Whiting's imperious rejection of so many of its pieces was stinging, and was viewed as nothing less than an ignorant insult from a narrow-minded, biased individual. Taylor's greatest wish was for Rookwood to be recognized as the embodiment of fine art. Whiting was seriously impeding this goal. Since mat glazes were now the world's fair ideal of Boston's ceramic arbiter of

Figure 17. Rookwood's display in the Palace of Varied Industries, Department of Manufacturers, the Louisiana Purchase Exposition, St. Louis, Missouri, 1904. *Cincinnati Museum Center–Cincinnati Historical Society Library.*

taste, there was another issue. The Cincinnati pottery competed more with European than with American potteries. Its competition had never come from the United States, where Rookwood was recognized as the preeminent art pottery. The Cincinnati firm looked to the likes of Sèvres of France, Royal Copenhagen of Denmark, and Meissen of Germany to gauge its competitive edge. The European potteries were not as vested in mat glazes as the American potteries. And so, while Rookwood could give up its Standard line as having run its course, it did not want to give up its Iris line that was so well aligned with European taste, and judged superior to European quality in the 1900 Paris fair. Yet another issue was that Rookwood's stock-in-trade was decoration under the glaze, something mat glazes could not promote. What the Pottery needed, and had been developing since 1900, was a seemingly oxymoronic translucent mat glaze.[129]

The Vellum Glaze Line

It was at the Louisiana Purchase Exposition that Rookwood debuted its Vellum glaze line, which featured a sensational, translucent mat glaze.[130] A slip-painted decoration could be seen under this mat glaze, although it gave a misty appearance to the composition. These first examples featured floral decorations, with a few marine depictions.[131] A reviewer noted, "Technically, it would seem that mat glaze on pottery could develop no further."[132] This was an extreme compliment during a hypersensitive period for mat-glazed ceramics. In 1905 Rookwood decorator Albert Valentien painted the first land-

scape under this glaze, which marked the beginning of forty-three years of financial and aesthetic success with the "scenic" Vellum line.[133]

If Rookwood's fascination with the American Indian were to continue after 1904, it would be in the Vellum and/or Iris glaze lines. By this time the Standard glaze line was twenty years old, becoming outdated, and looking Victorian. In 1890 Taylor noted that the rich, dark tones of the Standard line suited many surroundings.[134] This was true at the time, but they did not suit the lighter, more tailored surroundings of this later Arts and Crafts era. Taylor did not want an aging Victorian image for his Pottery and promoted the newer lines, which sold better in any case. Contrary to Rookwood's claim that "the effort has not been to suit the taste of the market, but to raise that taste," the market's taste was the deciding factor in production.[135]

By 1904 most of the major artists who produced Indian subject matter were gone: Matt Daly left in 1903, Bruce Horsfall in 1895, Sturgis Laurence in 1904, Artus Van Briggle in 1899, and Grace Young in 1903. Others such as William McDonald, Harriet Wilcox, Olga Geneva Reed, Ed Hurley, and Sallie Toohey remained beyond 1905, but none expressed a vested interest in Indian subject matter or the Standard glaze line. The Standard line was discouraged at the Pottery, and the newer, lighter-colored lines did not offer the same sensibilities of ethos and moral character thought necessary for the success of Indian portraiture. The remaining artists had no qualms about the newer direction with its fresh potential for decoration.

The Aftermath of Indian Portraiture

Any Indian subject matter appearing after 1904 is in the Iris or Vellum glaze lines, and it is exceedingly rare. Two Vellum vases are known. Both are dated 1909, and were decorated by Ed Hurley. One depicts a Native American encampment at twilight with Indians engaged in activity and tipis, all in shades of green and gray (fig. 18). The other also depicts tipis and Indian activities at twilight, in dark shades with a quiet pink horizon reflecting in a body of water. Offering its hazy effect, the Vellum glaze enhances the early morning or late evening atmosphere in the hushed mood of the compositions. These images could have been inspired by photographs. Ed Hurley was an inveterate photographer who developed many of his own prints, and would often choose early morning or late evening for his outdoor shots.[136] It is intriguing to think that these scenes might reflect the 1896 Sioux encampment at the Cincinnati Zoo. Whatever the source of inspiration, in both,

Figure 18. Vase, 1909. The Rookwood Pottery Company, decorated by Edward Timothy Hurley (1869–1950). Height 8½ inches. Unknown collection. *Courtesy of Cincinnati Art Galleries.*

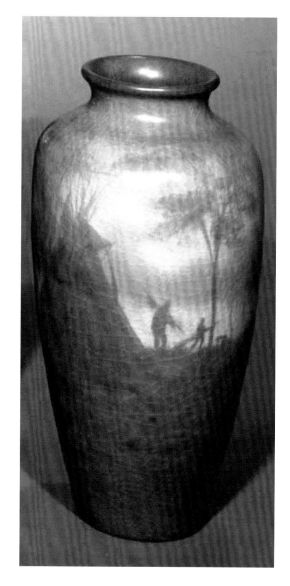

the subject matter is actually vested more in the atmosphere of twilight than in the activity of Indians. Mood is primary; the Indian activity is secondary. These are Tonalist depictions enhanced by the Vellum glaze.[137] Hurley had a particular allegiance to the Vellum line because it enhanced his Tonalist compositions. According to his daughter, Joan Hurley O'Brian, "Every other word was 'Vellum.' He loved it."[138] Significantly, neither piece depicts portraiture.

The one known Indian Iris vase (fig. 19) is by Edward George Diers (1870–1947) and dated 1911. The cylindrical vase tapering to the top incorporates a gray ground that is banded in the lower half with a gray silhouette of Native Americans on horseback in a wooded area, backed by blue-shaded mountains and white sky. Diers began at Rookwood in 1896 and seems to have painted no Indian portraits. He preferred to work in the Iris line. His 1911 example is a tonal composition that, once again, displays Indians in activity.

Rookwood's fascination with the American Indian had, in effect, ended by 1911. But in 1930 Rookwood produced a commercial ware bookend (fig. 20) designed by the Indian portrait decorator William McDonald.[139] It is rarely seen on the market, suggesting that it did not sell well, or that it had the misfortune of being produced just as the Great Depression was getting under way. In 1946 Flora King (1918–after 1968) painted at least twelve mugs with Indian portraits taken from the same Rookwood photographic

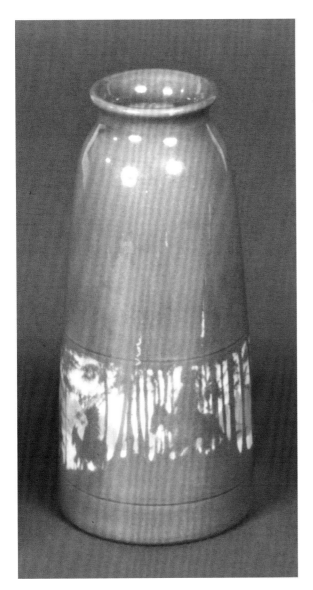

Figure 19. Vase, 1911. The Rookwood Pottery Company, decorated by Edward George Diers (1870–1947). Height 7 ¾ inches. Unknown collection. *Courtesy of Cincinnati Art Galleries.*

library as the earlier genre. For example, her image of Owns The Dog (fig. 21) is the same as that used in the 1898 vase (cat. no. 27) by William McDonald. While Flora King can be lauded for her efforts, her Indian portraits are anachronistic. They lack the richness of the Standard glaze, the pathos of current history, the quality of painting, and the technological skills needed to translate the nobility of the image to underglaze decoration. In comparison with the earlier era, by 1946 Rookwood was a shadow of its former self. If nothing else, the shortcomings expressed in Flora King's mugs serve as a reminder of the consummate technical and artistic skills needed from the potter, decorator, glazer, and kiln master that Rookwood once enjoyed in the creation of its masterpiece production.

The Number Produced

A survey of more than fourteen thousand artist-decorated pieces of Rookwood from 1881 to 1955 yielded slightly more than 160 objects depicting Indian subject matter.[140] This suggests that the Pottery's Indian output was about one percent of its artist-decorated product. A calculation of Rookwood's production based on its annual reports between

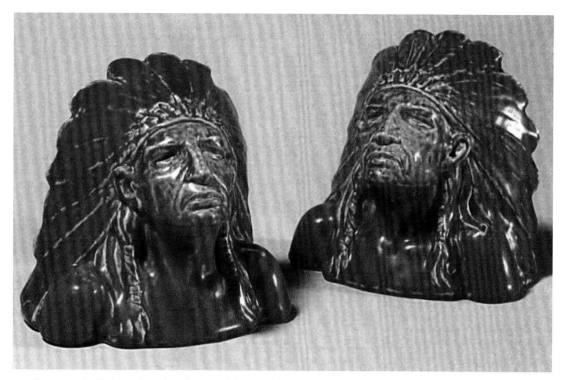

Figure 20. Indian head bookends, 1930. The Rookwood Pottery Company, designed by William Purcell McDonald (1864–1831). Height 5 ¾ inches. Unknown collection. *Courtesy of Cincinnati Art Galleries.*

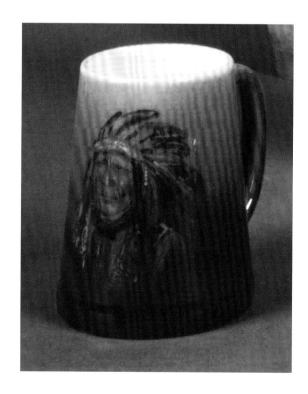

Figure 21. Mug: Owns The Dog, 1946. The Rookwood Pottery Company, decorated by Flora King (1918–?). Height 5 inches. Unknown collection. *Courtesy of Cincinnati Art Galleries.*

1880 and 1931 (with estimates made where a report offers only a monetary value for a year's production instead of an object count) yields approximately five hundred thousand pieces of decorated ware made.[141] One percent of that total figure suggests that as many as five thousand objects decorated with Indian subject matter were produced at Rookwood. During the height of the Pottery's Indian fashion, from 1898 to 1901, when slightly more than fifty-three thousand decorated examples were produced, probably between one thousand and three thousand ceramic objects were decorated with Native American subject matter. These numbers are not scientific, but they offer a reasonable estimate of production and relative numbers for the genre.

Who Did Not Paint Indians on Rookwood

Twenty-three Rookwood decorators are known to have painted Indian portraits, but some very fine artists are absent from the roster, namely Kataro Shirayamadani (1865–1948), Albert Robert Valentien (1862–1925), Carl Schmidt (1875–1959), and John Hamilton Delaney Wareham (1871–1954). Keeping in mind that an Indian portrait could, in fact, exist by any one of these artists, it is safe to say that each had artistic inclinations that did not promote Indian portraiture. Valentien, as has been mentioned, was expert in floral painting. Kataro Shirayamadani worked mainly in a Japanese mode of decoration. John Wareham and Carl Schmidt, who joined Rookwood in 1893 and 1896, respectively, were weaned as decorators in the newer lines and were never noted for their Standard ware. In fact, Harold Bopp, a Rookwood ceramic engineer, stated, "It was to a great extent through Mr. Wareham's influence that the 'Iris type' of decoration, using a clear colorless glaze, was developed."[142] While William Watts Taylor determined the direction that decoration of the ware would take, he offered some leeway to artists to indulge in their individual expertise as long as their pieces continued to sell.

The Criteria for Quality Decorators

The Pottery allowed only its best decorators to paint portraits. Artistically, the subject matter is very demanding, and Rookwood was always seeking the lowest loss ratio possible. Large pieces, which utilized more clay, took longer to decorate, used more glaze, took more valuable space in the kiln, and used more energy, were reserved for the best

decorators. It was unacceptable to lose a large piece due to artistic shortcomings. Rookwood's estimation of a decorator can be judged by the overall size of the objects produced. Also, objects thrown by a potter cost more to produce than molded (slip cast) pieces. Consequently, at least in theory, knowing the size and production technique of ware decorated by the artists would define the best decorators without the need even to look at their decorations. Does this mean that an artist who produced decorations for slip cast pieces of around nine inches high or smaller could not be good? No. To comprehend this, it is important to understand the hiring process for decorators, the pricing of the wares, and the gender bias at Rookwood.

Hiring Decorators at Rookwood

Records do not exist that explain the hiring process under founder Maria Longworth Nichols, but Taylor gives a good idea of the regimen. With rare exception, decorators were hired from the Art Academy of Cincinnati. Maria's father underwrote the academy, and employing its graduates went without saying. At first Rookwood employed promising academy students on a part-time basis to train them and judge their talents before hiring them full-time. This did not prove satisfactory because student work did not meet Rookwood's standards. In 1890 Taylor wrote, "We have one or two still attending the Art School, we are terminating as rapidly as possible all part time arrangements as we find it too embarrassing in our work."[143] Henceforth, only graduates were considered for hire. The underglaze technique was difficult and required a lengthy training period. It could take up to several years for an artist to acquire the ability to handle ceramic materials and to develop his or her own methods and individuality.[144] Taylor considered a probationary period of six months sufficient to form a practical judgment of an artist.[145] Judgment was based on quantitative as well as qualitative results. When Edwin AtLee Barber questioned the artist ciphers, Taylor responded, "We have these put on mainly for our own convenience in tracing work."[146] Bessie Brain tells us that strict records were kept showing how many pieces each decorator produced, and if they sold, how much they commanded.[147] If artists did not bring in more than their salaries within six months, they were dismissed. Being able to track the sales of a decorator was the original, and until 1894, the only purpose for an artist's signature on Rookwood. Most unidentified signatures on objects after 1885, when Taylor stopped the sale of Rookwood blanks,

were of artists who did not remain beyond the probationary period and were never recorded. After the probationary period, an artist was kept as long as there was a sufficient profit margin on the number of pieces he or she decorated. This policy discouraged experimentation by decorators. Experimentation caused losses, and artists did not want losses on their records. That is why Taylor would have to issue directives for experimentation in new subject matter and new glaze lines, and why so many artists were reluctant to switch to new glaze lines requiring a change in the use of colors and techniques.

Pricing the Product

As with all business concerns, pricing was a science at Rookwood. The entire process to make a vase, from acquiring and preparing the clay, to throwing or casting an object, to decorating it, to biscuit-firing it, to glazing it, to glaze-firing it, and finally to selling it, took at least six weeks, and often longer.[148] Added to that is the time needed for experimentation on the part of the "chemists," or ceramic engineers, in regard to clays, slip colors, and glazes. All was taken into account when pricing the product, which developed into a formula based on size. In 1887, when almost all decoration was floral, Taylor noted the cost of Rookwood's bread-and-butter pieces, "vases from 8 to 10 inches high range from $3 and $4 to $7 or $8 each and those from 10 to 12 inches high from $5 or $6 to $8 or $10 each."[149] Pieces of singular quality, such as a large, successful, Tiger Eye example, could cost in the $50–$200 range. But for the daily fare, the slight variable in range depended on the technical perfection in the firing and quality of the decoration. By 1894, not only were prices generally higher, the variation in cost among pieces of the same size became considerably greater because the quality of decoration became more significant. Until 1890, almost all decoration was still floral. During that year decorators were emerging from the Duveneck class, and Taylor began pushing for male-oriented subject matter. In December 1890 he wrote that "often pieces of the same size vary materially in price."[150] This had to do with the widening variation in decorations and the growing sophistication of the background colors. As many as eight or ten colors were often blended to make the particular shading of a single piece.[151] Indeed, the subtly shaded ground color was a Rookwood signature that distinguished it from its American and especially European counterparts. In 1892 portraits of monks began to appear. In 1893 Edwin AtLee Barber commented on the fancy heads. In 1894 "strong pressure" was

"brought upon the decorators during the last six months for quality rather than quantity."[152] Prior to 1894 Taylor would rarely give out the names of the decorators, although he received many requests to do so. Concerning the artists' signatures, in 1887 Taylor told Howell and James, Ltd., Rookwood's London retailers, that "to them you need pay no attention."[153] As late as 1891, he refused to let the eminent Edwin AtLee Barber publish all the decorators' names and ciphers, noting that "their merit is not great enough to deserve this much notice. . . . Each piece is successful only to the extent that *all* [i.e., potter, glazer, kiln master, etc.] have done their work well."[154] But by 1893, with the introduction of the fancy heads, all that changed. There was a marked difference in artistic talent between floral decoration and portraiture. In 1894, for the first time, Taylor published the artist ciphers and their names in a marketing booklet.[155] Price now depended more on the quality of the decoration than on the size or technical quality of the object. The more highly regarded pieces, especially portraits, were now in the $25–$50 range or higher.[156] It is not surprising for Taylor to note that fewer pieces were produced in 1895, but that they were of a higher value.[157] The strong distinction in price based on decoration created a stronger hierarchy among the decorators, and for the most part, that hierarchy accentuated a strong gender bias.

The Gender Bias

The founder of Rookwood, although a woman, preferred to hire men. She openly stated, "[M]y somewhat expensive experience convinces me that to rely upon women's work for the decorative department of Rookwood would be to fail entirely."[158] Her first, full-time regular decorator was Albert Valentien.[159] Women were eventually hired as full-time regular decorators, but it probably had more to do with cost and the hiring pool than with preference. Valentien became the first supervisor of the decorating department, a position that was forever after filled by men. Taylor, hired by Maria, continued the bias. Only male decorators were sent abroad to study. These included Artus Van Briggle, Albert Valentien, William McDonald, Matt Daly, and Kataro Shirayamadani. John D. Wareham was also sent abroad, but with only a stipend, not the stipend plus his salary. Women who went abroad for study—for example, Bessie Brain, Anna Valentien, Grace Young, Sallie Toohey, and Virginia Demarest—did so at their own expense and usually quit the Pottery to do so. Salaries are difficult to discern, but when they are mentioned, they were also

biased in favor of the men. Kataro Shirayamadani was hired on May 3, 1887. By November of that year he was being paid $15 per week.[160] When hired, he was asked by Louis Wertheimer, Rookwood's Boston agent, not to discuss his salary with other decorators because the best artists were paid more and it might cause unpleasantness. This suggests that in 1887, Rookwood's best or male artists made more than $15 per week. When decorator Bessie Brain was hired in the fall of 1898, eleven years later, after having graduated from the Art Academy with honorable mentions and having studied for two years in the Duveneck class, she began "as they [i.e., women] all did," at $5 per week.[161] The following spring her salary was raised to $7 per week. The pay of decorators varied widely. According to Herbert Peck, in the mid-1890s a "newcomer" began at $3 per week, whereas an experienced decorator might get as much as $150 per month.[162] Peck does not distinguish between genders, but he does note that the highest paid decorators were Albert Valentien, William McDonald, and Matt Daly. The workday was the same for all decorators. It began at 8:00 a.m .and ended at 5:00 p.m., with one-half hour at noon for lunch and short breaks at 9:00 a.m. and 3:00 p.m.[163] Saturday work hours were 6:30 a.m. to 1:15 p.m., until the Great Depression ushered in the five-day workweek.

Which Decorators Were the Best

Of the twenty-three Rookwood decorators known to have painted Indian portraits, the question usually arises as to who were the best. With an understanding of hiring, pricing, and a built-in gender bias—which, it should be noted, was typical of the period—it is possible to review Indian portraiture artists in three quality categories: good, very good, and masterful. The mere fact that a decorator painted portraits meant that he or she was good. Indeed, only the best decorators even attempted portraiture because no one wanted to be charged with a loss. As all were at least good at the genre, it is only necessary to discuss the very good and the masterful Indian portrait artists.

Artus Van Briggle offered the greatest promise, but it went unfulfilled. He left to study abroad in January 1894 and returned in June 1896, at which time he concentrated his energies on developing mat glazes. He painted Old Masters and Indians, and his work was often very good, but was sometimes uneven, perhaps due to his ill health.

Sturgis Laurence was very good and rather prolific. He painted many Old Masters as well as Indians. He often painted tankards and especially mugs, probably to go with

ale sets, but also produced larger pieces. His highlights tended to be harder-edged than most, and he did not hesitate to use red, either by itself or blended with brown.

Harriet Wilcox was very good. She painted Old Masters as well as Indians. She is not noted for her portraits, probably because she did not do many. She made her name in the mat glaze lines, where her skill at painted mat and painted mat inlay was masterful.

Adeliza Sehon was very good. Little is known about her life or education. She was at Rookwood from 1896 to 1902 during the height of the fashion for Indian portraiture and was very comfortable in the genre. No Old Masters by her are known. Her pieces are rarely larger than nine inches high, and she can be overlooked, despite her skill.

Olga Geneva Reed was masterful. Matt Daly thought enough of her talent to encourage her to work for Rookwood, and he probably helped her once there. Her style offers a very soft blending of colors with no sharp contrasts in her compositions. Reed captured the soul of her subjects. She does not seem to have painted any Old Masters. She was equally adept in the Iris glaze line, for which she is probably better known. She commonly used thrown forms of ten inches or higher.

William McDonald was masterful. He painted Old Masters as well as Indians, but does not seem to have done many of either. He used sharp contrasts of light and dark with hard edge brush strokes that are dramatic, but not jarring. His compositions display a heavy use of red, either by itself or mixed with brown. He readily used blue, which adds to the color and complexity of his portraits.

Matt Daly was masterful. He used dramatic contrasts of light and dark in his compositions, and hard edge brush strokes to define his sitters. His portraits tend to be in profile or full frontal, and he sometimes incorporated gorgets into his compositions, usually around the shoulder of the vase. He mixed browns with red or with blue, and used red and blue by themselves to great effect. Daly shaded his ground colors in a way that makes them integral to, not simply a backdrop for, the compositions. In drama and contrast, his work probably comes closer to Duveneck's Munich style than any of the others. He was prolific in Old Master portraits as well as in the Indian genre. Except for an occasional mug, his pieces are often more than nine inches high and thrown.

Grace Young was masterful. Virginia Cummins regarded her as a gifted painter who was among the first to introduce portrait painting on vases at Rookwood.[164] She was by far the most prolific painter of Indian portraits and Old Master subjects at the Pottery. Her compositions tend to be marked by complexity in color and color blends, with a free use of blue and red. Her portraits can be shoulder-length or full-figure. She used the form, or body, of the vase, or plaque, as part of the composition. For example,

she might have placed a neck-length portrait of an Indian looking to the right on the left half of the flat surface of a pillow vase (e.g., cat. no. 47). She was equally comfortable working on a charger, a vase, or a plaque. She could paint the very young with innocence, or the very old with dignity. She did not hesitate to paint Indians engaged in activity and their horses, and could create convincing illusional depth to a composition on a flat or rounded surface with the simple placement of a foot (e.g., cat. no. 39) or the turn of a head. Each composition offers a different mood, whether it is dramatic, sympathetic, dark, light, somber, pleasant, tonal, colorful, simple, or complex. There is no one formula to her extraordinary work. When she left Rookwood in 1903 to study in Paris, the genre of Indian portraiture, not to mention Old Master depictions, effectively came to an end.

American Indians and the American Culture

There were, of course, much broader reasons for the debut and abandonment of Indian subject matter at Rookwood. During the last third of the nineteenth century, the American Indian "problem" was uppermost in the nation's mind. Relocations to reservations, warfare, and treaties were being reported in the newspapers, often on a daily basis, into the beginning of the 1890s. Battle locations such as Little Big Horn and Wounded Knee, and names such as George Custer, Sitting Bull, and Geronimo still resonate today. Nancy Owen convincingly argues that Rookwood's Indian portraits, which were primarily intended for American male consumption, embody the tensions within the doctrine of the "strenuous life."[165] Briefly, the doctrine proposes that the rise of industrialization induced a schizophrenic mental set that encouraged a sentimental yearning for a simpler way of life, including a nostalgic adulation for Native Americans, as well as an imperialistic drive that necessitated Indian removal. The American Indian was the poster child for these two seemingly contradictory strands of thought. Imperialism taught us to vilify Indians because we wanted the land they inhabited, while industrialization, with its deforestation and unchecked pollution, inspired admiration of Indians because their simpler way of life was at one with nature. The art of the white man expressed both sides of this dichotomous attitude. The western paintings of Frederic Remington (e.g., "A Dash for the Timber," 1889, oil on canvas) and Charles M. Russell (e.g., "A Desperate Stand," 1898, oil on canvas) often show European Americans being attacked by American Indians or battling them to the death.[166] At the same time, other artists offer a sympathetic reaction to the plight of the oppressed, such as Henry Farny (e.g., "The Song of

the Talking Wire," 1904, oil on canvas), or James Earl Fraser (e.g., "End of the Trail, 1915, bronze).[167] Cincinnati painters Henry Farny and Joseph Henry Sharp were sensitive to the Indian plight, and they had direct influence on the decorators at Rookwood. They were known and respected in Cincinnati as nationally noted, successful Indian genre painters. Through the Cincinnati Art Club and other social arenas such as the Art Museum, they were colleagues of many of the decorators. Sharp taught many of the decorators while he was at the Art Academy of Cincinnati. Consequently, it is not surprising that Rookwood's Indian portraits were sympathetic.

A Metaphor for Loss

But there is more to it than simply the influence of colleagues and mentors. The following argument will point to an element not specifically mentioned in Nancy Owen's fine discourse on the "strenuous life," although it is embedded in it, and strengthens the rationale for the type of Indian portraiture that Rookwood used. While the dual strands of nostalgia for a simpler way of life and bellicose insistence on finding new frontiers still persisted side by side, during the last five years of the century sentiment was tilting slightly in favor of nostalgia. The Indians no longer threatened the lives or imperialistic drives of the white man. European Americans did not so much vilify the Indian as mourn his plight. Even though they do not seem to have experienced a collective sense of guilt, there was a growing collective sense of sympathy. The expression of sympathy was like saying to the American Indian, "I feel your pain," which seems preposterous. Or was it?

By 1859 Cincinnati was second only to Philadelphia as the most industrialized city in the nation.[168] By August 1875, *Scribner's Monthly* was commenting on the Queen City's industrial pollution: "They breathe an atmosphere of lamp-black, and the ladies are accomplished in the delicate art of blowing flocculent carbon from their ears, as it drops from chimneys that vomit blackness."[169] The paradigm had shifted from the agrarian to the industrial model. What was perceived as a simpler way of life that was at one with nature had shifted to the complex, faster pace of polluted urbanization. Cincinnatians, reflecting industrialized America, longed for the simple life embodied by the American Indian. The Pottery's Native American decorations offered a psychological retreat to unmolested nature, an escape from the growth of nineteenth-century urbaniza-

tion and its concomitant devastating pollution.[170] The passing of the Indian way of life stood as a metaphor for a parallel loss by white Americans. The sentiment was more than just a preposterous "I feel your pain." It was, "I feel your pain. We have both lost a way of life." This is the sentiment expressed in the Rookwood portraits. They are a metaphor for the sentiment of loss.

The Pottery's Indian images were chosen selectively. Rookwood did not utilize images of bare-breasted women or bare-chested men, even though such images were photographed for, and could be obtained from, the Bureau of American Ethnology. Either William Watts Taylor or someone acting for him, such as William McDonald, selected and purchased the photographs from which the decorators could draw. Even though all of the decorators almost always inscribed the name of the Indian depicted on a vase at the bottom of the vessel, the identity of the sitter was of little consequence. It was the emotional value of the image that was important. Noted Indian chiefs, such as Geronimo or Sitting Bull, can be seen on smaller objects, while Indians of lesser rank, such as little-known males or unidentified women, can be seen on larger, more significant objects. It was not the identity of the Indian that sold the ware; it was the wistful sentiment of the image. The painted images almost always express longing. Women decorators were more likely to depict women and children, or young males, and men decorators were more inclined to depict warrior chiefs, but they all chose to embody the element of nostalgic loss.

Generally, the decorators were not dogmatically precise about compositional details. They cropped photo images, almost always eliminated busy design patterns on printed shirts or blankets, simplified or eliminated some apparel, and took liberties in simplifying the beadwork design on brow bands and other elements of dress. Such adaptations were due in part to the broad-brush nature and difficult blending of underglaze painting and to the problems inherent in firing certain colors, while other changes reflected the decorators' need to use time economically because their work was being tracked; but the adjustments also suited a desire to simplify the composition in order to concentrate on expression. Grace Young was the rare decorator who flaunted detail, painted full figures, and did not hesitate to paint Indians in activity. She did not seem to be as concerned about having her work tracked, or toeing the company line on expression.

Grace Young aside, the sentiment of loss was the driving force behind the portraits. It connected with the industrial urban buyer, who represented Rookwood's market. In order to heighten the sentiment, some artists added dramatic lighting. No decorator did

this as well as Matt Daly. His profile or frontal portraits half in shadow accentuate the drama and elevate the acceptance of loss. Not only did he use dramatic lighting, he layered his metaphor with the depiction of prehistoric gorgets, the very same gorgets that ultimately began the Indian genre at Rookwood in 1888. There are two known vases, both dating from 1899, on which Daly utilized the gorget motif, and on both he also incorporated copper overlay that was applied at Rookwood. On one, a Maricopa Indian is dramatically depicted with a vertical line of red paint streaming from the lower lid of each eye down his cheeks, almost as if symbolizing tears.[171] On the shoulder of the vase, isolated from the portrait, is the incised image of a gorget with its swirled decoration, encircling the shoulder as a repeated pattern. The lip of the vase is coated with electrodeposited copper. Daly knew exactly what he was doing. He was not simply lumping disparate decorations on one vase under the rubric of American Indian. The source of the image was the same Bureau of Ethnology article used by Van Briggle over a decade earlier. Daly knew that the gorget represented the prehistoric moundbuilders, a race no longer in existence. He used it on this vase as a metaphor for the vanishing of the American Indian. To drive home his point, on the bottom of the vase he incised, "A Nation's Cry." The "Nation" is purposely left ambiguous. It could be the Indian nation or the white man's nation, or more likely both.

The second such vase (cat. no. 7) echoes the same sentiment yet more profoundly. There is no inscription on the bottom of the vase except the name of the sitter, "Bloody Mouth," and his band of Sioux, "Onkpapa." The gorgets are all different, suggesting several owners. They are coated with electrodeposited copper and stand out in relief, unlike the incised subtlety of the previous vase. They are depicted as still attached to the cords that held them around the necks of the moundbuilders. They too are placed on the shoulder of the vase, as if hung there like trophies, and kept separate from the dramatically shaded countenance of Bloody Mouth, who gazes into the distance. Daly just as easily could have painted the gorgets around Bloody Mouth's neck to signal the metaphor. Instead, he chose to keep the gorgets by themselves, lifeless without their former owners. Bloody Mouth wears an unidentified trinket hanging from a string of beads around his neck, which is picked out on his chest by lengths of his hair that fall on either side. Notice that this element of hair is not in Alexander Gardner's photograph (cat. no. 7, fig. 1). It is as if the gorgets are saying to Bloody Mouth, "You too shall pass, your nation shall vanish, and your neckpiece shall be left lifeless, the trophy of another race." The viewer can only empathize, projecting his own sense of a lost way of life.

The Sentiment of Loss Ends

Rookwood Indian portraiture ceased barely ten years after it had begun, ostensibly because it no longer sold well. The internal reasons have all been mentioned, among them the fact that the Standard glaze line was outdated, and many of the artists who were proficient in the genre had left the Pottery. But there is a much broader reason for the iconographically trenchant images to lose their appeal. Americans no longer identified with the sentiment of loss. The United States became ardently imperialistic just before the turn of the century. The closing of the frontier led many European Americans to believe that opportunities for growth in the continental United States were finished, and new areas of expansion were sought. In addition, industrialization forced American business to become international, encouraging a constant search for foreign markets. In 1898, with the onset of the Spanish-American War and U.S. involvement in Cuba, the Indian issues retreated into the past. Even Buffalo Bill Cody's Wild West show began incorporating enactments of the Battle of San Juan Hill, complete with detachments from Teddy Roosevelt's "Rough Riders."[172] To be sure, industrialization had not gone away, but the pervading sentiment was no longer one of loss, but of expansion. Eventually the United States built the Panama Canal and "annexed" Puerto Rico, Guam, and the Philippines. Ironically, at Rookwood, Grace Young's work continued to sell precisely because her pieces did not depend on the sentiment of loss for their appeal.

The Ironies of Today

There are many ironies in the story of Rookwood's fascination with the American Indian besides that embodied in the work of Grace Young. Industrialization was the reason for the sense of loss, and industrialization was the reason for its dissipation. The ironies do not stop there. Rookwood itself was a product of industrialization. Underglaze portraiture was a technical tour de force, a premiere product of industrialization helping the buyer to escape industrialization by allowing the vicarious return to nature through the American Indian. (That irony exists today in our paradigm shift from the industrial age to the information age. Our computer terminals offer screensavers depicting limpid lagoons surrounded by white beach sands and lush vegetation of the perfect island retreat where there are no computers.)

The final irony is that Rookwood's Indian genre, especially its portraiture, is today as popular as ever. A large masterful example can command tens of thousands of dollars at auction, making it one of the Pottery's highest-prized products. Perhaps our current paradigm shift is ushering in the same sense of loss as the previous shift. We too long to return to nature, and express this vicariously in our four-wheeled sports utility vehicles with names like Pathfinder, Explorer, Outback, Forrester, and Range Rover, even though very few of us ever do much more than city driving. We too have lost a previous way of life. Perhaps Rookwood's self-expressive, psychologically engaging Indians retain their intimacy with today's viewer because they mirror a compelling introspection into our own nostalgic loss.

Notes

1. For this study, a survey of four private collections, thirty auction catalogues of the last fifteen years from the Cincinnati Art Galleries, the Treadway Gallery, Inc., and David Rago Auctions, plus collection catalogues from the Philadelphia Museum of Art, the Charles Hosmer Morse Museum of American Art, the Newark Museum, and the Cooper-Hewitt Museum, and also the exhibition catalogues *From our Native Clay: American Art Pottery, 1875–1930; Ode to Nature: Flowers and Landscapes of the Rookwood Pottery, 1880–1940; Toward the Modern Style: Rookwood Pottery: The Later Years, 1915–1950; Art Pottery of the Midwest;* and *Rookwood Pottery: The Glorious Gamble* offered a review of more than fourteen thousand pieces of Rookwood that imaged more than 160 objects exhibiting American Indian subject matter. There is no pretense that the survey is inclusive of all Rookwood or that it is strictly scientific. It does, however, analyze a critical mass that strongly suggests trends from which assumptions have been made.

2. Josephine W. Duveneck, *Frank Duveneck: Painter—Teacher* (San Francisco: John Howell, 1970), 35. The following information is also taken from this source, 28–29.

3. Michael Quick, *An American Painter Abroad: Frank Duveneck's European Years* (Cincinnati: Cincinnati Art Museum, 1987), 14. The following information is also taken from this source, 14–27.

4. Duveneck, *Frank Duveneck,* 42.

5. Herbert Peck, *The Book of Rookwood Pottery* (Tucson: Herbert Peck Books, 1986), 4. The following information is also taken from this source, 5–8.

6. Kevin Phillips, *Wealth and Democracy: A Political History of the American Rich* (New York: Broadway Books, 2002), 27.

7. Rose Angela Boehle, *Maria Longworth* (Dayton, OH: Landfall, 1990), 81.

8. M. Louise McLaughlin to Mr. Ross C. Purdy, March 9, 1939, Ross C. Purdy Collection. Cincinnati Historical Society Library at The Museum Center.

9. "War Among the Potters, T. J. Wheatley Secures a Patent on American Limoges," *Cincinnati Daily Gazette,* October 7, 1880. For a more detailed discussion of why Maria Longworth Nichols founded

Rookwood, see Anita J. Ellis, *The Ceramic Career of M. Louise McLaughlin* (Athens: Ohio University Press, 2003), 92–93.

10. Peck, *Book of Rookwood Pottery,* 9–10.

11. Denny Carter, *Henry Farny* (New York: Watson-Guptill, 1978), 19.

12. Ibid., 15. Unless otherwise noted, the following information is taken from the same source, 21.

13. Robert Taft, "The Pictorial Record of the Old West: Artists of Indian Life: Henry F. Farny," pt. 10, *Kansas Historical Quarterly* 18, no. 1 (February 1950): 10. The following information is also taken from this source.

14. "Lo! The Poor Indian: Farny Discourses on Ye Noble Red Man," pt. .3, *Cincinnati Enquirer,* November 8, 1881. The following information is also from this source.

15. "Studio Studies: Hopkins, Lindsey, Farny, Dakin, Schmidt and Niehaus," *Cincinnati Commercial,* December 1, 1881.

16. Peck, *Book of Rookwood Pottery,* 15.

17. Ibid., 24–25. The following information about Taylor is also from this source.

18. Ibid., 147.

19. William Watts Taylor to James P. Farell, December 22, 1887, Letterpress Book 1886–1887, 495. Rookwood Pottery Collection, Mitchell Memorial Library, Mississippi State University (hereafter RPC, MML/MSU).

20. Virginia Raymond Cummins, *Rookwood Pottery Potpourri* (Silver Springs, MD: Cliff R. Leonard and Duke Coleman, 1980), 28–29.

21. Clarence Cook, ed., "Designs by Mr. Edward P. Cranch, Made for the Rookwood Pottery," *The Studio* 2, no. 7 (January 1887): 118.

22. William Watts Taylor to Howell and James, September 7, 1887, Letterpress Book 1886–1887, 410. RPC, MML/MSU.

23. Joy S. Kasson, *Buffalo Bill's Wild West: Celebrity, Memory, and Popular History* (New York: Hill and Wang, 2000), 72. The following information is also from this source, 76–77. Taken from *New York Dispatch,* July 18, 1886; Nate Salsbury Scrapbook, July 1885–August 1886, housed in the Denver Public Library.

24. Ibid., 72.

25. William Watts Taylor to C. S. Raymond, October 29, 1887, Letterpress Book 1887–1888, 32. RPC, MML/MSU.

26. Ida M. Tarbell, "Pottery and Porcelain," *Chautauquan* 8, no. 4 (January 1888): 222.

27. William Watts Taylor to James C. Prilling, October 22, 1888, Letterpress Book 1888–1889, 274. RPC, MML/MSU.

28. For a detailed discussion of photography and the American Indian see Paula Richardson Fleming and Judith Luskey, *The North American Indians in Early Photographs* (New York: Barnes and Noble Books, 1987; reprint 1992); Paula Richardson Fleming and Judith Lynn Luskey, *Grand Endeavors of American Indian Photography* (Washington, DC: Smithsonian Institution Press, 1993); and Tom Robothan, *Native Americans in Early Photographs* (Emmaus, PA: JG Press, 1994; reprinted North Dighton, MA: World Publishing Group, 2004).

29. The bowl can be seen in Nancy E. Owen, *Rookwood Pottery at the Philadelphia Museum of Art: The Gerald and Virginia Gordon Collection* (Philadelphia: Philadelphia Museum of Art, 2003), 35, plate 13.

30. Dorothy McGraw Bogue, *The Van Briggle Story* (Colorado Springs: Dorothy McGraw Bogue, 1968), 2. The following is also taken from this source.

31. William H. Holmes, "Art in Shell of the Ancient Americans,*" Second Annual Report of the Bureau of Ethnology, The Smithsonian Institution, 1880–81* (Washington, DC: GPO, 1883), 185–305, pl. LII, fig. 1.

32. James A. Brown, "Mound Builders," *Encyclopedia of North American Indians,* http://college .hmco.com/history/readerscomp/naind/html/na_023700_ moundbuilder.htm (accessed July 8, 2005). The following information is also from this source, 1–3.

33. *Cincinnati Museum Association Eighth Annual Report for the Year Ending December 31, 1888* (Cincinnati: C. F. Bradley, 1889), 19, 40. The number of specimens in the R. O. Collis and C. W. Riggs collections is not given. The C. W. Riggs collection is currently in the Cincinnati Museum of Natural History.

34. William Watts Taylor to C. W. A. Veditz, April 14, 1891, Letterpress Book 1890–1891, 306. RPC, MML/MSU.

35. *Cincinnati Museum Association Eighth Annual Report,* 26, 33.

36. *Art Academy Circular for 1899–1900* (Cincinnati: C. F. Bradley, 1899), 3, 4.

37. For a detailed discussion of this ongoing controversy, see Bruce Weber, "Frank Duveneck and the Art Life of Cincinnati, 1865–1900," in *The Golden Age: Cincinnati Painters of the Nineteenth Century Represented in the Cincinnati Art Museum* (Cincinnati: Cincinnati Art Museum, 1979), 23–30.

38. Maria Longworth Storer, "The Cincinnati Art School and Foreign Scholarships," *Cincinnati Commercial Gazette,* unrecorded date and page. Newspaper clipping found in The Cincinnati Art Museum Scrapbook, 1:88. Unless otherwise noted, the following is taken from this source.

39. *Circular and Sixth Annual Catalogue of the Art Academy of Cincinnati, 1890–1891* (Cincinnati: C. F. Bradley, 1890). The students for the 1889–90 school year are listed on pages 30–41, and total 341. Six students are listed on page 25 as being in the oil painting class for 1889–90. In the newspaper article "The Cincinnati Art School and Foreign Scholarships," Storer notes that there are only four taking the course. Two may have dropped out after registering.

40. "No Woman, Art Museum Stockholders Refuse to Elect Mrs. Storer," *Cincinnati Commercial Gazette,* March 4, 1890.

41. J. R. S., "The Art Museum: Here Is Somebody Who Doesn't Like the Man agement [*sic*]," *Cincinnati Commercial Gazette,* March 7, 1890.

42. "A New Art School: Mrs. Storer's Plans for a Rival to the Art Academy," *Cincinnati Commercial Gazette,* May 18, 1890.

43. For a detailed discussion of Duveneck's life between 1875 and 1890, see Duveneck, *Frank Duveneck,* 61–128.

44. "The New Art Class," *Cincinnati Commercial Gazette,* May 19, 1890. The following quotation is also from this source.

45. Additional information regarding the room in the museum for the class can be found in "Excellent for Study: The Arrangement of the Paintings at the Art Museum," *Cincinnati Commercial Gazette,* October 10, 1890. Information regarding the Art Academy scholarships to Duveneck's class can be found in Cincinnati Art Museum Archives, Record Group 3, Series 4, Box 1, Records of the Duveneck Class 1890–92, File: "Correspondence Concerning Scholarships." Maria Longworth Storer paid for two of the scholarships.

46. "Under Favorable Auspices: The New Painting Class Begins Its Work." *Cincinnati Times Star,* October 22, 1890. The following information is also from this source.

47. "Excellent for Study."

48. "The Duveneck Art Class: Academy Pupils Who Are to Receive Free Scholarships," *Cincinnati Times Star,* n.d. Newspaper clipping found in The Cincinnati Art Museum Scrapbook, 1:88. The following is also taken from this source.

49. Weber, "Frank Duveneck," 29. The following is also taken from this source.

50. Boehle, *Maria Longworth,* 90–91.

51. *Art Academy of Cincinnati Circular for 1900–1901* (Cincinnati: C. F. Bradley, 1899)*,* 6; *Art Academy of Cincinnati Catalogue 1905* (Cincinnati: Museum Press, 1905), 6; *Cincinnati Museum Association Art Academy of Cincinnati Catalogue 1919* (Cincinnati: Museum Press, 1919), 7. In 1900 the title for the person in charge of the Art Academy was changed from principal to chairman. *Cincinnati Catalogue 1905* (Cincinnati: Art Academy of Cincinnati, 1905), 6.

52. It is highly likely that Harriet Wilcox took the Duveneck course; she was one of the senior decorators at the time. She is probably pictured in a photograph (not reproduced here) of the class but is partially hidden by another student so that her identity cannot be confirmed.

53. William Watts Taylor to Thomas S. Noble, September 28, 1891, Letterpress Book 1891–1892, 115. RPC, MML/MSU.

54. "A New Art School."

55. William Watts Taylor to Scott Callowhill, April 23, 1890, RPC, Letterpress Book 1889–1890, 259. RPC, MML/MSU.

56. William Watts Taylor to John S. Bradstreet, February 16, 1891, Letterpress Book 1890–1891, 215. RPC, MML/MSU.

57. In an article entitled "Spooks," in the *Cincinnati Post,* June 3, 1892, Dave, the night watchman at Rookwood, insists that the place is visited by spooks every night. This is in the new building in Mt. Adams, not the old plant on Eastern Avenue where this ale set was decorated. It could, however, have been something as simple as ghost stories by the night watchman that inspired the first decorations. Indeed, the ghost depicted on the pitcher could have been the one frightening Rookwood's night watchman. It should be noted that while some pieces to this set are dated 1889, they could have been, and probably were, decorated in 1890 with the rest of the set. In the basement of the plant was the "damp room" where unfired ware (green ware) was held at the correct degree of moisture while awaiting decoration. A green ware item could remain there indefinitely until it was chosen by a decorator. An example of green ware made toward the end of 1889 could easily have been decorated sometime in 1890, especially if the decorator was waiting for additional forms to comprise a set.

58. The Valentien jug is pictured in Cincinnati Art Galleries, *Holiday Sale 2002,* November 3, 2002, cat. no. 1133. Auction catalogue. The Young mugs are pictured in Cincinnati Art Galleries, *Rookwood XIV,* June 6, 2004, cat. no. 1510. Auction catalogue. The Wilcox mug is pictured in Cincinnati Art Galleries, *Rookwood IV,* June 11, 1994, cat. no. 71. Auction catalogue.

59. The quotation is taken from William Watts Taylor to Mrs. E. R. Holbrook, June 28, 1888, Letterpress Book 1888–1889, 63. RPC, MML/MSU.

60. William Watts Taylor to Mrs. Francis McDonald, February 4, 1888, Letterpress Book 1887–1888, 229. RPC, MML/MSU.

61. William Watts Taylor to Charles F. Binns, April 8, 1904, American Archives of Art, Roll No. 3606, Charles Fergus Binns MC1—Correspondence 1904, S—T.

62. Annual Report, May 31, 1890. Corporate Minutes, 5.

63. William Watts Taylor to Mr. E. R. Garezynski, February 14, 1890, Letterpress Book 1889–1890, 173. RPC, MML/MSU.

64. William Watts Taylor to Mr. Lundgren, December 16, 1890. Letterpress Book 1890–1891, 95. RPC, MML/MSU.

65. William Watts Taylor to Messrs. D. Collamore and Co., December 11, 1890, Letterpress Book 1890–1891, 83. RPC, MML/MSU.

66. Annual Report, February 29, 1892. Corporate Minutes of The Rookwood Pottery Company, 157. Collection of Dr. and Mrs. Arthur J. Townley. (hereafter, Corporate Minutes).

67. Ibid.

68. For a detailed discussion of the World's Columbian Exposition, see *Report of the President of the Board of Directors of the World's Columbian Exposition: Chicago 1892–1893* (Chicago: Rand McNally, 1898).

69. William Watts Taylor to Mr. Bonfils, January 7, 1892, Letterpress Book 1891–1892, 301. RPC, MML/MSU; and William Watts Taylor to Duncan Haynes, April 20, 1891, Letterpress Book 1890–1891, 322. RPC, MML/MSU.

70. Frederick Jackson Turner, "The Significance of the Frontier in American History," in *Rereading Frederick Jackson Turner,* ed. John Mack Faragher (New York: Henry Holt, 1994), 1. The entire address is reprinted on pages 31–60. Additional discussions on the concept of the West and Turner's thesis can be found in Patricia Limerick, *Legacy of Conquest* (New York: Norton, 1982); Patricia Limerick, Clyde A. Milner II, and Charles E. Rankin, eds., *Trails: Towards A New Western History* (Lawrence: University Press of Kansas, 1991); and Richard White, *It's Your Misfortune and None of My Own* (Norman: University of Oklahoma Press, 1991).

71. "What the Columbian Exposition Will Do for America," *Century* 44, no. 6 (October 1892): 955.

72. Peck, *Book of Rookwood Pottery,* 47. Peck notes a fifth display in the collective exhibit of the United States Potters' Association in the Ceramics and Mosaics section of the Manufacturers and Liberal Arts Building, but this cannot be confirmed. Rookwood notes its exhibit in the Fine Arts Building in a marketing booklet produced by the Pottery: *Rookwood Pottery* (Cincinnati: Rookwood Pottery Company, 1894), 23. This can be found in the New York Public Library, Art Division. A microfilmed copy is also in the Archives of American Art, Smithsonian Institution, N48 Pottery, 16–34. The following quotation regarding Rookwood's Fine Arts Building display is taken from this marketing booklet, 23.

73. Beverly K. Brandt, "Worthy and Carefully Selected: American Arts and Crafts at the Louisiana Purchase Exposition, 1904," *Archives of American Art Journal* 28, no. 1 (1988): 3. The following information on Ives is also taken from this source.

74. References to medals won by Rookwood at the various fairs are based on the actual medals and certificates currently in the possession of Dr. and Mrs. Arthur J. Townley. In addition, the medals are noted in Rookwood records and various printed material, including Rookwood marketing catalogues.

75. We know that they were exhibited at the World's Columbian Exposition from S. G. Burt, *2,292 Pieces of Early Rookwood Pottery in the Cincinnati Art Museum in 1916* (Cincinnati: Cincinnati Historical Society, 1978), 105.

76. *Circular for the Ninth Annual Catalogue of the Art Academy of Cincinnati, 1893–94* (Cincinnati: C. F. Bradley, 1893), 23. The academy catalogues each list the roster of students from the previous year.

77. For a detailed discussion of Henry Sharp's life, see Marie Watkins, "Painting the American Indian at the Turn of the Century: Joseph Henry Sharp and his Patrons, William H. Holmes, Phoebe A. Hearst, and Joseph G. Butler, Jr." (PhD diss., Florida State University, 2000).

78. Cummins, *Rookwood Pottery Potpourri,* 34.

79. Edwin AtLee Barber, "A Typical American Pottery," *Art Interchange* 34 (January 1895): 3.

80. For the photographic images by Hillers, see Anita Ellis, *Rookwood Pottery: The Glorious Gamble* (New York: Rizzoli International, 1992), 80–81.

81. Cummins, *Rookwood Pottery Potpourri,* 34.

82. Jack Rennert, *100 Posters of Buffalo Bill's Wild West* (New York: Darien House, 1976), 8. Unless otherwise noted, additional information regarding this poster is taken from this source.

83. Kasson, *Buffalo Bill's Wild West,* 95.

84. Annual Report, February 17, 1894. Corporate Minutes, 165.

85. Nancy Owen, *Rookwood and the Art of Industry: Women, Culture, and Commerce, 1880–1913* (Athens: Ohio University Press, 2000), 165.

86. Edwin AtLee Barber, *Pottery and Porcelain of the United States* (New York: G. P. Putnam's Sons, 1893), 299. The following quotation is also taken from this source.

87. Annual Report, January 31, 1895. Corporate Minutes, 171. Unless otherwise noted, the following is also from this source.

88. Annual Report, January 31, 1896. Corporate Minutes, 176.

89. Susan Labry Meyn, "Cincinnati's Wild West: The 1896 Rosebud Sioux Encampment," *American Indian Culture and Research Journal* 26, no. 1 (2002): 4, and Susan Labry Meyn, "Who's Who: The 1896 Sicangu Sioux Visit to the Cincinnati Zoological Gardens," *Museum Anthropology* 16, no. 2 (June 1992): 21.

90. Cincinnati Art Galleries, *Rookwood II,* May 30–31, 1992, cat. no. 512. Auction catalogue. *The Glover Collection,* June 7–9, 1991, cat. no. 184. Auction catalogue.

91. Unless otherwise noted, all references to the Sicangu Sioux Encampment are taken from Meyn, "Cincinnati's Wild West," 1–20, and Meyn, "Who's Who." 21–26.

92. Robert Hurley (son of Edward Timothy Hurley), in discussion with the author, July 24, 2003.

93. According to Herbert Peck in *The Book of Rookwood Pottery* (62, 143, 145), Thomas Lunt is the first photographer to work for Rookwood from 1886 to 1892. From 1892 until 1900 Constance Baker was in charge of the photographic work, and in 1900 Fritz Van Houten Raymond became the Pottery's photographer. T. H. Kelley might have been commissioned by Rookwood to photograph the Indians, or Rookwood might have simply purchased prints of his work.

94. Susan Labry Meyn, "Mutual Infatuation: Rosebud Sioux and Cincinnatians," *Queen City Heritage* 52 (Spring/Summer 1994): 34.

95. Joan Hurley O'Brian (daughter of Edward Timothy Hurley), in discussion with the author, June 4, 1990.

96. This photograph can be seen in Forrest Fenn, *The Beat of the Drum and the Whoop of the Dance* (Santa Fe: Fenn, 1983), 99.

97. For a number of years, the Cincinnati Art Club raffled a "Tambola," or composite of miniature paintings by each of its members, to raise money for the club. The Cincinnati Art Museum has the Tambola for 1897, which reflects its members for that year.

98. For the monotypes, see Cincinnati Art Galleries, *Rookwood XIII,* June 8, 2003, cat. no. 1632. Auction catalogue.

99. "The Craft of Rookwood Potters," *World's Work Advertiser* (August 1904): n.p.

100. William Watts Taylor to Messrs. D. Collamore & Co., December 27, 1888, Letterpress Book

1888–1889, 471. RPC, MML/MSU. The following statistic is found in William Watts Taylor, "The Rookwood Pottery," *Forensic Quarterly* (September 1910): 206.

101. Annual Report, January 31, 1898. Corporate Minutes, 189.

102. Fleming and Lusky, *Grand Endeavors,* 81–82. The following information is also taken from this source.

103. This and the following information about the trip are taken from Kenneth R. Trapp, "Rookwood Pottery: The Glorious Gamble," in Ellis, *Rookwood Pottery: The Glorious Gamble,* 30.

104. Annual Report, January 31, 1898. Corporate Minutes, 188.

105. John Valentine, "Rookwood Pottery," *House Beautiful* 4, no. 4 (September 1898): 124.

106. Annual Report, January 31, 1899. Corporate Minutes, 196–98.

107. Dr. Gensel, "Tiffany Gläser—Rookwood Kunst Töpfereien," *Deutche Kunst und Dekoration* 7 (November 1900): 98.

108. "Rookwood Pottery for Paris Exhibit," *Keramic Studio* 1 (March 1900): 221, 228, 231.

109. Annual Report, January 31, 1901. Corporate Minutes, 209–11.

110. Joan Hurley O'Brian (daughter of Edward Timothy Hurley) in a discussion with the author, June 4, 1990.

111. Bogue, *Van Briggle Story,* 10 (when he left Cincinnati), 27 (his death date).

112. Annual Report, January 31, 1902. Corporate Minutes, 217. The following quotation is also from this source.

113. W. P. McDonald, "Rookwood at the Pan-American," *Keramic Studio* 3 (November 1901): 146. If "W. P. McDonald" is William Purcell McDonald, the Rookwood decorator, his comments can be held suspect.

114. Annual Report, January 31, 1902. Corporate Minutes, 217. The following information and quotation are also from this source.

115. For in-depth information on Grueby, see Susan J. Montgomery, *The Ceramics of William H. Grueby* (Lambertville, NJ: Arts and Crafts Quarterly Press, 1993).

116. For the story on how Rookwood's mat glazes began, see Annual Report, January 31, 1901. Corporate Minutes, 208–09, 212–13. The following quotation is taken from this source, 213. For Van Briggle's part in the initiation of mat glaze experiments at the Pottery, see Peck, *Book of Rookwood Pottery,* 53–54, 68–69. Taylor never officially recognized Van Briggle as the initiator of mat glazes at Rookwood because when Van Briggle left the Pottery in 1899 to move west for health reasons, Taylor did not believe him, and was stung by what he saw as opportunism, exploitation, and disloyalty.

117. Anita Ellis, *Rookwood Pottery: The Glaze Lines* (Atglen, PA: Schiffer, 1995), 56–94.

118. Cincinnati Art Galleries, *Rookwood II,* May 30–31, 1992, cat. no. 241. Auction catalogue.

119. Annual Report, January 31, 1903. Corporate Minutes, 222. The following quotation is also taken from this source.

120. Cincinnati Art Galleries, *Rookwood VI,* June 2, 1996, cat. no. 557. Auction catalogue.

121. For an in-depth discussion of the American fashion for all things Dutch at this time see Kathleen Eagen Johnson, "Frans Hals to Windmills: The Arts and Crafts Fascination with the Culture of the Low Countries," in *The Substance of Style: Perspectives on the American Arts and Crafts Movemet,* ed. Bert Denker (Winterthur, DE: Henry Francis du Pont Winterthur Museum, 1996), 47–67.

122. Fleming and Luskey, *Grand Endeavors,* 85.

123. Unless otherwise noted, information regarding this fair is taken from Brandt, "Worthy and Carefully Selected," 2–16, and Owen, *Rookwood and the Industry of Art,* 86–92, 139–40, and 161.

124. *Official Catalogue of Exhibitors, Universal Exposition, St. Louis, U.S.A., 1904* (St. Louis: Official Catalogue Co., 1904), passim; and *Official Catalogue of Exhibits: Department of Art* (St. Louis: Official Catalogue Co., 1904).

125. Brandt, "Worthy and Carefully Selected," 8.

126. Ibid., 13.

127. Annual Report, January 31, 1905. Corporate Minutes, 229.

128. "Louisiana Purchase Exposition Ceramics: Rookwood Pottery," *Keramic Studio* 7, no. 9 (January 1905): 194.

129. Burt, *2,292 Pieces of Rookwood Pottery,* 139, #42–44; 140, #64; 141, #81; 142, #105; 144, #143, #158; 145, #183.

130. For a detailed discussion of the Vellum line, see Ellis, *Rookwood Pottery: The Glorious Gamble,* 56–57.

131. For Rookwood's first examples of the Vellum glaze, see the Pottery's sales catalogue, *The Rookwood Book: Rookwood, an American Art* (Cincinnati: Rookwood Pottery Company, 1904), examples 80–102.

132. "Louisiana Purchase Exposition Ceramics," 193.

133. Burt, *2,292 Pieces of Rookwood Pottery,* 158, #8.

134. William Watts Taylor to The Cowell and Hubbard Co., September 20, 1890, Letterpress Book 1889–1890, 427. RPC, MML/MSU.

135. Walter Ellsworth Gray, "Latter-Day Developments in American Pottery—III," *Brush and Pencil* (March 1902): 360.

136. Joan Hurley O'Brian (daughter of Edward Timothy Hurley) in a discussion with the author, June 4, 1990; and Robert Hurley (son of Edward Timothy Hurley), in a discussion with the author, July 24, 2003.

137. For a detailed discussion on Rookwood and Tonalism, see Anita Ellis, "American Tonalism and Rookwood Pottery," in *The Substance of Style: Perspectives on the American Arts and Crafts Movement,* ed. Bert Denker (Winterthur, DE: Henry Francis du Pont Winterthur Museum, 1996), 301–15.

138. Joan Hurley O'Brian (daughter of Edward Timothy Hurley) in a discussion with the author, June 4, 1990.

139. Nick Nicholson, Marilyn Nicholson, and Jim Thomas, *Rookwood Pottery: Bookends, Paperweights, Animal Figurals* (Paducah, KY: Collector Books, Schroeder, 2002), 44.

140. See note 1.

141. It is impossible to calculate reasonable figures for production during and after the Great Depression.

142. H. F. Bopp, "Art and Science in the Development of Rookwood Pottery," *Bulletin of the American Ceramic Society* 15, no. 12 (1936): 444.

143. William Watts Taylor to Miss Camelia S. Cassady, September 17, 1890, Letterpress Book 1889–1890, 420. RPC, MML/MSU.

144. Bopp, "Art and Science," 444.

145. William Watts Taylor to Sones Wertheimer, November 5, 1887, Letterpress Book 1887–1888, 43. RPC, MML/MSU.

146. William Watts Taylor to Mr. Edwin A. Barber, July 18, 1891. Letterpress Book 1891–1892, 13. RPC, MML/MSU.

147. Cummins, *Rookwood Pottery Potpourri*, 15.

148. William Watts Taylor to Mr. Samuel Kramer, January 8, 1887, Letterpress Book 1886–1887, 10. RPC, MML/MSU.

149. William Watts Taylor to Mrs. G. M. Brandon, February 23, 1887, Letterpress Book 1886–1887, 83. RPC, MML/MSU.

150. William Watts Taylor to Mr. C. R. Feldersen, December 5, 1890, Letterpress Book 1890–1891, 63–64. RPC, MML/MSU.

151. William Watts Taylor to the Cowell and Hubbard Co., September 20, 1890, Letterpress Book 1889–1890, 427. RPC, MML/MSU.

152. Annual Report, January 31, 1895. Corporate Minutes, 171.

153. William Watts Taylor to Messrs. Howell and James, Ltd., February 28, 1887. Letterpress Book 1886–1887, 96. RPC, MML/MSU.

154. William Watts Taylor to Mr. Edwin A. Barber, July 18, 1891. Letterpress Book 1891–1892, 13. RPC, MML/MSU. Taylor did identify some artists' marks in January 1891, but it was not for the purpose of publication. See William Watts Taylor to C. Hennecke Co., January 17, 1891. Letterpress Book 1890–1891, 154. RPC, MML/MSU.

155. *Rookwood Pottery* (Cincinnati: The Rookwood Pottery Company, 1894), 26–27.

156. Rookwood's existing Letterpress Books do not go beyond May 17, 1892, so Taylor cannot be referenced quoting prices as before. The price range is taken from original sticker prices found on some pieces and anecdotal evidence.

157. Annual Report, January 31, 1896. Corporate Minutes, 176.

158. "Mrs. Nichols Pottery," *Cincinnati Daily Gazette,* September 13, 1880.

159. Peck, *Book of Rookwood Pottery,* 16, 32. For the following information on the male decorators who were sent abroad for study purposes, see Annual Report, January 31, 1894, January 31, 1895, January 31, 1896, January 31, 1899. Corporate Minutes, 164 (KS), 169 (AVB), 170 (ARV), 176 (MAD), 194 (WMcD, and JDM).

160. William Watts Taylor to Louis Wertheimer, May 4, 1887. Letterpress Book 1886–1887, 183–84. RPC, MML/MSU. The following information is also taken from this source.

161. Cummins, *Rookwood Pottery Potpourri,* 15. The following information is also from this source.

162. Peck, *Book of Rookwood Pottery,* 51. The following information is also from this source.

163. All work hours are taken from Peck, *Book of Rookwood Pottery,* 60.

164. Cummins, *Rookwood Pottery Potpourri,* 52.

165. For a detailed discussion of this argument, see Owen, *Rookwood and the Industry of Art,* 155–78. Unless otherwise noted the following information is taken from this source.

166. For these paintings and more, see Peter H. Hassrick and Michael Edward Shapiro, *Frederic Remington: The Masterworks* (New York: Harry N. Abrams, 1988), and Frederick G. Renner, *Charles M. Russell: Paintings, Drawings, and Sculpture in the Amon G. Carter Collection* (Fort Worth: University of Texas Press, 1966).

167. For Farny's "Song of the Talking Wire," see *The Taft Museum: European and American Paintings* (New York: Hudson Hills, 1995): 299–301. For the "End of the Trail," see *James Earl Fraser: American*

Sculptor—A Retrospective Exhibition of Bronzes from Works of 1913 to 1953 (New York: Kennedy Galleries, 1969): 59–61.

168. Charles Cist, *Cincinnati in 1859* (Cincinnati, 1859): 240.

169. "Topics of the Times: Cincinnati," *Scribner's Monthly* 10 (August 1875): 510.

170. The same argument can be made for Rookwood's persistent and ever-selling floral decorations.

171. This vase is imaged in Martin Eidelberg, ed., *From Our Native Clay* (New York: Turn of the Century Editions, 1987), 24, cat. no. 22.

172. Kasson, *Buffalo Bill's Wild West,* 251.

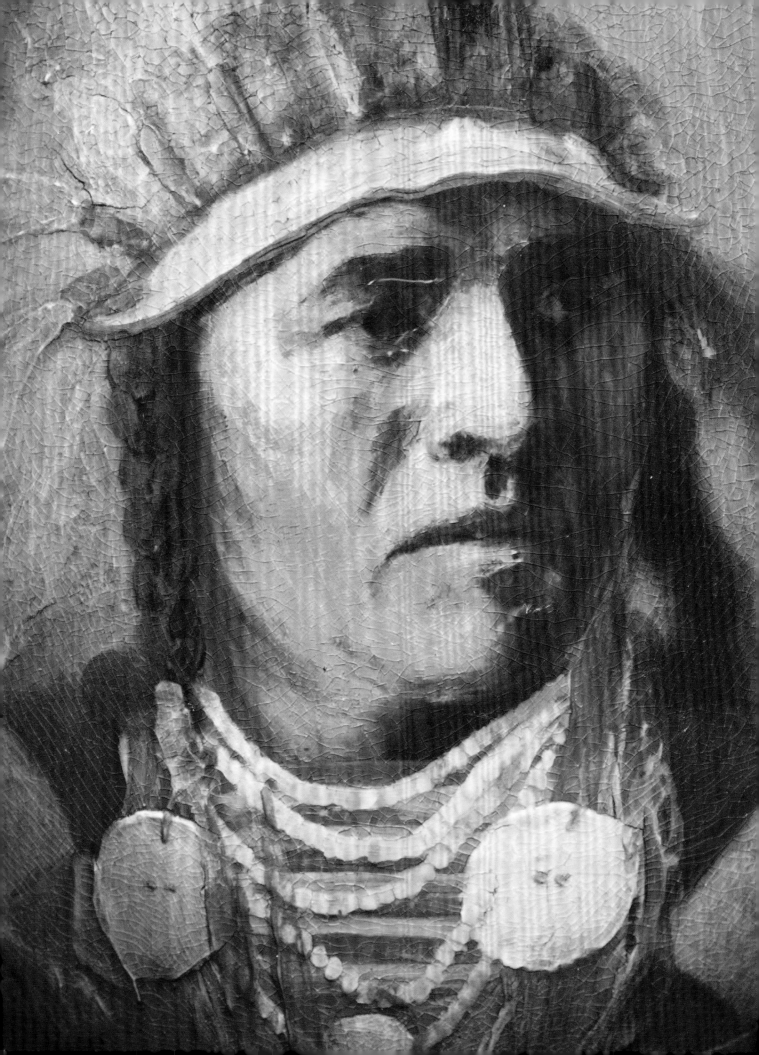

CATALOGUE
of the
JAMES J. GARDNER
COLLECTION

Notes on the Catalogue

1. Unless otherwise noted, all marks and labels are on the bottom of the vessels.

2. All paper labels not on the bottom of vessels have been removed to prevent visual obstruction, and then microencapsulated to preserve the record.

3. Entries are listed alphabetically by decorator, then chronologically by date of the object.

4. Spellings of Indian names and tribes vary.

 a. The American Indian name and spelling used for the person depicted on each piece is the one used in the *American National Biography Online,* and when the name is not in the *Biography,* the name given on the historic photograph has been used. When additional names are cited on the photograph, they are also given.

 b. Spellings of the names of tribes are those used in the Smithsonian's publication, *Handbook of North American Indians* (see note 6 below).

5. Some confusion revolves around the term "chief." This title was used liberally by whites, even when the man had not been officially designated a chief by his people. The reason is that whites preferred to negotiate with one Indian spokesperson and then continued to refer to that person as the "chief." Whites also used the term "chief" when a man was wearing an eagle feather warbonnet.

6. The sources for the American Indian biographies include the *American National Biography Online* (http://www.anb.org/articles/home.html); Frederick E. Hoxie, ed., *Encyclopedia of North American Indians* (Boston: Houghton Mifflin, 1996); William C. Sturtevant, *Handbook of North American Indians,* vol. 13, parts 1–2 (Washington, DC: Smithsonian Institution Press, 2001); and Herman J. Viola*, Diplomats in Buckskins: A History of Indian Delegations in Washington City* (Washington, DC: Smithsonian Institution Press, 1981).

7. The map of federal and state reservations shows the present location of the different tribes mentioned in the text. The authors felt this would be more useful to readers who are not closely acquainted with Indian history, with the extraordinary number of different Indian nations (more than five hundred), or with historic Indian movement from place to place—both voluntarily and under duress.

8. The American Indians shown on the Rookwood pottery pieces and in the accompanying historic photographs wear a wide variety of spectacular clothing and display an assortment

of traditional objects, many unfamiliar to whites. The following discussion of clothing and ornamentation on the Great Plains around 1900 explains how this nation's indigenous people used some manufactured items obtained through trade.

Prior to departing St. Louis in 1804, on their expedition into the then unknown Far West, Meriwether Lewis and William Clark amassed thousands of items for trade with or as gifts for the Indians they would encounter: sewing needles, brass kettles, ivory combs, calico shirts, brass hawk bells, cheap rings with glass stones, knives, scissors, and yards of red flannel. The Indians also had goods to trade, such as luxurious furs. Even more valuable, however, was their knowledge of the terrain and the seasonal movements of Indian peoples. This information was critical to the survival of early white explorers and travelers, who realized that all parties benefited through trade.

Many of the objects were not new to the Indians, but the promise of a steady flow of manufactured merchandise held great appeal. Lewis soon discovered that he had not brought enough blue beads or brass buttons. However, the Indians preferred objects created by the expedition's blacksmith to showy trinkets. All sorts of mass-produced items, as well as whisky, could be obtained through trade. Thus Indians set aside many of their traditional tools and methods and focused on the exciting new materials that they quickly incorporated into their clothing and wore in unique ways.

By 1890 the buffalo were nearly extinct and the government had forced Plains Indians to live on reservations. Despite unbelievable hardships, Plains culture survived and managed to retain a sense of tribal dignity through decorative art—art that incorporated many of the newly traded goods. In time bright trade beads often replaced native dyed porcupine quillwork, lathe-turned cow bone "hair pipes" replaced earlier conch shell columnar hair ornaments, and deep blue wool trade blankets replaced leather or fur. Fabric blankets were decorated with a beautifully beaded strip of leather that came to be called a "blanket strip." Large reflective mirrors replaced shell discs on otter fur bandoliers and neck ornaments. Other objects, such as brass sleigh bells, were high fashion for dancers who wanted noise-making ornaments. Soon small tin cones, sometimes made from snuff can tops, replaced the expensive and hard-to-find bells.

Indians wore their "updated" finery for photographers, world's fairs or expositions, Wild West shows, and wherever whites expected an Indian to "look Indian." Even the resplendent eagle headdress of Plains Indians changed; traditionally these were worn only by the most accomplished warriors and designated leaders, but, in time, they became an easily recognizable symbol of the American Indian. Thus the Plains Indian warbonnet reinforced a stereotype. Even Eastern Woodland Indians, such as the Cherokee, chose to wear these eagle feather warbonnets so that whites would know they were Indian.

Elizabeth Wheldon "Bessie" Brain

Born on November 3, 1870, in Springfield, Ohio, Bessie Brain attended public schools and expressed an interest in drawing, frequently sketching her classmates. After taking drawing lessons for a number of years, she enrolled in the Art Academy of Cincinnati in 1890. She was probably in both Duveneck classes (1890–91, 1891–92) and received two honorable mentions for her studies of heads from life. She worked in oils, pastels, and watercolors, and had a number of her pieces exhibited at the Cincinnati Art Museum before she returned to Springfield in 1896 to teach art in the public schools and execute portraits. She returned to Cincinnati in the fall of 1898; from then until the fall of 1899 she worked as a decorator at Rookwood. Brain noted in her memoirs that for Christmas of 1898, she painted an Indian on a large Rookwood vase and gave it as a present to her mother. Her work at Rookwood was surprisingly good, considering that her tenure lasted only one year. In September 1899, she traveled to Europe, studying that winter at James Abbott McNeill Whistler's studio in Paris, and the following spring at the Kensington School of Design in London. She returned to the United States in November 1900 and married in 1902, after which she continued to paint and draw for pleasure throughout her life. She died on March 23, 1960, at the age of ninety.

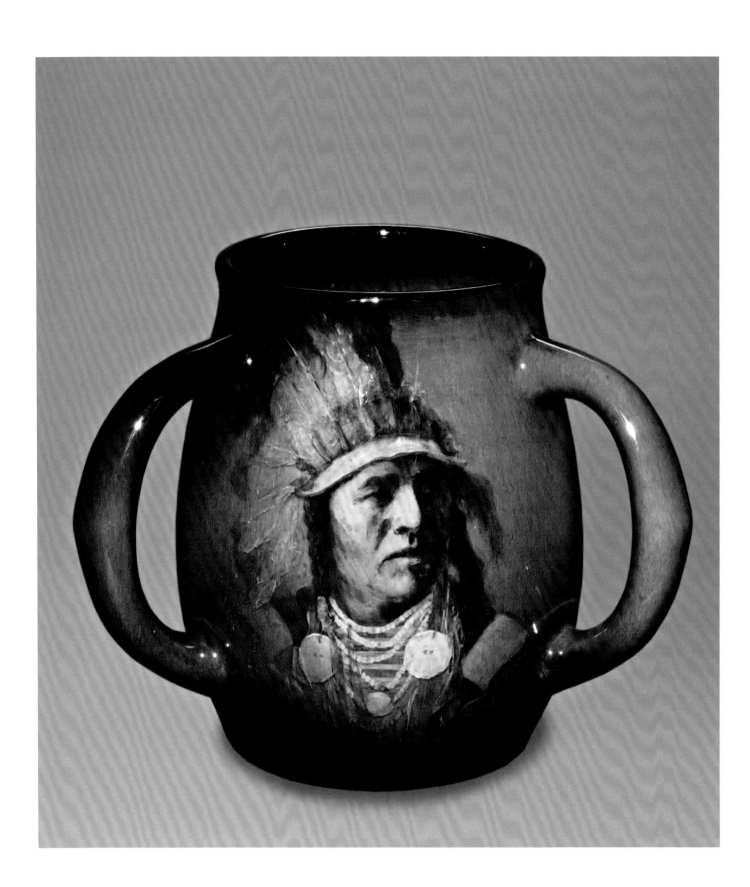

I

Loving Cup, 1899

Spotted Jack Rabbit

Elizabeth Wheldon Brain (1870–1960), decorator at Rookwood 1898–99

William Watts Taylor (1847–1913), director at Rookwood 1883–1913, shape designer

Standard glaze line; slip cast; white body (stoneware)
H. 6¼", w. (w/ one handle) 7½", d. (w/out handles) 5½" (16.0 x 19.0 x 14.0 cm)
Marks:
 impressed
 Rookwood logo surmounted by thirteen flames/"659" (no size letter given)
 incised
 a) EMB in script
 b) "Spotted Jack Rabbit/Crow"
Paper labels:
 a) rectangular label with black print on white ground, "Rookwood III/1683/Cincinnati Art Galleries"
 b) rectangular label hand printed in black on white ground, "Elizabeth W./Brain 1900" (paper label notes wrong date)

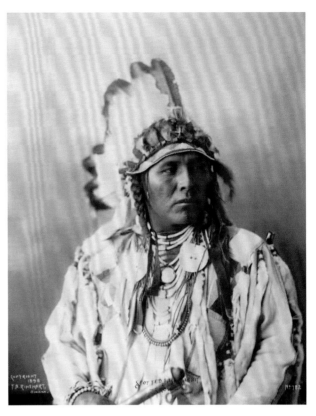

Figure 1. Spotted Jack Rabbit, Crow, by Frank Albert Rinehart, 1898, during the Omaha Trans-Mississippi and International Exposition, Omaha, Nebraska. *From the collections of the Omaha Public Library.*

Curator comments:

 See cat. nos. 28, 29, and 50 for additional depictions of Spotted Jack Rabbit. All were taken from the same photographic source.

 On the loving cup Brain painted Spotted Jack Rabbit's loop neck ornament—an object worn by Crow men and strung with round beads made of either shell or bone. Large shell discs, one on each side, decorate the loop necklace. Probably the necklaces did not have a specific meaning; numerous historic photographs show Crow men of all ranks wearing such ornaments.

Matthew Andrew "Matt" Daly

Matt Daly was born January 13, 1860, in Cincinnati, where he studied at the McMicken School of Design and at the Art Academy of Cincinnati. He began decorating pottery in 1882 at Cincinnati's Matt Morgan Pottery, leaving after several months to join the Rookwood Pottery, where he remained as a primary artist for twenty-one years. Daly was one of the students in Frank Duveneck's 1890–91 and 1891–92 classes. He was especially skilled at portraiture, and devoted his free time to painting portraits and landscapes in oil. His Rookwood work is mostly on large thrown vessels, which is a testament to his highly regarded stature at the Pottery. In 1903 he left Rookwood to head the art department at the U.S. Playing Card Company, where he retired in 1931. After the death of his first wife, he married Olga Geneva Reed Pinney, who had also been a Rookwood decorator. Matt Daly died of a heart attack while painting in his studio on November 23, 1937, at the age of seventy-seven.

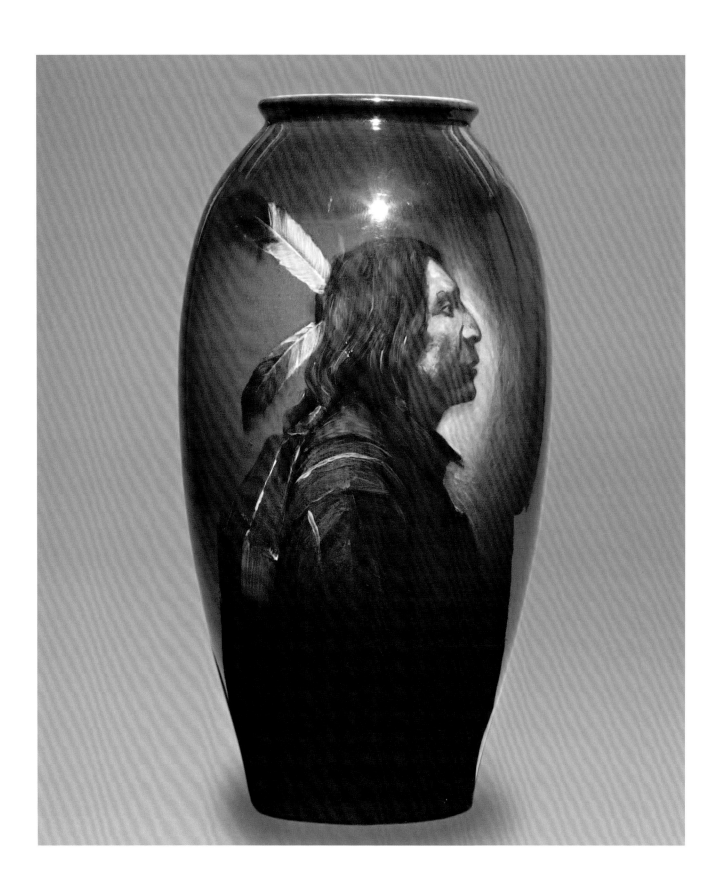

2

Vase, 1898

Striker

Matthew Andrew Daly (1860–1937), decorator at Rookwood 1882–1903

William Purcell McDonald (1864–1931), decorator at Rookwood ca. 1882–1931, shape designer

Standard glaze line; thrown; white body (stoneware)
H. 14¾", diam. 8¼" (37.5 x 21.0 cm)
Marks:
 impressed
 Rookwood logo surmounted by twelve
 flames/"857"
 incised
 a) "<u>MADaly</u>" (with two underscores)
 b) "Striker"/"Apache"
Paper label:
 square label with black print on white ground,
 "Cincinnati/Art Galleries/1231"

Curator comments:

 The decorator's signature on the bottom of the vase reveals a heavily incised "MAD" followed by a much smaller and lightly incised "aly." It is as if Daly added the "aly" as an afterthought. By 1899 he seems to have used "M.A. Daly" instead of the "MAD" that he used earlier. It is possible that he was making the transition from his monogram to his name at the time of this vase. Rookwood decorators often signed their names, instead of simply using their monograms, for pieces designated for world fairs. Daly's full-name Indian vases were probably intended for the 1900 Paris Universal Exposition.

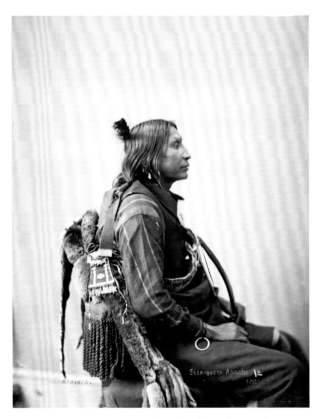

Figure 2. Striker, Kiowa-Apache, by Alexander Gardner, October 1872, Washington, DC. *(2584B) National Anthropological Archives, Smithsonian Institution.*

 According to the Rookwood Shape Book 1883–1900 (57), shape number 857 was first developed in June 1898, and was originally the trial shape number S1385.

 According to information on the reverse of the photograph, Striker was a Kiowa-Apache subchief from the Kiowa Reservation, Oklahoma. He was born ca. 1822 and may also have been known as Equestrian, Ta-ho, and Da-ho.

 In his portrait photograph, Striker displays a beaded "strike-a-light" pouch—a flat pouch first used for holding the flint and steel used for starting a fire, and later, for holding a reservation ration card. Numerous small metal cones decorate the edge of the upper flap and lower edge of the bag. Strike-a-light pouches usually hung from the waist; however, Striker opted to display his attached to a piece of fur, possibly his quiver, behind him.

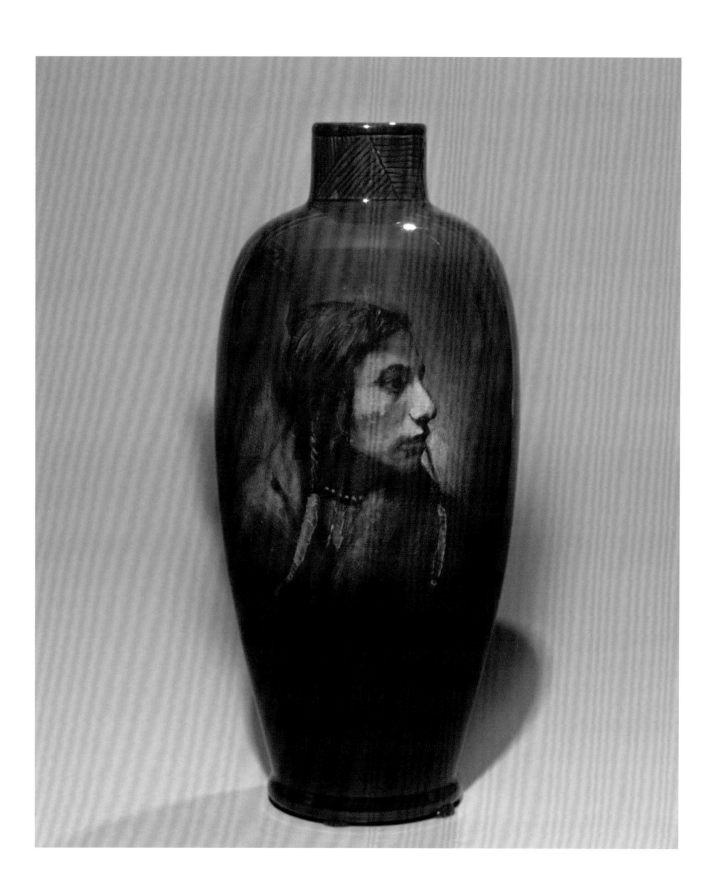

3

Vase, 1898

Lacóte

Matthew Andrew Daly, decorator

Standard glaze line; thrown; white body (stoneware)
H. 10", diam. 4½" (25.4 x 11.5 cm)
Marks:
> impressed
>> Rookwood logo surmounted by twelve
>> flames/"786C"
> incised
>> a) "MAD "
>> b) "Lacote"

Paper label:
> on exterior side of vase, rectangular label with
> black print on white ground, "31/Rook-
> wood IX/Cincinnati/Art Galleries"

Curator comments:

The decorator incised the line decoration on the neck to mimic Indian pottery decorations.

According to the Rookwood Shape Book 1883–1900 (186), the shape of this vessel was taken from a vase made at the Coalport porcelain factory in Coalport, near Broseley, Shropshire, England.

For another depiction of Lacóte see cat. no. 35.

According to the information on the front of the photograph, Lacóte was Hidatsa-Mandan.

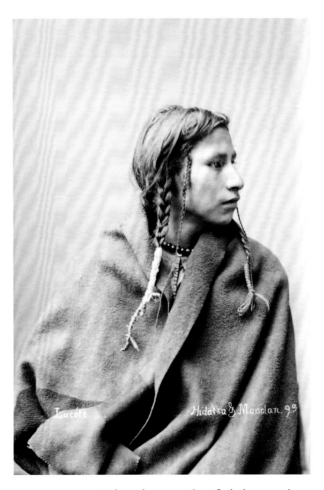

Figure 3. Lacóte, Hidatsa, by an unidentified photographer, 1884, Washington, DC. *(3456B) National Anthropological Archives, Smithsonian Institution.*

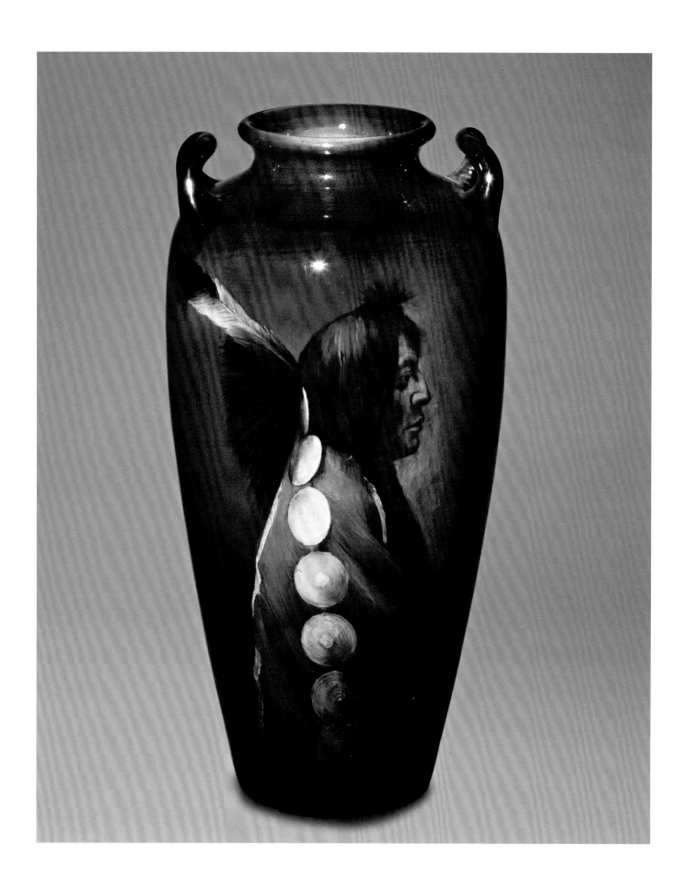

4

Vase, 1899

Big Mouth Hawk or Big Mouth (Indian name Bi-Nan-Set)

Matthew Andrew Daly, decorator

Joseph Bailey Sr. (ca. 1827–98), chemist and superintendent at Rookwood 1881–85, 1887–97, shape designer

Standard glaze line; thrown; white body (stoneware)
H. 14", w. (w/ handles) 7½", d. 7½" (35.6 x 19 x 19 cm)
Marks:
 impressed
 Rookwood logo surmounted by thirteen
 flames/"614B" painted in black underglaze
 incised
 a) "M.A.Daly"
 b) "Binanset./Arapaho"

Curator comments:

 The two lug handles opposite each other on the shoulder are not in the shape book, and are not original to the shape design.

 The painted marks underglaze suggest that Daly signed it after the first firing, in the biscuit stage. He simply forgot to sign it before it was fired, and did so after the first firing. Not only would he want to have been given credit for such a fine piece, it was a policy at Rookwood that the decorators had to sign their pieces so that sales of their work could be tracked.

 For his seated portrait, Bi-Nan-Set wears a magnificent Plains hair ornament made of unusually large German silver discs mounted on a strip that is either leather or trade wool. That ornament is attached to another typical man's hair ornament, a roach—a circular "fluff" of porcupine and deer hair that tapers to a point.

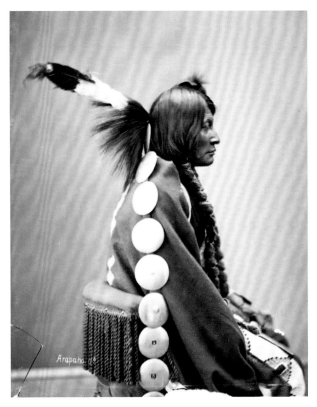

Figure 4. Big Mouth Hawk, Arapaho, by Alexander Gardner, 1872, Washington, DC. *(69) National Anthropological Archives, Smithsonian Institution.*

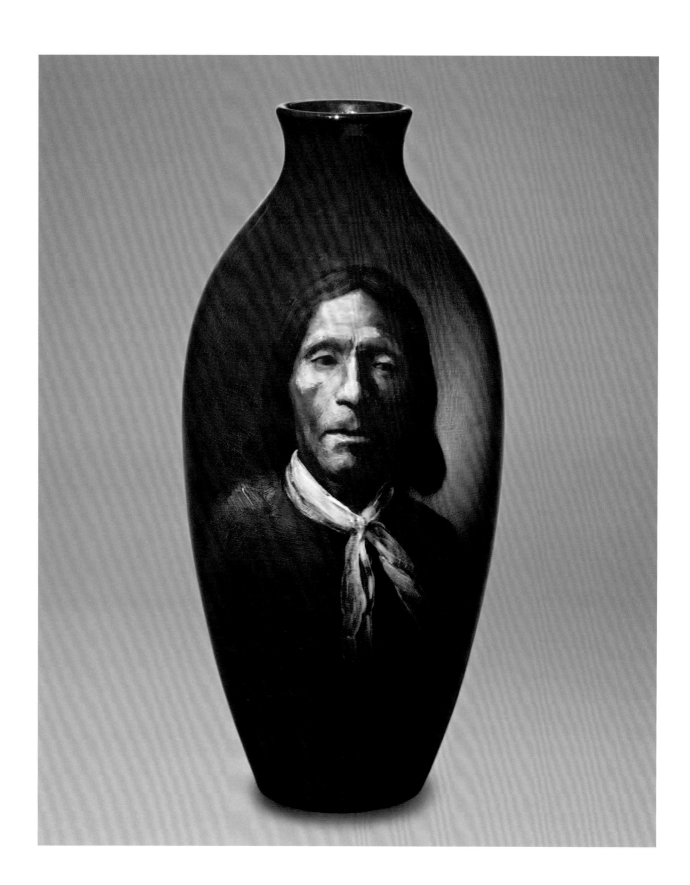

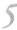

Vase, 1899

Pablino Diaz or Big Whip

Matthew Andrew Daly, decorator

Standard glaze line; thrown; white body (stoneware)
H. 10½", diam. 5" (26.6 x 12.6 cm)
Marks:

 impressed

 Rookwood logo surmounted by thirteen
 flames/"732B"

 incised

 a) "<u>M.A.Daly</u>"

 b) "Pablino Daiz" [*sic*]

Paper labels:

 a) rectangular label with red print on white
 ground, a line drawing of a kiln; to the left
 of the kiln is "Rookwood/Pottery/Cincin-
 nati/USA"; to the right of the kiln is "In-
 ternational/Exposition/Paris/1900"

 b) on interior, rectangular label with black
 print on white ground, "Cincinnati/Art
 Galleries/1074"

Curator comments:

 According to the Rookwood Shape Book 1883–1900
(182), shape number 732, first developed in April 1894, is
taken "From vase of Hugh Robertson/in Pottery Collec-
tion." Hugh Robertson was from a family of Robertsons of
Chelsea Keramic Art Works (1872–89) in Chelsea, Massa-
chusetts. During its time it was one of the most important
pottery works in the United States. Like Rookwood,

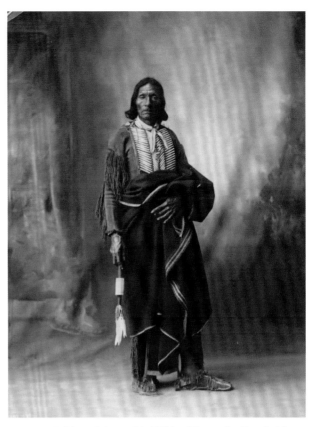

Figure 5. Pablino Diaz or Big Whip, Kiowa, by Frank Albert
Rinehart, 1898, during the Omaha Trans-Mississippi and
International Exposition, Omaha, Nebraska. *From the collec-
tions of the Omaha Public Library.*

Chelsea developed an underglaze slip technique and uti-
lized classically simple shapes. Rookwood was well aware
of Chelsea and obviously had an example from this pottery
in its own collection.

 Pablino Diaz, also known as Big Whip, can be seen
in the group image of Kiowas in cat. nos. 42 and 52; he is
on the far right.

 Daly painted Pablino Diaz's non-Indian neck scarf,
but chose not to illustrate the traditional Plains man's hair
pipe breastplate. Originally the hollow tubes decorated a
man's hair; later, in the nineteenth century, an enterprising
trader in New Jersey began turning bone copies on a lathe.
Today the hair pipes are usually made of plastic.

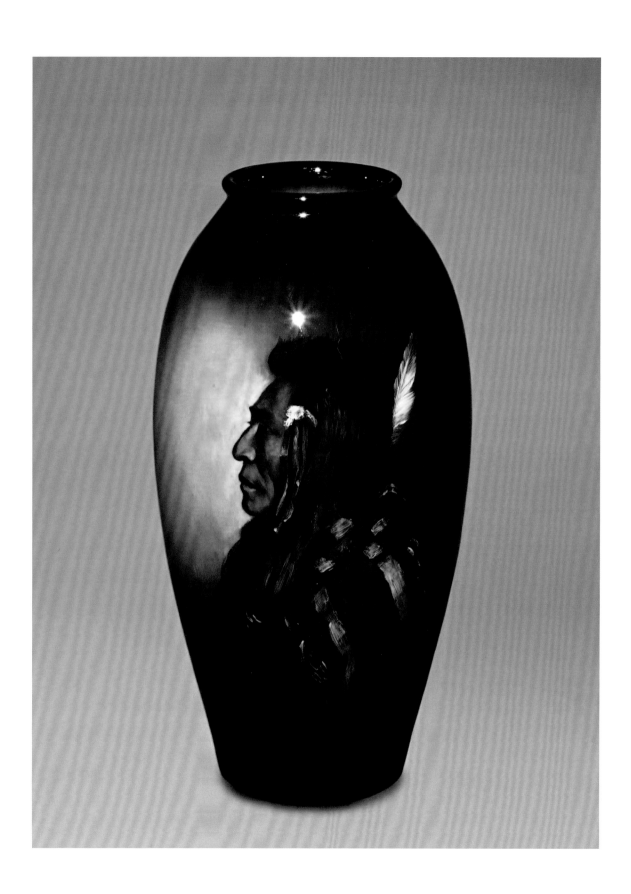

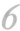

Vase, 1899

Weasaw

Matthew Andrew Daly, decorator

William Purcell McDonald, shape designer

Standard glaze line; thrown; white body (stoneware)
H. 14¾", diam. 8½" (37.5 x 21.6 cm)
Marks:
> impressed
>> Rookwood logo surmounted by thirteen
>> flames/"857" (no size letter given)
> incised
>> a) "M.A.Daly"
>> b) "Weasaw, Shoshone"

Paper labels:
> a) rectangular label with black print on white
>> ground, "65"
> b) circular label handwritten in blue on white
>> ground, "108"

Curator comments:

Daly illustrated Weasaw's intricately patterned trade blanket on the vase; however, he probably had difficulty painting its many brilliant colors. Red, for example, was difficult to reproduce in the Rookwood glazes. Blankets of this type, manufactured by Pendleton Woolen Mills and other companies, were highly valued by Indian people and often given as gifts to honor the recipient.

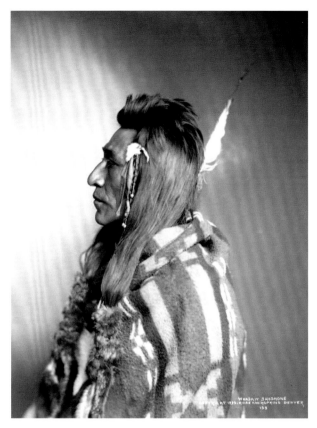

Figure 6. Weasaw, Shoshone, by Rose and Hopkins, ca. 1899. Denver Public Library, Western History Collection, Rose and Hopkins H-409.

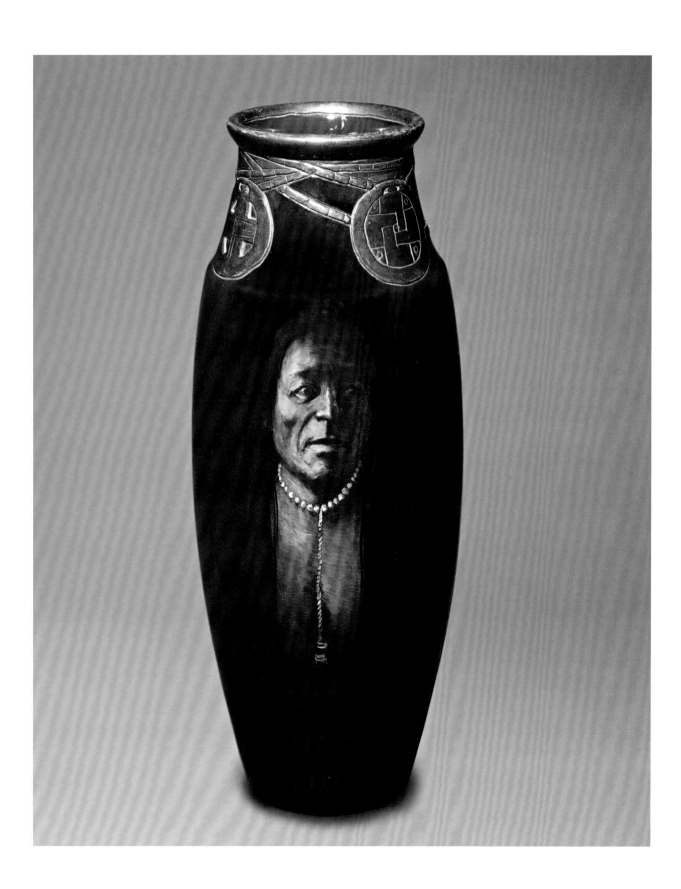

7

Vase, 1899

*Bloody Mouth (Indian name Wi-Cha-I-We,
or E-Wa-Hu, or E-Wa-He-A)*

Matthew Andrew Daly, decorator

Henry Yelland (dates unknown), thrower at Rook-
wood 1888–?, shape designer

Standard glaze line; thrown; white body (stoneware);
 copper overlay decoration around lip and
 shoulder
H. 12", diam. 5" (30.5 x 12.6 cm)
Marks:
 impressed
 Rookwood logo surmounted by thirteen
 flames/"538C"
 incised
 a) "M.A. Daly"
 b) "Bloody Mouth/Onkpapa" [*sic*]
Paper label:
 on interior, rectangular label with black print
 on white ground, "Rookwood
 VI/1756/Cincinnati Art Galleries"

Curator comments:

 Matt Daly depicts gorgets as a decoration on the
shoulder of the vase. (See details, figs. 8–10.) A gorget is
usually made from a marine shell or slate and often has
two drilled holes for suspension on a cord. The specific
function of a gorget continues to puzzle archaeologists.

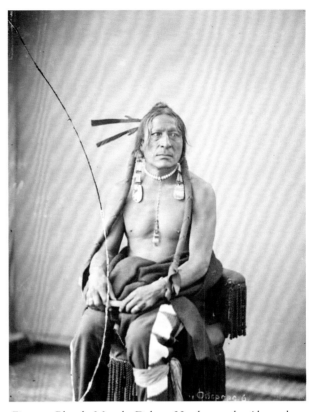

Figure 7. Bloody Mouth, Dakota Hunkpapa, by Alexander
Gardner, 1872, Washington, DC. *(06672000) National Anthro-
pological Archives, Smithsonian Institution.*

Figures 8–10. Detail of each of the three gorgets used as copper electrodeposited decoration on the vase.

The term "gorget" is French and means a piece of armor that protected a soldier's throat. Contemporary archaeologists think that gorgets may have been worn simply as an ornament or perhaps worn for ceremonies.

The gorgets on the vase were inspired by those worn by a vanished, prehistoric, Ohio Valley people—early Native Americans. Rookwood obtained images of the prehistoric gorgets (figs. 11–13) from an article by William H. Holmes, entitled "Art in Shell of the Ancient Americans," found in the *Second Annual Report of the Bureau of Ethnology, The Smithsonian Institution, 1880–81,* which the Pottery had in its library. Rookwood first used the gorgets as decorations on vases made in 1888. Daly used the gorgets to illustrate the relationship between the moundbuilders and America's Indians, and as a metaphor for the foreseeable extinction of the American Indian, represented by Bloody Mouth.

Bloody Mouth's spectacular earrings are made of slabs of abalone shell suspended from rows of tubular dentalium shells, both native to the Pacific coast. The highly prized shells were probably acquired through trade. Today Bloody Mouth's Indian band is spelled Hunkpapa. The band is well known because Sitting Bull was one of its principal leaders.

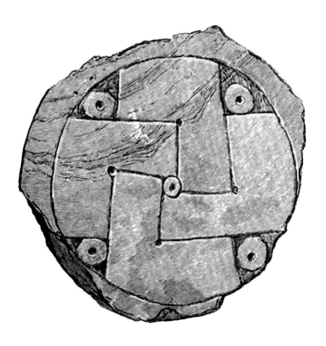

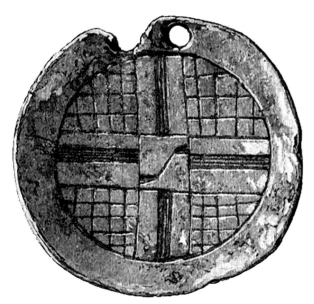

Figures 11–13. Gorgets as imaged in William H. Holmes, "Art in Shell of the Ancient Americans," *Second Annual Report of the Bureau of Ethnology, The Smithsonian Institution, 1880–1881* (Washington, DC: GPO, 1883), plate 52, nos. 1 and 3, and plate 51, no. 1.

8

Vase, 1899

Nasuteas-Kichai

Matthew Andrew Daly, decorator

Standard glaze line; thrown; white body (stoneware);
 copper overlay on handles
H. 13¾", w. 10¼", d. 9½" (35.0 x 26.0 x 24.1 cm)
Marks:
 impressed
 Rookwood logo surmounted by thirteen
 flames/"581C"
 incised
 a) "MADaly."
 b) "Ekichai Woman/Wichita"

Figure 14. Nasuteas-Kichai, by Frank Albert Rinehart, 1898, during the Omaha Trans-Mississippi and International Exposition, Omaha, Nebraska. *(01325A) National Anthropological Archives, Smithsonian Institution.*

Curator comments:

Almost certainly, the copper overlay on the handles was applied at Rookwood. It is curious that the overlay is barely discernible and does not appear to constitute an aesthetic enhancement. For this reason and the fact that the overlay process was time-consuming and expensive, the purpose must be questioned. Perhaps it was functional: to protect the handles from chipping or breaking; or, more probable, to conceal a chipped handle and save the vase for display and sale at a future exposition. If one or both of the handles, which protrude and are the most vulnerable part of the vase, were damaged, the resulting loss of the vase would have been considerable, and probably justified

the cost of the overlay. In a Rookwood Letterpress book for January 5–December 5, 1889, in The Cincinnati Historical Society Library at the Museum Center, Cincinnati, there is a copy of a letter from Rookwood's director, William Watts Taylor, to Messrs. George C. Shreves and Co., San Francisco, dated July 3, 1889. Shreves and Co. was the major department store in San Francisco, and Rookwood's retailer in that city. In referring to a special piece of Rookwood sent to Shreves and Co., Taylor notes, "The S803 [i.e., the particular object marked with this number] is quite defective but the defects might be concealed by the metal mounts." This strongly suggests that Rookwood

was not beyond hiding defects and saving a piece for sale by the use of "metal mounts," or copper overlay.

According to the Rookwood Shape Book 1883–1900 (181), shape number 581 was originally shape number S920. The shape was taken from a Royal Copenhagen piece, which in turn was taken from a Greek vase. The Royal Copenhagen porcelain factory in Copenhagen, Denmark, was one of the foremost producers of porcelain at the time. Herbert Peck, in his *The Second Book of Rookwood Pottery,* notes that shape number 581 was "from a drawing by G. H. Gest" (75). The Shape Book notes that it is a "copy of Greek," not "copy from Gest."

The uniquely American subject matter, in combination with the large size, the prominent decorator, the copper overlay, and the 1899 date, suggests that the vase was probably produced for display at the 1900 Paris Universal Exposition.

Kichai is a language variant for the tribal name Wichita; hence it is uncertain if "Kichai" is actually part of Nasuteas's name or not.

Henry Farny

Henry Farny was born François Henri Farny on July 15, 1847, in Ribeauville, France. When he was six years old, his family moved to the United States, and in 1859 they settled in Cincinnati. Nothing is known of any formal art training he might have had, but in 1865 he began to work for Harper Brothers, and his illustrations began to be seen in *Harper's Weekly* magazine. In 1866 he left for Europe, where he traveled extensively and studied with a variety of masters, including Thomas Buchanan Read. Returning to Cincinnati in 1870, he supported himself as an illustrator. He traveled to Europe two additional times prior to 1881, when he was hired by the Rookwood Pottery Company to create a logo and a printed label for the pottery. It was during his year at Rookwood that Farny created four plaques utilizing a printed technique to depict American Indian portraits. By the end of 1881 he had visited the West and become engrossed with Indian culture. From that time on, his work depicted the American Indian in oils on canvas and in works on paper. He became noted for this genre, and supported himself as an illustrator and painter of the West until his death on December 23, 1916, at the age of sixty-nine.

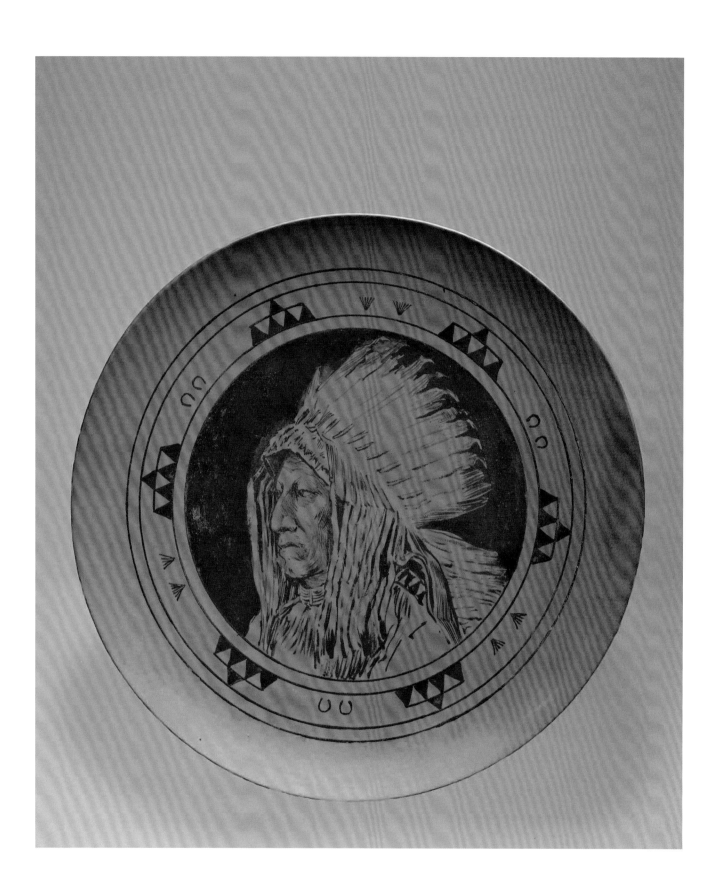

9

Plaque, 1881

John Grass (Indian name Pehzi or Pah-Zhe).
Also called Waha-Canka-Yapi /Used as a Shield

Henry Farny (1847–1916), decorator at Rookwood
1881

Unglazed; press molded; red body (earthenware)
H. 1½", diam. 11" (3.8 x 28.0 cm)
Marks on back:
 Printed in black
 •H•F•FARNY•/•1881•
Paper labels:
 a) circular label printed in black on gold
 ground, "The Schulman/Collection/[Rook-
 wood logo surmounted by fourteen
 flames]/Rago Auctions"
 b) rectangular label handwritten in blue on
 white ground, "From the Rookwood Pot-
 tery/Museum Collection purchased/by B.A
 & Co 1937. Farny was the famous designer
 of their Indian, etc."
 c) adhered to a rectangular tag on string, cir-
 cular label printed in black on green,
 "0068/Rago"

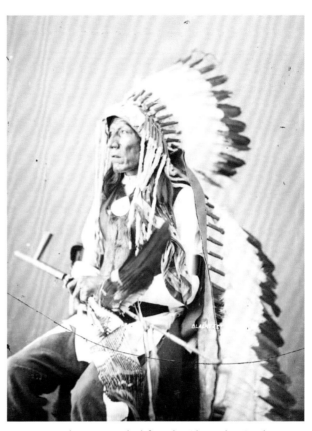

Figure 15. John Grass, Blackfoot, by Alexander Gardner,
1872, Washington, DC. *(3110) National Anthropological Archives,
Smithsonian Institution.* (The tribal name "Blackfoot" is sometimes
used instead of "Blackfeet.")

Curator comments:

The source of inspiration for Farny's portrait of John
Grass appears to have been the photograph taken in Wash-
ington, DC, by Alexander Gardner in 1872. This photo-
graph could have been in Rookwood's library; more
probable, since Rookwood was not promoting Indian dec-
orations at the time and its library was barely, if at all, de-
veloped in 1881, it was a photograph acquired by Farny. It
is also possible, because the photo and the sitter are not
exactly alike in details, that Farny photographed John
Grass during the artist's 1881 visit west to Fort Yates on
Standing Rock Reservation. Fort Yates is in present-day
North Dakota. Grass could have been at Fort Yates when
Farny was there; his Sihasapa band of the Blackfeet tribe

was assigned to the Standing Rock Indian Agency in the 1880s, and his name appears frequently in reports from that agency. Grass was known for his diplomatic skills and was accustomed to dealing with whites. As a guest of the fort commander, Farny likely would have been introduced to Indian leaders who worked with government officials.

According to the *Cincinnati Enquirer* for November 8, 1881, in an unsigned article entitled "Lo! The Poor Indian," Farny notes: "I met about six thousand Indians which were all Sioux . . . I took 124 photographs" (8). The final possibility is that Farny sketched John Grass while at Fort Yates, and the image is taken from the sketch. If the image is taken from a Farny photograph or sketch, then the plaque can be dated sometime after November 5, 1881, when Farny returned from his trip.

Unfortunately, there is no way of knowing if the plaque was made before or after the artist's 1881 trip west. Denny Young, in her book *Henry Farny* (1978, 24), says that Farny used his monogram until his initial trip west in 1881, when he began signing his name to his work. Farny signed this plaque with his name instead of his monogram.

In the section for 1881 of S. G. Burt's inventory, *2,292 Pieces of Early Rookwood Pottery in the Cincinnati Art Museum in 1916,* four plaques, numbers 14–17, are listed as being by Farny. Of these, the one depicted in this catalogue is probably Burt's number 14 or 15. Number 14 is noted as being signed "H. F. Farney [*sic*]." Number 15 is noted as being the "same" as number 14. Neither of the remaining two can be the plaque in question because they do not have the same format for the signature. Number 16 is noted as "not signed," and number 17 is noted as signed with the HFF cipher. Burt's inventory for numbers 14 and 15 in the 1881 section describes each as "Biscuit pc [piece] no glaze red clay with ground dull black decoration shown by red clay of body." This plaque is print-decorated in black on the biscuit-fired form (i.e., after the initial firing of the clay into ceramic). The black decoration has not been "hardened on" in a firing, nor has the plaque been glazed or fired the final time. It should also be noted that the portrait appears to be printed, but the black ground coloring around the portrait in the cavetto (central concave portion of the plaque) appears to have been painted with a brush.

The print technique used in the decoration was not unusual for Farny or Rookwood at the time. As an artist, Farny included prints among his oeuvre, and in 1881 he designed the only printed logo that Rookwood ever used for its wares, and probably the animal subjects that the company used for its first experiments in printed decorations. Edwin AtLee Barber, in his seminal work on *The Pottery and Porcelain of the United States* (1893, 286–87), notes that in 1881 Rookwood produced considerable quantities of ware decorated with underglaze blue and brown prints of animal subjects. Herbert Peck in his *The Book of Rookwood Pottery* (1968, 15) quotes Rookwood artist Clara Chipman Newton's list of everyone at the pottery who assembled in the kiln shed to help with the "new [printing] experiment." Although she does not say that Farny engraved the copper plates, she does note, "The first steps of this process, engraving the copper plates, were exceedingly expensive."

It is curious that Farny's biscuit-fired plaque was never fired to adhere to the decoration, and never glazed or fired a final time. The reason for this is given on page 189 of the Rookwood Shape Book 1883–1900. Next to an image of this shape, a handwritten note states that the imaged piece was decorated by Henry Farny, and adds: "Could not be fired hard enough [i.e., hot enough] to set the colors in manner desired by artist without destroying effect. Not saleable." This suggests that the red earthenware body could not withstand the heat needed to set the decoration successfully. Barber observes that the principal body used for Rookwood's printed pieces is an "intermediary between cream-colored and white granite wares" (286), or a body that fires somewhere between 1200° and 1320°C. Such an intermediary body could withstand a higher firing temperature than the red-bodied earthenware, which fires up to ca. 1150°–1200°C. Obviously, Farny felt that the red body was important to the overall effect because it suggested the red earthenware of Indian pottery, and he does not seem to have attempted his printed decoration of an Indian on Rookwood's creamy white intermediary clay body.

Although not noted on the plaque, the shape number is 189. The Shape Book notes that number 189 was cancelled (i.e., the number was no longer used) and that all

such shapes were transferred to number 188. The only difference between shape 188 and 189 is size; shape 189 is smaller. Sizes listed for shape number 188 are 12, 13, 14, and 16 inches in diameter. This plaque is 11 inches in diameter and, therefore, in agreement with the notation that it is shape number 189.

The "B.A. & Co" noted on the paper label as purchasing the plaque in 1937 is the celebrated B. Altman and Co. department store in New York. The store, located at Thirty-fourth Street and Fifth Avenue by 1906, closed in 1989. In 1930 B. Altman and Co. became one of the sales agents for Rookwood Pottery in New York City, and probably acquired the plaque for sale in its store in 1937.

John Grass (ca. 1840–1918) was born in present-day South Dakota and became a respected leader of the Sihasapa Sioux people, just like his father and grandfather. During the 1870s Grass counseled peace, and after 1876 gained influence when he encouraged his people to learn to farm and become educated.

His willingness to cooperate with government policies marked him as a "progressive," and he was named chief justice of the Court of Indian Offenses for Standing Rock Agency. Grass's influence increased when Gall, a war leader who fought at the battle of the Little Big Horn, also began to accept assimilationist policies. Gall and Grass became friends, working to protect the lands and interests of their people. This put Gall and Grass at odds with Sitting Bull, who remained suspicious of the federal government.

When the government attempted to take additional Sioux land and break up the Great Sioux Reservation, Grass resisted. In 1889 he opposed the government's attempt to get Sioux approval for the sale of the land, noting that in the past, the government had failed to honor its promise of payment. He also felt that the offered payment of $1.25 per acre was too low. Eventually Grass succumbed to pressure and to arguments that if he and the other Sioux leaders did not agree, the government might simply take the land without compensation. An agreement was reached in 1889, but the government failed to honor this treaty. This, plus the near extinction of the buffalo, led to the Ghost Dance Movement, and then to the death of Sitting Bull and the 1890 Wounded Knee Massacre. Throughout this difficult time Grass remained committed to peace, maintaining that there was no alternative. He died at his home near Fort Yates on Standing Rock Reservation.

Plains Indians in their chief-like warrior attire appealed to artists. For this plaque Henry Farny focused on the idealized portrait of American Indians—a man wearing the prized badge of office for military accomplishments, an eagle feather warbonnet with beaded brow and ermine fur or tails at the sides. John Grass, a respected Blackfeet elder, holds other traditional objects: a catlinite pipe, an eagle feather fan, and a beaded tobacco bag with long, flat rawhide fringe wrapped in quillwork. Catlinite is a soft red stone named for the American artist George Catlin; the stone hardens when exposed to air.

Robert Bruce "Bruce" Horsfall

Bruce Horsfall was born on October 21, 1869, in Clinton, Iowa. He studied art briefly there and intermittently at the Art Academy of Cincinnati between 1888 and 1895. He was considered the best student in Frank Duveneck's 1890–91 class, and was consequently awarded a $1,000 scholarship to travel abroad. He left for Europe in 1891 to study in Munich and Paris. Upon his return in 1893, he became a Rookwood decorator. He is one of the early painters of portraits on pottery at Rookwood. He left in 1896 to pursue a career in wildlife painting and illustration, for which he became noted. Horsfall died March 24, 1948, in Washington, DC, at the age of seventy-eight.

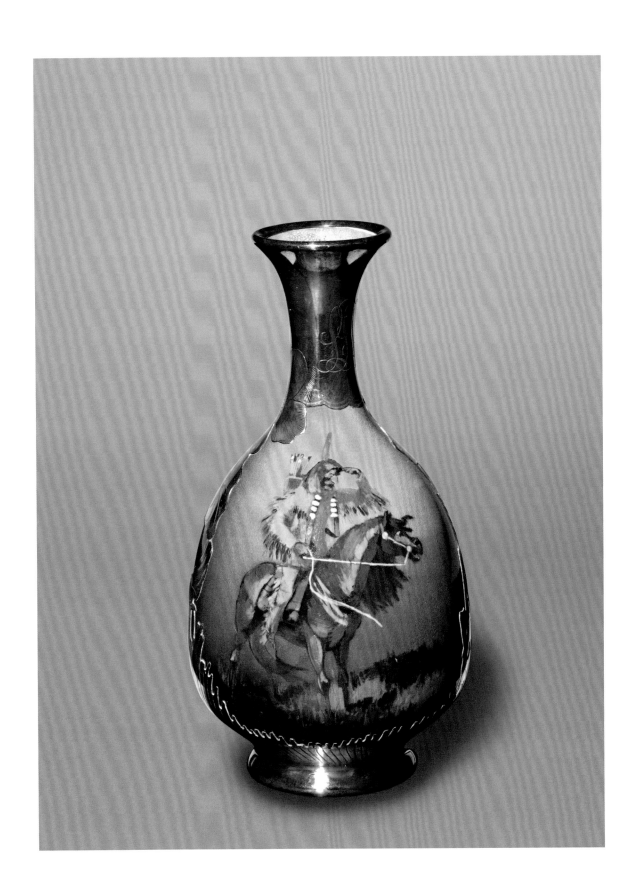

10

Vase, 1893

Indian Scout

Robert Bruce Horsfall (1869–1948), decorator at Rookwood 1893–95

William Watts Taylor, shape designer

Gorham Mfg. Company (1865–1961), Providence, Rhode Island, silver maker

Standard glaze line; slip cast; white body (stoneware); silver overlay around lip, neck, body, and foot rim
H. 8¾", diam. 4½" (22.2 x 11.5 cm)
Marks on ceramic:
 impressed
 a) Rookwood logo surmounted by seven
 flames/"657C"
 b) "W"
 incised
 "B——"
Marks on silver:
 engraved
 a) at neck "LLW" in script
 b) on bottom of foot rim, "R 1426"
 die-struck
 on bottom of foot rim, "GORHAM
 MFG.CO."
Paper label:
 on side of vase, rectangular label printed in
 black on white ground, "Cincinnati/Art
 Galleries/1590"

Curator comments:
 The mark "R 1426" engraved on the bottom of the foot band of the silver overlay is an inventory code number used by the Gorham Manufacturing Company of Provi-

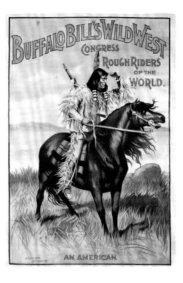

Figure 16. Indian Scout, *An American,* a poster printed by A. Hoen and Co., Baltimore, Maryland, ca. 1893. *Buffalo Bill Historical Center, Cody, Wyoming; 1.69.51.*

dence, Rhode Island. In her exhibition catalogue, *Sumptuous Surrounds: Silver Overlay on Ceramic and Glass* (1990), Jayne E. Stokes comments, "The known records for the glass and ceramic wares that Gorham worked with are all prefixed by the letters "D" or "S." . . . It is possible that "R" numbers form a distinct series used only for Rookwood pottery. . . . The existence of a Rookwood series can only be speculated upon at this time as no documentation for it has been discovered" (38). Gorham used various codes to reference special orders. If the "R" prefix was reserved for Rookwood pottery orders, it would suggest that Rookwood commissioned the Gorham overlay for this piece.

 The Gorham overlay respects the Rookwood decoration with greater sensitivity than is normally seen on overlaid pieces. It actually mimics the grasses in the lower part of the imaged Indian scout composition. It is possible that this is one of the pieces of Rookwood in the Gorham Manufacturing Company's display at the 1893 World's Columbian Exposition in Chicago.

 The image is taken from a popular poster for Buffalo Bill Cody's Wild West show. As the poster is in color, we can see what liberties the artist took not only with the composition, but with the color as well.

 The image on the poster and the one on the vase reinforce the stereotypical image of American Indians—the warrior wearing leather garments with flowing fringe, astride a horse and ready to charge across the open plains.

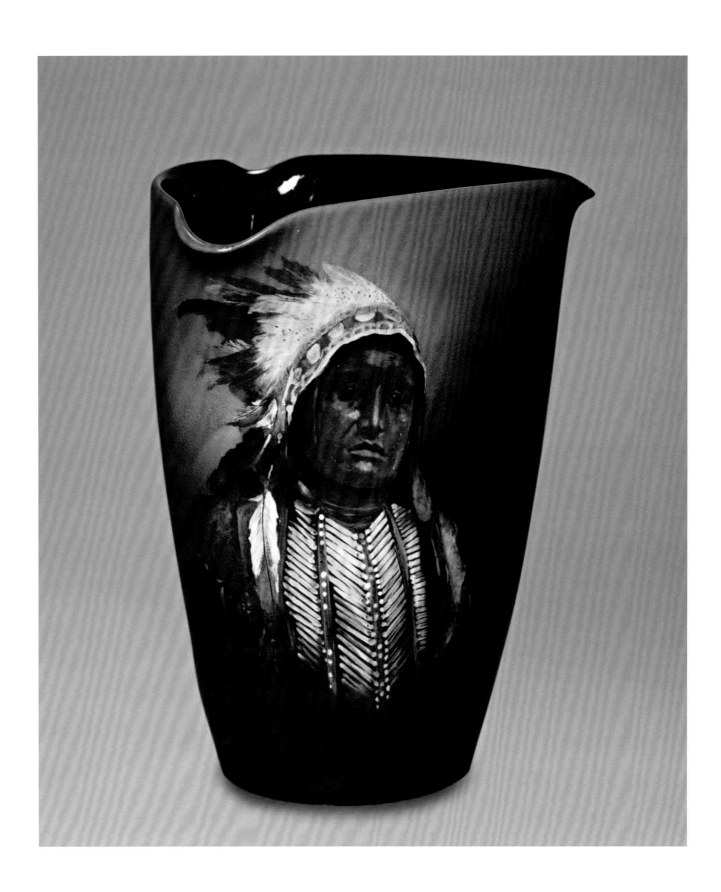

II

Crucible Pitcher, 1895

Powder Face

Robert Bruce Horsfall, decorator

Pitts Harrison Burt (1837–1906), trustee at Rookwood 1890–1906, shape designer

Standard glaze line; slip cast; white body (stoneware)
H. 8½", w. 9⅜", d. 6" (21.6 x 23.7 x 15.3 cm)
Marks:
 impressed
 Rookwood logo surmounted by nine
 flames/"259B"
 incised
 "B_____"
Paper label:
 on interior, rectangular label with black print
 on white ground, "The Glover/Collection/
 0395/Cincinnati Art Galleries"

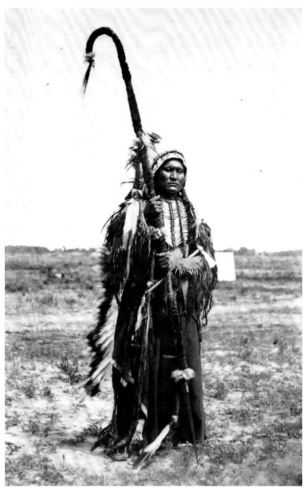

Figure 17. Powder Face, Arapaho, by William Stinson Soule, 1869–74, probably at Fort Sill, Indian Territory, Oklahoma. *Denver Public Library, Western History Collection, William Stinson Soule #X-32132.*

Curator comments:

 According to the Rookwood Shape Book 1883–1900 (59) for shape number 259, this pitcher was not designed as part of a set that includes drinking vessels such as mugs. Even without the Shape Book information, this can be determined from several clues. The triangular shape of the pitcher does not lend itself to drinking vessels because it would be awkward to drink from a triangular container. There is a size letter impressed on the bottom of this pitcher, but pieces to sets do not have size letters because

they were made in only one size. Also, when the pitcher is held in the right hand, the portrait faces the pourer and therefore was not decorated for use in a social context in which the portrait would be facing the guests.

The identity of the Indian is not noted by the artist on the pitcher. Unlike other Rookwood decorators, Bruce Horsfall did not often note the identity of the sitters of his Indian portraits.

Powder Face's long "fur covered spear" is probably his coup stick, a lance used to strike an enemy. Counting coups or "blows," striking an enemy and running away unscathed, was perhaps the bravest deed a warrior could accomplish. This required cunning and stealth, and left the enemy alive to endure his shame.

Edward Timothy Hurley

Edward Hurley was born in Cincinnati in 1869. He received a degree from Xavier University in 1887, and took various classes at the Art Academy of Cincinnati during the years 1893–98. There are no records that show he studied under Frank Duveneck, although his obituary notes that he did, and his daughter, Mrs. Robert (Joan) Hurley O'Brian, said that he "worshiped Duveneck." Hurley began at Rookwood in 1896, and remained until 1948. Very versatile, he executed a few Indian portraits, but is mostly noted for his tonal landscapes in the Vellum glaze line. Privately, he painted landscapes and cityscapes with oils on canvas, but gained his national reputation as an etcher. According to Hurley's son, Robert, Frank Duveneck told his father that he was a line artist, not a painter. He stopped painting in 1929 to devote his free time to etching. Hurley died on November 29, 1950, at the age of eighty-one.

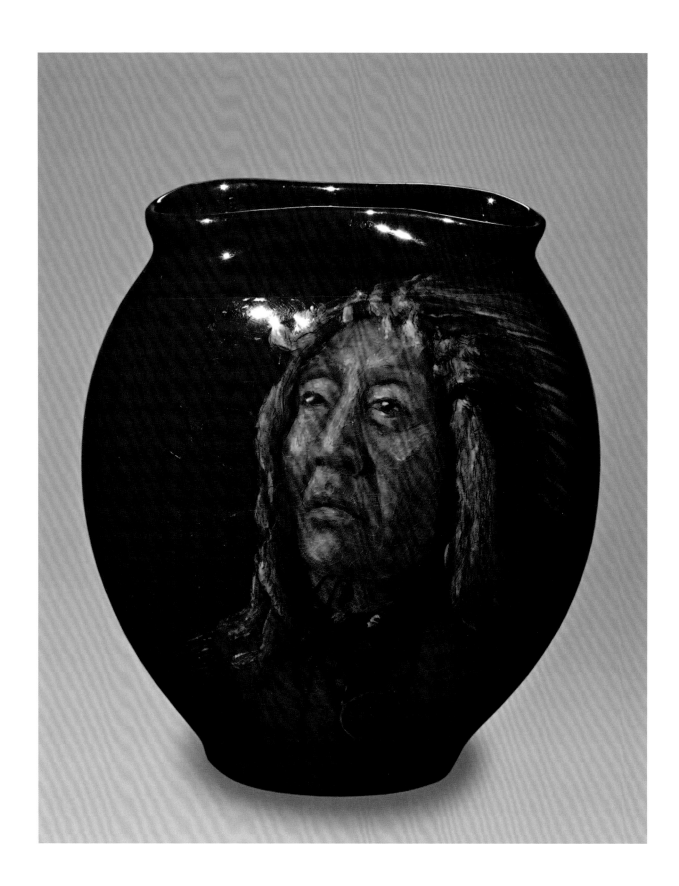

I2

Vase, 1900

High Bear

Edward Timothy Hurley (1869–1950), decorator at
Rookwood 1896–1948

Standard glaze line; slip cast; white body (stoneware)
H. 5½", w. 5½", d. 3½" (14.0 x 14.0 x 8.9 cm)
Marks:
> impressed
>> Rookwood logo surmounted by fourteen
>> flames/"707B"
> incised
>> a) ETH cipher
>> b) "High Bear/Sioux"

Curator comments:

Some vases molded in the shape design number 707
are lobed. The decorator chose a vase that was not lobed
because it offered a larger ground on which to paint the
portrait. (See also cat. nos. 23, 31, 42, and 51 for the same
shape.)

For the vase image, Hurley painted High Bear wear-
ing a peace medal—a silver medal presented to important
Indian leaders—and a regal military warbonnet. High Bear
also wears a traditional Lakota man's shirt with fine porcu-
pine quillwork strips and long fringe.

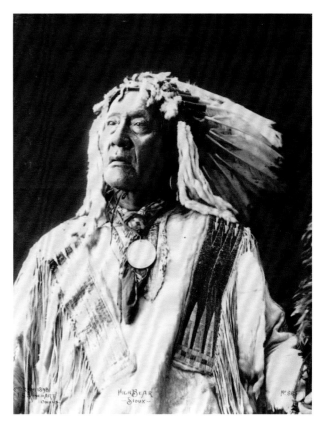

Figure 18. High Bear, Sioux, by Frank Albert Rinehart, 1898,
during the Omaha Trans-Mississippi and International
Exposition, Omaha, Nebraska. *From the collections of the
Omaha Public Library.*

Frederick Sturgis "Sturgis" Laurence

Sturgis Laurence was born October 13, 1870, in New York City of English parents. In the 1890s he worked as a decorator for the Ceramic Art Company (est. 1889), later known as the Lenox China Company, of Trenton, New Jersey. While there he painted full portrait figures in underglaze blue on ale sets. Rookwood might have approached him for hire because of his skill in underglaze portraiture. This is suggested by the facts that he was not a graduate of the Art Academy of Cincinnati, a general prerequisite for decorators at Rookwood and that he is most renowned at the Cincinnati pottery for his Indian portraits on ale sets. Whatever the case, he began as a decorator at Rookwood in 1895. His output in the genre of Indian portraiture appears to be second only to that of Grace Young. In 1904 he was placed in charge of Rookwood's newly established New York City office to promote the growth of Rookwood's architectural projects in the eastern United States. In 1917 he enlisted in the armed forces and served in World War I. It is possible that he returned to Rookwood after the war, but he would have left when the New York branch was closed in the 1920s. The 1930 Census of the United States lists him as a secretary, living in North Hempstead, Nassau, New York. He died February 21, 1961, at the age of ninety, and is buried in Arlington National Cemetery.

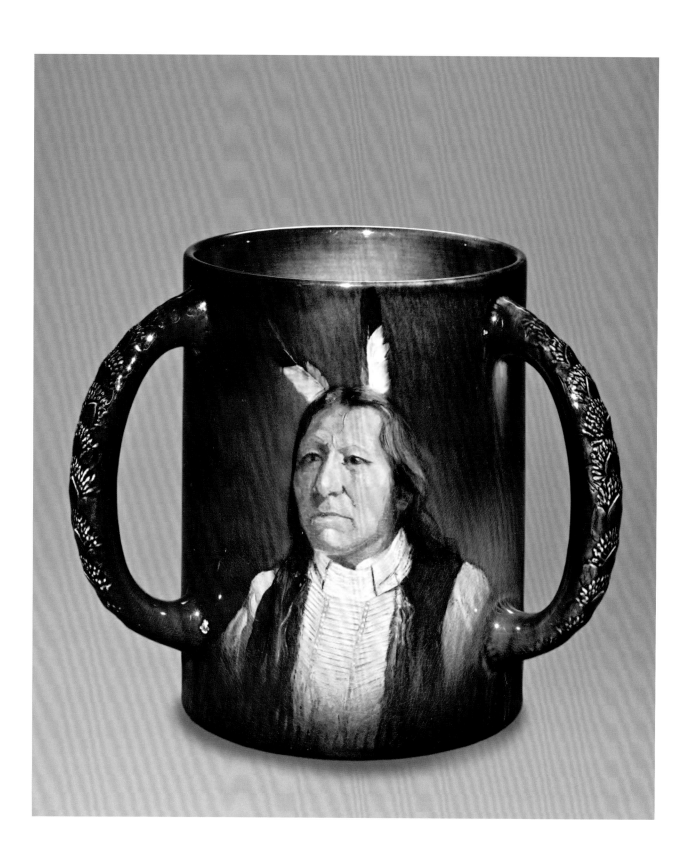

13

Loving Cup, 1896

White Eagle

Frederick Sturgis Laurence (1870–1961), decorator at
Rookwood 1895–1904

Standard glaze line; thrown; white body (stoneware)
H. 7½", w. (w/ one handle) 8¼", d. (w/out handles) 5
¾" (19.0 x 21.0 x 14.6 cm)
Marks:
 impressed
 Rookwood logo surmounted by ten
 flames/"S1213"
 incised
 a) "Sturgis Laurence/—Sep. '96"
 b) "'*White Eagle,*'/(Ponca Tribe)"

Curator comments:

The shape number S1213 designates that this was a
special piece made directly from a sketch or drawing bear-
ing that number.

The handles exhibit a relief decoration of a repeated,
stylized flowering cactus design, which is rare.

For his portrait, White Eagle proudly displays Indian
finery: a pipe tomahawk, the bowl of which was acquired
through trade; a hair pipe breastplate; a choker that ap-
pears to be made of trade beads; and eagle feathers in his
hair. Standing Bear, his companion in the photograph,
wears a bear claw neck ornament.

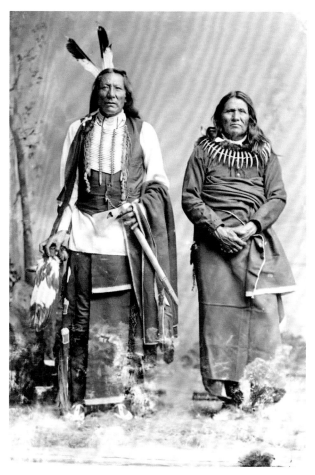

Figure 19. White Eagle, Ponca, by Charles Milton Bell, no
date, possibly Washington, DC. *(52895) National Anthropo-
logical Archives, Smithsonian Institution.*

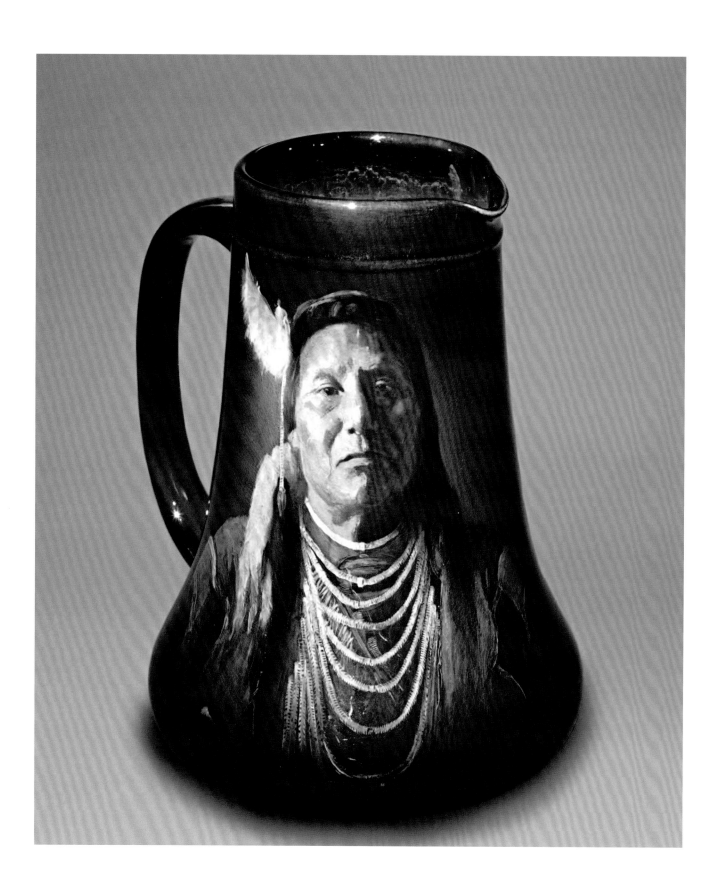

14

Pitcher to Ale Set, 1898

Joseph (Indian name Hinmaton-Yalatkit or Hin-Ma-Toe-Ya-Lut-Kiht/Thunder Coming from the Water Up Over the Land) Also known as Chief Joseph.

Frederick Sturgis Laurence, decorator

William Watts Taylor, shape designer

Standard glaze line; slip cast; white body (stoneware)
H. 9 ½", w. (w/ handle) 9", d. 7 ½" (24.1 x 22.9 x 19.0
 cm)
Marks:
 impressed
 Rookwood logo surmounted by twelve
 flames/"656" (no size letter given)
 incised
 a) "Sturgis Laurence."
 b) "'Joseph,'/Chief of the Nez Perces"
Paper label:
 on interior, rectangular label with black print
 on white ground, "Rookwood V/764/
 Cincinnati Art Galleries"

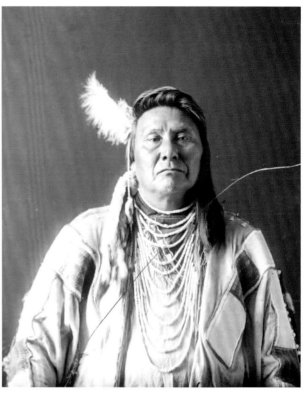

Figure 20. Joseph, Nez Percé, by Wells Moses Sawyer, April 1897. *(2908B) National Anthropological Archives, Smithsonian Institution.*

Curator comments:

According to the Rookwood Shape Book 1883–1900 (56), shape number 656 was originally the trial shape number S1100S.

There is one pitcher to every ale set, but the Shape Book does not note how many mugs are in an ale set. The set that includes this pitcher contains six. Sets are sometimes pieced together at a later date, but the objects in this one appear to be original to the set because they are decorated by the same artist in the same year.

This pitcher is en suite with the mugs, seen in cat. nos. 15–20.

Joseph (ca. 1840–1904) was a Nez Percé leader who was also known as Young Joseph. He was born in present-day eastern Oregon to Old Joseph, a Cayuse man, and Asenath, a Nez Percé woman. Joseph's parents received their Anglo names at baptism from missionaries working

for the American Board of Commissioners for Foreign Missions, a group that had established itself in the area in the 1830s.

Fiercely independent Old Joseph, and later his son, opposed the federal government's policy of confining the Nez Percés to a reservation located in present-day Idaho. Following the death of his father in 1871, Young Joseph became a "civil chief," responsible for diplomacy and the political leadership of his people. The 1877 Nez Percé War brought changes to all the Nez Percés—Christian and non-Christian alike.

The Nez Percés, like many other Indian groups, were constantly pressured to sign treaties that diminished their reservation land and allowed settlers and miners to move across their borders. Tensions increased and conflict ensued when the government ordered all Nez Percé chiefs whose bands resided "off" the small reservation to return to it within thirty days. During the relocation process several angry warriors killed some white settlers and ignited the 1877 war. Joseph, Looking Glass, and several other chiefs decided to flee with their people—first east, and then north toward Canada. As they ran, covering more than a thousand miles, they bravely repulsed the U.S. military, winning several battles. Many Nez Percés and several chiefs died; Chief Joseph finally surrendered, close to the Canadian border, on October 5, 1877.

Americans praised the Nez Percés' extraordinary military performance and credited Joseph for it, but in fact general military strategy was determined in council and it was Looking Glass, not Joseph, who was the most influential member. Joseph is remembered for his persistent fortitude in the face of great obstacles and his famous words spoken while surrendering to Colonel Nelson Miles: "From where the sun now stands I will fight no more forever."

Laurence depicts a regal Joseph wearing a loop neck ornament and eagle plume with a long beaded ornament in his hair.

15

Mug to Ale Set, 1898

Spotted Tail (Indian name Sinte Galeshka [sic])

Frederick Sturgis Laurence, decorator

William Watts Taylor, shape designer

Standard glaze line; slip cast; white body (stoneware)
H. 5", w. (w/ handle) 5", d. 4" (12.6 x 12.6 x 10.2 cm)
Marks:
 impressed
 Rookwood logo surmounted by twelve
 flames/"656" (no size letter given)
 incised
 a) "SL_____"
 b) "'Spotted Tail,' Chief/Brule–
 Dakota/Sioux."

Curator comments:
 This mug is part of an ale set (see cat. no. 14).
 Spotted Tail (ca. 1823–81), whose Sioux name was Sinte Gleska, was a member of the Sicangu or Brulé band who now live on Rosebud Reservation in South Dakota. He was a political leader and great warrior who fought for peace among his people, as well as peace with the whites who dominated North America. He maintained that negotiation was a better alternative to war.
 Spotted Tail was born near present-day Pine Ridge, South Dakota, the son of a Blackfeet/Sioux father and a Sicangu mother. By the age of thirty he was a "shirt wearer"

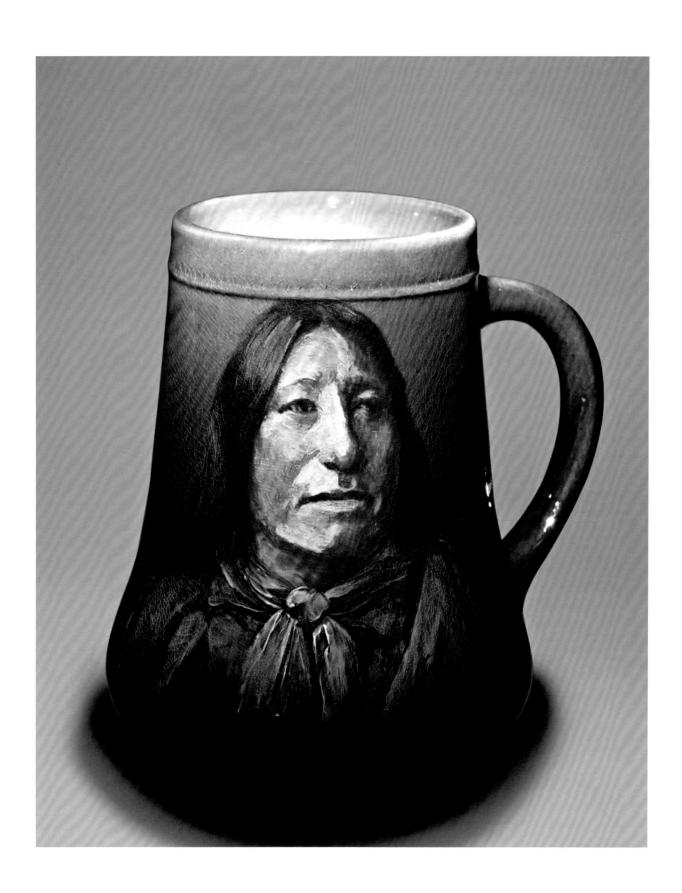

and entitled to wear his badge of office—a leather shirt decorated with more than one hundred locks of human hair representing his accomplishments, such as scalps, coups, and captured horses. Very little else is known about his life until the middle 1850s, when he participated in two fierce battles with the U.S. military. He was wounded in the second battle and, hoping to prevent further bloodshed, surrendered at Fort Laramie in October 1855. He realized that his people did not stand a chance against the military strength of the United States and that the Sioux needed to coexist peacefully in order to survive. Thus he promoted diplomacy instead of war.

The 1866–68 conflicts along the Bozeman Trail led Spotted Tail to advise his people to resolve their differences with settlers and miners and seek a settlement. He agreed to the Treaty of Fort Laramie in 1868, a treaty that established the Great Sioux Reservation. Spotted Tail was not pleased with his band's new location and in 1870 traveled to Washington to meet with President Grant about another settlement area.

A few years later General George Custer confirmed the presence of gold in the Black Hills, some areas of which are sacred to the Lakota Sioux, and sought to exclude the Indians from these lands. Spotted Tail himself investigated the discovery of gold and upon learning that there were significant deposits, requested more money from the federal government in exchange for purchase or lease of the land. The U.S. government, however, eager to retain ownership of the land, negotiated a new treaty that was not signed by the requisite number of adult Lakota Sioux men. Under the terms of this treaty, the Sioux lost the Black Hills. More than a century later, the Sioux have continued to refuse all offers of financial settlement for their religious lands in the Black Hills, hoping instead to have their lands returned to them.

Spotted Tail, in council with others, sent several of his children and grandchildren to Carlisle Indian School in Pennsylvania, but angrily withdrew them when he learned that they had been baptized and given Christian names, dressed like U.S. soldiers, and received vocational training rather than an academic education. Throughout his life Spotted Tail maintained that education, including a

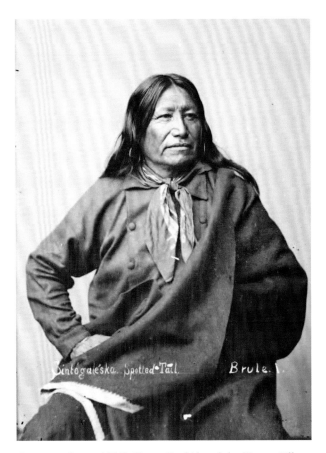

Figure 21. Spotted Tail, Sioux, Brulé band, by Henry Ulke, 1877, Washington, DC. *(3118) National Anthropological Archives, Smithsonian Institution.*

knowledge of English, was an important key to his people's survival. At the same time, he strove to preserve his traditional Lakota Sioux culture. Sinte Gleska University on Rosebud Reservation is named for him.

At home Spotted Tail faced opposition from Crow Dog, a subordinate leader and serious political adversary. Crow Dog shot and killed Spotted Tail on August 5, 1881.

Laurence chose to paint Spotted Tail in informal attire: a neck scarf and a cavalry shirt; Henry Ulke, the photographer, included Spotted Tail's English trade blanket of stroud, a fabric manufactured in England and readily recognizable by its undyed, zigzagged white selvage. Stroud was popular as a trade item with Native Americans.

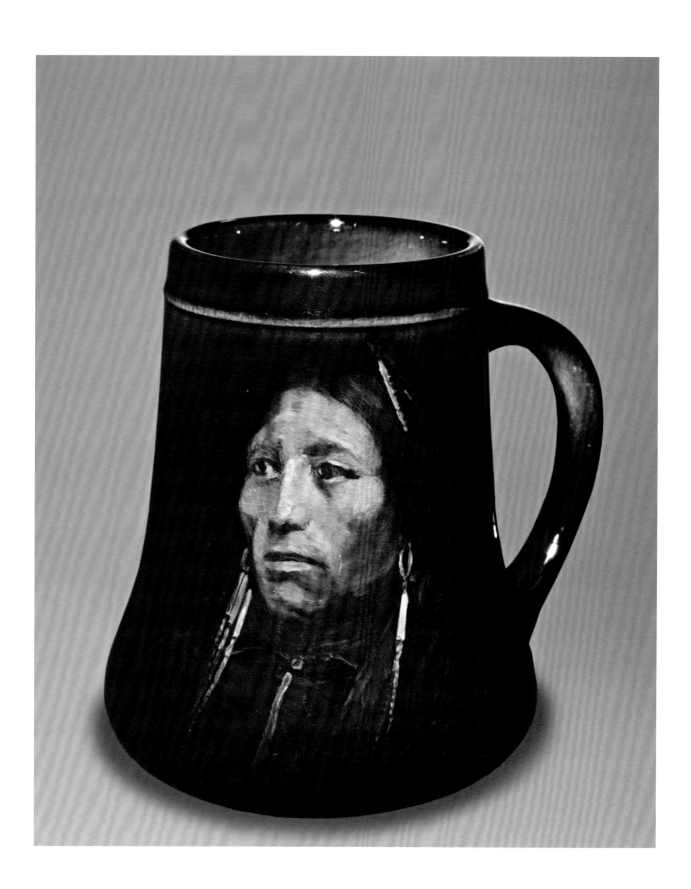

16

Mug to Ale Set, 1898

Pacer

Frederick Sturgis Laurence, decorator

William Watts Taylor, shape designer

Standard glaze line; slip cast; white body (stoneware)
H. 5", w. (w/ handle) 5", d. 4" (12.6 x 12.6 x 10.2 cm)
Marks:
> impressed
> Rookwood logo surmounted by twelve
> flames/"656" (no size letter given)
> incised
> a) "SL_____"
> b) "'Pacer,'/Apache"

Curator comments:

This mug is part of an ale set (see cat. no. 14).

This image of Pacer was taken at Carlisle Indian School in Pennsylvania, a military-style government school that opened in 1879 on the site of an abandoned army base. Richard Henry Pratt, an army officer who had operated an Indian prisoner of war camp in St. Augustine, Florida, was the school's first director. The unusual thing about this photograph is that Pacer kept one section of his hair fur-wrapped, while the rest appears to have been cut. It is possible that the photograph was meant to show Pacer in transition from his Indian to a "civilized" persona. Cutting the young students' hair was considered part of the "civilizing" goal at Carlisle.

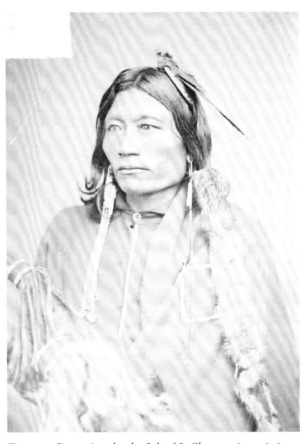

Figure 22. Pacer, Apache, by John N. Choate, 1879–1898, Carlisle, Pennsylvania. *(06836700) National Anthropological Archives, Smithsonian Institution.*

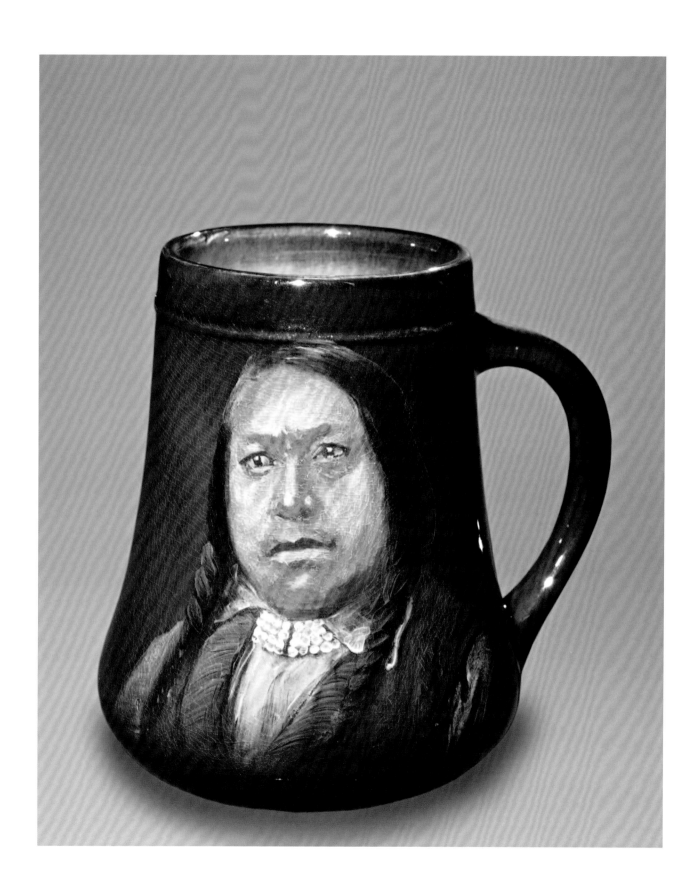

17

Mug to Ale Set, 1898

Ouray

Frederick Sturgis Laurence, decorator

William Watts Taylor, shape designer

Standard glaze line; slip cast; white body (stoneware)
H. 5", w. (w/ handle) 5", d. 4" (12.6 x 12.6 x 10.2 cm)
Marks:
 impressed
 Rookwood logo surmounted by twelve
 flames/"656" (no size letter given)
 incised
 a) "SL_____"
 b) "'Ouray,'/Chief of the Ute"

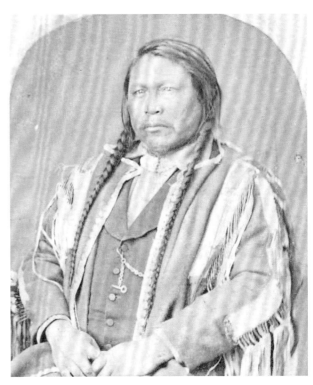

Figure 23. Ouray, Ute, by William Henry Jackson, 1870–80.
(01603602) National Anthropological Archives, Smithsonian Institution.

Curator comments:

This mug is part of an ale set (see cat. no. 14).

Ouray (ca. 1830–80) was born in Taos, New Mexico. His father was Jicarilla Apache and his mother was Tabeguache (now the Uncompahgre) Ute. Ouray, who spent most of his childhood working for Mexican sheepherders, learned Spanish from them and later became fluent in English and a number of Indian languages. In 1860, following the death of his father, he became chief of the Tabeguache.

His fluency in English and Indian languages enabled Ouray to emerge as a leader when negotiating treaties and to serve as a spokesperson for several bands. He made several trips to Washington to meet with President Ulysses S. Grant and petition for the preservation of his people's land; he hoped to keep the Ute in Colorado.

In 1880 Ouray journeyed to Washington and was a significant participant in the Agreement of 1880. This treaty relocated the White River Ute, as well as Ouray's Tabeguache band, to the Uintah and Ouray reservations in Utah. Viola, in *Diplomats in Buckskins,* notes that while he was in Washington, tailors outfitted Ouray, a short stocky man, with "white" clothing. His shirts had to be special ordered and were expensive; the clothing bill totaled $32.25. These and other trappings of white civilization, such as a wagon and a team of horses, alienated Ouray from his people.

Shortly after he returned home from this trip, Ouray died while on a trip to Ignacio, the site of the Southern Ute agency. He was buried there and eventually reburied in Ute homeland near Montrose, Colorado.

Jackson photographed Ouray wearing non-Indian clothing and sporting facial hair; Laurence eliminated Ouray's stubbly beard and emphasized his Indian neck ornament.

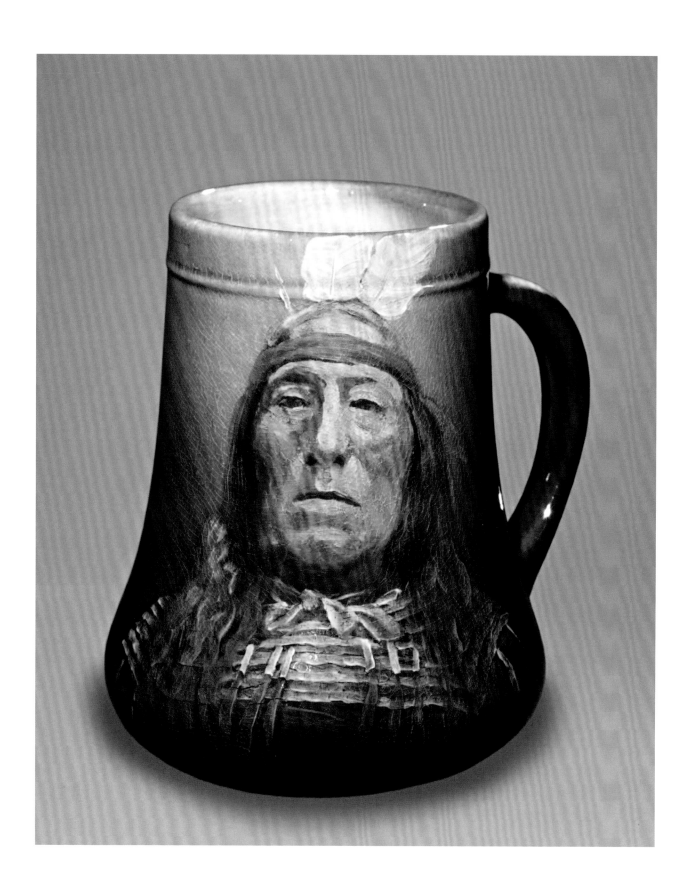

18

Mug to Ale Set, 1898

Lean Wolf (Indian name Cheshakhadakhi or Tcecaqadaqic)

Frederick Sturgis Laurence, decorator

William Watts Taylor, shape designer

Standard glaze line; slip cast; white body (stoneware)
H. 5", w. (w/ handle) 5", d. 4" (12.6 x 12.6 x 10.2 cm)
Marks:
 impressed
 Rookwood logo surmounted by twelve
 flames/"656" (no size letter given)
 incised
 a) "SL_____"
 b) "'Lean Wolf'/Chief of the Hidatsa/Sioux"

Curator comments:

This mug is part of an ale set (see cat. no. 14).

Chief Lean Wolf is seen here in a frontal pose. For a profile of Chief Lean Wolf see cat. no. 33. It was common for a photographer to take different poses in one sitting.

Lean Wolf was a member of a delegation that traveled to Washington, DC, in 1880. For his official portrait, Lean Wolf wears a magnificent hide shirt decorated with elaborate porcupine quillwork and locks of hair.

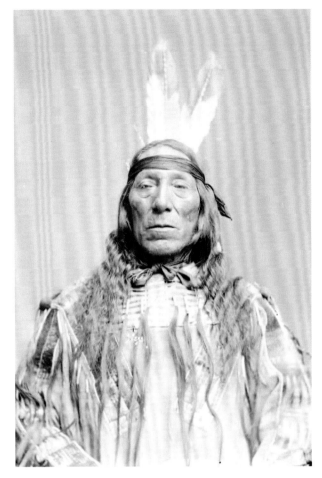

Figure 24. Lean Wolf, Hidatsa, by Charles Milton Bell, 1880, Washington, DC. *(00005) National Anthropological Archives, Smithsonian Institution.*

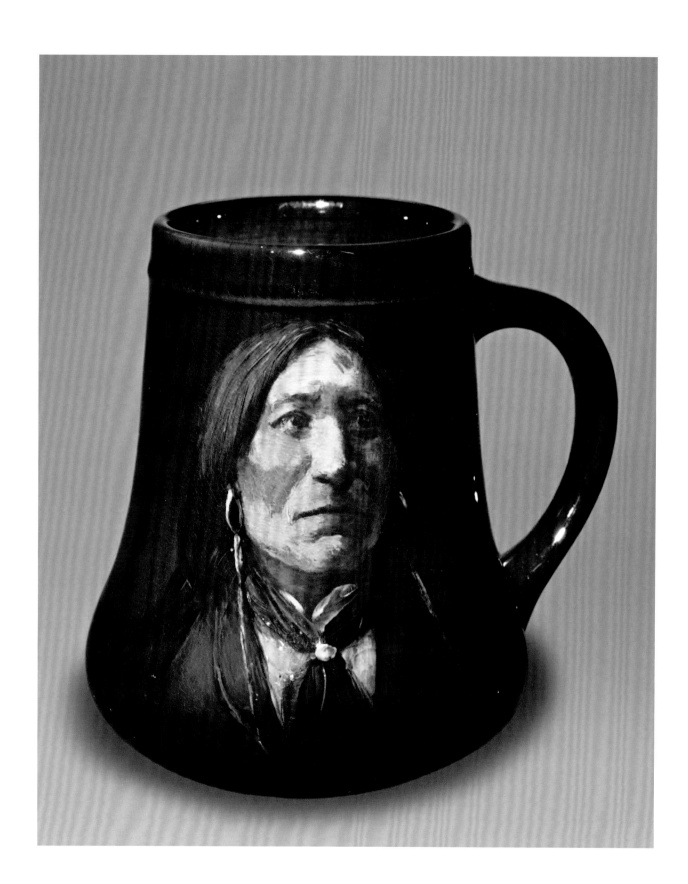

19

Mug to Ale Set, 1898

Lone Wolf (Indian name Guipagho)

Frederick Sturgis Laurence, decorator

William Watts Taylor, shape designer

Standard glaze line; slip cast; white body (stoneware)
H. 5", w. 5", d. 4" (12.6 x 12.6 x 10.2 cm)
Marks:
 impressed
 Rookwood logo surmounted by twelve
 flames/"656" (no size letter given)
 incised
 a) SL cipher
 b) "'Lone Wolf'/Kiowa"

Curator comments:

 This mug is part of an ale set (see cat. no. 14).

 Lone Wolf (ca. 1820–79), whose Indian name was Guipagho, was Kiowa. He was highly skilled at the two highest-status activities in Kiowa society—hunting, and raiding white settlements in Texas and Mexico.

 Lone Wolf was part of the Southern Plains delegation of 1863, which journeyed to Washington to meet with Abraham Lincoln. (A photograph of the 1863 delegation also appears in *Diplomats in Buckskins,* 143.) He was not intimidated by his visit and remained a hostile, believing that whites would all kill one another off during the Civil War. In 1866 Lone Wolf became principal chief of the Kiowa. Lone Wolf refused to sign the Medicine Lodge Treaty of 1867, which established the boundaries of the combined Comanche and Kiowa Reservation in Indian Territory, mostly present-day Oklahoma. After the Kiowa rejected the treaty, General Philip Sheridan retaliated by taking Lone Wolf and another chief hostage, claiming that Lone

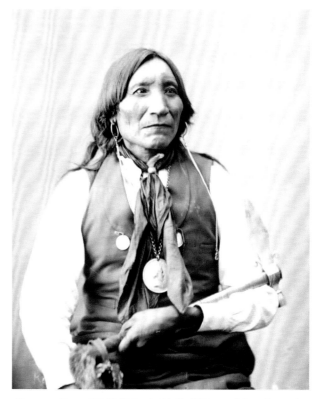

Figure 25. Lone Wolf, "Head chief of Kiowas," by Alexander Gardner, 1872, Washington, DC. *(01003805) National Anthropological Archives, Smithsonian Institution.*

Wolf was a liar and murderer responsible for the misconduct of his people. The chiefs were released in February 1869; shortly thereafter, Lone Wolf traveled to Washington, where he skillfully negotiated the release of two other imprisoned chiefs.

 During the 1874–75 Red River War, Lone Wolf and others organized a spectacular attack against Texas Rangers. In 1875, however, Lone Wolf and his band of over 250 followers surrendered at Fort Sill, located in Indian Territory. Lone Wolf was sent to the prison in Fort Marion, Florida, where he contracted malaria. In May 1878, he was released from Fort Marion and permitted to return to his homeland, where he died the following year.

 For his portrait, Lone Wolf holds a spontoon pipe tomahawk and wears what is probably a Lincoln peace medal. His ear ornaments could be watch chains.

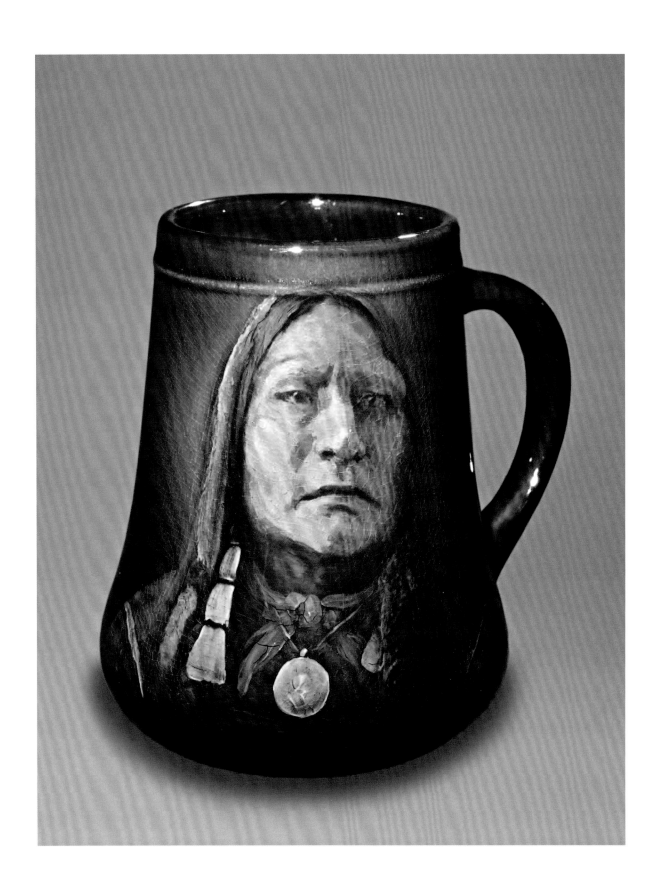

20

Mug to Ale Set, 1898

Running Antelope (Indian name Ta-To-Ka-In-Yan-Ka or Tan-To-Ha-Eah-Ka)

Frederick Sturgis Laurence, decorator

William Watts Taylor, shape designer

Standard glaze line; slip cast; white body (stoneware)
H. 5", w. (w/ handle) 5", d. 4" (12.6 x 12.6 x 10.2 cm)
Marks:
> impressed
>> Rookwood logo surmounted by twelve
>> flames/"656" (no size letter given)
> incised
>> a) "SL_____"
>> b) "'Running Antelope,'/Chief,/Oncpapa
>> [*sic*], /Sioux."

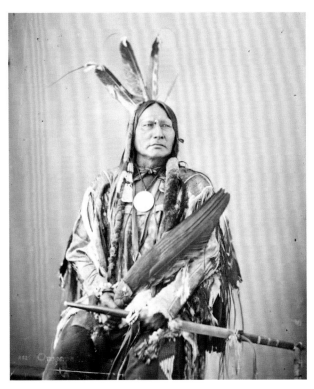

Figure 26. Running Antelope, Hunkpapa, by Alexander Gardner, 1872, Washington, DC. *(3184A) National Anthropological Archives, Smithsonian Institution.*

Curator comments:

This mug is part of an ale set (see cat. no. 14).

"Oncpapa," the tribal name used by George Catlin in the early 1800s, is an early language variant of Hunkpapa.

Running Antelope wears his Plains finery for this portrait: a peace medal, a grand deerskin shirt with fringe and porcupine quillwork, long dentalium shell earrings, and fur wrappings for his hair. He holds a feather fan and a catlinite pipe. Laurence decided to paint only two of these objects on the Rookwood mug.

The federal government used Running Antelope's image on an 1899 five-dollar Silver Certificate.

Figure 27. Five-dollar Silver Certificate issued in 1899 featuring Running Antelope. *Courtesy of John Painter.*

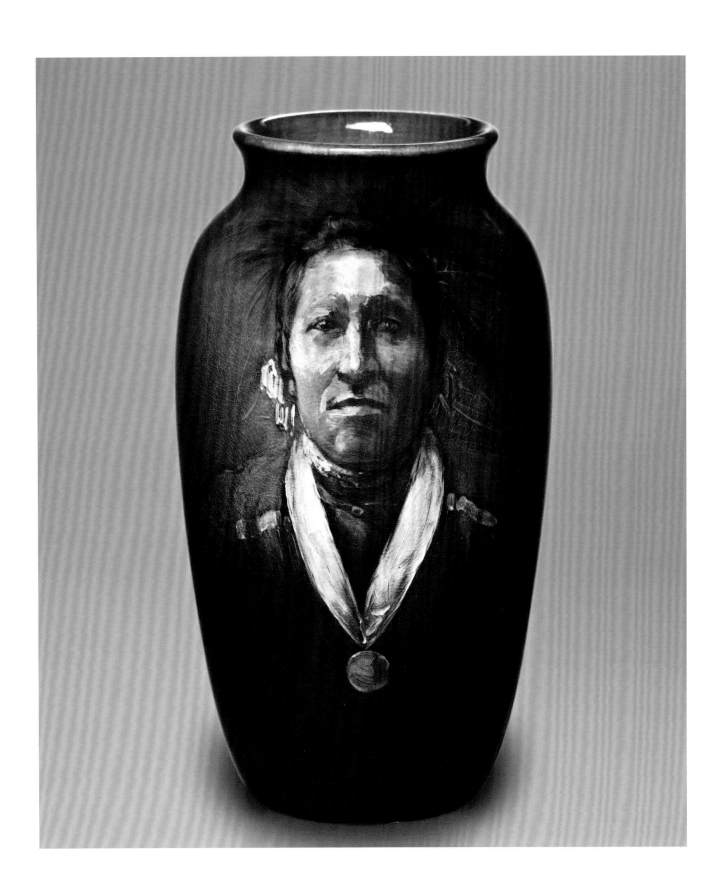

21

Vase, 1898

*Bushy Tail (Indian name Thinche Poshke
or Thintcheposhke)*

Frederick Sturgis Laurence, decorator

Standard glaze line; thrown; white body (stoneware)
H. 6¾", diam. 4" (17.1 x 10.2 cm)
Marks:
 impressed
 Rookwood logo surmounted by twelve
 flames/"80B"
 incised
 a) "SL_____"
 b) "Bushy Tail/Oto"

Curator comments:
 For his photograph, Bushy Tail wears a peace medal
on a ribbon and displays a fine spiked ball head club with
brass tack decorations. Laurence painted the medal and
the clusters of tin cones in Bushy Tail's ears. Wisps of his
hair roach can be seen behind his head.

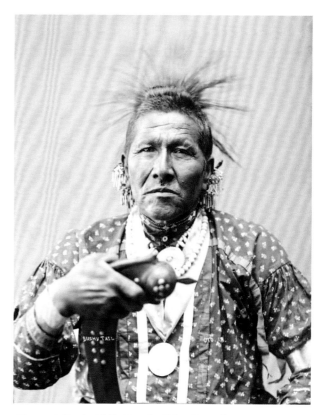

Figure 28. Bushy Tail, Oto, by John K. Hillers, 1894, possibly Washington, DC. *(3854A) National Anthropological Archives, Smithsonian Institution.*

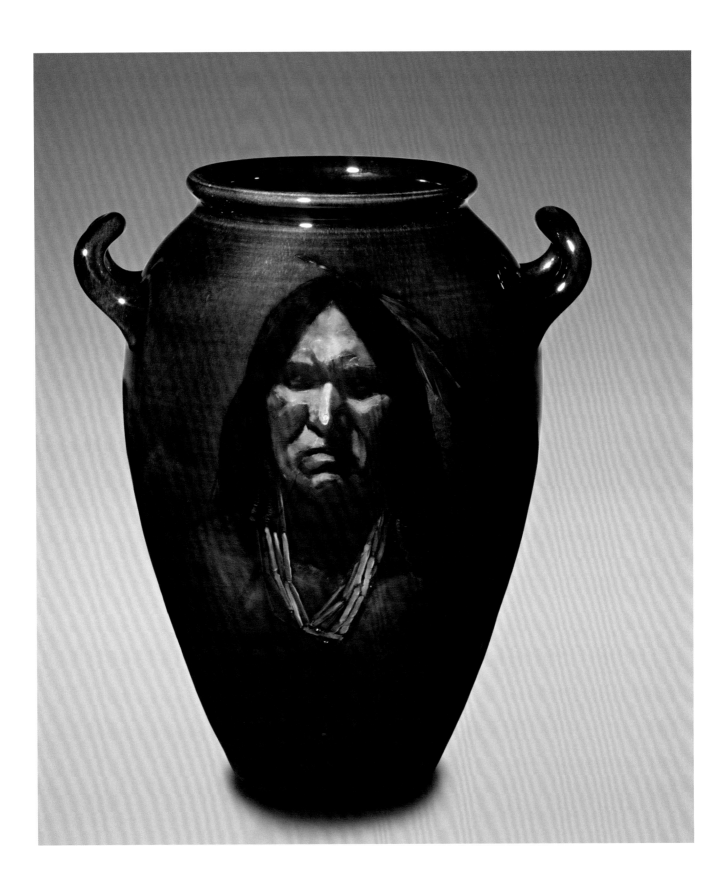

22

Vase, 1898

Rabbit Hunter

Frederick Sturgis Laurence, decorator

Standard glaze line; thrown; white body (stoneware)
H. 9", w. (w/ handles) 9½", d. (w/out handles) 6¼"
 (22.9 x 24.1 x 16.0 cm)
Marks:
 impressed
 Rookwood logo surmounted by twelve
 flames/"581E"
 incised
 a) "Moki [*sic*] Rabbit Hunter/Sturgis Lau-
 rence/–98"painted in red
 b) "340–'06"
Paper label:
 on side of vase, rectangular label printed in
 black on white ground, "Cincinnati/Art
 Galleries/1439"

Curator comments:

According to the Rookwood Shape Book 1883–1900 (181), shape number 581 was originally shape number S920 (see cat. no. 8).

This vase was passed down through descendants of the original owners until its sale on November 7, 2004, at Cincinnati Art Galleries (Holiday Sale 2004, cat. no. 1439). It had been on loan to the Cincinnati Art Museum during the early part of the twentieth century and is listed in Stanley Gano Burt's *2,292 Pieces of Early Rookwood Pottery in the Cincinnati Art Museum in 1916* (129, #93).

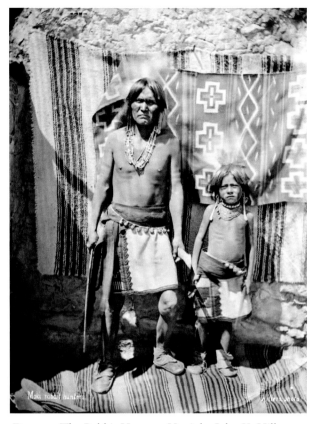

Figure 29. The Rabbit Hunters, Hopi, by John K. Hillers, 1879, Arizona First Mesa, Walpi. *(1807A) National Anthropological Archives, Smithsonian Institution.*

Moki is an early spelling for Hopi—the English transliteration of the name the Hopi use for themselves. Laurence exercised artistic license by putting a feather in the Hopi man's hair; the artist also changed the shape of the man's traditional pueblo beads, making the portrait appear more Plains than Pueblo.

The Hopi are a group of Pueblo people who live in northeastern Arizona, mostly on a high desert plateau, and cultivate corn. Rabbits are also an important source of food; their pursuit is sometimes connected with ceremonial activities. The adult hunter poses with a rabbit stick in his left hand—a throwing stick with a distinctive flat curved shape, used to hunt rabbits.

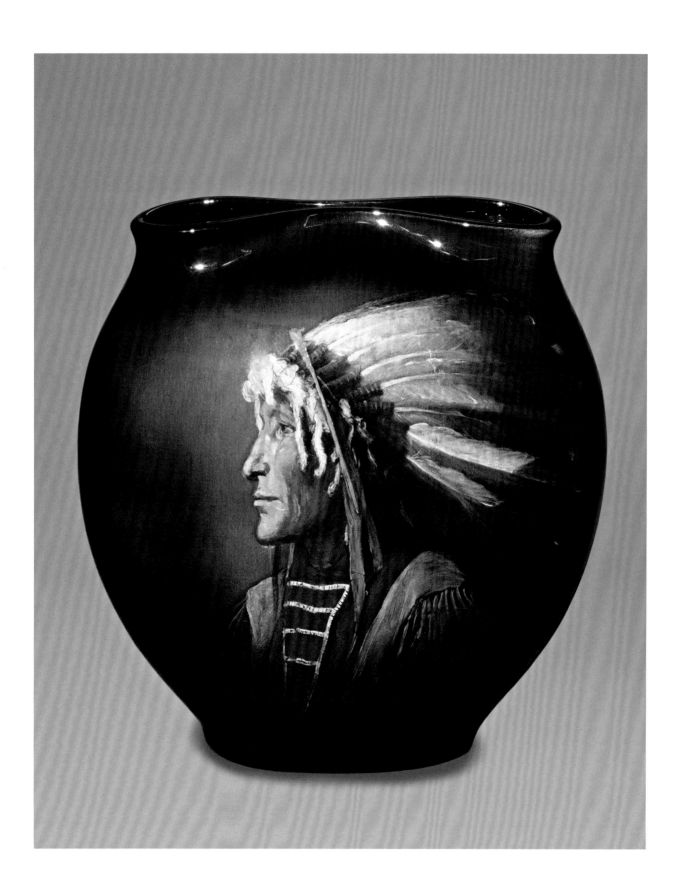

23

Vase, 1899

Afraid of the Bear (Indian name Mato Kokipa or Ma-To-Ko-Kepa)

Frederick Sturgis Laurence, decorator

Standard glaze line; slip cast; white body (stoneware)
H. 9½", w. 9½", d. 5¼" (24.1 x 24.1 x 13.3 cm)
Marks:
 impressed
 Rookwood logo surmounted by thirteen
 flames/"707AA"
 incised
 a) "SL____"
 b) "MA-TA-KO-KI-PA."/("Afraid of the
 Bear")/Upper Yankton."

Curator comments:

See cat. no. 12 for a discussion of the shape design.

The vase tells us that Afraid of the Bear was "Upper Yankton" and the reverse of the photograph reads "Dakota Yanktonai." Yankton and Yanktonai are two distinct groups of people, who originally were geographically dispersed. Today they occupy different reservations. Thus it is difficult to determine Afraid of the Bear's people. In addition, "the" was probably not part of the translation of his name.

Afraid of the Bear poses in a grand deerskin shirt with eagle feathers hanging from the shoulders. On the vase Laurence focuses on the eagle warbonnet, complete with what are probably strips of ermine fur, and red trade cloth wrapped at the base of each feather. Also visible in the photograph is Afraid of the Bear's tobacco bag made of English stroud, a woolen fabric recognizable by its undyed white selvage. The stem of the pipe extends from the bag.

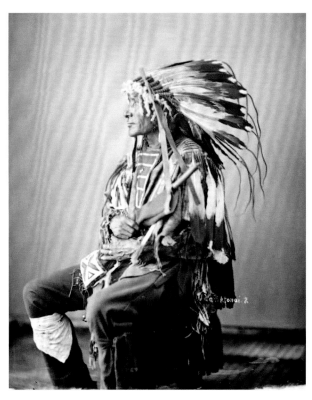

Figure 30. Afraid of the Bear, Dakota Yanktonai, by Alexander Gardner, 1872, Washington, DC. *(3531B) National Anthropological Archives, Smithsonian Institution.*

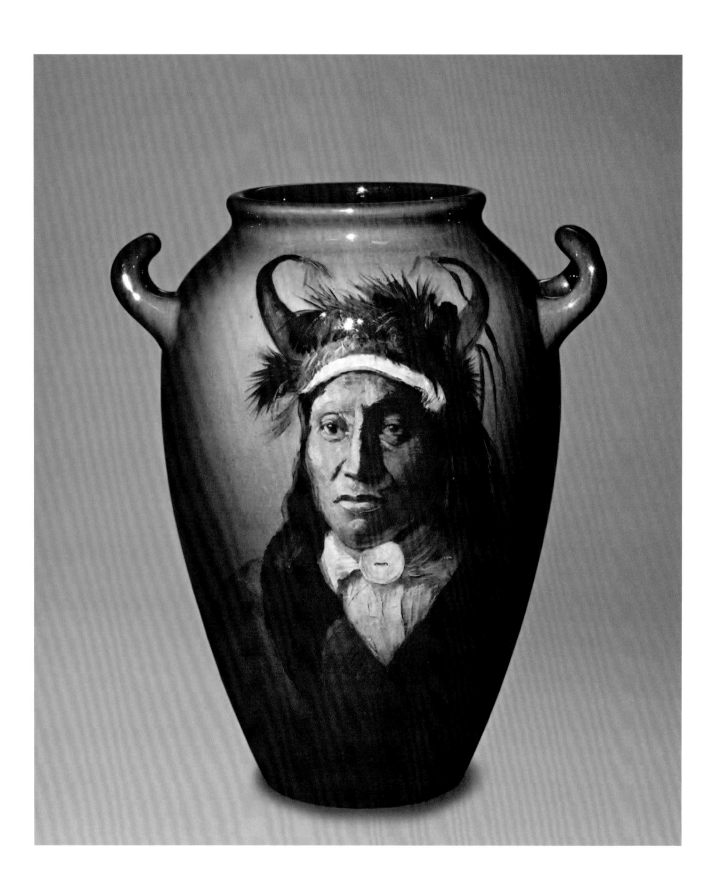

24

Vase, 1900

Wets It

Frederick Sturgis Laurence, decorator

Standard glaze line; thrown; white body (stoneware)
H. 9", w. 7 ¾", d. 6 ½" (22.9 x 19.7 x 16.5 cm)
Marks:
 impressed
 Rookwood logo surmounted by fourteen
 flames/"581E"
 incised
 a) SL cipher
 b) "Chief 'Wetsit'[*sic*]/Assiniboine"
 wheel-ground through glaze
 "X"
Paper label:
 on interior, rectangular label with black print
 on white ground, "The
 Glover/Collection/0833/Cincinnati Art
 Galleries"

Curator comments:
 According to the Rookwood Shape Book 1883–1900
(181), shape number 581 was originally shape number S920
(see cat. no. 8).
 Even though there is a wheel-engraved "X" on the
bottom, there do not appear to be any obvious flaws in the
body, decoration, or glaze to suggest that it was withheld
from sales and later sold as a "second" (i.e., second grade).
Consequently, this vase was probably held from sales for
another reason: perhaps to be shipped to the Universal Ex-

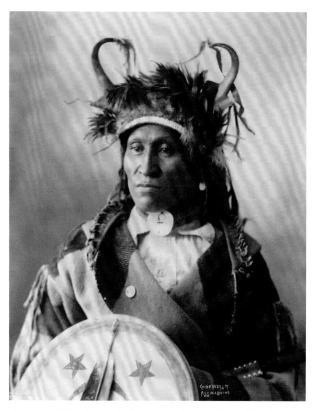

Figure 31. Wets It, Assiniboine, by Frank Albert Rinehart,
1898, during the Omaha Trans-Mississippi and Interna-
tional Exposition, Omaha, Nebraska. *From the collections of
the Omaha Public Library.*

position held in Paris, France, in 1900; to be photographed
for marketing purposes; to be used as a model for future
pieces; or to be used by the decorator as a holiday present.
It was a custom that the decorators were allowed a Christ-
mas piece. They could buy the shape (i.e., pay for the clay),
and use the colors and have it fired for no charge. They
were not allowed to decorate a holiday piece on company
time.
 Wets It displays his Plains finery and Laurence cap-
tured some of it on the vase: a typical Assiniboine war-
bonnet with curving horns tipped with feather fluffs, and
a trade blanket coat or "capote," which received its name
from the French word for hood. Blanket coats were spread
by and became popular with the fur trade.

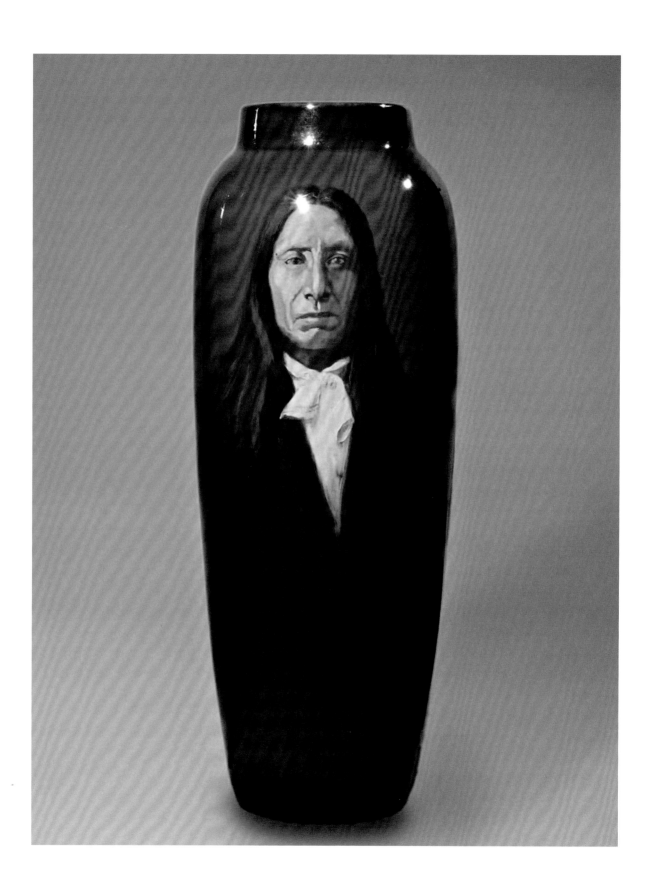

25

Vase, 1900

Red Cloud

Frederick Sturgis Laurence, decorator

John Jacob Menzel (ca. 1861–1911), foreman and master potter at Rookwood 1884–1911, shape designer

Standard glaze line; thrown; white body (stoneware)
H. 16⅞", diam. 6¾" (40.3 x 17.1 cm)
Marks:
 impressed
 Rookwood logo surmounted by fourteen
 flames/"907B"
 incised
 a) "SL_____"
 b) "'Red Cloud,'/Chief of the Sioux"

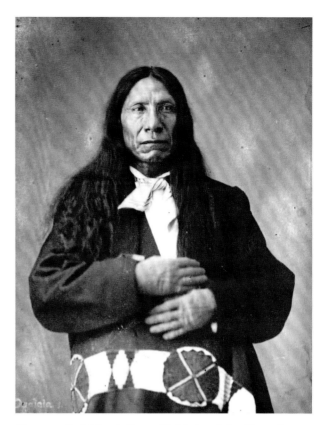

Figure 32. Red Cloud, Sioux, Oglala band, by Alexander Gardner, 1872, Washington, DC. *Denver Public Library, Western History Collection, Alexander Gardner #X-31824.*

Curator comments:

Because of the large size, the fine quality, and the date of the piece, it is possible that it was created for the 1900 Universal Exposition held in Paris, France.

Oglala Lakota Sioux Red Cloud's (ca. 1822–1909) early years remain obscure. His Indian name was Mahpiya-Luta. By the middle 1860s his people recognized him as a leading warrior and whites recognized him as a chief. During negotiations, whites insisted on dealing with a single spokesperson, a head chief, for each tribe, even though the people may not have recognized that individual as their head chief.

In summer 1866 Red Cloud met with soldiers at Fort Laramie in present-day Wyoming. He wanted the Bozeman Trail closed to settlers moving west to Montana's gold mines because the trail passed through the Lakota Sioux's best buffalo hunting grounds. The negotiations ended abruptly when Red Cloud left in a huff; U.S. soldiers already were building forts along the trail without tribal permission. The already tense situation erupted in December 1866 when the Lakota Sioux massacred Lieutenant Colonel W. J. Fetterman and his soldiers.

This battle demonstrated the importance of negotiating a peace with the Lakota Sioux, particularly Red Cloud, who insisted that the military leave their forts along the Bozeman Trail. Finally, after much discussion and the promise of presents and annuities, the Lakota Sioux agreed to abandon the warpath and move to the Great Sioux Reservation in present-day South Dakota. Red Cloud "put his mark" on the 1868 Treaty of Fort Laramie.

The long and complicated document was difficult for the Indians to understand, resulting in a decade of frustrating negotiations that government officials repeatedly attempted to explain to Red Cloud. He made several trips to Washington to meet with the president; Red Cloud excelled as an orator and spokesperson for his people, often speaking before overflowing crowds who responded with deafening applause. By 1882 the federal government had divided the Great Sioux Reservation into six smaller reservations and negotiated for the cession of "surplus" lands into public domain. Red Cloud had already agreed to move to Pine Ridge Reservation, one of the smaller reservations in western South Dakota.

Red Cloud kept the peace he had promised in 1868 at Fort Laramie, and only verbally opposed the gold miners in the Black Hills. Thus, as an older man, Red Cloud lost his influence with the younger Oglala, who felt they should resume the warpath. Still other Oglala felt Red Cloud blocked their path to progress along the white man's road. The transitional situation Red Cloud and his people confronted was without precedent. He is one of the most important figures in the history of the American Indian.

For his portrait photograph, Red Cloud dressed simply. He appears to be wearing a heavy coat, but it may also be a large blanket, because a large beaded blanket strip is clearly visible in the photograph.

William Purcell McDonald

William McDonald was born in Cincinnati on September 18, 1864. He was an accomplished violinist who had to choose between art and music for his career. Choosing art, he studied at the McMicken School of Design and attended the Art Academy of Cincinnati from 1887 to 1892. He was in both (1890–91, 1891–92) of Frank Duveneck's classes. In 1882 he joined the nascent Rookwood, where he excelled as a decorator. During 1898 the Pottery gave McDonald a seventeen-week absence with pay for a trip to Europe and two hundred dollars for expenses. McDonald attended schools in France and joined Cincinnati sculptor Clement Barnhorn in Italy to study sculpture. In 1899 he was in charge of the decorating department during Albert Valentien's absence. He does not seem to have executed many Indian portraits, but the extant ones are superb. In 1904 McDonald was placed in charge of the architectural faience department. His daughter Margaret Helen McDonald joined the Rookwood decorating staff in 1913. William McDonald remained a premier decorator at Rookwood until his death July 9, 1931, at age sixty-six.

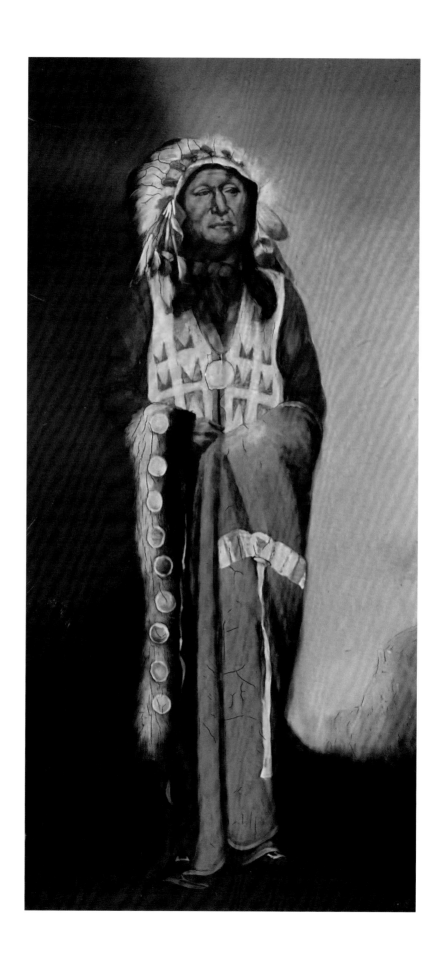

26

Plaque, 1896 or later

Young Iron Shell

William Purcell McDonald (1864–1931), decorator at Rookwood 1882–1931

Standard glaze line; press molded; white body
(stoneware)
H. 23¼", w. 11¼", d. 1¼" (50.9 x 28.6 x 3.2 cm)
Marks on back:
impressed
a–d) Rookwood logo at each of four compass points
Marks on left edge:
impressed
four times, "WPMcD"
Marks on right edge:
impressed
six times, "WPMcD"
Marks on front:
impressed
lower right, "WPMcD"

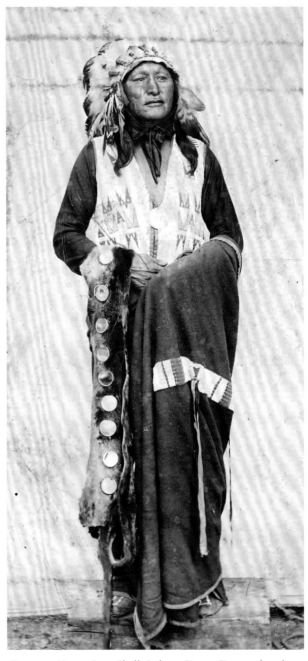

Figure 33. Young Iron Shell, Lakota Sioux, Sicangu band, possibly by T. H. Kelley, Constance Baker, or Enno Meyer, 1896, Cincinnati. *Rookwood Pottery Photograph Collection, SC148, Cincinnati Museum Center—Cincinnati Historical Society Library.*

Paper labels:

 a) on back of plaque, circular label printed in
 black on gold ground, "The Schulman/Collec-
 tion/[Rookwood logo surmounted by fourteen
 flames]/Rago Auctions"

 b) on back of plaque, circular label printed in
 black on green ground, "0067"

 c) on back of plaque, partly torn, white page
 printed in black, cut out and adhered to plaque
 showing image of plaque over which is "15" and
 under which are "31" and " . . . [GENUI]NE
 AND IMPORTANT/ . . . [PLA]QUE/ . . .
 [Wi]lliam P. McDonald with a standing/ . . .
 [we]aring a full headdress and brown, green,/
 . . . [oran]ge and yellow robes in a 'Standard'
 glaze/ . . . [stamp]ed with firm's mark four times
 on reverse and/ . . . [WPM]cD on lower right-
 hand corner and several times on/the sides—11
 ¼ x 23 ¼ in. (28.5 c 59 cm.)/EX COLLEC-
 TION/Rookwood Museum, Cincinnati, Ohio
 (deaccessioned in 1937)"

 d) on back of frame, rectangular label handwritten
 in black on white ground, "45"

Curator comments:

Although his identity is not noted on the plaque, the Indian portrayed is Young Iron Shell, a Lakota Sioux of the Sicangu or Brulé band, who, during the summer of 1896, participated in the Wild West show and encampment at the Cincinnati Zoo. For his portrait photograph, Young Iron Shell wears his father's peace medal; his father, Iron Shell, received it when he traveled to Washington in 1872 as part of a delegation that met with President Ulysses S. Grant. (Information is located in a newspaper article in the National Anthropological Archives: "Ideal American Red Men," *Washington Evening Star,* September 20, 1872.) Young Iron Shell displays other Plains finery: a blanket with an elaborate beaded band, a beaded vest, an eagle feather warbonnet, and a fur neck ornament with trade mirrors. McDonald captured all of these in the image on the plaque.

The photograph of Young Iron Shell (fig. 33) in the pose used by Rookwood artists dates from the Cincinnati encampment of 1896. (Susan Labry Meyn, "Mutual Infatuation: Rosebud Sioux and Cincinnatians," *Queen City Heritage* 52 [Spring/Summer 1994]: 34.) The photographer is unknown but might be T. H. Kelley, ex-president of the Cincinnati Camera Club, or Constance Baker, a decorator at Rookwood who was also in charge of the photographic work from 1892 to 1900.

The plaque is not dated but cannot date from before 1896, the year of the photograph from which it was taken. In the David Rago auction catalogue of the Toni Schulman collection of Rookwood Pottery, March 6, 2004 (number 67), the plaque is dated 1886. This is because the Rookwood logo impressed on the back of the plaque bears no impressed flames, or tongues of fire, over the logo and therefore would suggest 1886. However, the logo used for the plaque is that used for architectural elements, which is simply the reversed "R" conjoined with the "P." It never bears the flames.

Typical of architectural elements, the clay body is very coarse, containing a large proportion of grit in order to keep such a large plaque from warping. Besides being very gritty, the clay body is also very thick at 1 ¼ inches. Nonarchitectural plaques, or plaques intended to be

framed and hung like paintings, are rarely more than ¾ inches thick. Rookwood's architectural department did not begin until 1901, suggesting that the plaque does not date from before then. The decorator, William McDonald, was placed in charge of the architectural department in 1904, and would have been comfortable working with architectural elements. The architectural logo, the thickness of the plaque, and the coarseness of the clay indicate that the plaque might originally have been created as a commission for an architectural element. In addition, the one impressed McDonald cipher on the front of the plaque is placed so low in the lower right corner that if the plaque were intended for a frame, the frame would conceal it; whereas if the plaque were intended for placement in a wall, perhaps as part of a fireplace or as part of a larger mural, the cipher would be seen. Stanley Gano Burt in his inventory *2,292 Pieces of Early Rookwood Pottery in 1916* does not note this piece even though it was supposedly in Rookwood's collection until 1937. It might have been considered unusable because of the crazing in the decoration and never placed in the intended architectural element. The frame is not the typical Rookwood Arts and Crafts oak frame, and the plaque is particularly heavy for hanging on a wall.

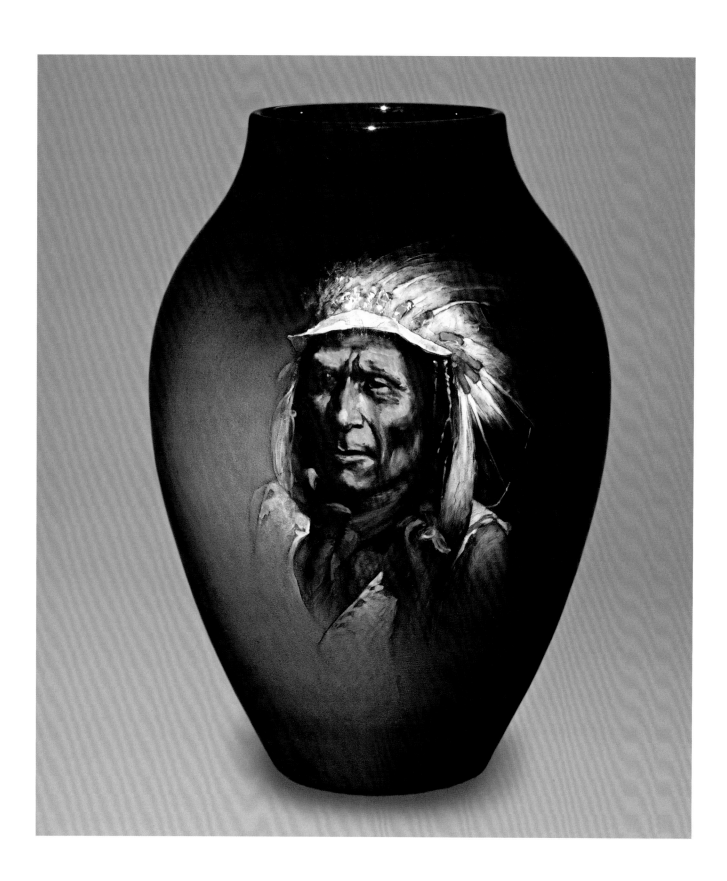

27

Vase, 1898

Owns The Dog

William Purcell McDonald, decorator

John Jacob Menzel (ca.1861–1911), foreman and master potter at Rookwood 1884–1911, shape designer

Standard glaze line; thrown; white body (stoneware)
H. 9 ¼", diam. 6 ¾" (23.5 x 17.2 cm)
Marks:

> impressed

>> Rookwood logo surmounted by ten flames/"604C"

> incised

>> a) WMcD cipher

>> b) "Owns-a-Dog [*sic*]/Sioux Indian/Chief"

Paper label:

>> circular label handwritten in black on yellow ground, "CAG/No 12"

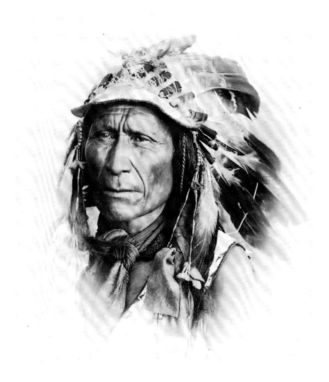

Figure 34. Owns The Dog, Lakota Sioux, Sicangu band, possibly by T. H. Kelley, 1896. Cincinnati, *Cincinnati Museum Center—Cincinnati Historical Society Library.*

Curator comments:

James Albert Green, a longtime trustee on the board of the Public Library of Cincinnati and Hamilton County, wrote and submitted to *Harper's Weekly* a manuscript describing the 1896 encampment. His unpublished manuscript is not dated, but all activities and some names match those in local newspapers and on the contracts in the National Archives. In his article Green described Owns The Dog as "one of the most remarkable of all Indians. . . . He is 78 years old and is still as lithe and active as a boy. He rode his pony as carelessly, or perhaps frantically would be a better word, as any of the young bucks. He was another of the men directly concerned in the Custer Massacre,

which was a topic by the way none of them would discuss." The manuscript included photographs of six Indians, including this one of Owns The Dog, which McDonald used for his depiction on the Rookwood vase. Green acknowledged the photographer, stating that the images in the manuscript were taken by T. H. Kelley. (James Albert Green, unpublished manuscript, Mss G797u Box 2, Cincinnati Museum Center, Cincinnati Ohio.) Research has determined that Kelley was the ex-president of the Cincinnati Camera Club.

Olga Geneva "Geneva" Reed

Geneva Reed was born in 1873 and lived with her parents in Cincinnati in Mount Adams. Rookwood decorator Matt Daly often saw her sketching on her porch as he passed her house on the way to work. When her sketches had progressed significantly enough, he persuaded her to work at Rookwood, where she became a decorator in 1890. She attended the Art Academy of Cincinnati between 1890 and 1894, and was quite possibly a student in one or both of Frank Duveneck's 1890–91 and 1891–92 classes. Her Indian portraiture work is very fine, but she is noted mostly for her work in the Iris glaze line. The fact that many of her pieces are large and thrown on the potter's wheel suggests that she was held in high regard at the Pottery. She married Joseph Pinney, and continued to work at Rookwood until 1909, always signing her work "O.G.R." After her husband died in 1925, she married the widowed Matt Daly in 1928. Geneva Reed died in Cincinnati on November 2, 1955, at the age of eighty-two.

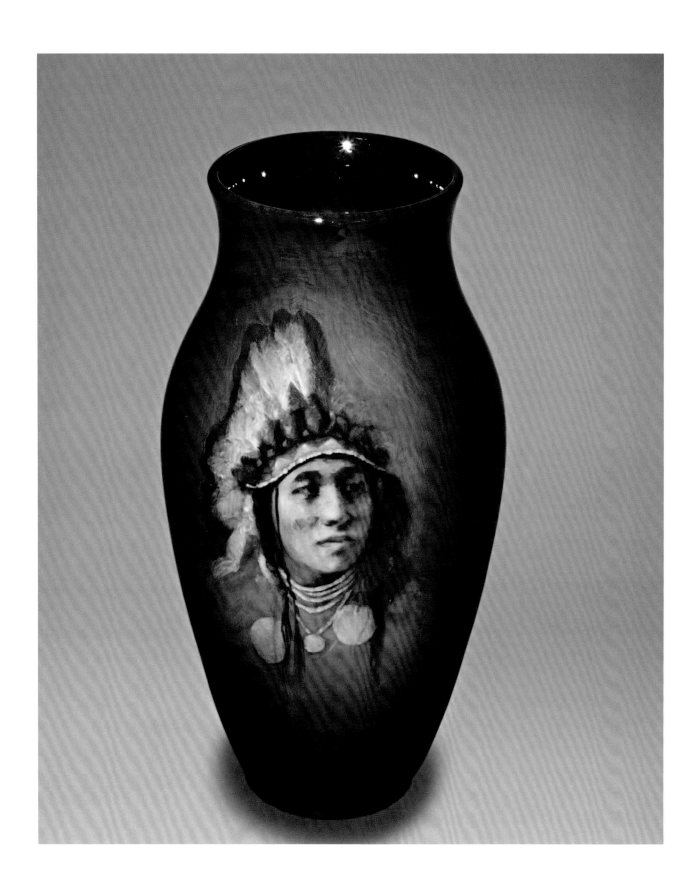

28

Vase, 1899

Spotted Jack Rabbit

Olga Geneva Reed (1873–1955), decorator at Rookwood 1890–1909

William Purcell McDonald, shape designer

Standard glaze line; thrown; white body (stoneware)
H. 10¾", diam. 6¼" (27.3 x 16.0 cm)
Marks:
 impressed
 Rookwood logo surmounted by thirteen
 flames/"827" (no size letter given)
 incised
 a) "O.G.R."
 b) "Spotted Jack Rabbit/Crow"
Paper label:
 rectangular label with black print on white
 ground, "Rookwood III/1780/Cincinnati
 Art Galleries"

Curator comments:

 According to the Rookwood Shape Book 1883–1900 (27), this vase shape was originally designed with two small handles at the shoulder.

 See also cat. nos. 1, 29, and 50 for additional images of Spotted Jack Rabbit.

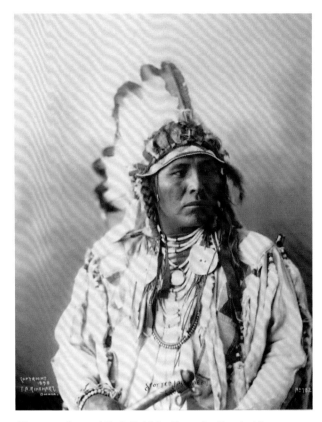

Figure 35. Spotted Jack Rabbit, Crow, by Frank Albert Rinehart, 1898. *From the collections of the Omaha Public Library.*

Adeliza Drake Sehon

Adeliza Sehon was born in Hartford, West Virginia, in 1871. It is not known when she came to Cincinnati, but she studied at the Art Academy of Cincinnati during the years 1894–97. She did not study under Frank Duveneck, but probably took courses from Joseph Henry Sharp. Sehon was hired as a decorator at the Pottery in 1896, and was painting Indian portraits by 1900. Her work was very good and probably would have continued to progress had typhoid fever not caused her untimely death on April 5, 1902, at the age of thirty-one.

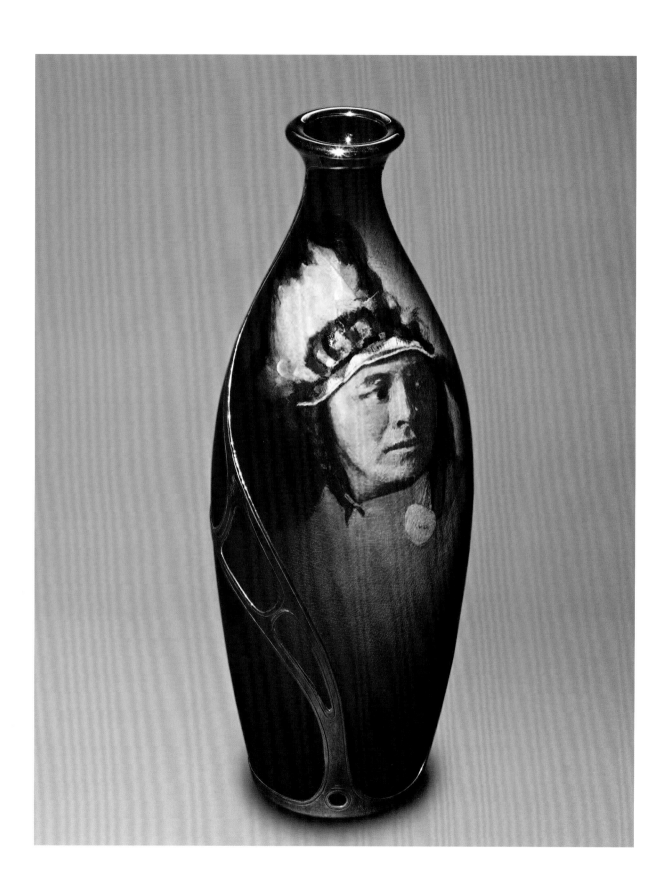

29

Vase, 1901

Spotted Jack Rabbit

Adeliza Drake Sehon (1871–1902), decorator at
Rookwood 1896–1902

John Jacob Menzel, shape designer

Gorham Mfg. Company (1865–1961), Providence,
Rhode Island; silver maker

Standard glaze line; thrown; white body (stoneware); sil-
 ver overlay around lip, body, and foot rim
H. 10", diam. 4" (25.4 x 10.2 cm)
Marks on ceramic:
 impressed
 Rookwood logo surmounted by fourteen
 flames/"I/796B"
 incised
 a) "A.D.S."
 b) "Spotted Jack Rabbit/Crow"
Marks on silver overlay:
 die-struck
 a) on the side of the foot band, lion
 passant/anchor/Gothic G
 b) on the side of the foot band, "L" over "F
 O"
Paper label:
 rectangular label with black print on white
 ground, "The Glover/Collection/0567/
 Cincinnati Art Galleries"

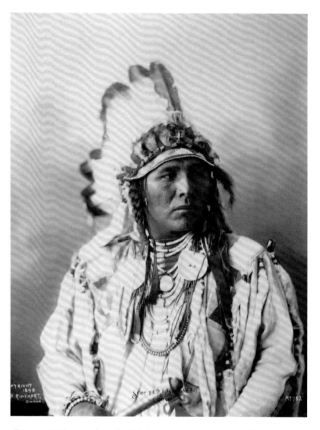

Figure 36. Spotted Jack Rabbit, Crow, by Frank Albert
Rinehart, 1898. *From the collections of the Omaha Public Library.*

Curator comments:

 The struck mark of "L/F O" on the silver overlay is
an inventory code of initials used by the Gorham Manu-
facturing Company of Providence, Rhode Island. The
Gorham costing slip for this piece, provided by Samuel J.
Hough of The Owl at the Bridge, notes that the silver
overlay was completed August 31, 1906, five years after the
vase had been created at Rookwood. The slip also notes
that the vase was a "sample," which Mr. Hough says is "a
prototype or exhibition piece." It is doubtful that Rook-
wood commissioned Gorham to apply the silver overlay
to the vase. Rookwood had not produced an Indian por-
trait vase in several years, and by 1906 was eagerly promot-
ing its mat glaze lines.

 See also cat. nos. 1, 28, and 50 for additional images
of Spotted Jack Rabbit.

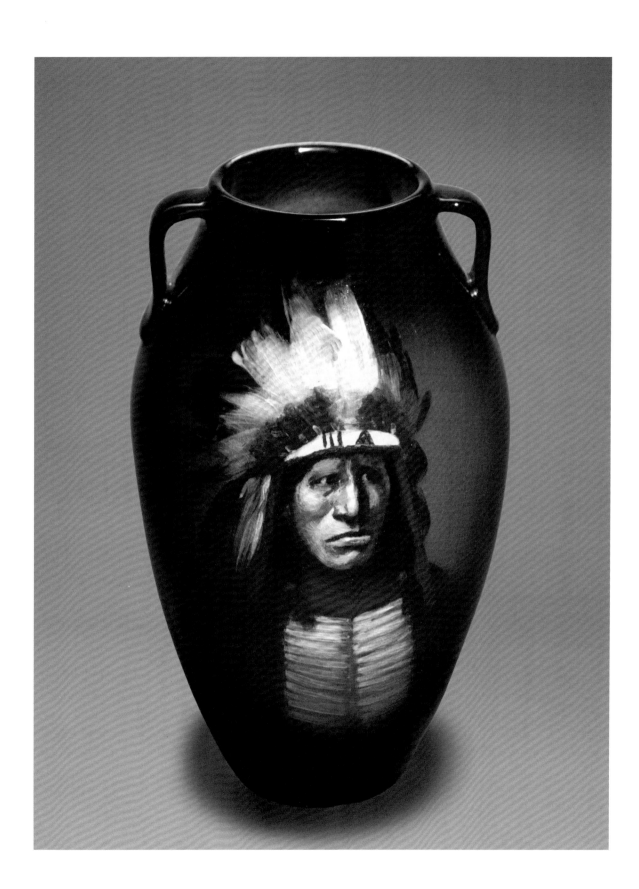

30

Vase, 1901

Eagle Deer

Adeliza Drake Sehon, decorator

John Jacob Menzel, shape designer

Standard glaze line; thrown; white body (stoneware)
H. 7", w. (w/ handles) 4¼", d. 4¼" (17.8 x 10.8 x 10.8
 cm)
Marks:
 impressed
 Rookwood logo surmounted by fourteen
 flames/"604D"
 incised
 a) "A.D.S."
 b) "Eagle Deer/Sioux."
Paper label:
 circular label handwritten in red on white
 ground, "5500"

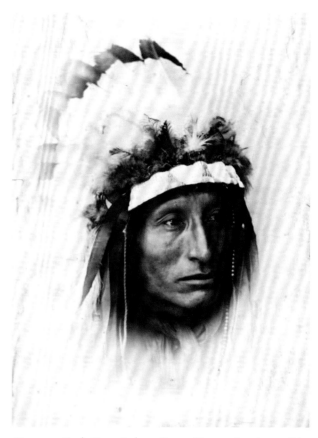

Figure 37. Eagle Deer, Lakota Sioux, Sicangu band, possibly by T. H. Kelley, 1896, Cincinnati. *Rookwood Pottery Photograph Collection, SC148. Cincinnati Museum Center-Cincinnati Historical Society Library.*

Curator comments:
 Shape number 604 was taken from a drawing by John Jacob Menzel numbered S509.
 For another depiction of Eagle Deer see cat. no. 47.
 Eagle Deer, the son of Little Bald Eagle, was one of the Sicangu band of Lakota Sioux who traveled from Rosebud Reservation in South Dakota and camped at the Cincinnati Zoo during the summer of 1896. Little Bald Eagle's photograph, marked "Zoo Series 1896," is one of the source photographs in the Rookwood Pottery image collection at the Cincinnati Museum Center. What is interesting is that Adeliza Drake Sehon practiced artistic license and added a hair pipe neck ornament to Eagle Deer's image on the vase. She also changed the beaded decoration on the brow band.

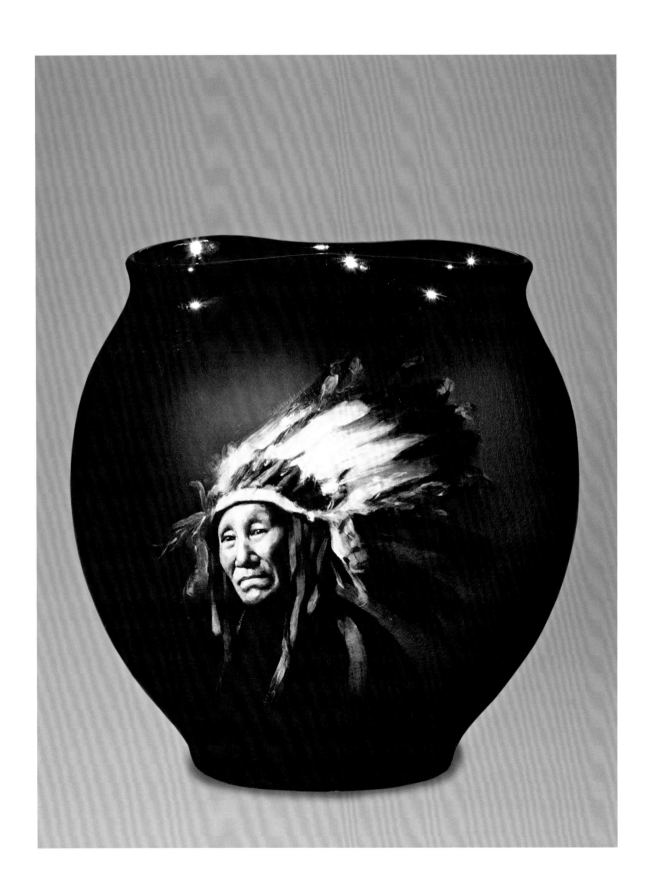

31

Vase, 1901

Susie Shot In The Eye

Adeliza Drake Sehon, decorator

Standard glaze line; slip cast; white body (stoneware)
H. 9½", w. 9½", d. 5¼" (24.1 x 24.1 x 13.3 cm)
Marks:

> impressed

>> Rookwood logo surmounted by fourteen
>> flames/"I/707/AA"

> incised

>> a) "A.D.S."
>> b) "Susie-Shot-In-The-Eye [*sic*]/Sioux"

Paper label:

>> rectangular label with black print on white
>> ground, "Rookwood III/1262/Cincinnati
>> Art Galleries"

Curator comments:

See cat. no. 12 for a discussion of the shape design.

Susie Shot In The Eye was the wife of Shot In The Eye. Here she is depicted wearing an eagle feather warbonnet, something Indian women would not normally do. Susie Shot In The Eye may have worn the warbonnet simply because it was a prop owned by the photographer who asked her to put it on for her photographic depiction.

Susie Shot In The Eye is not the only woman to be shown in an eagle feather bonnet. Sleeping Bear (cat. no. 41) is another woman depicted in such a warbonnet. Both Sleeping Bear and Susie Shot In The Eye were photographed in Frank A. Rinehart's studio. Rookwood might

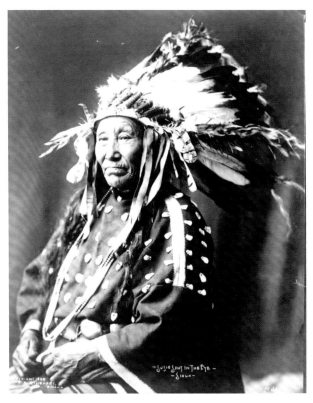

Figure 38. Susie Shot In The Eye, Sioux, by Adolph F. Muhr while working for Frank Albert Rinehart, 1898, during the Omaha Trans-Mississippi and International Exposition, Omaha, Nebraska. *Courtesy of the Library of Congress.*

very well have thought that Susie Shot In The Eye was male. In any event, the Pottery used her image for marketing purposes. She can be seen as the subject for a Standard ware plaque on page 26 of Rookwood's marketing booklet, *Rookwood Pottery,* published in 1902.

In addition to the eagle warbonnet, in the photograph Susie Shot In The Eye is wearing a traditional Plains dress lavishly ornamented with rows of the upper canine teeth of elk. These teeth are rare because each mature elk has only two. That so many elk are represented indicates that Susie Shot In The Eye had a highly skilled hunter in her family. This prestigious garment is made from a dark trade wool fabric called stroud; the Indians liked the undyed white selvages and utilized the white edge to accentuate seam lines and borders.

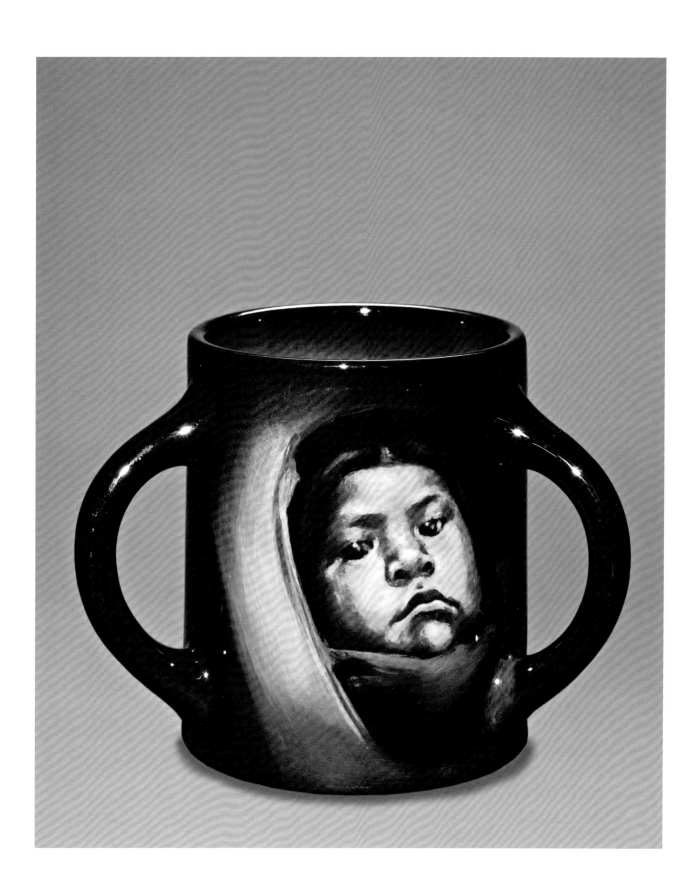

32

Loving Cup, 1901

Ute Baby

Adeliza Drake Sehon, decorator

Standard glaze line; slip cast; white body (stoneware)
H. 4¾", w. (w/ one handle) 5½", d. (w/out handles) 4"
　　　(12.1 x 14.0 x 10.2 cm)
Marks:
　　impressed
　　　　Rookwood logo surmounted by fourteen
　　　　　flames/"I/830E"
　　incised
　　　　a) "A.D.S."
　　　　b) "Ute."

Curator comments:

　　This mother proudly displays her infant in a magnificent cradle of typical Ute style: an inverted U-shaped board covered with deerskin and elaborately beaded. The soft hide covering formed a shallow bag that held the baby comfortably. Extending out from the board just above the baby's head is a twig awning that shaded the baby's eyes from the sun. Various ornaments used to entertain the baby hang from the sides.

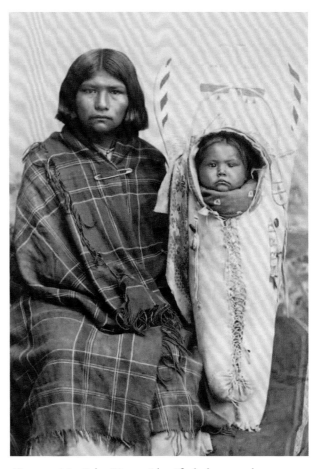

Figure 39. Ute Baby, Ute, unidentified photographer, unknown date. *Image courtesy of Buyenlarge.com.*

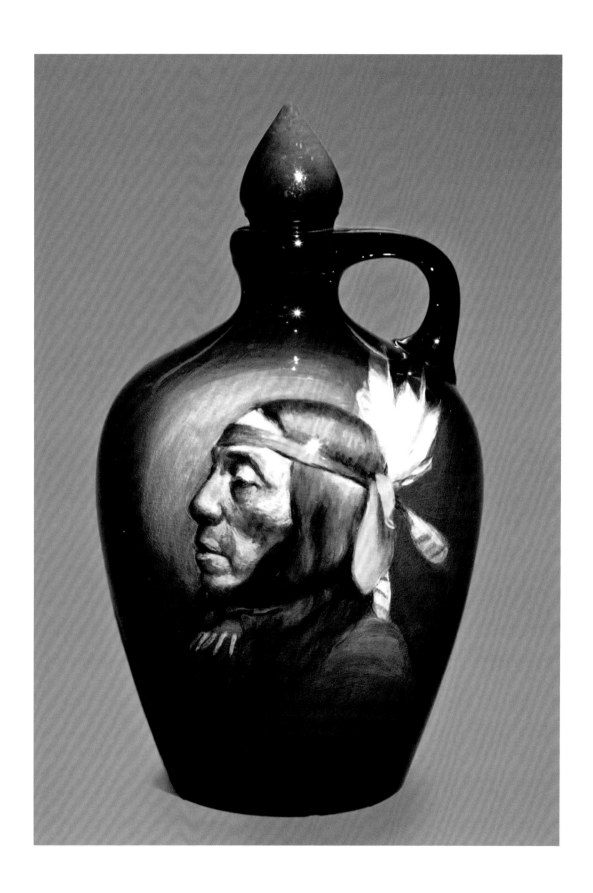

33

Jug with Stopper, 1901

Lean Wolf (Indian name Cheshakhadakhi or Tcecaqadaqic)

Adeliza Drake Sehon, decorator

William Watts Taylor, shape designer

Standard glaze line; thrown; white body (stoneware)
H. (w/ stopper) 9 ⅝", h. (w/out stopper) 7 ¾", w. (w/
 handle) 5 ½", d. 5 ½" (24.5/19.7 x 14.0 x
 14.0 cm)
Marks:
 impressed
 Rookwood logo surmounted by fourteen
 flames/"I/512B"
 incised
 a) "A.D.S."
 b) "Lean Wolf/Chief of Hidatsa/Sioux"
Paper label:
 rectangular label with black print on white
 ground, "Rookwood VIII/1228/Cincinnati
 Art Galleries"

Curator comments:

 Lean Wolf is seen here in profile. For a frontal pose of Lean Wolf see cat. no. 18. It was common for a photographer to take several different views, frontal and profile, in one sitting.

 In addition to eagle feathers, Lean Wolf wears feathers from another kind of raptor, either a hawk or an owl, in his hair.

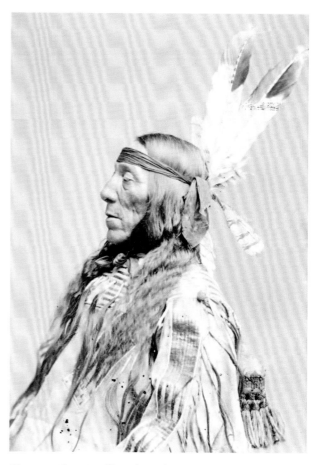

Figure 40. Lean Wolf, Hidatsa, by Charles Milton Bell, 1880, Washington, DC. *(00006) National Anthropological Archives, Smithsonian Institution.*

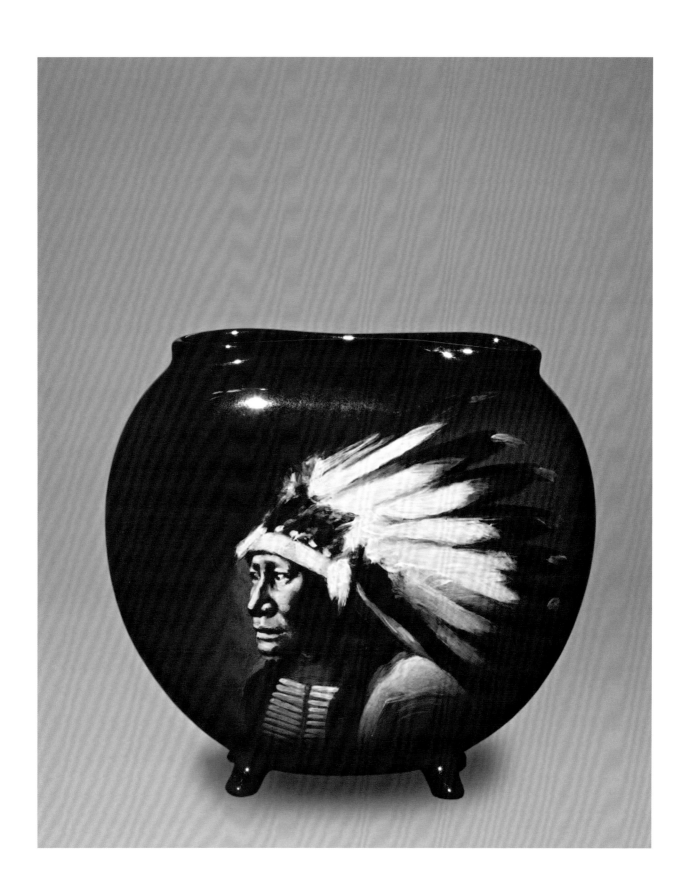

34

Pocket Vase, 1901

Hollow Horn Bear

Adeliza Drake Sehon, decorator
Standard glaze line; slip cast; white body (stoneware)
H. 7 ¼", w. 7 ¾", d. 3 ½" (18.4 x 19.7 x 8.9 cm)
Marks:

>impressed

>>Rookwood logo surmounted by fourteen
>>flames/"I/90/A"

>incised

>>a) "A.D.S."

>>b) "Chief Hollow/Horn Bear/Sioux"

Paper label:

>>on interior, rectangular label with black print
>>on white ground, "The Glover/Collection/
>>0053/Cincinnati Art Galleries"

Curator comments:

There is red paint residue on the bottom of the vase
that might suggest that it was part of Rookwood's collec-
tion of Rookwood pottery on loan to the Cincinnati Art
Museum. However, there is nothing that relates to this vase
in Stanley Gano Burt's record book of his inventory of
2,292 pieces of Rookwood pottery on loan to the Cincin-
nati Art Museum in 1916.

When Rookwood began in 1880, it looked for inspi-
ration to the leader in art pottery, Haviland and Co., based
in Limoges, France. Rookwood's shape number 90 (as seen

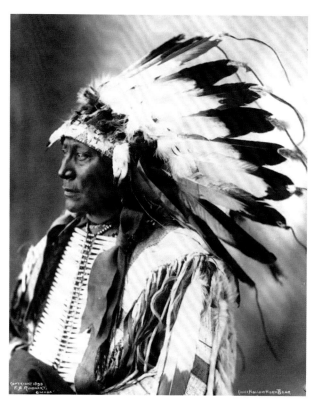

Figure 41. Hollow Horn Bear, Lakota Sioux, Sicangu or
Brulé band, by Frank Albert Rinehart, 1898, Omaha, Ne-
braska, during the Omaha Trans-Mississippi and Interna-
tional Exposition. *Denver Public Library, Western History
Collection, Frank A. Rinehart #X-31518.*

also in cat. no. 47) is almost identical to Haviland's shape
number 17, produced in the 1870s (see the exhibition cat-
alogue *Céramique Impressionniste,* Le Musée Fournaise,
April 26–November 4, 2001, 32–33). It is not surprising
that shape number 90, when first used by Rookwood in
1882, was produced for the Cincinnati pottery's Limoges
glaze line that looks very much like its French counterpart.
Offering a large flat surface for a painted decoration, the
shape is similar to Rookwood's later vase shape number
707 (see cat. nos. 12, 23, 31, 42, and 51), which was first
used in 1898. It differs from number 707 because it stands
on four feet. Shape number 90 probably lost favor to the
later shape without feet for two reasons: the applied feet

often developed firing cracks where they were attached to the body, and the later shape offered greater stability with a base rim instead of the feet.

Hollow Horn Bear is also seen in cat. no. 45 without the eagle feather warbonnet.

Hollow Horn Bear's headdress is ornamented on the sides with what appear to be ermine tails.

Harriette Rosemary Strafer

Harriette Strafer was born in 1873, a native of Covington, Kentucky. She took courses at the Art Academy of Cincinnati from 1888 to 1895, and again from 1910 to 1911. She is listed as taking a course in oil painting during the 1890–91 school year, which might have been the Frank Duveneck class. Strafer began at Rookwood in 1890. She did not paint many Indian portraits on pottery, although she was adept at portraiture, especially of African Americans. In 1899 she left Rookwood to further her art studies in New York. She died on April 27, 1935, in Covington, at the age of sixty-two.

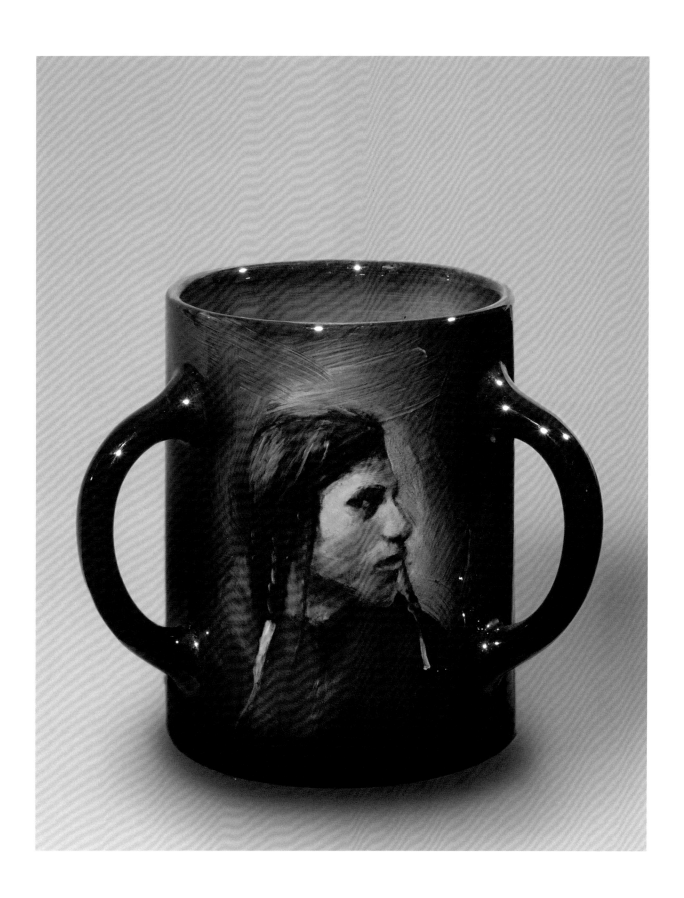

35

Loving Cup, 1898

Lacóte

Harriette Rosemary Strafer (1873–1935), decorator at
Rookwood 1890–99
Standard glaze line; slip cast; white body (stoneware)
H. 6½", w. (w/ one handle) 6¾", d. (w/out handles) 4
 ¾" (16.5 x 17.1 x 12.1 cm)
Marks:
 impressed
 Rookwood logo surmounted by twelve
 flames/"830D"
 incised
 "H.R.S."

Curator comments:
 For another depiction of Lacóte see cat. no. 3.
 According to the information on the front of the
photograph, Lacóte was Hidatsa-Mandan.

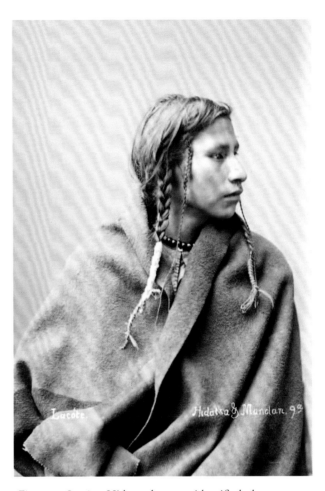

Figure 42. Lacóte, Hidatsa, by an unidentified photographer, 1884, Washington, DC. *(3456B) National Anthropological Archives, Smithsonian Institution.*

Artus Van Briggle

Artus Van Briggle was born in Felicity, Ohio, on March 21, 1869. Displaying artistic skills at an early age, he moved to Cincinnati in 1886 for further training and development. After a brief time painting faces on China dolls at the Arnold Fairyland Doll Store, he became an apprentice at the Avon Pottery where he studied under Carl Langenbeck, Rookwood's former ceramic engineer. It was under Langenbeck that Van Briggle learned the technical process of pottery making. The artist joined Rookwood in 1887 and soon became its most promising talent owing to his excellent artistic skills as well as his technical knowledge of clay. While at Rookwood, Van Briggle was one of the students in Frank Duveneck's 1890–91 and 1891–92 classes, and thereafter continued to take courses at the Art Academy of Cincinnati. In January 1894 Rookwood sent Van Briggle to study ceramics in Europe. Upon returning in June 1896, he spent much of his time at the Pottery experimenting with mat glazes. During the spring of 1899, just as his experiments were reaching fruition, Van Briggle left Rookwood. He had contracted tuberculosis and chose to leave Cincinnati for the dryer climate of Colorado Springs, Colorado. Once there, he set up the Van Briggle Pottery that became famous for its mat glazes. Having underwritten his training in Europe and disbelieving his ill health, Rookwood felt exploited and refused to give its former employee credit for introducing mat glazes to the Pottery. One can imagine the mixed emotion when Rookwood learned that Artus Van Briggle had died of tuberculosis in Colorado Springs on July 4, 1904, at the age of thirty-five.

36

Plaque, 1893

Pedro José Quivera (Indian name Ah-fit-che)

Artus Van Briggle (1869–1904), decorator at Rookwood 1887–1899

Standard glaze line; press molded; white body
 (stoneware)
H. 2", diam. 15 ½" (5.1 x 39.3 cm)
Marks on back:
 printed in black
 a) large (1 ¾" x 1 ½") Rookwood logo sur-
 mounted by seven flames painted in red
 b) "36.'o [?]"
 c) "36.1900"
Marks on front:
 incised lower right edge
 "A•V•B•"
Paper labels:
 a) on back of plaque, rectangular label with red
 border handwritten in black on white ground,
 "Standard/1883 [*sic*]/A Van Briggle"
 b) on back of plaque, rectangular label printed in
 black on white ground, "NOT FOR SALE"
 c) on back of plaque, rectangular label printed in
 black "15/[handwritten in black] Schott" on
 white ground
 d) attached by string to wire on back of plaque,
 rectangular label printed on front in black on
 green ground, "COWAN'S/AUCTION,
 INC./BIDDER NUMBER/[handwritten]
 295/546"; handwritten on back in black on
 green ground, "33036"

Curator comments:

In his inventory of Rookwood pottery on loan to the
Cincinnati Art Museum in 1916 (105, #45), Stanley Gano
Burt documents a paper label originally on this plaque
from the World's Columbian Exposition held in Chicago

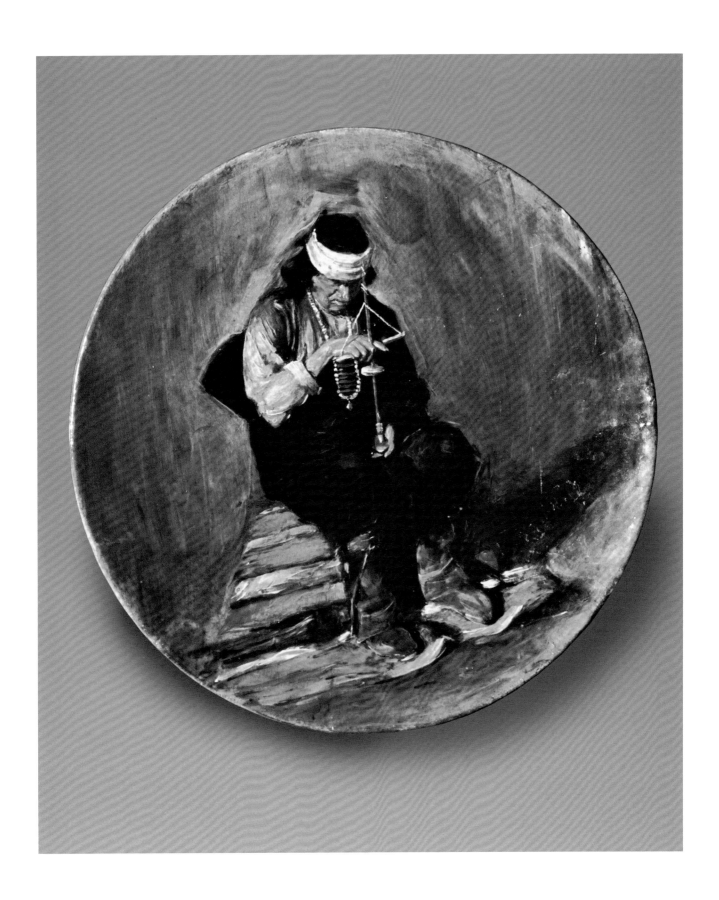

in 1893. An existing label on the back of the plaque notes that it was made in 1883. The 1883 notation is mistaken, since Van Briggle was not at Rookwood until 1887. Indeed, he did not move to Cincinnati until 1886. Created for the Chicago fair in 1893, the plaque represents one of Rookwood's first examples of Indian subject matter painted under the glaze and displayed in an international arena. Typical of the earliest examples of this genre, the Indian is depicted engaged in activity rather than posing for a portrait, as is common in later depictions.

John K. Hillers, who became the Bureau of Ethnology's photographer in 1879, photographed southwestern Indians and their lifeways; he created an extensive compendium about the placid Pueblo farmers who live along the Rio Grande and its tributaries. Pedro José Quivera, who was reportedly the governor of San Felipe Pueblo in New Mexico, sat for the well-known Hillers photograph (fig. 43) taken during the winter of 1880. Quivera, wearing traditional attire and sitting on a Pueblo textile, is demonstrating the use of a pump bow drill, a tool Pueblo Indians used to drill or perforate turquoise or shell beads. Rookwood acquired a copy of the photograph from the Smithsonian Institution, the administrative office for the Bureau of Ethnology.

While remaining true to the photographic source, Artus Van Briggle eliminated the narrow stripes in the Indian blanket to reduce his painting time and to better adapt the composition to the technical qualities of underglaze painting. The longer an artist spent on decorating a piece, the more expensive it was to produce; and fine detail, such as narrow stripes, was more difficult to paint and fire in decoration under the glaze.

Technical difficulties with the clay, as seen in the firing crack about halfway up the plaque extending from the right edge toward the figure, had yet to be resolved when the plaque was made. The clay body is very coarse and probably contains bits of clay that have been fired and ground, added to prevent shrinking and warping. This gritty type of body was being developed at Rookwood in the 1890s for use in large planar objects (e.g., cat. no. 26). Ultimately perfected, it was used in the Pottery's architectural division, where it was known as faience. Because the

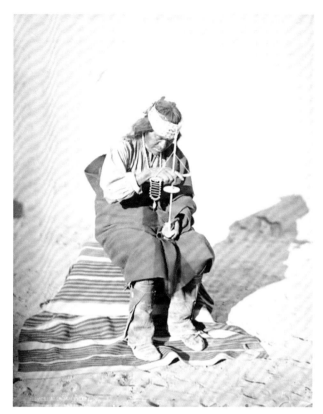

Figure 43. Pedro José Quivera, by John K. Hillers, 1880, Washington D.C. *(GN 02145) National Anthropological Archives, Smithsonian Institution.*

Pottery wanted to flaunt its Indian imagery in the Chicago exposition, the technical flaws in the plaque were overlooked in favor of a timely and unique submission.

Considered a special achievement, this plaque and an additional Indian plaque (cat. no. 37) were retained by the Pottery for its own display collection. In 1941 the Schott Group bought The Rookwood Pottery Company in a bankruptcy sale. Individuals in the group kept preferred examples from the Pottery's collection and sold the rest. Walter E. Schott kept the two Van Briggle Indian plaques, which were inherited by his son Charles J. Schott, and then by Charles's widow Margaret "Marge" Unnewehr Schott. James J. Gardner acquired the plaques at the Marge Schott estate sale in June 2006.

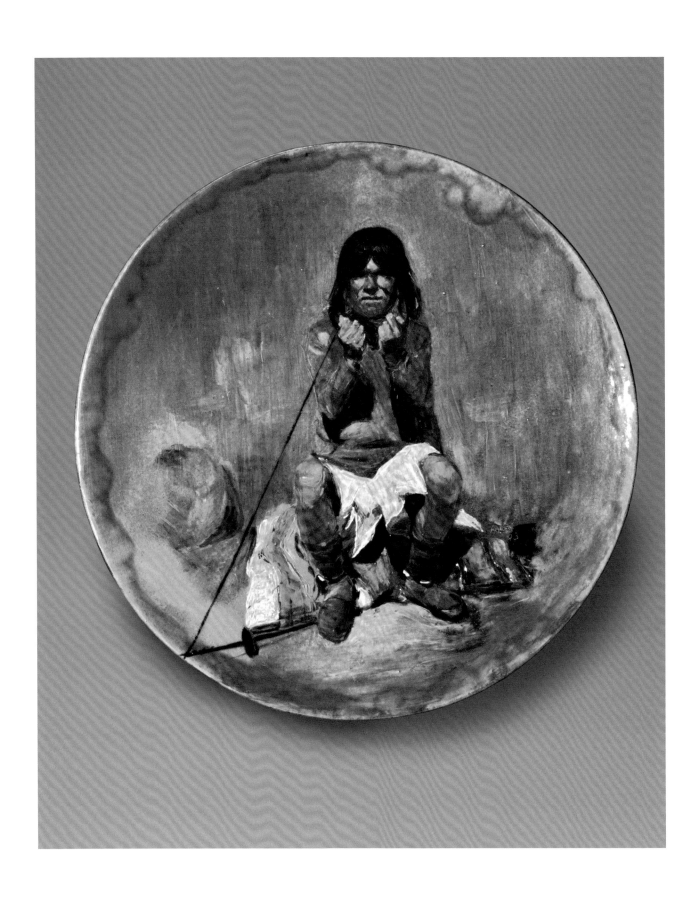

37

Plaque, 1893

Hopi Man Spinning Wool or Cotton

Artus Van Briggle, decorator

Standard glaze line; press molded; white body
 (stoneware)
H. 2", diam. 19" (5.1 x 48.2 cm)
Marks on back:
 impressed
 Five iterations of the Rookwood logo sur-
 mounted by seven flames, at each of four
 compass points and in the center
 painted in red
 "389.'01"
Marks on front:
 incised lower right
 "A•V•B•/93"
Paper label:
 attached by string to wire on back of plaque,
 rectangular label printed in black on green
 ground, "COWAN'S/AUCTION,
 INC./BIDDER NUMBER/[handwritten]
 295/545"; handwritten on back in black on
 green ground, "33035"

Curator comments:

 The artist makes no notation on the plaque as to the identity of the Indian. The information comes from the photographic source (fig. 44). In 1879 John K. Hillers was commissioned by the Bureau of Ethnology to document the lifeways of the southwestern Indians. He photographed

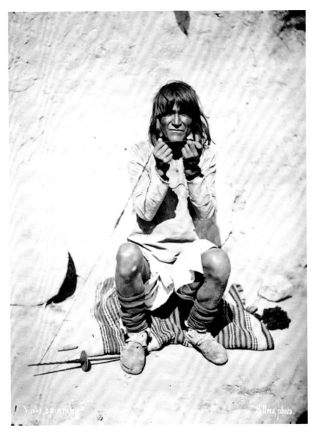

Figure 44. Man [Hopi] in Native Dress on Blanket Using Spindle [to spin cotton or wool], by John K. Hillers, 1879, Washington, DC. *(GN 01837B) National Anthropological Archives, Smithsonian Institution.*

the Pueblo farmers who live along the Rio Grande, in addition to the Acoma, Laguna, Zuni, and Hopi. This photograph, taken that same year, depicts a Hopi man from Walpi, Arizona, demonstrating the use of a spindle whorl. Among the Pueblo people, men are the weavers.

 Artus Van Briggle's depiction of the spinner is fairly faithful to the Hillers photograph. He did, however, eliminate the narrow stripes in the blanket and clothing for reasons of expediency (see cat. no. 36).

 According to Stanley Gano Burt in his inventory of Rookwood pottery on loan to the Cincinnati Art Museum in 1916 (105, #62), the plaque originally had a paper label noting that it was on display at the Chicago World's

Columbian Exposition in 1893. The plaque was probably expressly made for the exposition. It is among the first of Rookwood's Indian subjects and depicts a Native American engaged in activity rather than posing for a portrait, as the genre was later to evolve.

The body for this plaque is very coarse and probably contains bits of clay that have been fired and ground to reduce shrinking and warping (see cat. no. 36). Around the front edge of the plaque, a shoreline created by the glaze suggests additional technical problems. In spite of this, Rookwood chose to exhibit the plaque in the exposition in order to put the Pottery in the forefront of Indian subject matter painted under the glaze.

This plaque shares the same history of ownership as the Van Briggle plaque depicting Pedro José Quivera (see cat. no. 36).

Harriet Elizabeth "Hattie" Wilcox

Hattie Wilcox was born in 1869 and began at Rookwood in 1886. In spite of the importance of her work at the Pottery, very little is known about her. She left Rookwood in 1907, returning after a few years and remaining until 1931, when the decorators were dismissed as a result of the Great Depression. She attended classes at the Art Academy of Cincinnati from 1884 to 1889, and almost certainly attended one or both of the Frank Duveneck classes in 1890–91 and 1891–92. Although she was very good at portraiture, she did not paint many Indians on Rookwood, and is today noted mostly for her mastery of the very difficult and labor-intensive painted mat technique. She died in 1943, at the age of seventy-four.

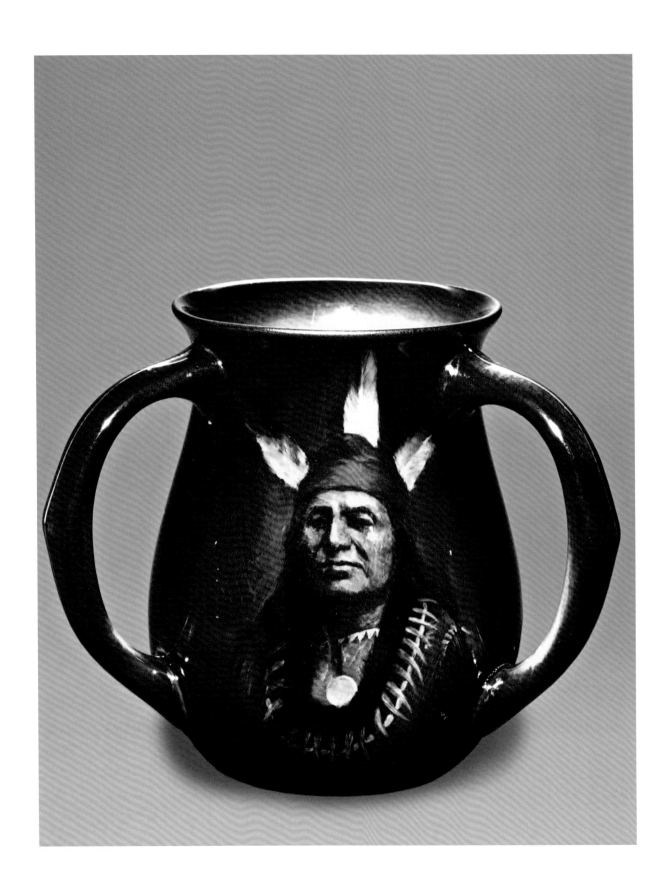

38

Loving Cup, 1896

Rushing Bear

Harriet Elizabeth Wilcox (1869–1948), decorator at
Rookwood 1886–1907, returned later until 1931

Standard glaze line; slip cast; white body (stoneware)
H. 5 ¾", w. (w/ one handle) 6 ½", d. (w/out handles) 5"
 (14.6 x 16.5 x 12.6 cm)
Marks:
 impressed
 Rookwood logo surmounted by ten
 flames/"729" (no size letter given)
 incised
 "H.E.W."
Paper label:
 rectangular label with black print on white
 ground, "The
 Glover/Collection/1101/Cincinnati Art
 Galleries"

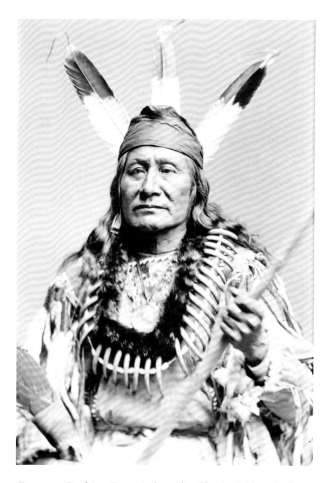

Figure 45. Rushing Bear, Arikara, by Charles Milton Bell,
1880, possibly Washington, DC. *(00123A) National Anthropo-
logical Archives, Smithsonian Institution.*

Curator comments:

Rushing Bear is wearing a peace medal. He was part of a delegation to Washington in June 1880; however, we know that he did not receive the medal at that time because no presentation medals were given to the Indians during the Rutherford B. Hayes administration. For his portrait, Rushing Bear also wears a superb Plains grizzly bear claw neck ornament, which Wilcox painted on the loving cup. The now extinct Great Plains grizzly had distinctive, long, light brown claws as opposed to the short, dark claws of the mountain grizzly. A Plains man felt that wearing the claws of a fierce predator helped him acquire those traits for himself.

Grace Young

Grace Young was born in Covington, Kentucky, October 25, 1869. She attended the Art Academy of Cincinnati during the years 1884–98 and was in the class taught by Frank Duveneck in 1890–91. She began at Rookwood in 1886. A gifted painter, Young was among the first to introduce portraiture at the Pottery, and is especially known for her portraits of Indians. She left Rookwood in July 1891, to study in Munich, Germany, for five years. Upon returning in 1896, she resumed her work at Rookwood until 1903, when she left for France to study at the Colorossi Academy of Art in Paris. In 1906 she returned to Cincinnati to teach at the Art Academy of Cincinnati. She left the Academy in 1916 upon her marriage to Fritz van Houten Raymond, the photographer for Rookwood and the Cincinnati Art Museum. She died August 26, 1947, at the age of seventy-seven.

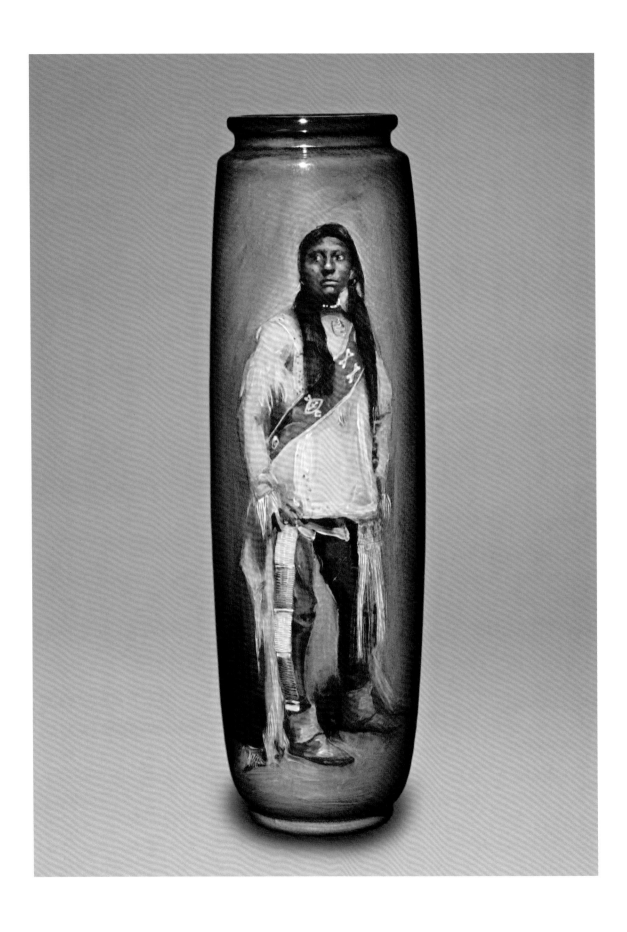

39

Vase, 1898

Suriap

Grace Young (1869–1947), decorator at Rookwood 1886–91, 1896–1903

Kataro Shirayamadani (1865–1948), decorator at Rookwood 1887–ca. 1912, ca. 1920–48, shape designer

Standard glaze line; thrown; white body (stoneware)
H. 11½", diam. 3½" (29.2 x 8.9 cm)
Marks:
 impressed
 Rookwood logo surmounted by twelve
 flames/"589D"
 incised
 a) "Ute/Suriup" [*sic*]
 b) GY cipher (very faint)
Paper label:
 square label with black print on white ground,
 "Cincinnati/Art/Galleries/1290"

Curator comments:

 Suriap participated in a delegation to Washington in 1868; for his official photograph he wears traditional garments and holds his heavily fringed tobacco bag, just visible hanging against his left leg. His right legging displays a striking but simple beaded design, indicating that the beads are probably relatively large glass "pony" beads—an early European trade good packed in on horses.

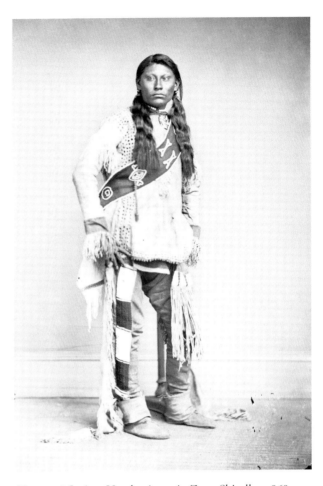

Figure 46. Suriap, Ute, by Antonio Zeno Shindler, 1868, Washington, DC. *(1573) National Anthropological Archives, Smithsonian Institution.*

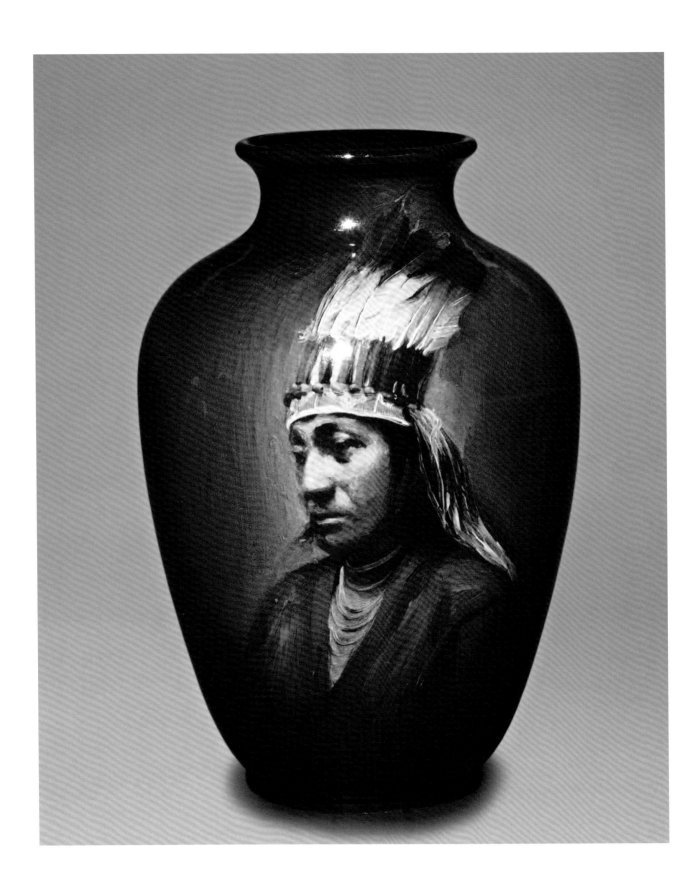

40

Vase, 1898

Peo

Grace Young, decorator

Standard glaze line; slip cast; white body (stoneware)
H. 9 ½", diam. 7" (24.1 x 17.8 cm)
Marks:
> impressed
>> Rookwood logo surmounted by twelve
>> flames/"814A"
> incised
>> a) "Umatilla–Peo–"
>> b) GY cipher

Curator comments:

Grace Young depicted the same image of Peo on at least one other vase painted in 1901, as seen in the Cincinnati Art Galleries catalogue Rookwood VI, #1555.

Peo, a leader of the Umatilla people, was part of the 1890 delegation that traveled to Washington, DC. The Umatilla live on the Umatilla Reservation in Oregon with the Cayuse and Walla Walla people. Peo wears a Blackfeet-style warbonnet of upright eagle feathers in this official portrait. In another official photograph taken by Charles M. Bell, Peo is shown wearing identical clothing and pictured with other leaders from the reservation; each man is wearing a different style of warbonnet. The image is in Sturtevant (12:414).

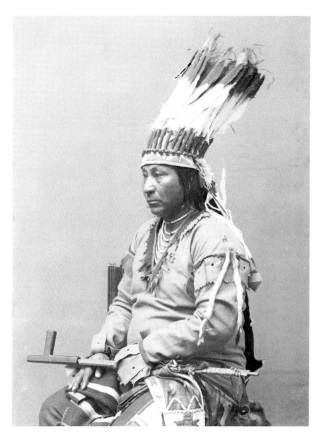

Figure 47. Peo, Umatilla, by an unidentified photographer, 1890, Washington, DC. *(2888B) National Anthropological Archives, Smithsonian Institution.*

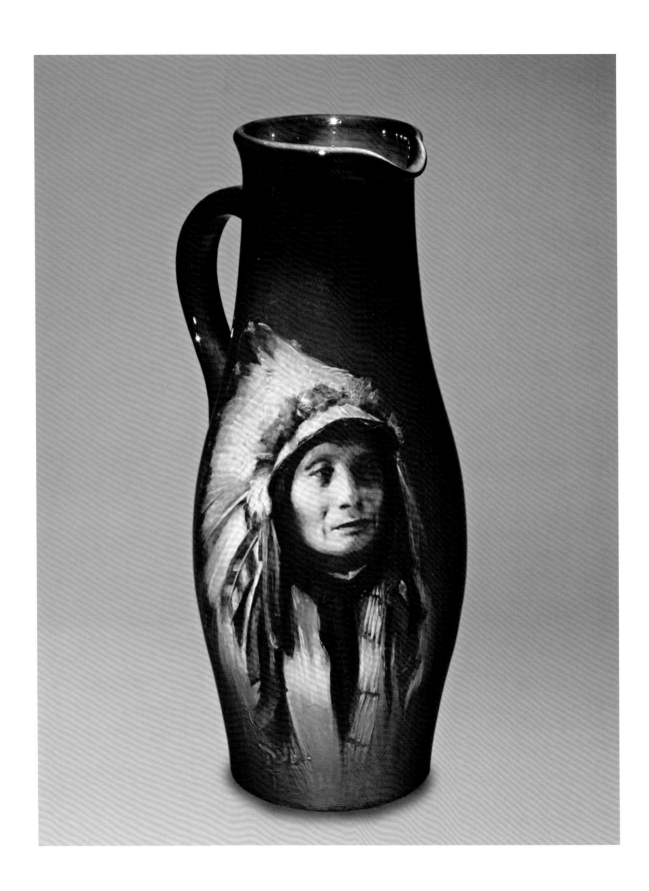

41

Pitcher, 1899

Sleeping Bear

Grace Young, decorator

Pitts Harrison Burt (1837–1906), trustee at
Rookwood 1890–1906, shape designer

Standard glaze line; thrown; white body (stoneware)
H. 14½", w. (w/ handle) 8", d. 6¼" (36.8 x 20.3 x 16 cm)
Marks:
> impressed
>> Rookwood logo surmounted by thirteen
>> flames/"838A"
> incised
>> a) "Sleeping Bear./Sioux"
>> b) Grace Young cipher

Paper label:
>> on interior, rectangular label with black print
>> on white ground, "Rookwood
>> II/0769/Cincinnati Art Galleries"

Curator comments:

Shape number 838 was originally taken from a sketch
or drawing by Pitts Harrison Burt bearing the number
S1299C.

According to the Rookwood Shape Book 1883–1900
(38), this pitcher was not designed in combination with
drinking vessels such as mugs. If the pitcher were held in
the right hand, the portrait would be facing the guests, not
the pourer, which suggests that it was decorated for use in
a social context. However, the fact that it has an impressed
letter on the bottom denoting the size of the vessel tells us
that it was not part of a set because Rookwood sets have no
size letters.

The hair pipe neck ornament, with the pipes strung
vertically around the neck, tells us that Sleeping Bear may
be a woman. Plains men did not usually wear this configu-
ration of hair pipes; they wore breastplates with hair pipes
strung horizontally across the chest. However, it is also un-
usual to see an Indian woman wearing a neck scarf and an

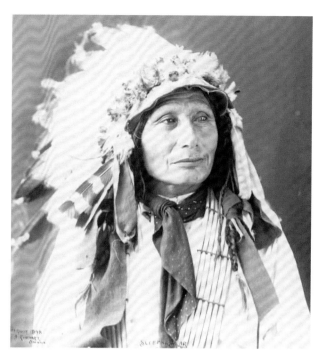

Figure 48. Sleeping Bear, Lakota Sioux, Sicangu or Brulé
band, by Frank Albert Rinehart, October 7, 1898, during
the Omaha Trans-Mississippi and International Exposition,
Omaha, Nebraska. *(85–1401) National Anthropological Archives,
Smithsonian Institution.*

eagle feather warbonnet. One other depiction, that of Susie
Shot In The Eye (cat. no. 31), also portrays a woman wear-
ing an eagle feather warbonnet. Frank Albert Rinehart took
both photographs during the Omaha Trans-Mississippi
and International Exposition in Omaha, Nebraska, in
1898. This exposition included an Indian Congress that
brought together the leaders of many different Indian na-
tions. In *The Face of Courage,* a book published in 1972 by
Old Army Press that features some of Rinehart's images,
both men and women are pictured wearing the popular
hair pipes strung in a variety of ways. Indians wore hair
pipes as hair ornaments, ear pendants, close-fitting chok-
ers, and bandoliers. Men wore breastplates and women
wore simple or complex neck ornaments. However, Rine-
hart did photograph two men and one woman—Crazy
Bear, Elk Woman, and Chief Fast Thunder—wearing what
appears to be the same hair pipe ornament. The pipes are
strung vertically, exactly like those on Sleeping Bear; hence
the gender of Sleeping Bear remains uncertain.

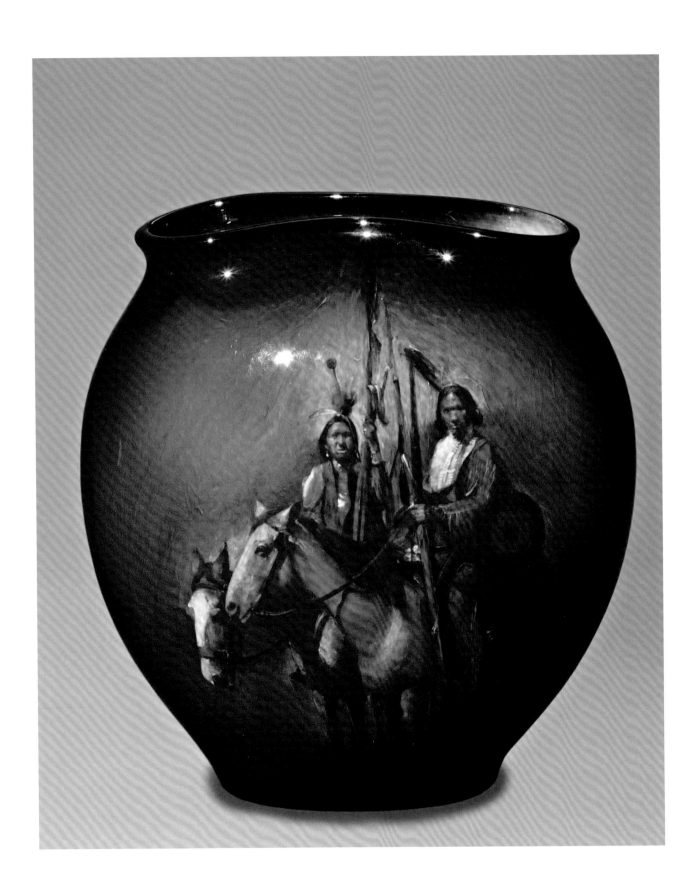

42

Vase, 1899

Kiowas

Grace Young, decorator

Standard glaze line; slip cast; white body (stoneware)
H. 11½", w. 11½", d. 6½" (29.2 x 29.2 x 16.5 cm)
Marks:
> impressed
>> Rookwood logo surmounted by thirteen
>> flames/"707/X"
> incised
>> a) "Kiowa____"
>> b) GY cipher
> wheel-ground through glaze
>> "X"
Paper label:
> rectangular label handwritten in black on
> white ground, "1305"

Curator comments:

See cat. no. 12 for a discussion of the shape design. This vase displays the largest known size for the shape.

For a discussion of the purpose of the wheel-ground "X" on the bottom see cat. no. 24. There are no technical flaws in the vase; consequently, it was not withheld as a "second."

It is unusual because it exhibits Indians engaged in activity instead of portraiture.

Grace Young used this image at least one additional time, in 1903, for an Iris glazed plaque (cat. no. 52). No other decorator appears to have used it.

This photograph, taken at the exposition that featured an Indian Congress with its gathering of different tribes, shows Plains men in traditional attire and holding lances, probably in preparation for a riding demonstration or perhaps a mock battle. The mounted figure on the right is Pablino Diaz, also known as Big Whip, who can be seen in a solo portrait in cat. no. 5, and on the far right in the group portrait in cat. no. 52.

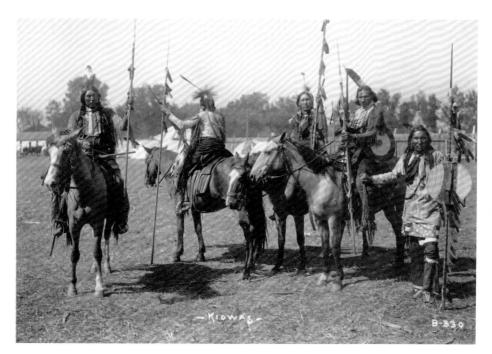

Figure 49. Kiowas, by Frank Albert Rinehart, 1898, during the Omaha Trans-Mississippi and International Exposition, Omaha, Nebraska. *From the collections of the Omaha Public Library.*

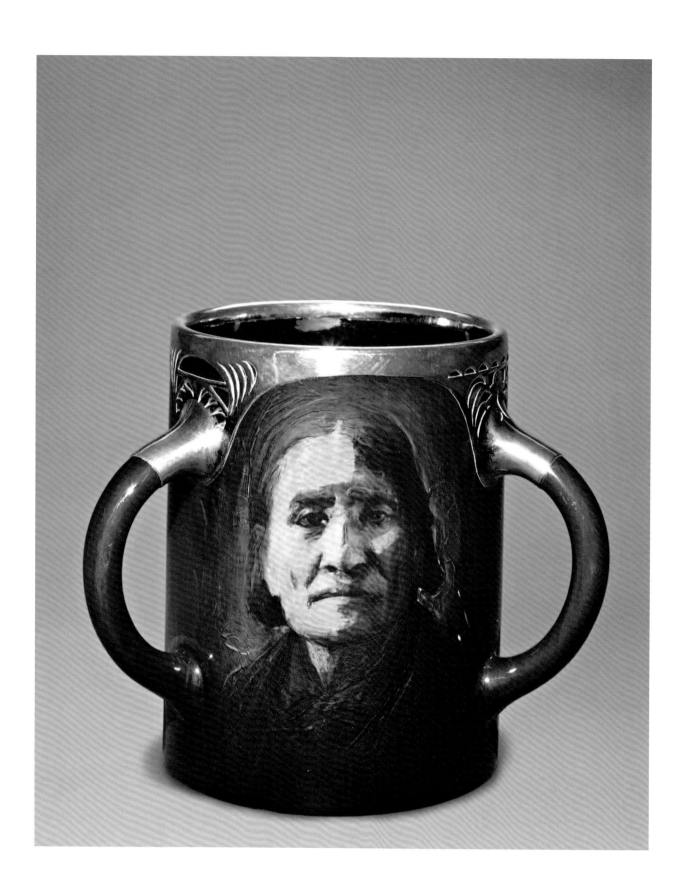

43

Loving Cup, 1899

Geronimo (Indian name Guiyatle/One Who Yawns)

Grace Young, decorator

Standard glaze line; thrown; white body (stoneware); sil-
 ver overlay around lip and at top of the
 handles
H. 6½", w. (w/ one handle) 7", d. (w/out handles) 5"
 (16.5 x 17.8 x 12.6 cm)
Marks:
 impressed
 Rookwood logo surmounted by twelve
 flames/"830D"
 incised
 a) "Geronimo (Guiyatle)/*Apache*"
 b) GY cipher

Figure 50. Geronimo, Apache, by Frank Albert Rinehart,
1898, during the Omaha Trans-Mississippi and International
Exposition, Omaha, Nebraska. *Denver Public Library, Western
History Collection, Frank A. Rinehart #X-32165.*

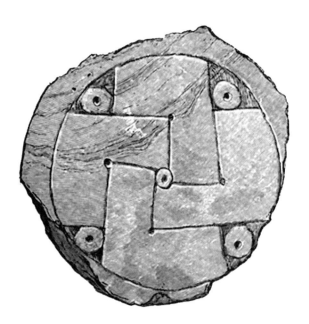

Figure 51. Detail of image of a gorget, taken from William H. Holmes, "Art in Shell of the Ancient Americans," *Second Annual Report of the Bureau of Ethnology, The Smithsonian Institution 1880–81* (Washington, DC: GPO, 1883), Plate LI, no. 1.

Curator comments:

It is possible that Rookwood applied the silver overlay because the date of the loving cup is within the 1899–1903 period when Rookwood was producing copper and silver electrodeposited wares; and because the gorget motif (fig. 51) pierced in the silver overlay had been used in the past at Rookwood (see Ellis essay, fig. 5), and was being used as electrodeposited motifs in 1899 on additional pieces (for example, see cat. no. 7). It is taken somewhat loosely from a gorget (fig. 51) illustrated by William H. Holmes in the article "Art in Shell of the Ancient Americans," published in the *Second Annual Report of the Bureau of Ethnology, The Smithsonian Institution 1880–81* (Washington, DC: GPO, 1883), plate 51, fig. 1. On this vessel, it appears to be used simply as decoration, not as a metaphor for the extinction of the American Indian or his way of life.

Geronimo (ca. 1823–1909) was a Bedonkohe Apache war leader whose Indian name was also spelled Goyahkla,

One Who Yawns. As a young man Geronimo lived in the arid and mountainous terrain of the Southwest. Even among the Apache, who were renowned as warriors, Geronimo excelled at fighting. In 1851 Mexicans slaughtered Geronimo's mother, wife, and three of his children, an act that fueled Geronimo's hatred of Mexicans and his persistent raids into that country. He received the name for which he is known at that time.

Following the treaty of Guadalupe Hidalgo in 1848, and the United States' acquisition of New Mexico and California, the Apache world began to change. The settlers' and miners' relentless expansion west resulted in general warfare between Geronimo's people and U.S. troops. Intense fighting erupted periodically over the next several decades; the last battle, in May 1871, resulted in the death of Lieutenant Howard B. Cushing.

Throughout his life Geronimo fought confinement to a reservation. In 1877 his war party lost a battle in southwestern New Mexico and he was arrested. He managed to avoid being tried for atrocities and remained at San Carlos Reservation in Arizona until April 4, 1878. He fled the reservation, was captured, and fled that reservation again for the freedom of Mexico. From the Sierra Madre Mountains in April 1882, Geronimo and his long-term ally, Juh, accomplished the most remarkable feat of Apache fighting on record. The two men led a group of several hundred Indians from the San Carlos Reservation to Mexico, fighting military units the whole way until they reached the relative safety of the Sierra Madre. In 1883 General George Crook persuaded the Apache to return to San Carlos, but in 1885 Geronimo fled yet again to Mexico. All the while, his reputation as a fearsome warrior grew.

In 1886 Geronimo surrendered, went on the warpath again, and once again was persuaded to surrender. Finally, he was sent into exile in Florida, where other Apaches, both friendly and hostile, were detained. From there he was sent to Fort Sill, Oklahoma, where he died.

Geronimo was one of the last Indians to surrender and during his last years was sought out by thrill-seekers. He remains an American legend, a man whose fame outstripped even his spectacular deeds.

The custom of yelling "Geronimo!" when parachuting from an airplane can be traced to Aubrey Eberhardt, a member of the U.S. Army's parachute test platoon at Fort Benning, Georgia, in 1940. The military planned to test the feasibility of jumping from the plane in quick succession and the parachutists, understandably nervous, went to see a movie to relieve their stress for the next day. Most probably they saw *Geronimo* (1939) and, following the movie, some of the men began to tease Eberhardt, saying he would be just as frightened as they were. This annoyed the six-foot-eight Eberhardt, who then declared, "To prove to you that I'm not scared out of my wits when I jump, I'm gonna yell 'Geronimo' loud as hell when I go out that door tomorrow!" (The Straight Dope, http://www.straightdope.com/classic/a5_146.html)

Figure 52. Detail of silver electrodeposit gorget decoration on the loving cup.

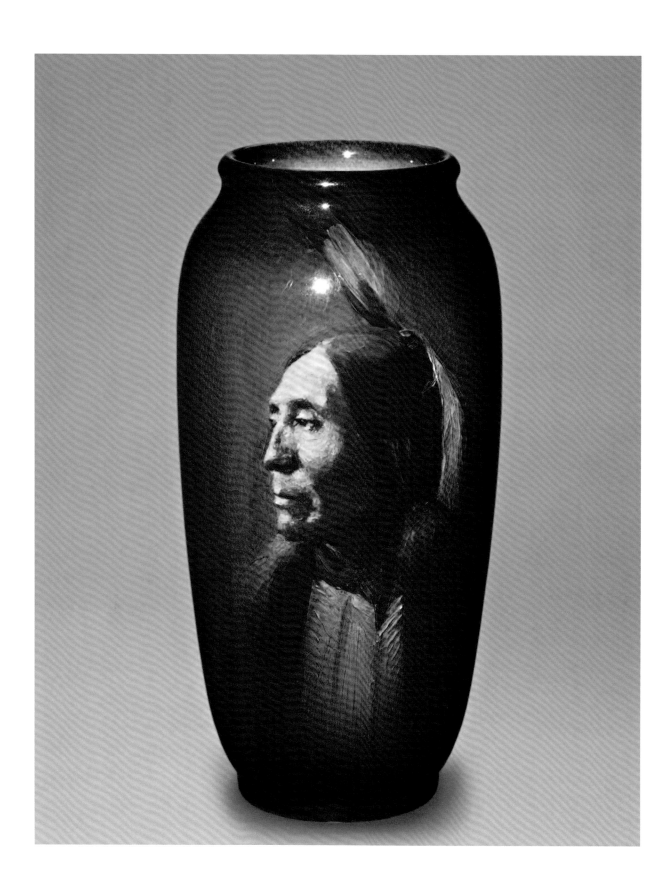

44

Vase, 1900

White Man

Grace Young, decorator

John Jacob Menzel (ca. 1861–1911), foreman and master potter at Rookwood 1884–1911, shape designer

Standard glaze line; thrown; white body (stoneware)
H. 9", diam. 5" (22.9 x 12.6 cm)
Marks:
 impressed
 a) Rookwood logo surmounted by fourteen
 flames/"892C"
 b) GY cipher
 incised
 "Chief White Man/(Kiowa)"
Paper label:
 on interior, rectangular label with black print
 on white ground, "Rookwood
 III/1256/Cincinnati Art Galleries"

Curator comments:

 For his portrait, taken at the 1898 Omaha Trans-Mississippi and International Exposition, White Man accentuates his hair by wrapping it in strips of fur.

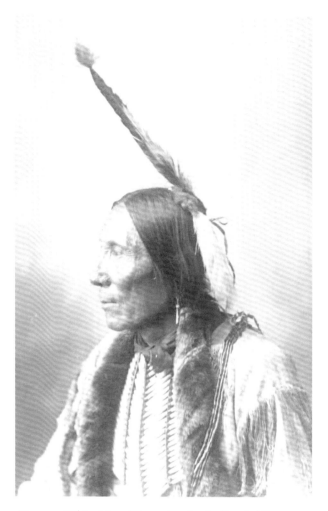

Figure 53. White Man, Kiowa-Apache, by Frank Albert Rinehart, 1898, during the Omaha Trans-Mississippi and International Exposition, Omaha, Nebraska. *From the collections of the Omaha Public Library.*

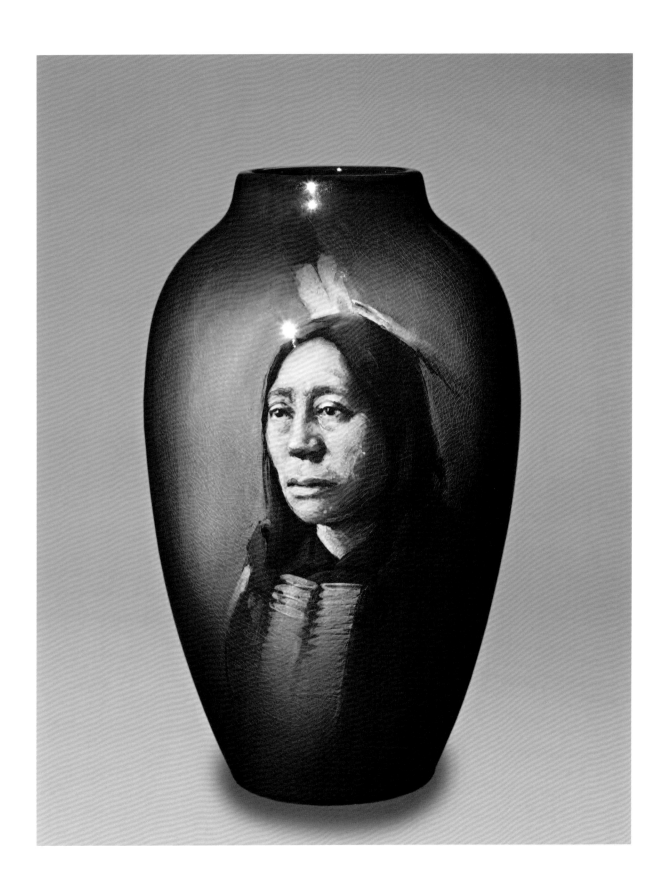

45

Vase, 1901

Hollow Horn Bear

Grace Young, decorator

Standard glaze line; slip cast; white body (stoneware)
H. 9 ½", diam. 6 ¼" (24.1 x 16.0 cm)
Marks:
> impressed
>> a) Rookwood logo surmounted by fourteen
>> flames/"I/900/B"
>> b) GY cipher
> incised
>> "Hollow Horn/Bear/(Sioux)"

Paper label:
> circular label handwritten in black on yellow
> ground, "CAG/No. 11"

Curator comments:

Hollow Horn Bear is also seen in cat. no. 34 with full warbonnet.

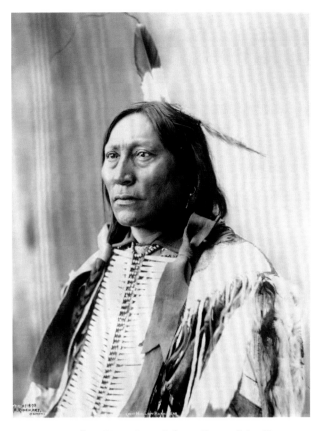

Figure 54. Hollow Horn Bear, Lakota Sioux of the Sicangu or Brulé band, Sioux, by Frank Albert Rinehart, 1898, during the Omaha Trans-Mississippi and International Exposition, Omaha, Nebraska. *Courtesy of the Library of Congress.*

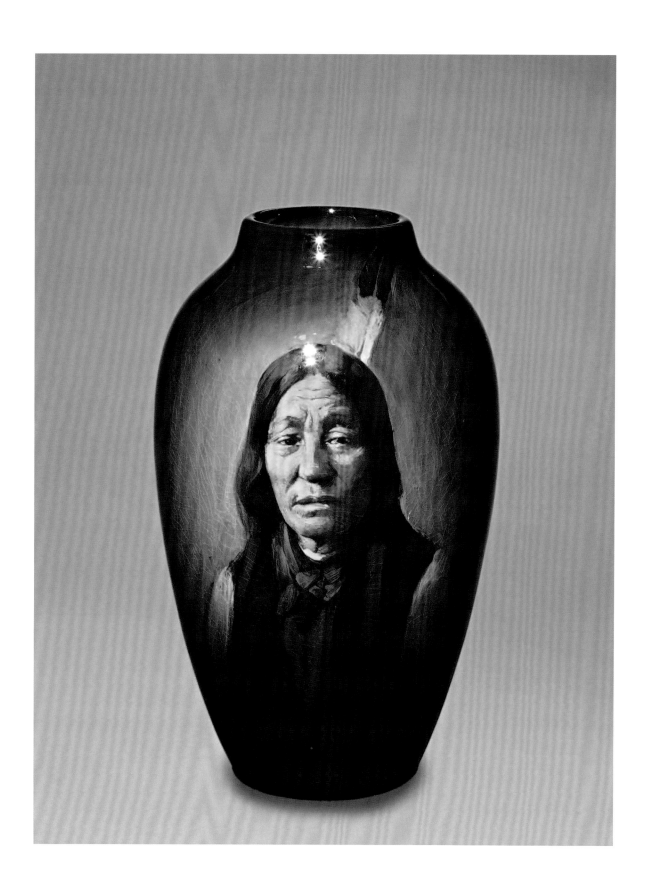

46

Vase, 1901

White Buffalo

Grace Young, decorator

Standard glaze line; slip cast; white body (stoneware)
H. 9", diam. 5½" (22.9 x 14.0 cm)
Marks:
 impressed
 a) Rookwood logo surmounted by fourteen
 flames/"I/900B"
 b) GY cipher
 incised
 "White Buffalo/(Arapahoe)" [*sic*]
Paper labels:
 a) rectangular label (part missing) with three
 red horizontal lines on cream ground
 b) rectangular label with red print on cream
 ground, "Rookwood Pottery/Cincinnati
 U.S.A./1904/Louisiana Purchase/Exposi-
 tion St. Louis"
 c) rectangular label with red print on cream
 ground, RP logo "DO NOT/REMOVE/
 THIS LABEL"/three red lines
 d) on interior, rectangular label with black
 print on white ground, "Rookwood
 VI/1706/Cincinnati Art Galleries"

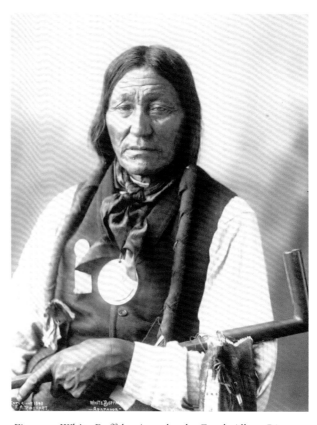

Figure 55. White Buffalo, Arapaho, by Frank Albert Rine-hart, 1898, during the Omaha Trans-Mississippi and International Exposition, Omaha, Nebraska. *From the collections of the Omaha Public Library.*

Curator comments:

Shape number 900 was originally taken from a sketch or drawing bearing the number S1617.

White Buffalo is wearing a peace medal and holding a catlinite pipe.

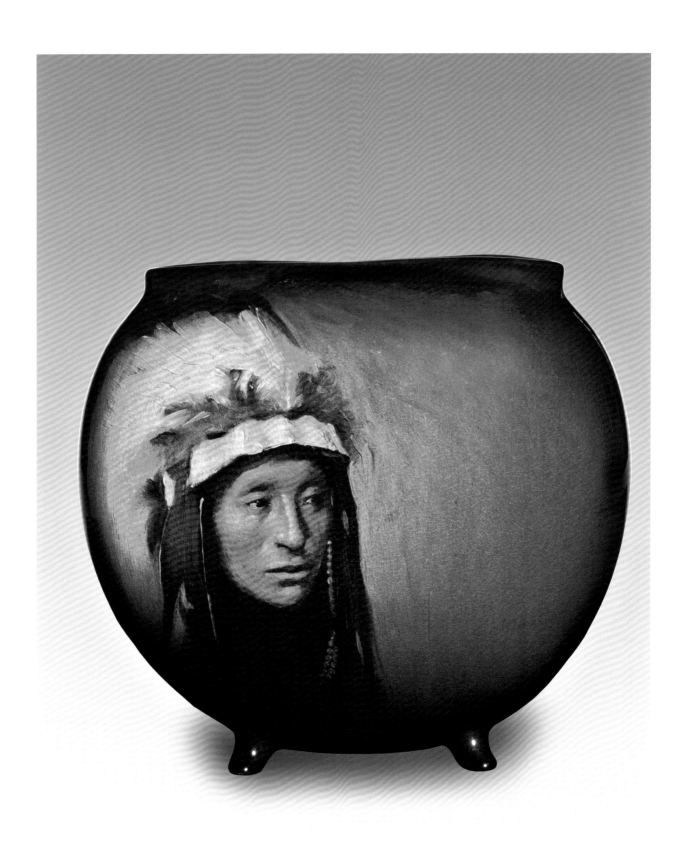

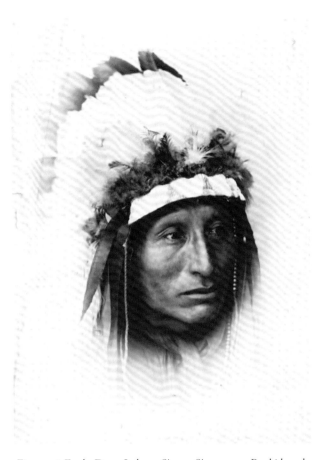

Figure 56. Eagle Deer, Lakota Sioux, Sicangu or Brulé band, possibly by T. H. Kelley, or Constance Baker, 1896, Cincinnati. *Rookwood Pottery Photograph Collection, SC148. Cincinnati Museum Center—Cincinnati Historical Society Library.*

47

Pocket Vase, 1901

Eagle Deer

Grace Young, decorator

Standard glaze line; slip cast; white body (stoneware)
H. 7 ⅛", w. 8", d. 3 ½" (18.1 x 20.3 x 8.9 cm)
Marks:
 impressed
 a) Rookwood logo surmounted by fourteen
 flames/"I/90A"
 b) GY cipher
 incised
 "Eagle Deer/Son [*sic*] of Little
 Bald/Eagle/(Sioux)"
Paper label:
 on side of vase, rectangular label printed in
 black on white ground, "Cincinnati/Art
 Galleries/1643"

Curator comments:
 Eagle Deer, son of Little Bald Eagle, was one of the Indians who camped at the Cincinnati Zoo during the summer, 1896.
 See cat. no. 34 for a discussion of the shape.
 For another depiction of Eagle Deer see cat. no. 30.

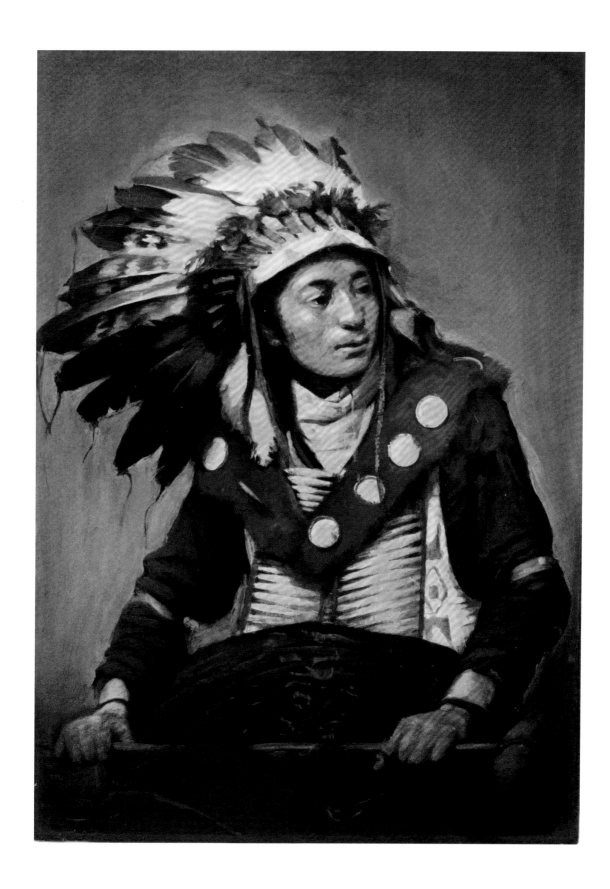

48

Plaque, 1902

High Hawk

Grace Young, decorator

Standard glaze line; press molded; white body
 (stoneware)
H. 14¼", w. 10¼", d. ¾" (36.2 x 26.0 x 2.0 cm)
Marks on back:
 impressed
 Rookwood logo surmounted by fourteen
 flames/"II"
 hand-inscribed in lead pencil
 a) "Mrs. Geo [Leo?] H. Warren/3443 So Irv-
 ing"
 b) "3–248–4"
 c) "349" in an oval
 d) "10 x [illegible]"
Marks on left edge:
 impressed
 GY cipher
 incised
 "–High Hawk–Ogallala [*sic*]–Sioux"
Paper labels:
 a) on back of plaque, circular label printed in blue
 with the Rookwood logo surmounted by four-
 teen flames on a white ground
 b) on back of plaque, rectangular, serrated label
 printed in red on white ground, "Rookwood
 Pottery/Cincinnati, USA/1904/Louisiana Pur-
 chase/Exposition, St. Louis"
 c) on back of frame, circular label printed in black
 on green ground, "0034/Rago"
 d) on back of frame, circular label printed in black
 on gold ground, "The
 Schulman/Collection"/Rookwood logo sur-
 mounted by fourteen flames/"Rago Auctions"
 e) same as d) above
 f) on back of frame, rectangular label written in
 black on white ground, "144"

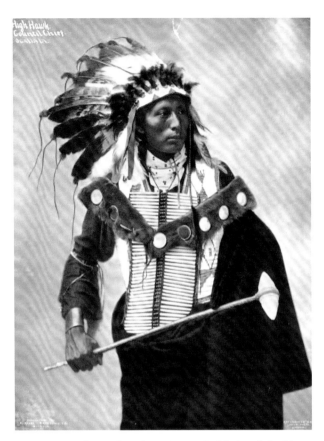

Figure 57. High Hawk, Lakota Sioux, Oglala band, by Her-
man Heyn of Heyn Photo, 1899. Color halftone reproduc-
tion published by Burkley Printing Co., Omaha, Nebraska.
*Denver Public Library, Western History Collection, Heyn Photo #X-
33684.*

 g) on back of frame, printed in white on black,
 plastic labeling tape, "ROOKWOOD/1903
 [*sic*]/ST.LOUIS EXPOSITION . . .
 904/ARTIST . . . GRACE YOUNG/CHIEF
 HIGH HAWK/OGALLA [*sic*].SIOUX/10
 INCHES BY 14 3/4 INCHES/SIGNATURE
 ON SIDE EDGE/GY.HIGH
 HAWK.OGALLA [*sic*].SIOUX"

Curator comments:

 High Hawk poses in his splendid Plains attire, wear-
ing a beaded vest, an eagle feather warbonnet, and a fur
neck ornament with trade mirrors, and holding a fine war
club. Today the name of his band is spelled Oglala; they
live on Pine Ridge Reservation in South Dakota.

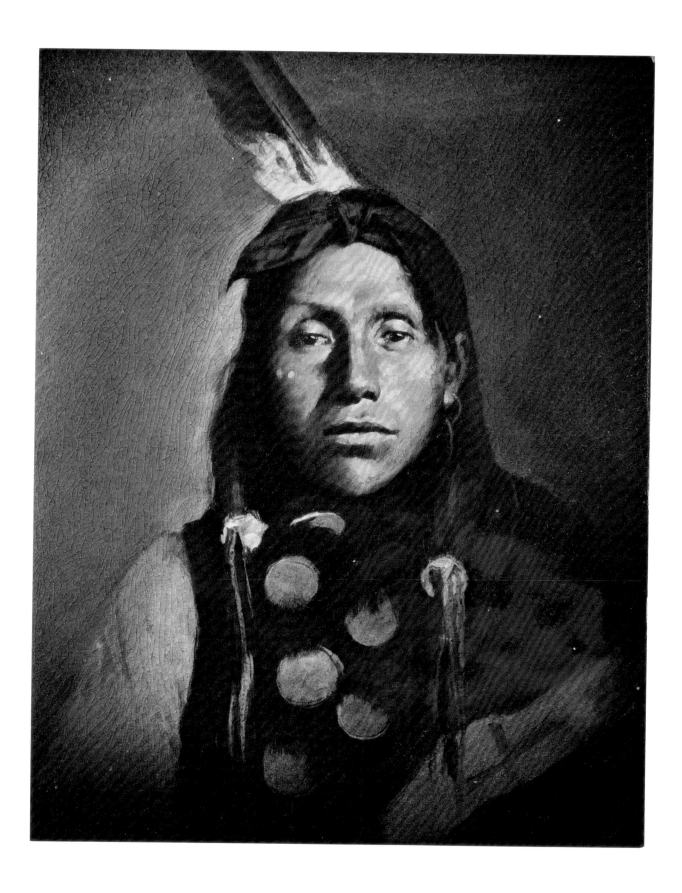

49

Plaque, 1902

Wanstall

Grace Young, decorator

Standard glaze line; press molded; white body
 (stoneware)
H. 8¾", w. 7", d. ½" (22.2 x 17.8 x 1.3 cm)
Marks:
 impressed on back
 a) Rookwood logo surmounted by fourteen
 flames/"II"
 b) GY cipher
 incised on the left edge
 "Wanstall–Arapahoe [*sic*]"
 hand-inscribed in black graphite on back
 "Artist: Grace Young"/"Subject: Winstall [*sic*]
 Arapahoe [*sic*]"
Paper label:
 applied to foam core backing, rectangular
 label printed in black on a white ground,
 "Cincinnati/Art Galleries/0898"

Curator comments:
 Wanstall wears a fur neck ornament embellished
with large trade mirrors; just barely visible is his wool blan-
ket with a beaded blanket strip.

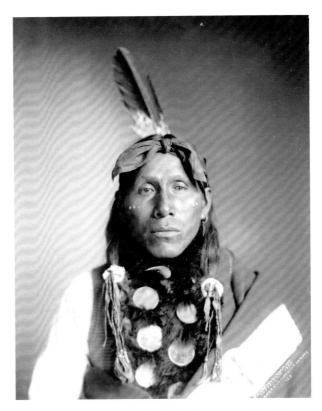

Figure 58. Wanstall, Arapahoe [*sic*], by Rose and Hopkins,
ca. 1899. Denver Public Library, Western History Collection,
Rose and Hopkins #H-410.

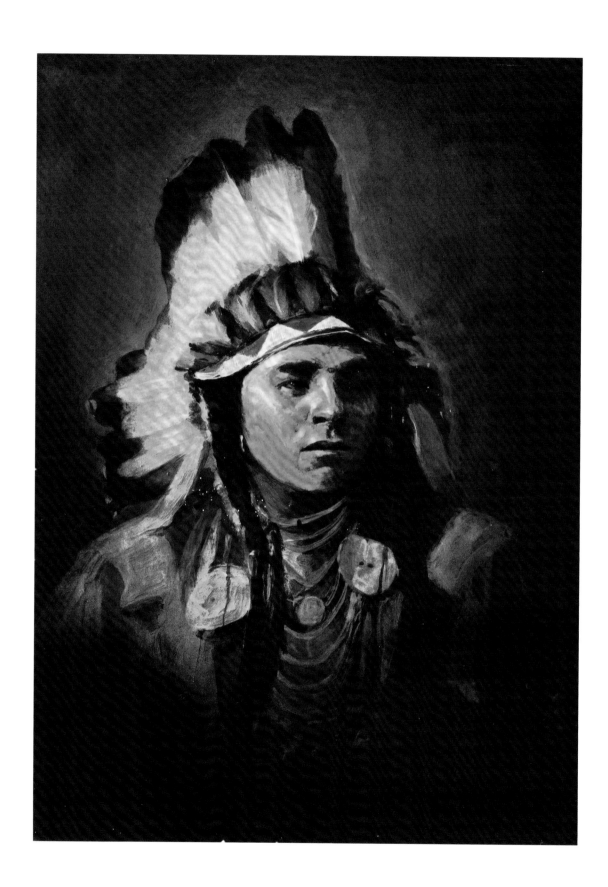

50

Plaque, 1902

Spotted Jack Rabbit

Grace Young, decorator

Standard glaze line; press molded; white body
 (stoneware)

H. 14¼", w. 10¼", d. ¾" (36.2 x 26.0 x 2.0 cm)

Marks on back:
 impressed
 Rookwood logo surmounted by fourteen
 flames/"II/X499AX"
 hand-inscribed in graphite
 a) "5173–4"
 b) "1349" within an oval
 c) "10 x [illegible]"

Marks on left edge:
 impressed
 GY cipher
 incised
 "Spotted Jack Rabbit–Crow"

Curator comments:

 At least six additional plaques are known to be impressed with Rookwood chemist Stanley Gano Burt's trial notation "X499AX." Two are imaged in the Cincinnati Art Galleries 1990, Glover auction, cat. nos. 328 (Carl Schmidt, Iris glaze line, scenic, no date) and 653 (Grace Young, Standard glaze line, Squaw and Papoose, 1903); two are imaged in Cincinnati Art Galleries *Holiday Sale 2001,*

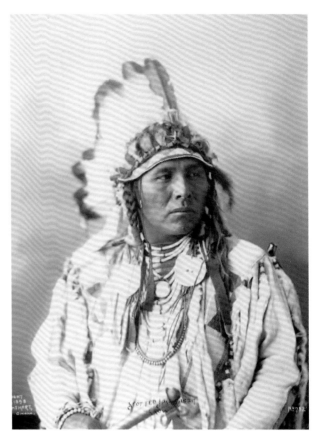

Figure 59. Spotted Jack Rabbit, Crow, by Frank Albert Rinehart, 1898, during the Omaha Trans-Mississippi and International Exposition, Omaha, Nebraska. *From the collections of the Omaha Public Library.*

cat. nos. 1007 (Grace Young, Iris glaze, Portrait of a Young Woman, 1903) and 1008 (possibly by Grace Young, Iris glaze, Portrait of a Cavalier, 1903); and two are imaged in Virginia Cummins's *Rookwood Pottery Potpourri* (126, both by Sturgis Lawrence, Iris glaze line, scenics, 1903). The sizes of all are different, but five are dated 1903, and one is not dated although it is probably 1903. Almost certainly, Burt was experimenting with the clay to prevent warping in the body and crazing in the glaze.

 See cat. nos. 1, 28, and 29 for images of the same sitter.

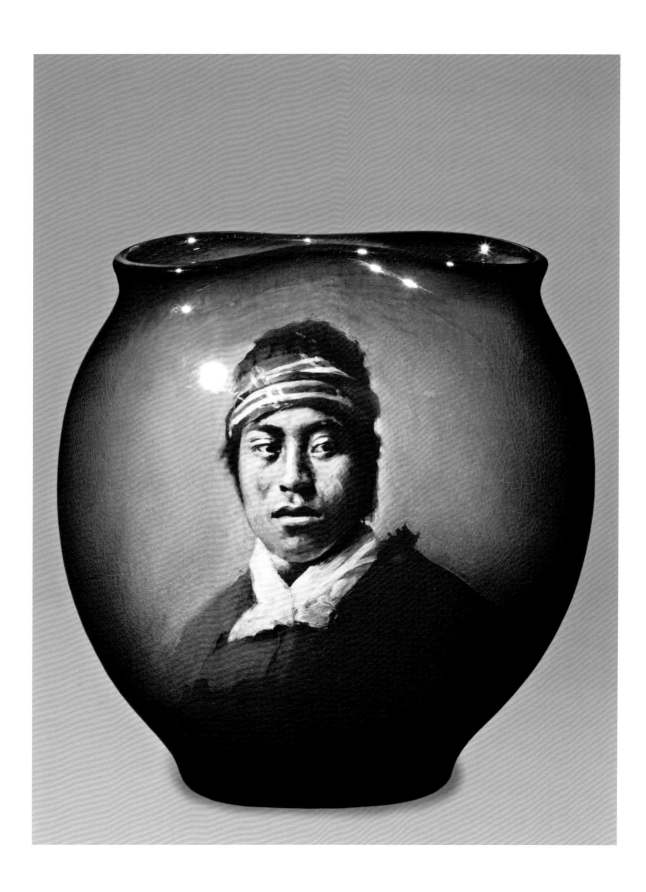

51

Vase, 1902

Songlike

Grace Young, decorator

Standard glaze line; slip cast; white body (stoneware)
H. 9½", w. 9½", d. 5¼" (24.1 x 24.1 x 13.3 cm)
Marks:
 impressed
 Rookwood logo surmounted by fourteen
 flames/"II/707/AA"
 incised
 a) GY cipher
 b) "Songlike/Pueblo"
 wheel-ground through glaze
 "X"
Paper label:
 rectangular label with black print on gold
 ground, "Rookwood Pottery and/the Arts
 & Crafts Movement/1880–1915/October 16,
 1987–January 31, 1988/Milwaukee Art Mu-
 seum"

Curator comments:

The wheel-engraved "X" on the bottom means that the vase was withheld from sales. See cat. no. 24 for a discussion of the "X" notation. This vase has no technical flaws. It was perhaps intended for display at the 1902 International Exposition of Modern Decorative Art, in Turin, Italy. It could also have been exhibited in 1904 at the Louisiana Purchase Exposition in St. Louis, Missouri. It was not uncommon for Rookwood to display an object in more than one exposition. By 1902 there were very few Indian portraits being created because Rookwood was emphasizing its mat-glazed products. Nevertheless, because the Indian portraits were considered a tour de force, even

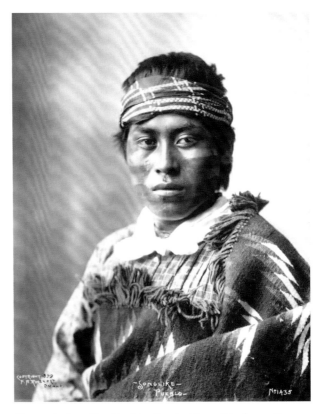

Figure 60. Songlike, Pueblo, Frank Albert Rinehart, 1899, possibly Washington, DC. *Denver Public Library, Western History Collection, Frank A. Rinehart #X-30739.*

if no longer considered the height of fashion, the Pottery would have kept some examples on hand to exemplify that genre at world fairs.

See cat. no. 12 for a discussion of the shape design.

It is unusual for Rookwood to depict a Pueblo Indian on its wares because at the time, the iconic American Indian was the Plains Indian, not the Pueblo Indian. Rookwood believed that depictions of the Plains Indians were easier to sell because they were stereotypical. It is another example of decorator Grace Young disregarding a Rookwood marketing strategy to depict other than a Plains Indian on her ware.

Songlike, a Pueblo Indian man, not a member of a Plains group, is wearing face paint, a trade blanket, scarf, and headband.

Plaque, 1903

Kiowas

Grace Young, decorator

Iris glaze line; press molded; white body (stoneware)
H. 14¼", w. 10¼", d. ¾" (36.2 x 26.0 x 2.0 cm)
Marks on back:
> impressed
>> a) Rookwood logo surmounted by fourteen
>> flames/"III/X1168X"
>> b) GY cipher
> incised
>> "Kiowa Men"

Paper label:
> rectangular label with black print on white
> ground, "Rookwood VIII/0820/Cincinnati
> Art Galleries"

Curator comments:

The clay body is not as finely grained as Rookwood's smaller, white body plaques. It is slightly gritty from the extra grog (biscuit-fired, ground clay) added to the green (unfired) clay to reduce the rate of clay shrinkage during drying and in the firing. This prevents warping, which is a particular problem in plaques of this size.

The composition is taken from the same source as an 1899 vase (cat. no. 42), also by Grace Young.

Throughout Rookwood's eighty-seven-year history the Pottery produced more than 500,000 pieces of artist-decorated ceramics. There are fewer than twenty known Iris glaze line plaques, and this is the only one known to depict Indians. The dates of the known Iris plaques range from 1900 to 1904, with most tending to be from 1903. Rookwood probably began experimenting with the Iris glaze on plaques shortly before the 1900 Paris Universal Exposition. Prior to this, with the exception of one 1883 Limoges plaque, all known non-mat plaques belonged to the Standard glaze line.

The number "X1168X" on the back of this plaque is Stanley Gano Burt's trial notation. It is distinctive because of the "X" before and after the number. As Burt was Rookwood's "chemist" (today he would be called a ceramic engineer), it denotes an experiment in the clay body, or possibly in the glaze. And since this is an early, large plaque, Burt was probably testing a new clay body for warping and glaze compatibility. The same trial notation can be seen on at least one other large Iris glaze plaque (see Cincinnati Art Galleries *Rookwood IX & Keramics 1999* auction cat. no. 627, 1903, by Sturgis Laurence).

The mounted figure on the right is Pablino Diaz, also known as Big Whip, who can be seen in a solo portrait in cat. no. 5, and on the far right in the group portrait in cat. no. 42.

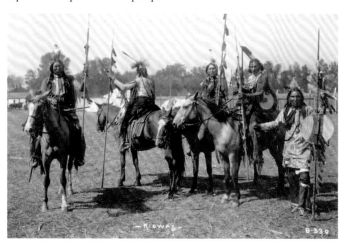

Figure 61. Kiowas, by Frank Albert Rinehart, 1898, during the Omaha Trans-Mississippi and International Exposition, Omaha, Nebraska. *From the collections of the Omaha Public Library.*

Appendix I

Rookwood Artists of Indian Portrait Decoration

	At Rookwood	*Life dates*
Constance Amelia Baker	1892–1904	1860–1932
Elizabeth Wheldon Brain	1898–99	1870–1960
Matthew A. Daly	1882–1903	1860–1937
Virginia B. Demarest	1898–1903	unknown
Henry Farny	1881	1847–1916
Edith Regina Felton	1896–1904	1878–1962
Robert Bruce Horsfall	1893–95	1869–1948
Edward T. Hurley	1896–1948	1869–1950
Flora King	1945–ca. 1946	1918–after 1968
Frederick Sturgis Laurence	1895–1904 (as decorator)	1870–1961
Sadie Markland	1892–99	1870–99
William P. McDonald	1882–1931	1864–1931
Edith Noonan	1904–10	1881–1978
Marie Rauchfuss	1899–ca. 1903	1879–after 1941
Olga Geneva Reed	1890–1909	1874–1955
Adeliza Drake Sehon	1896–1902	1871–1902
Harriette Rosemary Strafer	1890–99	1873–1935
Jeanette Carick Swing	1900–1904	1868–1942
Sarah Alice Toohey	1887–1931	1872–1941
Anna Marie Valentien	1884–1905	1862–1947
Artus Van Briggle	1887–99	1869–1904
Harriet Elizabeth Wilcox	1886–1907, ?–1931	1869–1943
Grace Young	1886–91, 1896–1903	1869–1947

Appendix II

Photographers of American Indians
Whose Work Was Used at Rookwood

Constance Baker (at Rookwood 1892–1904, decorator and company photographer)

Charles Milton Bell (1848–93), Washington, DC (active 1860–74)

William Gunnison Chamberlain (1815–1910)

John N. Choate (1848–1902), Carlisle, PA (active ca. 1879–ca. 1891)

Alexander Gardner (1821–82), Washington, DC (active 1858–82)

Herman Heyn (b. 1852)—Heyn Photo Company, Omaha, NE

John K. Hillers (1843–1925), United States Geological Survey. Studio in Washington, DC (active 1871–1890s)

T. H. Kelley (1854–1931), probably a president of the Cincinnati Camera Club

Enno Meinhardt Meyer (1874–1947), Cincinnati photographer

Adolph F. Muhr (ca. 1860–1913), Omaha, NE (active 1880–1913)

Frank A. Rinehart (1861–1928), Omaha, NE (active 1878–1886)

Rose & Hopkins Studio, Denver, CO (active 1886–1927)

Wells Moses Sawyer (1863–1960)

Antonio Zeno Shindler (1823–99), Washington, DC

William Stinson Soule (1836–1908)

Bibliography

Enduring Encounters

Aiken, Albert W. *Joe Phenix's Double Deal; Or, the Diamond Daggers.* New York: Beadle and Adams, 1897.

Baldwin, Charles C. *Memorial of Colonel Charles Whittlesey, Late President of the Western Reserve Historical Society.* Cleveland: Williams' Book Publishing House, 1887.

"Barnumizing the Fair." *Harper's Weekly* 37, no. 1920 (1893): 967.

Billington, Ray Allen. *The American Frontier.* Washington, DC: Service Center for Teachers of History, American Historical Association, 1958.

———. *Frederick Jackson Turner: Historian, Scholar, Teacher.* New York: Oxford University Press, 1973.

Boas, Franz. "Ethnology at the Exposition." *Cosmopolitan* 15 (1893): 607–9.

Bond, Beverly W., Jr., ed. "Dr. Daniel Drake's Memoir of the Miami Country, 1779–1794." *Quarterly Publication of the Historical and Philosophical Society of Ohio* 18, no. 2–3 (1923): 39–117.

Catlin, George. *Letters and Notes on the Manners, Customs, and Condition of the North American Indians.* 2 vols. Minneapolis, MN: Ross and Haines, 1841; reprint 1965.

Cincinnati Commercial Gazette, "Buffalo Bill's Wild West at the Ball Grounds Yesterday," October 20, 1884, 8.

———, "Buffalo Hunt," June 3, 1883, 2.

———. "Close of the 'Wild West' Show Last Night," June 11, 1883, 5.

———, "Kohl & Middleton's Dime Museum," March 12, 1893, 10.

———, "The National Jury," March 12, 1893, 9.

———, "A Needless Cruelty," December 18, 1890, 12.

———, "A Painter on the Plains: Artist Farny's Autumn Outing Among Aborigines," October 28, 1894, 22.

Cincinnati Commercial Tribune, "Dr. C. L. Metz Dies at 79," December 22, 1926, 2.

Cincinnati Daily Atlas, "The Chippewas," November 28, 1848, 3.

———, "Things about Town," November 30, 1848, 3.

Cincinnati Daily Enquirer, "Removal of Indians," October 13, 1846, 3.

Cincinnati Daily Gazette, "Amusements," December 31, 1872, 4.

———, "Amusements," January 6, 1873, 4.

———, "Exhibition of Indian Portraits," May 27, 1833, 3.

Cincinnati Enquirer, "Art and Artists," November 11, 1894, 19.

———, "Art Notes," July 5, 1896, 23.

———, "Death Rode upon the Blast . . . ,"August 23, 1896, 1.

———, "Historical Cincinnati Because . . . ,"August 16, 1896, 19.

———, "Indian Shows at the Zoo," June 20, 1896, 6.

———, "Indian Squaws," June 26, 1896, 6.

———, "Last Day of the Indians," September 6, 1896, 19.

———, "Notes," June 30, 1896, 7.

———, "Notes," August 12, 1896, 10.

———, "The Only Genuine Wild . . . ," June 29, 1896, 5.

———, "Our Indian Village Inhabited . . . ," July 3, 1896, 8.

———, "Show Gossip," September 2, 1896, 9.

———, "A Sioux Maiden." August 20, 1896, 6.

———, "Small Was the Gold Meeting Held at the Zoo by the McKinley Club," August 20, 1896, 10.

———, "Stormswept Was This City Last Night," August 23, 1896, 5.

———, "To-Day at the Zoo," July 23, 1895, 19.

———, "To-Day at the Zoo," July 26, 1896, 19.

———, "Weird Scene in the Sioux Camp," August 1, 1896, 8.

———, "Weird and Wild Was the Ceremony," August 3, 1896, 8.

———, "The Zoo's Wild West," June 28, 1896, 19.

———, "The Zoo To-Day," July 7, 1895, 19.

———, "The Zoo To-Day." August 23, 1896, 19.

Cincinnati Gazette. "Daily Receipts by the Miami Canal," October 13, 1846, 3.

———, "Emigrating Indians," October 12, 1846, 2.

———, "The Miamis," October 13, 1846, 2–3.

———, "Removal of Indians," October 13, 1846, 2.

———, "Shipments," October 13, 1846, 3.

Cincinnati Illustrated Business Directory. Cincinnati: Spencer and Craig, 1887–88.

Cincinnati Times Star, "Ancient Indian Lore Familiar to Farny Who Reveals Secrets," August 25, 1911, 11.

———, "Grand Display," May 4, 1896, 10.

———, "Great Is Buffalo Bill," May 5, 1896, 3.

———, "Thomas Cleneay's Death," October 21, 1887, 7.

Clarke, Robert. *The Pre-Historic Remains Which Were Found on the Site of the City of Cincinnati, Ohio With a Vindication of the 'Cincinnati Tablet.'* Cincinnati: Robert Clarke, 1876.

Deloria, Philip J. *Playing Indian.* New Haven, CT: Yale University Press, 1998.

Deloria, Vine, Jr. "The Indians." In *Buffalo Bill and the Wild West,* 45–56. Brooklyn, NY: Brooklyn Museum, 1981.

De Vere, Clara. *The Exposition Sketch Book: Notes of the Cincinnati Exposition of 1881.* Cincinnati: H. W. Weisbrodt, 1881.

Donaldson, Thomas C., ed. *Report on Indians Taxed and Indians Not Taxed in the United States (Except Alaska).* Washington, DC: GPO, 1894.

Drake, Daniel. *Natural and Statistical View, or Picture of Cincinnati and the Miami Country, Illustrated by Maps.* Cincinnati: Looker and Wallace, 1815.

Drake, Daniel, et al. "Art. XXIII. An Address to the People of the Western Country." *American Journal of Science* 1 (1818): 203–6.

Dyck, Paul. *Brulé: The Sioux People of the Rosebud.* Flagstaff, AZ: Northland, 1971.

Ehrlinger, David. *The Cincinnati Zoo and Botanical Garden: From Past to Present.* Cincinnati: Cincinnati Zoo and Botanical Garden, 1993.

Ewers, John C. "The Emergence of the Plains Indian as the Symbol of the North American Indian." In *Annual Report of the Board of Regents of the Smithsonian Institution* for the Year Ended June 30, 1964, 531–44. Washington, DC: Smithsonian Institution, 1965.

Exposition Commission. *Seventh Cincinnati Industrial Exposition: Official Catalogue and Exposition Guide.* Cincinnati: Seventh Cincinnati Exposition Commission, 1879.

Farny, Henry. "Columbian Exposition—The Dance of the Dahomans in the Midway Plaisance." *Harper's Weekly* 37, no. 1920 (October 1893): 965.

———. "The Last Scene of the Last Act of the Sioux War." *Harper's Weekly* 35, no. 1782 (February 1891): 120.

Fenn, Forrest. *The Beat of the Drum and the Whoop of the Dance: A Study of the Life and Work of Joseph Henry Sharp.* Santa Fe, NM: Fenn, 1983.

Final Report of the Ohio State Board of Centennial Managers to the General Assembly of the State of Ohio. Columbus: Nevins and Myers, 1877.

Fleischmann, John. "The Labyrinthine World of the Scrapbook King." *Smithsonian* 22, no. 11 (1992): 79–87.

Flint, Timothy. "Cincinnati Museums." *Western Monthly Review* 1 (1827–28): 78–80.

Force, M. F. "To What Race Did the Mound-Builders Belong?" In *Some Early Notices of the Indians of Ohio*, 41–75. Cincinnati: Robert Clarke, 1879.

Ford, Henry A., and Kate B. Ford, compilers. *History of Cincinnati, Ohio.* Cleveland: L. A. Williams, 1881.

Gest, Erasmus. "Ancient Hieroglyphic Stone." *Cincinnati Gazette,* December 24, 1842, 2.

Guest, Moses. *Poems on Several Occasions.* Cincinnati: Looker and Reynolds, 1823.

Hall, James. *The Romance of Western History: Or, Sketches of History, Life, and Manners in the West.* Cincinnati: Applegate, 1857.

———. *Sketches of History, Life, and Manners, in the West.* 2 vols. Philadelphia: Harrison Hall, 1835.

Hamilton, Henry W., and Jean Tyree Hamilton. *The Sioux of the Rosebud: A History in Pictures.* Norman: University of Oklahoma Press, 1980.

Harrison, William Henry. *A Discourse on the Aborigines of the Valley of the Ohio.* Cincinnati: Cincinnati Express, 1838.

Howells, William Dean. *A Boy's Town.* New York: Harper and Brothers, 1890.

———. *Stories of Ohio.* New York: American Book Co., 1897.

"The Indians in American Art." *Crayon* 3 (1856): 28.

Johannsen, Albert. *The House of Beadle and Adams and Its Dime and Nickel Novels.* Norman: University of Oklahoma Press, 1950.

Jones, A. E. *Extracts from the History of Cincinnati and the Territory of Ohio, Showing the Trials and Hardships of the Pioneers in the Early Settlement of Cincinnati and the West.* Cincinnati: Cohen, 1888.

Lepper, Bradley T., and Jeff Gill. "The Newark Holy Stones." *Timeline: A Publication of the Ohio Historical Society* 17, no. 3 (2000): 16–25.

Low, Charles F. "Archaeological Explorations Near Madisonville, Ohio." *Journal of the Cincinnati Society of Natural History* 3, no. 1 (1880): 40–68; no. 2 (1880): 128–39; no. 3 (1880): 203–20.

McGuffey, William H. *McGuffey's New Sixth Eclectic Reader: Exercises in Rhetorical Reading, with Introductory Rules and Examples.* Cincinnati: Winthrop B. Smith, 1857.

McMullen, Charles H. "The Publishing Activities of Robert Clarke & Co., of Cincinnati, 1858–1909." *Papers of the Bibliographical Society of America* 34, no. 4 (1940): 315–26.

Metz, Charles L. "The Prehistoric Monuments of Anderson Township, Hamilton County, Ohio." *Journal of the Cincinnati Society of Natural History* 4, no. 4 (1881): 293–305.

———. "The Prehistoric Monuments of the Little Miami Valley." *Journal of the Cincinnati Society of Natural History* 1, no. 3 (1878): 119–28.

Meyn, Susan Labry. "Cincinnati's Wild West: The 1896 Rosebud Sioux Encampment." *American Indian Culture and Research Journal* 26, no. 4 (2002): 1–20.

———. "Mutual Infatuation: Rosebud Sioux and Cincinnatians." *Queen City Heritage: Journal of the Cincinnati Historical Society* 52, no. 1–2 (1994): 30–48.

———. "Who's Who: The 1896 Sicangu Sioux Visit to the Cincinnati Zoological Gardens." *Museum Anthropology: Journal of the Council for Museum Anthropology* 16, no. 2 (1992): 21–26.

Moorehead, Warren K. "Commercial vs. Scientific Collecting. A Plea for 'Art for Art's Sake.'" *Ohio Archaeological and Historical Publications* 13 (1904): 112–17; 563–66.

———. *The Hopewell Mound Group of Ohio.* Anthropological Series 6. Chicago: Field Museum of Natural History, 1922.

———. "Recent Archaeological Discoveries in Ohio." *Scientific American Supplement* 34, no. 869 (August 27, 1892): 13886–90.

———. *The Stone Age in North America.* 2 vols. Boston: Riverside Press Cambridge, 1910.

Moses, L. G. "Indians on the Midway: Wild West Shows and the Indian Bureau at World's Fairs, 1893–1904." *South Dakota History* 21 (1991): 205–29.

———. *Wild West Shows and the Images of American Indians, 1883–1933.* Albuquerque: University of New Mexico Press, 1996.

"Mr. Catlin's Exhibition of Indian Portraits." *Western Monthly Magazine* 1 (1833): 535–38.

"Nate Salsbury Originated Wild West Show Idea." *Colorado Magazine* 32, no. 3 (1955): 204–14.

Niles' National Register. "The Wyandot Indians." August 26, 1843, 414–15.

Pratt, Richard Henry. *Battlefield and Classroom: Four Decades with the American Indian, 1867–1904.* New Haven, CT: Yale University Press, 1964.

Priest, Josiah. *American Antiquities, and Discoveries in the West.* Albany, NY: Hoffman and White, 1833.

Prucha, Francis Paul. *The Great Father: The United States Government and the American Indians.* 2 vols. Lincoln: University of Nebraska Press, 1986.

Quaife, Milo Milton, ed. *The Indian Captivity of O. M. Spencer.* New York: Citadel Press, 1968.

Read, M. C. "The Archaeological Exhibit for the Ohio Centennial." *Ohio Archaeological and Historical Publications* 1 (1887): 170–73.

Remington, Frederic. "A Gallop through the Midway." *Harper's Weekly* 37, no. 1920 (1893): 963.

Russell, Don. *The Lives and Legends of Buffalo Bill.* Norman: University of Oklahoma Press, 1961.

———. *The Wild West.* Fort Worth, TX: Amon Carter Museum of Western Art, 1970.

Rydell, Robert W. *All the World's a Fair: Visions of Empire at American International Expositions, 1876–1916.* Chicago: University of Chicago Press, 1984.

Sargent, Winthrop. "A Letter From Colonel Winthrop Sargent to Dr. Benjamin Smith Barton." *Transactions of the American Philosophical Society* 4 (1799): 177–80.

Shapiro, Henry D., and Zane L. Miller, eds. *Physician to the West: Selected Writings of Daniel Drake on Science and Society.* Lexington: University Press of Kentucky, 1970.

Shine, Carolyn R. "Art of the First Americans: In Search of the Past." In *Art of the First Americans: From the Collection of the Cincinnati Art Museum.* Cincinnati: Cincinnati Art Museum, 1976.

Spiess, Philip D., II. "Exhibitions and Expositions in 19th Century Cincinnati." *Cincinnati Historical Society Bulletin* 28, no. 3 (1970): 171–92.

Squier, Ephraim G., and Edwin H. Davis. *Ancient Monuments of the Mississippi Valley.* Smithsonian Contributions to Knowledge 1. Washington, DC: Smithsonian Institution Press, 1848. Reprint 1998.

Starr, Stephen Frederick. *The Archaeology of Hamilton County Ohio.* Cincinnati: Cincinnati Museum of Natural History, 1960.

Sutton, Walter. *The Western Book Trade: Cincinnati as a Nineteenth-Century Publishing and Book-Trade Center.* Columbus: Ohio State University Press, 1961.

Swanton, John R. *The Indian Tribes of North America.* Washington, DC: Smithsonian Institution Press, reprint 1979.

Tanner, Helen Hornbeck, ed. *Atlas of Great Lakes Indian History.* Norman: University of Oklahoma Press, 1987.

Tolzmann, Don Heinrich. *The First Description of Cincinnati and Other Ohio Settlements: The Travel Report of Johann Heckewelder (1792).* Lanham, MD: University Press of America, 1988.

Trennert, Robert A., Jr. "A Grand Failure: The Centennial Indian Exhibition of 1876." *Prologue* 6, no. 2 (1974): 118–29.

Tucker, Louis Leonard. "'Ohio Show-Shop': The Western Museum of Cincinnati, 1820–1867." In *A Cabinet of Curiosities: Five Episodes in the Evolution of American Museums,* by Whitfield J. Bell et al., 73–105. Charlottesville: University Press of Virginia, 1967.

Twenty-third Annual Report of the Zoological Society of Cincinnati for the Year 1896. Cincinnati: Webb Stationery and Printing, 1897.

Venable, W. H. *Beginnings of Literary Culture in the Ohio Valley.* Cincinnati: Robert Clarke, 1891.

———. "Literary Periodicals of the Ohio Valley." *Ohio Archaeological and Historical Publications* 1 (1887): 201–5.

Viola, Herman J. *Diplomats in Buckskins: A History of Indian Delegations in Washington City.* Washington, DC: Smithsonian Institution Press, 1981.

———. *The Indian Legacy of Charles Bird King.* Washington, DC: Smithsonian Institution Press, 1976.

Wheeler, Edward L. *Deadwood Dick Jr. in Cincinnati.* New York: Beadle and Adams, 1889.

Whittlesey, Charles. *Descriptions of Ancient Works in Ohio.* Smithsonian Contributions to Knowledge 3. Washington, DC.: Smithsonian Institution Press, 1850.

Williams, Samuel W. "The Tammany Society in Ohio." *Ohio Archaeological and Historical Publications* 22 (1913): 349–70.

Williams' Cincinnati Directory. Cincinnati: Cincinnati Directory Office, 1800–1900.

Archival Sources

Buffalo Bill Historical Society, McCracken Research Library
 Joseph H. Sharp papers
Cincinnati Museum Center, Cincinnati Historical Society
 James Albert Green papers
 Charles L. Metz papers
 Rookwood Collection
Cincinnati Museum Center, Cincinnati Museum of Natural History
 Enno Meyer Collection
National Archives, Washington, DC, and Kansas
 Records of the Bureau of Indian Affairs
Ohio Historical Society
 Warren K. Moorehead papers
 "Ninth Annual Report of the Ohio State Archaeological and Historical Society to the Governor for the Year 1893." This is an unpublished report, Mss 106, Archives 1175.

Public Library of Cincinnati & Hamilton County
 Rare Books and Special Collections, Theodore Langstroth Collection

Rookwood and the American Indian

Annual Reports, 1890–1934. Corporate Minutes of The Rookwood Pottery Company. Collection of
 Dr. and Mrs. Arthur J. Townley.
Art Academy of Cincinnati: Catalogues and Circulars for 1888–1905, and 1919. Art Academy of
 Cincinnati Collection. Cincinnati Art Museum Archives in The Mary R. Schiff Library.
Barber, Edwin AtLee. *Pottery and Porcelain of the United States.* New York: G. P. Putnam's Sons, 1893.
———. "A Typical American Pottery." *Art Interchange* 34 (January 1895): 2–5.
Boehle, Rose Angela. *Maria Longworth.* Dayton, OH: Landfall Press, 1990.
Bogue, Dorothy McGraw. *The Van Briggle Story.* Colorado Springs: Dorothy McGraw Bogue, 1968.
Bopp, Harold F. "Art and Science in the Development of Rookwood Pottery." *Bulletin of the American
 Ceramic Society* 5, no. 12 (1936): 443–45.
Brandt, Beverly K. "Worthy and Carefully Selected: American Arts and Crafts at the Louisiana Pur-
 chase Exposition, 1904." *Archives of American Art Journal* 28, no. 1 (1988): 2–16.
Branner, John Casper. "Bibliography of Clays and the Ceramic Arts." *United States Geological Survey*
 (1896): 5–114.
Brown, James A. "Mound Builders." *Encyclopedia of North American Indians, http://college.hmco.com/
 history/readerscomp/naind/html/na_023700_moundbuilder.htm* (accessed July 8, 2005).
Burt, S. G. *2,292 Pieces of Early Rookwood Pottery in the Cincinnati Art Museum in 1916.* Cincinnati:
 Cincinnati Historical Society, 1978.
Carter, Denny. *Henry Farny.* New York: Watson-Guptill, 1978.
Cincinnati Art Museum Archives in The Mary R. Schiff Library, Cincinnati Art Museum. Record
 Group 3, Series 4, Box 1, Records of the Duveneck Class 1890–1892.
Cincinnati Commercial. "Studio Studies. Hopkins, Lindsey, Farny, Dakin, Schmidt and Niehaus."
 December 1, 1881.
Cincinnati Commercial Gazette. "Excellent for Study: The Arrangement of the Paintings at the Art Mu-
 seum." October 10, 1890.
———. "New Art Class." May 19, 1890.
———. "New Art School: Mrs. Storer's Plans for a Rival to the Art Academy." May 18, 1890.
———. "No Woman, Art Museum Stockholders Refuse to Elect Mrs. Storer." March 4, 1890.
Cincinnati Daily Gazette. "Mrs. Nichols Pottery." September 13, 1880.
———. "War Among the Potters, T. J. Wheatley Secures a Patent on American Limoges." October
 7, 1880.
Cincinnati Enquirer. "Lo! The Poor Indian: Farny Discourses on Ye Noble Red Man." Pt 3. November
 8, 1881.
Cincinnati Museum Association Eighth Annual Report for the Year Ending December 31, 1888. Cincinnati:
 C. F. Bradley, 1889.
Cincinnati Post. "Spooks." June 3, 1892.
Cincinnati Times Star. "Duveneck Art Class: Academy Pupils Who Are to Receive Free Scholarships."
 Cincinnati, no date. Newspaper clipping found in The Cincinnati Art Museum Scrapbook,
 vol. 1, 88.
———. "Under Favorable Auspices: The New Painting Class Begins Its Work." October 22, 1890.

Cist, Charles. *Cincinnati in 1859.* Cincinnati: Charles Cist, 1859.

Cook, Clarence, ed. "Designs by Mr. Edward P. Cranch, Made for the Rookwood Pottery." *The Studio* 2, no. 7 (January 1887): 118–20.

"Craft of Rookwood Potters." *World's Work Advertiser,* August 1904, n.p.

Cummins, Virginia Raymond. *Rookwood Pottery Potpourri.* Silver Spring, MD: Cliff R. Leonard and Duke Coleman, 1980.

Dietz, Ulysses G. *The Newark Museum Collection of American Art Pottery.* Newark, NJ: Newark Museum, 1984.

Duveneck, Josephine W. *Frank Duveneck: Painter—Teacher.* San Francisco: John Howell, 1970.

Eidelberg, Martin, ed. *From Our Native Clay: Art Pottery from the Collections of the American Ceramic Arts Society.* New York: Turn of the Century Editions, 1987.

Ellis, Anita. "American Tonalism and Rookwood Pottery." In *The Substance of Style: Perspectives on the American Arts and Crafts Movement,* edited by Bert Denker, 301–15. Winterthur, DE: Henry Francis du Pont Winterthur Museum, 1996.

———. *The Ceramic Career of M. Louise McLaughlin.* Athens: Ohio University Press, 2003.

———. *Rookwood Pottery: The Glaze Lines.* Atglen, PA: Schiffer, 1995.

———. *Rookwood Pottery: The Glorious Gamble.* New York: Rizzoli International, 1992.

Faragher, John Mack, ed. *Rereading Frederick Jackson Turner.* New York: Henry Holt, 1994.

Fenn, Forrest. *The Beat of the Drum and the Whoop of the Dance.* Santa Fe, NM: Fenn, 1983.

Fleming, Paula Richardson, and Judith Luskey. *Grand Endeavors of American Indian Photography.* Washington, DC.: Smithsonian Institution Press, 1993.

———. *The North American Indians in Early Photographs.* New York: Barnes and Noble Books, 1987.

Frelinghuysen, Alice Cooney. *American Art Pottery: Selections from the Charles Hosmer Morse Museum of American Art.* Seattle: University of Washington Press, 1995.

Gensel, Dr. "Tiffany Gläser—Rookwood Kunst Töpfereien." *Deutsche Kunst und Dekoration* 7 (November 1900): 90–98.

Golden Age: Cincinnati Painters of the Nineteenth Century Represented in the Cincinnati Art Museum. Cincinnati: Cincinnati Art Museum, 1979. An exhibition catalogue.

Gray, Walter Ellsworth. "Latter-Day Developments in American Pottery—III." *Brush and Pencil* (March 1902): 353–60.

Hassrick, Peter H., and Michael Edward Shapiro. *Frederic Remington: The Masterworks.* New York: Harry N. Abrams, 1988.

Holmes, William H. "Art in Shell of the Ancient Americans." In *Second Annual Report of the Bureau of Ethnology, The Smithson Institution, 1880–81,* 185–305. Washington, DC: GPO, 1883.

James Earl Fraser: American Sculptor—A Retrospective Exhibition of Bronzes from Works of 1913 to 1953. New York: Kennedy Galleries, 1969.

Johnson, Kathleen Eagen. "Frans Hals to Windmills: The Arts and Crafts Fascination with the Culture of the Low Countries." In *The Substance of Style: Perspectives on the American Arts and Crafts Movement,* edited by Bert Denker, 47–67. Winterthur, DE: Henry Francis du Pont Winterthur Museum, 1996.

Kasson, Joy S. *Buffalo Bill's Wild West: Celebrity, Memory, and Popular History.* New York: Hill and Wang, 2000.

Keen, Kirsten Hoving. *American Art Pottery 1875–1930.* Wilmington: Delaware Art Museum, 1978.

Koehler, Vance A. *American Art Pottery: Cooper-Hewitt Museum.* Washington, DC: Smithsonian Institution, 1987.

Limerick, Patricia. *Legacy of Conquest.* New York: Norton, 1982.

Limerick, Patricia, Clyde A. Milner II, and Charles E. Rankin, eds. *Trails: Towards A New Western History*. Lawrence: University Press of Kansas, 1991.

"Louisiana Purchase Exposition Ceramics: Rookwood Pottery." *Keramic Studio* 7, no. 9 (January 1905): 193–94.

McDonald, W. P. "Rookwood at the Pan-American." *Keramic Studio* 3 (November 1901): 146–48.

Meyn, Susan Labry. "Cincinnati's Wild West: The 1896 Rosebud Sioux Encampment." *American Indian Culture and Research Journal* 26, no. 1 (2002) 1–20.

———. "Mutual Infatuation: Rosebud Sioux and Cincinnatians." *Queen City Heritage* 52 (Spring/Summer 1994): 30–48.

———. "Who's Who: The 1896 Sicangu Sioux Visit to the Cincinnati Zoological Gardens." *Museum Anthropology* 16, no. 2 (June 1992): 21–26.

Montgomery, Susan J. *The Ceramics of William H. Grueby*. Lambertville, NJ: Arts and Crafts Quarterly Press, 1993.

Nelson, Marion John. *Art Pottery of the Midwest*. Minneapolis: University Art Museum, University of Minnesota, 1988.

Nicholson, Nick, Marilyn Nicholson, and Jim Thomas. *Rookwood Pottery: Bookends, Paperweights, Animal Figurals*. Paducah, KY: Collector Books, Schroeder Publishing, 2002.

Official Catalogue of Exhibitors, Universal Exposition, St. Louis, U.S.A., 1904. St. Louis: Official Catalogue Company, 1904.

Official Catalogue of Exhibits: Department of Art. St. Louis: Official Catalogue Company, 1904.

Owen, Nancy. *Rookwood and the Art of Industry: Women, Culture, and Commerce, 1880–1913*. Athens: Ohio University Press, 2000.

———. *Rookwood Pottery at the Philadelphia Museum of Art: The Gerald and Virginia Gordon Collection*. Philadelphia: Philadelphia Museum of Art, 2003.

Peck, Herbert. *The Book of Rookwood Pottery*. Tucson: Herbert Peck Books, 1986.

Phillips, Kevin. *Wealth and Democracy: A Political History of the American Rich*. New York: Broadway Books, 2002.

Quick, Michael. *An American Painter Abroad: Frank Duveneck's European Years*. Cincinnati: Cincinnati Art Museum, 1987. An exhibition catalogue.

Renner, Frederick G. *Charles M. Russell: Paintings, Drawings, and Sculpture in the Amon G. Carter Collection*. Fort Worth: University of Texas Press, 1966.

Rennert, Jack. *100 Posters of Buffalo Bill's Wild West*. New York: Darien House, 1976.

Report of the President of the Board of Directors of the World's Columbian Exposition: Chicago 1892–1893. Rand McNally, 1898.

Robotham, Tom. *Native Americans in Early Photographs*. Emmaus, PA: JG, 1994; reprinted North Dighton, MA: World Publishing Group, 2004.

Rookwood Book: Rookwood, an American Art. Cincinnati: Rookwood Pottery Company, 1904.

Rookwood Pottery. Cincinnati: Rookwood Pottery Company, 1894.

Rookwood Pottery Booklet, 1894. New York Public Library, Art Division.

"Rookwood Pottery for Paris Exhibit." *Keramic Studio* 1 (March 1900): 221, 228, 231.

Rookwood Pottery Letterpress Books for December 21, 1886–January 5, 1889, December 5, 1889–May 17, 1892. Rookwood Pottery Collection, Mitchell Memorial Library, Mississippi State University.

Rookwood Pottery Letterpress Book for January 5–December 5, 1889. Cincinnati Historical Society Library at The Museum Center.

Rookwood Pottery Marketing Circulars and Catalogues, 1900, 1901, 1902, 1904, 1915. Rookwood Collection. Cincinnati Art Museum Archives, The Mary R. Schiff Library.

Rookwood Pottery Pamphlet, 1889. New York Public Library, Art Division.

Ross C. Purdy Collection. Cincinnati Historical Society Library at The Museum Center.

S., J. R. "The Art Museum: Here Is Somebody Who Doesn't Like the Man agement [*sic*]." *Cincinnati Commercial Gazette.* March 7, 1890.

Storer, Maria Longworth. "The Cincinnati Art School and Foreign Scholarships." *Cincinnati Commercial Gazette.* March 7, 1890.

Taft, Robert. "The Pictorial Record of the Old West: Artists of Indian Life: Henry F. Farny." Pt. 10. *Kansas Historical Quarterly* 18, no. 1 (February 1950): 1–19.

The Taft Museum: European and American Paintings. New York: Hudson Hills, 1995.

Tarbell, Ida M. "Pottery and Porcelain." *Chautauquan* 8, no. 4 (January 1888): 220–22.

Taylor, William Watts. "The Rookwood Pottery." *Forensic Quarterly* (September 1910): 203–18.

"Topics of the Times: Cincinnati." *Scribner's Monthly* 10 (August 1875): 510–11.

Trapp, Kenneth R. *Ode to Nature: Flowers and Landscapes of the Rookwood Pottery 1880–1940.* New York: Jordan-Volpe Gallery, 1980.

———. "Rookwood Pottery: The Glorious Gamble." In *Rookwood Pottery: The Glorious Gamble,* 11–41. New York: Rizzoli International, 1992.

———. *Toward the Modern Style: Rookwood Pottery the Later Years 1915–1950.* New York: Jordan-Volpe Gallery, 1983.

Turner, Frederick Jackson. "The Significance of the Frontier in American History." In *Rereading Frederick Jackson Turner,* edited by John Mack Faragher. New York: Henry Holt, 1994.

Valentine, John. "Rookwood Pottery." *House Beautiful* 4, no. 4 (September 1898): 120–29.

Watkins, Marie. "Painting the American Indian at the Turn of the Century: Joseph Henry Sharp and his Patrons, William H. Holmes, Phoebe A. Hearst, and Joseph G. Butler Jr." PhD diss., Florida State University, 2000.

"What the Columbian Exposition Will Do for America." *Century* 44, no. 6 (October 1892): 953–55.

White, Richard. *It's Your Misfortune and None of My Own.* Norman: University of Oklahoma Press, 1991.

Archival Sources

Buffalo Bill Historical Society, McCracken Research Library
 Joseph H. Sharp papers
Cincinnati Art Museum Archives
 Rookwood Collection
Cincinnati Museum Center, Cincinnati Historical Society
 Rookwood Collection
Mitchell Memorial Library, Mississippi State University
 Rookwood Pottery Collection
Public Library of Cincinnati & Hamilton County
 Rare Books and Special Collections, Theodore Langstroth Collection

Index

Afraid of the Bear, 194–95
ale set, 78–80, 111
Allison, James, 19
American Exhibition (London), 67–68
American Indians
 and American culture, 113–14
 artistic stereotypes, 24
 conflict with early settlers, 4–7
 connections with Cincinnati, introduction, vii–viii
 delegations and visits east, 19–20
 Duveneck's interest in, 62
 in 1890 census, 27–28
 ethnological displays, 15, 19, 29–33. *See also* Cincinnati
 Zoo
 hiring from reservations, 34–35
 idealized portrait, 159
 mounds. *See* mounds
 observations regarding, 48–51
 performance in shows. *See* Wild West
 plight of, as metaphor for loss, 114–16
 in popular literature, 7–8
 reasons for imagery, xv
 romanticized ideal, 2
 on Rookwood pottery. *See* Indian Rookwood
 variations in names, 131
 villages burned, 5
 See also individual tribal names
American Indians, live exhibits of
 as attendance boosters, 19
 at 1876 Philadelphia Centennial Exhibition, 18
 See also Cincinnati Zoo
Americanism, search for identity, 82–83
Anderson, John A., 36
anthropology
 and art history, combined in exhibition, ix
 emerging role in expositions, 17–18
antiquities and artifacts
 early collections, 2–3
 excavated, 12–13
 in Western Museum, 13–14
Apache, 24, 49, 181, 251. *See also* Kiowa-Apache
Arapaho, 46, 143, 165, 259, 265
archaeology, Cincinnati, 11–13
architectural plaque, 202–5
Ariel Blue glaze line, 88–89

Arikara, 239
Art Academy of Cincinnati, and Maria Longworth
 Storer, 73–75
art history, and anthropology, combined in exhibition,
 ix
"Art in Shell of the Ancient Americans," 69, 71, 150–51,
 251–52
The Artist in His Museum, 16–17
Arts and Crafts Movement, and Frederick Allen Whiting,
 101
Assiniboine, 197

baby, Ute, 220–21
Bailey, Joseph, 143
Baird, Spencer F., 18
Baker, Constance, 96
Barber, Edwin AtLee, 85, 88, 110, 158
Beadle and Co., 7
Bear, Oliver T., 42–43
Bell, Charles Milton, 173, 185, 223, 239
Belt, Arthur. *See* Blokaciqa
Big Mouth Hawke, 142–43
birdstone, slate, 15
Black Bear, 41
Blackfoot, 157
Black Hawk, Sauk, 20
Black Hawk, Sioux, 43
blankets
 Navajo, 38
 trade, 146–47
Blokaciqa, 42, 43, 49–50
Bloody Mouth, 116, 148–50
Bodmer, Karl, 20–21
bookends, 104, 106
A Boy's Town, 22, 23
Bozeman Trail, 179, 199
Brain, Elizabeth Wheldon, 96, 108, 111
 bio, 133
 loving cup, 133–35
buffalo, near extinction, 28, 132
Buffalo Bill. *See* Cody, William F. "Buffalo Bill"
Buntline, Ned, 7, 24–25
Bureau of Ethnology, 11
 reports, 69, 71
 as source of photographs, 85, 115, 116, 233, 235

Bureau of Indian Affairs (BIA), 18
 and ethnological exhibits, 33
 orders to cut hair, 49–50
Burt, Pitts Harrison, 165, 247
Burt, Stanley Gano, 158, 271
 award to, 96
 and mat glazes, 98
 and Seger cones, 93
Bushy Tail, 190–91

Catlin, George, 2, 20–21
Centennial Exposition of the Ohio Valley and Central
 States (1888), 13, 14, 16
ceramics, field open to women, 62
Chelsea Keramic Art Works, 145
Cherokee, and Indian Removal Act, 21
Cheyenne, 46
Cheyenne River Reservation, 33
Chicago Exposition of 1893. See World's Columbian
 Exposition (1893)
"chief," confusion around term, 131
Chippewa, trip through Cincinnati, 23–24
Choate, John N., 181
Cincinnati
 archaeology, 11–13
 art academy (see Art Academy of Cincinnati, and
 Maria Longworth Storer)
 attitudes and perceptions of Indians, 2–3
 Buffalo Bill in, 24–25
 centennial celebration, 16, 70–72
 connections with American Indians, introduction,
 vii–viii
 dime novels set in, 7
 early view, 4
 frontier period, 1–2
 and Indian Removal Act, 21–24
 observations about Sicangu time in, 48–51
 Western Museum, 13–14
 Wild West, 34–45, 91
Cincinnatians, early, and Indian mounds, 8–10
Cincinnati Art Club, 51, 92
Cincinnati Art Museum, Indian specimens in 1889, 72
Cincinnati Industrial Exposition (1879), 16
Cincinnati Museum Association, and Maria Longworth
 Storer, 74–75
Cincinnati Tablet, 9–10, 11–12
Cincinnati Zoo
 Cree encampment, 34–36, 89–90
 financial failure of Sicangu exhibit, 45
 Sicangu encampment, 36–45, 91–92, 204, 217
Clark, William, 132
Clarke, Robert
 and Cincinnati Tablet, 10
 publishing firm, 7, 8
clay, technical difficulties, 233
Cleneay, Thomas, 14–15, 71
clothing, Indians', 38–39, 40, 132
Cody, William F. "Buffalo Bill," 2, 7
 in London, 67–68

poster, 162
and Wild West, 24–26
zoo exhibition modeled after, 34
collectors, 71
 early, 2–3
 and rise of expositions, 14–17
Collis, R. O., collection, 71–72
colors
 blue substituted for red, 92
 comparing lithograph to fired pottery, 87
 Grueby green, 97
 slip, 81
composition, simplified, 115
conflict, between early settlers and Indians, 4–7
Cook, Clarence, 67
copper overlay, 153
correspondence. See letters
The Cotton States and International Exposition (1895),
 89
coup stick, 166
Cox, Joseph, 14, 71
Cree, encampment in Cincinnati, 34–36, 89–90
Crow, 135, 211, 215, 267
crucible pitchers
 Daly, 80–81
 Horsfall, 164–66
 Van Briggle, 72–73

Dakota Hunkpapa, 149
Dakota Yanktonai, 195
Daly, Matt, 93, 95
 artistic quality, 112
 bio, 137
 crucible pitcher, 80–81
 departure from Rookwood, 103
 dramatic lighting, 115–16
 salary, 111
 vases, 138–39, 140–41, 142–43, 144–45, 146–47, 148–51,
 152–54
Davis, Edwin, 11
Davis Collamore and Co., 80
decorations, grotesque, 78, 121
Delaware, imprisoned at Fort Washington, 5
Demarest, Virginia, 96
Dengler, Frank, 61
Descriptions of the Ancient Works in Ohio, 11
Diaz, Pablino. See Big Whip
Diers, Edward George, 104–5
Diez, Wilhelm, 61–62
dime novels, 7, 24
Donaldson, Thomas, 27
Dorfeuille, Joseph, 13–14
Drake, Daniel, 4–6
 and Indian mounds, 8–9
 and Western Museum, 13
Duveneck, Frank, 60–62
 classes, 75–77
 hiring as Rookwood teacher, 74–75
 Indian Head, 64

legacy, 77–78, 91
 self-portrait, 63
Eagle Deer, 47, 216–17, 260–61
 sister of, 43
eagle feather warbonnet, illustration, 51
Eastern Woodland Indians, 2
Eclectic Readers series, 7–8
ethnology
 displays of American Indians, 15, 19, 29–33
 See also Bureau of Ethnology
European potteries, vs. American potteries, 102
excavation, Indian mounds, 12–13
expositions
 adding sideshows and other popular attractions, 15
 Centennial Exposition of the Ohio Valley and Central
 States (1888), 13, 14, 16
 Cincinnati Industrial (1879), 16
 The Cotton States and International (1895), 89
 emerging role of anthropology, 17–18
 exhibiting piece at multiple, 269
 industrial, 16
 International Exposition of Modern Decorative Art
 (Turin, Italy), 99
 live Indians as attendance boosters, 19
 Louisiana Purchase (1904), 100–102
 Ohio Valley and Central States, 13
 Omaha Trans-Mississippi and International (1898),
 93–94, 249
 Pan-American (1901), 98
 Paris Universal (1900), 94–96
 rise of, and collectors, 14–17
 "sketchbook" for, 16–17
 various, in 1901, 97
 See also World's Columbian Exposition (1893)

"fancy heads," 88, 90–91
Farny, Henry
 bio, 155
 and ethnologic displays at World's Columbian Exposi-
 tion, 30
 and first Indian decoration, 65–66
 illustration of Indian family, 21–22
 photographs of Sicangu, 46–47, 92
 pictured, 61
 plaque, 156–59
 relationship with Sicangu, 42
 sensitivity toward Indians, 49–50, 113–14
 and Sitting Bull, 27
 sketchbook illustration, 16–17
Felten, Edith Regina, 96
firing, limitations with Farny's plaque, 158
food, eaten by Sicangu, 38–39
Force, Manning Ferguson, 14
Fort Laramie, treaty, 199–200
Fort Washington, Indians imprisoned at, 5–6
Fort Yates, Farny's visit, 65, 157–58
frontier period
 and Cincinnati, 1–2
 closing, 28–29

Gardner, Alexander, 139, 143, 149, 157, 189, 195, 199
Gardner, James J., ix
Geronimo, 49, 250–53
Ghost Dance, 26
ghostly decorations, 78, 121
glazed pottery. *See* mat-glazed ware; Standard glaze;
 Vellum glaze line
glaze lines, new, 88–89, 102
Goes to War, 35, 36, 40, 99
Goetz, John, Jr., 34, 36, 45
Good Voice Eagle, 42, 43–45
gorgets, 69–71
 on loving cup, 250–53
 in Matt Daly's work, 116
 on vase, 148–51
Gorham Manufacturing Company, 163, 215
Goshorn, Alfred T., 16, 17
Grass, John, 156–59
graves, limestone, located in Ohio, 32
Great Plains Indians, 2
 clothing and ornamentation, 132
 and public imagination, 20–21
 vs. Pueblo Indians, 269
Green, James Albert, 207–8
Grueby Pottery, 97–98
Guest, Moses, 10

haircuts
 BIA's orders, 49–50
 transitioning to, 181
hair ornament, 143
hair pipe ornaments, worn by men vs. women, 247
Hall, James, 6, 20
Harrison, William Henry, and Indian mounds, 8–9
Hauser, John, 49–51
Haviland and Co., 225
Heck, Will S., 34–35, 42, 44, 47
Heckewelder, Johann, 5–7
Heyn, Herman, 263
Hidatsa, 185, 223, 229
Hidatsa-Mandan, 141
High Bear, 168–69
High Hawk, 262–63
Hillers, John K., 191, 193, 233, 235
Historical Cincinnati, 40
History of the Indian Tribes of North America, 20
Hollow Horn Bear, 224–26, 256–57
Hopi, 193, 234–36
horses, stealing, 5
Horsfall, Bruce, 86–87, 90–91
 bio, 161
 crucible pitcher, 164–66
 departure from Rookwood, 103
 vase, 162–63
Howells, William Dean, 22, 23
Hudson River School of American painting, 82–83
Hunkpapa, 189. *See also* Dakota Hunkpapa
Hurley, Edward T., 91–92
 bio, 167

Hurley, Edward T. *(continued)*
 departure from Rookwood, 103
 vases, 103–4, 168–69
Indian Congress, at Omaha Trans-Mississippi and International Exposition, 94
Indian Head, 64
Indian Removal Act, Cincinnati and, 21–24
Indian Rookwood artists, 92–93, 96
 best, 111–13
 departures, 103
 list of, 273
 See also Baker, Constance Amelia; Brain, Elizabeth Wheldon; Daly, Matt; Demarest, Virginia; Farny, Henry; Horsfall, Bruce; Hurley, Edward T.; King, Flora; Laurence, Frederick Sturgis; Markland, Sadie; McDonald, William P.; Noonan, Edith; Rauchfuss, Marie; Reed, Olga Geneva; Sehon, Adeliza Drake; Strafer, Harriette Rosemary; Swing, Jeanette Carick; Toohey, Sarah Alice; Valentien, Anna; Van Briggle, Artus; Wilcox, Harriet Elizabeth; Young, Grace
Indian Rookwood pottery
 bookends, 104, 106
 Farney's first decoration, 65–66
 first depiction, 72–73
 first motifs, 69–70
 ironies, 117–18
 movement toward portraiture, 88
 mugs, 104, 106
 number produced, 105, 107
 plaque, 98–99
 sentimental depictions, 87–88
 at World's Columbian Exposition, 84–88
 See also ale set; bookends; crucible pitchers; jug with stopper; loving cups; mugs; pitchers; plaques, Indian; pocket vases; portraiture, Indian; vases
Indians. *See* American Indians
Indian Scout, poster and vase, 162–63
industrialization, as loss, 114–15
International Exposition of Ceramics and Glass (1901), 97
International Exposition of Modern Decorative Art (Turin, Italy), 99
Iris glaze line, 102–3
 Edward George Diers vase, 104–5
 introduction, 88–89
 plaques, 271
 sales, 96
Iroquois, 32
Ives, Halsey Cooley, 83, 100–101

Jackson, William Henry, photo by, 183
Joseph (Chief), 175–76
Journal of the Cincinnati Society of Natural History, 12
Judson, E.Z.C. *See* Buntline, Ned
jug with stopper, 222–23

Kelley, T. H., 40
Kickapoo, imprisoned at Miami, 5
Kidd, H. A., 7

King, Charles Bird, 20
King, Flora, 104–5, 106
Kiowa-Apache, 139, 255
Kiowas
 engaged in activity (plaque), 270–71
 engaged in activity (vase), 248–49
 Lone Wolf, 187
 Pablino Diaz, 145
Kohl and Middleton's Dime Museum, 33, 36

Lacóte, 140–141, 228–229
Lakota Archives and Historical Research Center, 46
Lakota Sioux, 30, 203, 204, 207, 217, 225, 247, 257, 261, 263. *See also* Sicangu
"The Last Scene of the Last Act of the Sioux War," 27
Laurence, Frederick Sturgis, 91, 93, 96
 artistic quality, 111–12
 bio, 171
 departure from Rookwood, 103
 loving cup, 172–73
 mugs, 177–89
 pitcher, 174–76
 vases, 190–200
Lean Wolf, 184–85, 222–23
Leibl, Wilhelm, 62
letters
 between Blokaciqa and Sharp, 50
 from Duveneck in Munich, 64
 between Enno Meyer and Sicangu Indians, 41–43
Lewis, Meriwether, 132
lighting, dramatic, 115–16
Literary and Scientific Society of Madisonville, 12–13
literature, popular, American Indians in, 7–8
Little Bald Eagle, 35, 36
Little Left Hand Bull, death, 41
London, Wild West in, 67–68
Lone Wolf, 186–87
Longworth, Joseph, 73
Longworth, Maria. *See* Nichols, Maria Longworth; Storer, Maria Longworth
Louisiana Purchase Exposition (1904), 100–102
loving cups
 Brain, 134–35
 Laurence, 172–73
 Sehon, 220–21
 Strafer, 228–29
 Wilcox, 238–40
 Young, 250–53

Madisonville Society. *See* Literary and Scientific Society of Madisonville
Mandan, 21
maps
 current reservations, 131
 "Federal and State Reservations," xvi
 prehistoric earthworks and Cincinnati streets ca. 1960, 9
marketing, gender in, 78–79
Markland, Sadie, 93
masculine subject matter, 78, 80
mat-glazed ware, 97–98

emphasis shifted to, 99
Van Briggle's role in initiating, 124
McChesney, Charles E., 35
McDonald, William P., 91, 92–93, 94
 artistic quality, 112
 bio, 201
 bookends, 104, 106
 departure from Rookwood, 103
 plaque, 202–5
 salary, 111
 as shape designer, 139, 147, 211
 vase, 206–8
McGuffey, William Holmes, 7–8
McKenney, Thomas L., 20
McKenzie, Valentine, 35, 37, 41
McKinley Club, 40
Menzel, John Jacob, 199, 207, 215, 217, 255
Metz, Charles L., 12–13, 16, 30–31
Meyer, Enno, 41–43, 46, 49, 51, 92
Miami, 5, 23
"Miami slaughter house," 2, 3
Mohawk, 8
monks, as subject matter, 80–82
Moorehead, Warren K., 30–32
Morgan, Thomas J., 32
mounds
 artifacts in Western Museum, 13–14
 early Cincinnatians and, 8–10
 exhibits from, 70–72
 gorgets from, 149–51
Mount Adams, move to, 80
mugs
 King, 104, 106
 Laurence, 177–79, 180–81, 182–83, 184–85, 186–87,
 188–89
 See also loving cups
Muhr, Adolph F., 219
Munich, Frank Duveneck in, 60–62

Nasuteas-Kichai, 152–54
"A Nation's Cry," 116
Native American. See American Indian
Natural and Statistical View, or Picture of Cincinnati and
 the Miami Country, 8
Nevin, Fred E., 35
New Sixth Eclectic Reader, 8
Newton, Clara Chipman, 158
Nez Percés, 175–76
Nichols, Maria Longworth, 62–63. See also Storer, Maria
 Longworth
Noble, Thomas Satterwhite, 73–74
Noonan, Edith, 100
Northwest Coast, 32

Oakley, Annie, 25
O'Fallon, Benjamin, 20
Ohio Mechanics Institute, 13, 15, 16
Ohio River, and early Cincinnatians, 3
Ohio Valley and Central States Exposition, 13
Ohio Valley Historical Series, 7, 8

Old Masters
 Duveneck's imitation of, 61–62
 fancy heads by Grace Young, 100
 style on Rookwood pottery, 88
 taught by Duveneck, 77–78, 91
Omaha Trans-Mississippi and International Exposition
 (1898), 93–94, 249
Oto, 191
Ouray, 182–83
overlay
 copper, 153
 silver, 162–63, 214–15, 250–51
Owen, Nancy, 87–88, 113, 114
Owns The Dog, 47, 206–8

Pacer, 180–81
paint, slip, 81
Pan-American Exposition (1901), 97, 98
Paris Universal Exposition (1900), 94–96
Pawnee, 25
Pawnee Bill's Historic Wild West and Great Far East
 Show, 45, 46
peace medal, 189, 240
Peale, Charles William, 16–17
Peo, 244–45
Philadelphia Centennial Exhibition (1876), 17–18
photographers
 list of, 275
 working for Rookwood, 123
 See also Baker, Constance; Bell, Charles Milton;
 Choate, John N.; Gardner, Alexander; Heyn, Her-
 man; Hillers, John K.; Kelley, T.H.; Meyer, Enno;
 Muhr, Adolph F.; Rinehart, Frank A.; Rose & Hop-
 kins Studio; Sawyer, Wells Moses; Shindler, Anto-
 nio Zeno; Soule, William Stinson
photographs
 by Bureau of Ethnology, 69, 115, 116
 identifying, 46–47
 at Omaha Trans-Mississippi and International Exposi-
 tion, 94
 selected for subject matter, 115
 taking, of Sicangu, 41–43, 92
Piankeshaw, 5
Pine Ridge Reservation
 hiring Indians from, 26, 34
 Massacre at Wounded Knee, 26
pitchers
 to ale set, 174–76
 crucible, 72–73, 80–81, 164–66
 Young, 246–47
Plains Indians. See Great Plains Indians
plaques, Indian, 85–86, 98–99
 of 1881, 65–66
 Farny, 156–59
 McDonald, 202–5
 Van Briggle, 231–33, 234–36
 Young, 262–63, 264–65, 266–67, 270–71
pocket vases
 Sehon, 224–26
 Young, 260–61

poetry, on Indian mounds, 10
Ponca, 173
portraiture
 best artists, 111–13
 as decoration, beginnings, 80–82
 movement toward, 88
 quality demands for, 107–8
 See also "fancy heads"
portraiture, Indian, 88, 93–94
 aftermath, 103–5
 decrease in, 98–100
 end of, 100–102
 increase in, 96
 vs. non-Indian, 93
poster, "An American," 86–87
Powder Face, 164–66
Powontonamo, 8
Pratt, Richard Henry, 33
Prayer on the Battlefield, 61
The Pre-Historic Remains Which Were Found on the Site of
 the City of Cincinnati, Ohio With a "Vindication of
 the Cincinnati Tablet," 10
pricing, 109–10
print technique, 158
productivity
 and Cree encampment, 89–91
 improved with new technology, 93
Public Library of Cincinnati and Hamilton County,
 46
Pueblo Indians
 Songlike, 269
 vs. Great Plains Indians, 269
Putnam, Frederic W., 12, 29–30, 33
Putnam, Rufus, 5–6
pyrometer, 93

Quivera, Pedro José, 231–33

rabbit hunters, 192–93
Rauchfuss, Marie, 93
Red Cloud, 198–200
Reed, Olga Geneva, 93
 artistic quality, 112
 bio, 209
 departure from Rookwood, 103
 vase, 210–11
Remington, Frederic, 30, 113
Report on Indians Taxed and Indians Not Taxed, 27
reservations
 maps, xvi, 131
 Pine Ridge, 26, 34
 Rosebud, 34–35, 42
 scarcity on, 34
Riggs, C. W., collection, 72
Rinehart, Frank A.
 as Bureau of American Ethnology photographer, 94
 photos by, 135, 145, 153, 169, 197, 211, 215, 225, 247, 249,
 251, 255, 257, 267, 269, 271
Robert Clarke & Co., 7
Robertson, Hugh, 145

Rookwood artists
 criteria for hiring, 108–9
 gender bias and salary disparity, 110–11
 not painting Indians, 107
 signatures and recognition, 110
 See also Indian Rookwood artists
Rookwood pottery
 considerations with firing, 158
 Indian images on (see Indian Rookwood pottery)
 pricing, 109–10
 quality demands, 107–8, 110
 size of pieces, 89
 subject matter, 68, 72, 73, 78, 80, 103
 at World's Columbian Exposition, 83–84
 See also ale set; bookends; crucible pitchers; jug; loving
 cups; mugs; pitchers; plaques; pocket vases; vases
Rookwood Pottery Company
 architecture department, 205
 awards at Paris Universal Exposition, 96
 bankruptcy and sale, 233
 beginnings, 62–63
 between 1881 and 1888, 66–67
 first classes, 75–77
 move to Mount Adams, 80
 productivity, and Cree encampment, 89–91
 promotion of, prior to Paris Universal Exposition, 96
 Sicangu photographed at, 92
 Taylor as president and treasurer, 79–80
 and Wild West, 67–68
Rookwood's Showroom (Mount Adams), 90
Rose & Hopkins Studio, 147, 265
Rosebud Reservation
 hiring Indians from, 34–35
 insight into lifestyle, 42
 See also Sicangu
Royal Academy of Fine Arts (Munich), 60–61
Royal Copenhagen, 154
Running Antelope, 188–89
Rushing Bear, 238–40
Russell, Charles M., 113

Sargent, Winthrop, 8
Sauk, 20
Sawyer, Wells Moses, 175
Schmidt, Carl, 107
The Scouts of the Prairie, 24
Sea Green glaze line, introduction, 88–89
Seger cones, 93
Sehon, Adeliza Drake, 96
 artistic quality, 112
 bio, 213
 jug with stopper, 222–23
 loving cup, 220–21
 vases, 214–15, 216–17, 218–19, 224–26
settlers
 captured, 6–7
 early, conflict with Indians, 4–7
Sharp, Joseph Henry, 49–50, 51, 84–85
 relationship with Sicangu, 42, 43
 sensitivity toward Indian plight, 114

shell gorgets, 69–71
Shindler, Antonio Zeno, 243
Shirayamadani, Kataro, 107, 111, 243
Shoshone, 147
Shreves and Co., 153
Sicangu
 Cincinnati Zoo encampment, 36–45, 91–92, 204, 217
 evaluation of Cincinnati visit, 46–47
 images from Rookwood Pottery collection, 47
 observations about time in Cincinnati, 48–51
 photographing, 41–43, 92
"The Significance of the Frontier in American History," 28–29
silver overlay, 162–63, 214–15, 250–51
Sinte Gleska University, 46
Sioux, 25
 High Bear, 169
 government's attempt to break up, 159
 and Massacre of Wounded Knee, 26–27
 Oglala band, 199–200
 Spotted Tail, 179
 Susie Shot In The Eye, 219
 surrender of, 65
 See also Lakota Sioux; Sicangu; Sitting Bull
Sitting Bull, 25
 death of, 26–27
 surrender of, 65
Sleeping Bear, 219, 246–47
slip colors, painting with, 81
Smith, Thomas, 35
Smithsonian Contributions to Knowledge, 11
Smithsonian Institution. See Bureau of Ethnology
Songlike, 268–69
Soule, William Stinson, 165
Southwestern Literary Journal and Monthly Review, 7
Spencer, Oliver, 6–7
Spotted Jack Rabbit, 134–35, 210–11, 214–15, 266–67
Spotted Owl, 36
Spotted Tail, 177–79
Squier, Ephraim, 11
stamps, scarcity on reservation, 42
Standard glaze
 compatibility with fancy heads, 91
 giving way to mat glaze, 100, 102
 vs. new glazes, 88–89
Standing Bear, 173
Storer, Maria Longworth
 turning company over to Taylor, 79
 vs. Art Academy of Cincinnati, 73–74
 See also Nichols, Maria Longworth
Stories of Ohio, 23
Strafer, Harriette Rosemary, 96
 bio, 227
 loving cup, 228–29
Striker, 138–39
students, Duveneck's first classes, 76–77
subject matter
 carefully selected images, 115
 changes in, 73, 78, 80, 103

Rookwood pottery, 68, 72
 See also portraiture
Suriap, 242–43
Susie Shot In The Eye, 218–19
Swing, Jeannette Carick, 96
Symmes, John Cleves, 6

Tamenend, 3
Tammany Society, 3
Taylor, William Watts
 award to, 96
 beginning interest in Indian imagery, 67–69
 and copper overlay, 153
 and Frederick Allen Whiting, 101
 and gender in marketing, 78–79
 hired at Rookwood, 66
 hiring practices, 108–9
 and mat glaze, 98
 and Paris Universal Exposition, 94–96
 as president and treasurer of Rookwood, 79–80
 as shape designer, 135, 163, 175, 177, 181, 183, 185, 187, 189, 223
 and Van Briggle, 124
technology, progress in, 93
Tonalist compositions, 104
Toohey, Sarah Alice, 93, 103
trade, manufactured goods, 132
traders, conflict with, 5–6
"Trail of Tears," 21
treaties
 Agreement of 1880, 183
 dissatisfaction with, 4–6, 179
 Fort Laramie, 179, 199–200
 Greenville (1795), 1
Turner, Frederick Jackson, 28, 82–83

Ulke, Henry, photos by, 179
Umatilla, 245
Ute
 baby, 220–21
 Ouray, 183
 Suriap, 243

Valentien, Albert Robert
 award to, 96
 and gender bias, 110
 painting Vellum line, 102–3
 preference not to work in Indian portraiture, 67, 107
 salary, 111
Valentien, Anna, 98–99
Van Briggle, Artus, 69–70
 artistic promise, 111
 artistic skill, 85
 bio, 230
 crucible pitcher, 72–73
 departure from Rookwood, 96, 103
 pieces at World's Columbian Exposition, 84
 plaques, 231–33, 234–36
 role in initiating mat glaze, 124

vases
 Daly, 138–39, 140–41, 142–43, 144–45, 146–47, 148–51, 152–54
 first Indian motifs, 69–70
 with gorgets, 70, 116, 148–51
 Horsfall, 162–63
 Hurley, 168–69
 Laurence, 190–91, 192–93, 194–95, 196–97, 198–200
 McDonald, 206–8
 pocket, 224–26, 260–61
 Reed, 210–11
 Sehon, 214–15, 216–17, 218–19
 Vellum, 103–4
 Young, 242–43, 244–45, 248–49, 254–55, 256–57, 258–59, 268–69
Vellum glaze line, 102–4

Wanbli Ho Waste. *See* Good Voice Eagle
Wanstall, 264–65
War Department gallery of Indian portraits, 20
Wareham, John Hamilton Delaney, 107
Wea, 5
Weasaw, 146–47
Western Museum Society, 13–14
Wets It, 196–97
White Buffalo, 258–59
White Eagle, 172–73
White Man, 254–55
Whiting, Frederick Allen, 101
Whittlesey, Charles, 11
Wilcox, Harriet Elizabeth, 93
 ale set, 78–79
 artistic quality, 112
 bio, 237
 departure from Rookwood, 103
 loving cup, 238–40

Wild West
 Buffalo Bill and, 24–26
 Cincinnati's, 34–45, 51, 91
 observations regarding Sicangu participation, 48–49
 Pawnee Bill's show, 46
 Rookwood and, 67–68
women
 bias at Rookwood, 110–11
 custom of wearing hair pipe ornaments, 247
 in pottery, 78–79
World's Columbian Exposition (1893), 12, 29–33, 82–84
 Buffalo Bill at, 25–26
 ethnological exhibits, 19, 29–33
 frontier thesis presented, 28
Wounded Knee, Massacre at, 26–27, 39
Wright, George J., 34–35
Wyandot, relocation march, 21–23

Yelland, Henry, 149
Young, Grace
 artistic expression, 115
 artistic quality, 112–13
 bio, 241
 contribution to Indian portraiture, 96
 departure from Rookwood, 103
 Indian portraiture 1902–3, 99–100
 loving cup, 250–53
 pitcher, 246–47
 plaques, 262–63, 264–65, 266–67, 270–71
 pocket vase, 260–61
 vases, 242–43, 244–45, 248–49, 254–55, 256–57, 258–59, 268–69
Young Iron Shell, 35, 36, 47, 202–5
 daughter of, 40
Young Joseph. *See* Joseph (Chief)